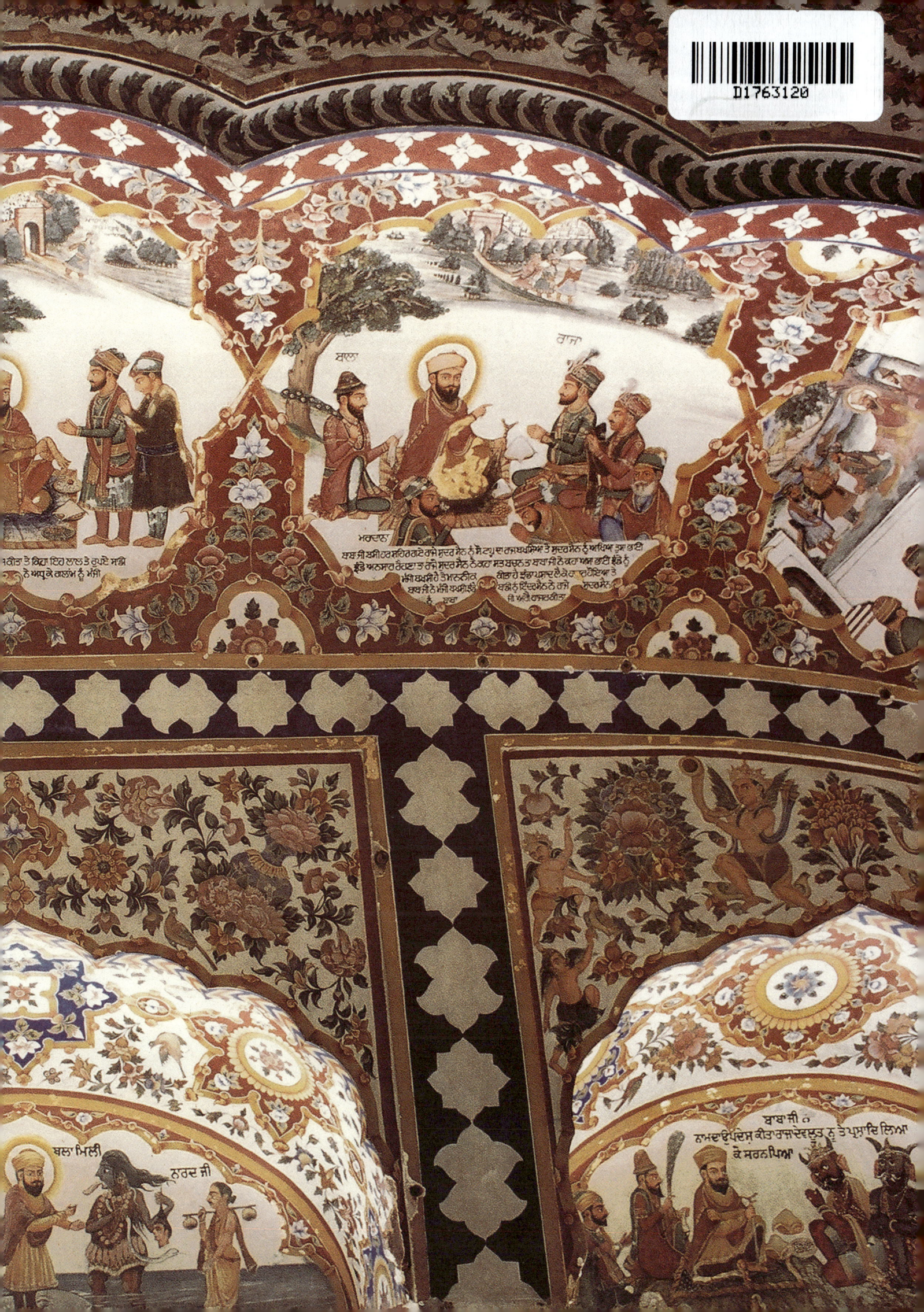

Sri Harimandar Sahib

The Body Visible of the Invisible Supreme

Sri Harimandar

The Body Visible
of the Invisible Supreme

Dr Daljeet & Prof P.C. Jain
Pictures: Rajbir Singh

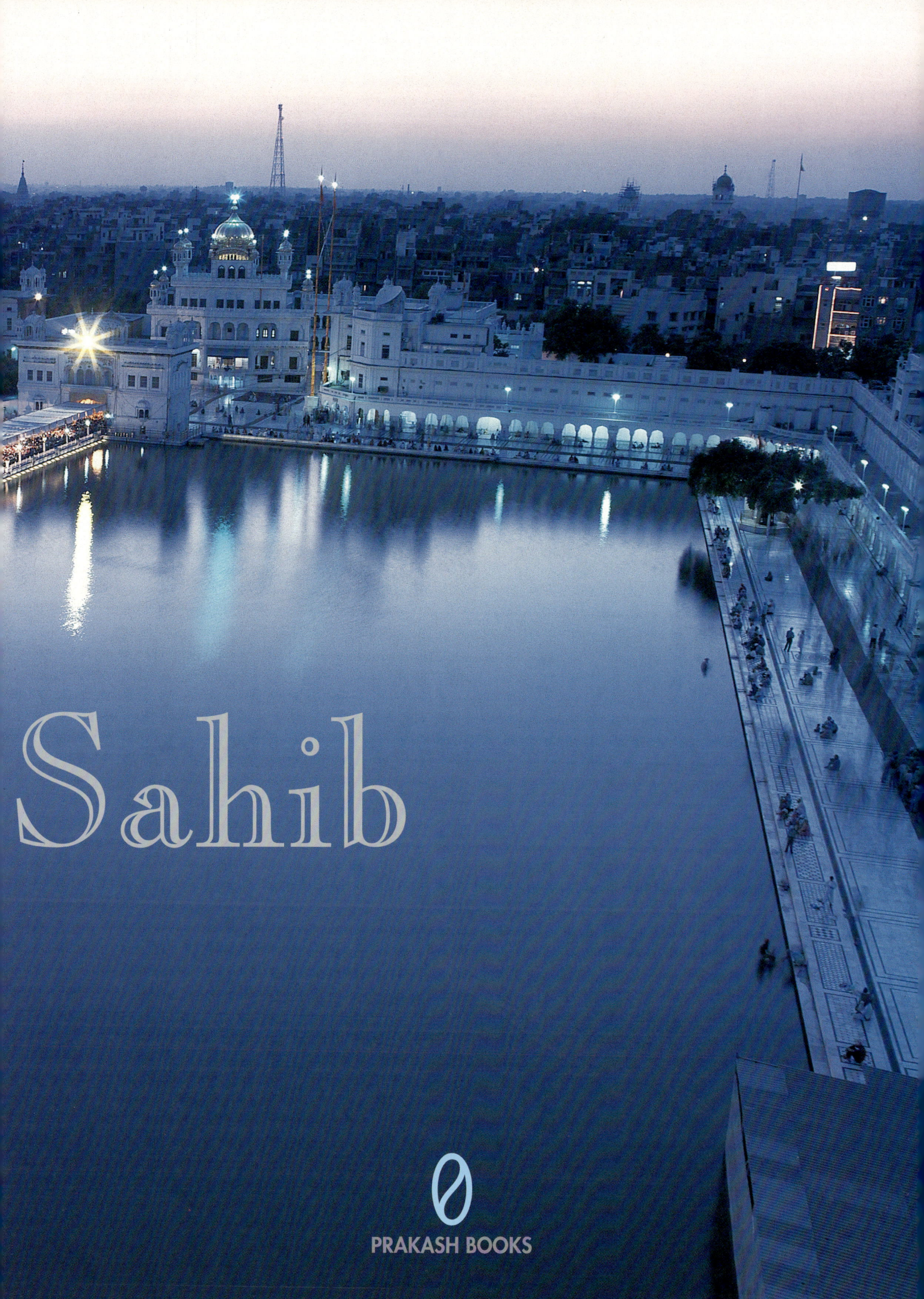

Sahib

PRAKASH BOOKS

Published 2006 by
Prakash Books India Pvt. Ltd.
1, Ansari Road, Daryaganj, New Delhi 110 002, India
Email: sales@prakashbooks.com. Website: www.prakashbooks.com
Tel.: 011-23247062-65

Copyright © 2006 Prakash Books India Pvt. Ltd.

Authors: Dr. Daljeet & Prof. P.C. Jain

Photo: Rajbir Singh

Designed by: Yogesh Suraksha Design Studio. www.ysdesignstudio.com

Photo courtesy: Robert A. Huber (6-7, 57, 63, 66, 80, 81, 87, 94-95, 102, 103, 104, 107, 108, 109, 120, 121, 132-133, 141, 149, 152-153), Sondeep Shanker (92), J.C. Arora (113, 116, 117), Harbans Photo Studio (136, 137)

All right reserved. No part of this publication may be reproduced, stored in a retrieval system or transmitted in any form or by any means, electronic, mechanical, photocopying, recording or otherwise, without the prior permission of the copyright holder.

ISBN: 81-7234-056-7

Printed & bound in India at Thomson Press

C O N T E N T S

11
THE TANK: AMRIT SAROVAR

41
SRI HARIMANDAR SAHIB

111
RITUALS, PRACTICES AND CELEBRATIONS

145
OTHER SIGNIFICANT SHRINES

DEDICATED TO
SAMBUDHA SWAMI OM PRAKASH SARASWATI

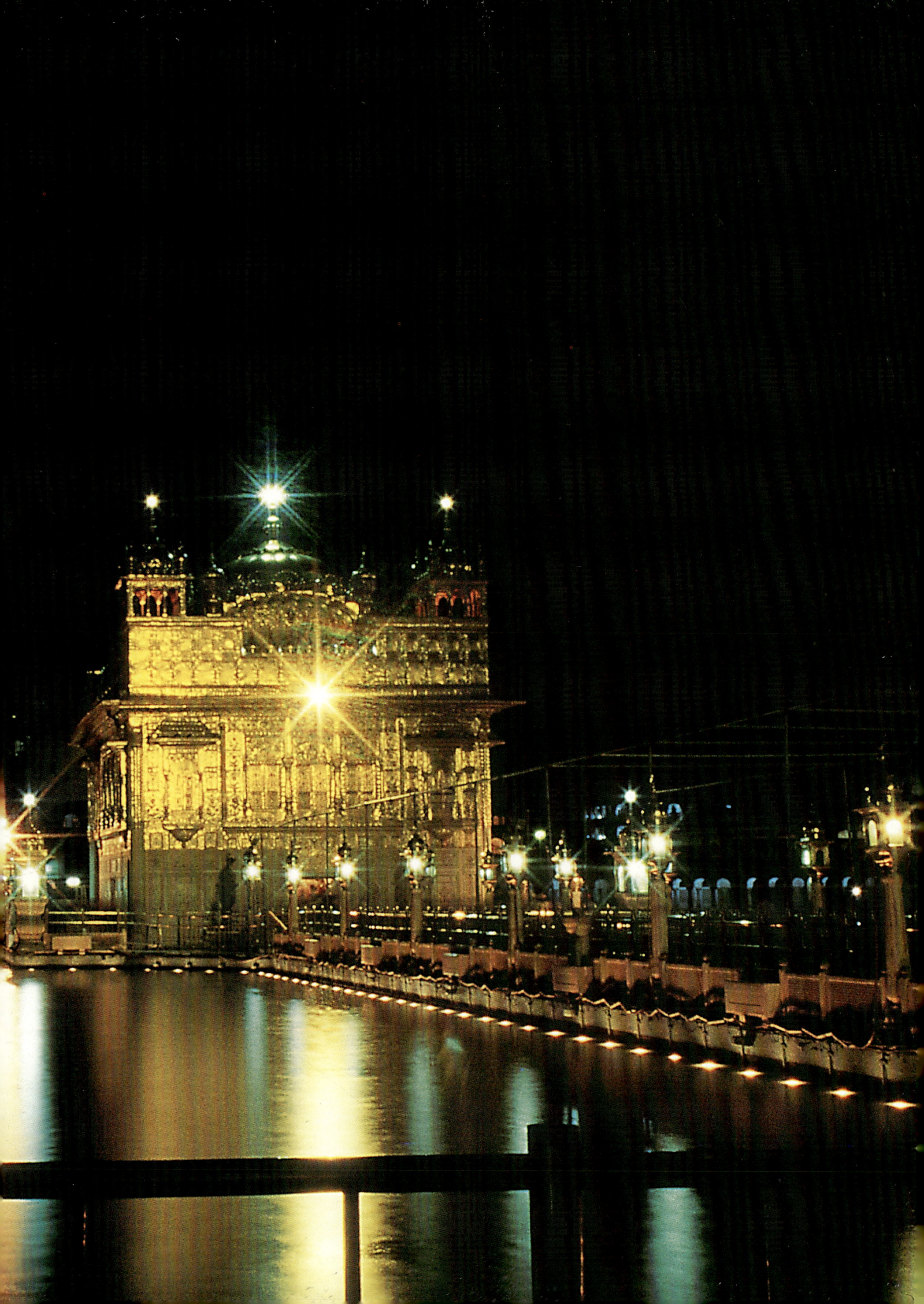

Preface

'*Sri Harimandar Sahib: The Body Visible of the Invisible Supreme*' is a humble attempt at unveiling the sublimity of an otherwise simple puritan brick-structure. It seeks to discover in the Sri Harimandar Sahib the cosmic as well as the spiritual vision of its founder. It is not a mere thesis of mind but something derived from its spiritual and technical perception that Sri Harimandar Sahib did not or rather could not deviate from its original concept, vision and design despite its recurrent renovation and reconstruction. It remains as Sri Guru Arjan Dev had conceived it. Sri Harimandar Sahib is, thus, a creation of divine hands born with timeless quality. It further contemplates how the Sri Harimandar Sahib embodies in an architectural form the body of a dogma, a massive faith, a live tradition and finally the glory of the Supreme. Sri Harimandar Sahib is, to the writers of this text, both, the lamp and the light, a thing 'created' but endowed also with the power 'to create'. Far more than a style of architecture, a building kind, or monument, this epicentre of the Sikh faith and the abode of the Divine Light, is seen as representing the apex of dedication of a great community and the ultimate of a great spiritual journey.

Architecture, chronology of its origin and growth, prevalent myths and legends and various factual aspects figure in the study, but it seeks more characteristically its theme in Sri Harimandar Sahib's strength to unite, mobilise, guide and spiritualise a newly-born community and give it a geography and identity. Sri Harimandar Sahib synthesises into its being the best of all prevalent architectural forms and traditions, though at the same time it as ably distances itself from them all – the mosque, Hindu or Jain temple, Buddhist *vihara* or a church. Even the wide expanse of Sikh architecture does not have, in form or in spiritual magnificence, a second Harimandar, the second abode of the *Nirankara*. Like *Ek-Omkar*, Sri Harimandar is only One, and none other. This study does not attempt at meriting it over or above others but at discovering what is special about it, its uniqueness, something, which only Sri Harimandar Sahib has.

This study attempts also at conciliating the conflicting issues – who chose this site for Sikhs' central seat; who laid the foundation of Sri Harimandar; which model Sri Harimandar followed for its design; whether the present structure adheres to its initial design and layout or is only a late work; whether the irregular octagonal extension of the *Har ki Paudi*, is a later addition and so on. Besides, it discovers the unique relationship of the tank and the temple and significance of water in the Sikh tradition. It also provides basic information of all Temple related rituals, practices, celebrations, etc. The book also discusses other shrines in the complex—both subsidiaries to Sri Harimandar and independent ones—the functional buildings and sacred memorials.

Incidentally, when the book was in print, *sarovar's kar-sewa*, a rare ritual in the Sikh *Panth*, was announced and the authors had occasion to witness and photograph it. The emptied *sarovar* unveiled its base to eyes as also Sri Harimandar in its entirety, from its ground plan to the apex. This confirmed what the authors had concluded from the earlier reported information and from intuition in regard to Sri Harimandar Sahib's ground plan, original and extended floor areas, kind of sub-structure, plinth and wall thickness and how its ground and upper floors emerged from it. The most amazing were the traces of a massive river buried under the bottom of the *sarovar*. Sarovar's bottom was excavated four to five feet deep for laying a pipeline to feed it with treated water. After about a two feet thick layer of clay, the entire bottom revealed from beneath a voluminous mass of sand, characteristic of a Himalayan river. The sand layer spread from one end to its other and was deeper than the excavated depth. The volume of sand suggested the presence of a buried river, which,

before it dried, might have had a massive size. The *sarovar* is said to have serious seepage problem, when constructed. It was a riddle, which the presence of this buried river solves. Practically, a mere two feet thick soil layer could not long retain the seventeen feet deep water on its bosom. The text was called back and revised to include this fresh information.

Sri Harimandar Sahib, with its ever divine glow, intermittent magic, great aesthetic beauty and sublimity of form, is as much a theme for the eye. Hence, *Sri Harimandar Sahib: The Body Visible of the Invisible Supreme* has as strong a visual thrust. A wide range of photographs brings forth the rich monumental wealth of this unique monument. It covers Sri Harimandar Sahib's round-the-clock glimpses, bright sunny days, dark and moonlit nights, drowsy evenings, ejecting dawns and its most curious and as much sublime postures. For a fuller perception, the camera has also caught the life at and around Sri Harimandar Sahib. The most alluring aspect of the book is its visual representation of the recent *kar-sewa*. For continuity of the tradition, photographs of earlier *kar-sewas* of 1923 and 1973 are also included. The book also carries the 18th century miniature paintings portraying Guru Nanak, Sri Guru Arjan Dev and Guru Hargobind, the 19th century lithographs and designs and the early 20th century camera photos of Sri Harimandar Sahib.

During our visits to Punjab, we found that a large section of society wished that the *Sri Harimandar Sahib: The Body Visible of the Invisible Supreme*, was brought out in *Gurmukhi* too as it would facilitate reading for those who do not know English or would prefer reading it in *Gurmukhi*. It was incidentally the 400th year of the first *Prakash Diwas* of the *Adi Granth*. Sri Harimandar Sahib was the seat of the first *Prakash-Utsava*. A book in *Gurmukhi* could, hence, be our humble tribute to the original language of the Holy Book. The publisher Shri Ashwani Sabharwal welcomed the idea and we hope that its *Gurmukhi* version would also become available to our readers.

It is by the grace of the Great Gurus that this book has been made possible. We are thankful to the SGPC for granting us permission to photograph the inside views of Sri Darbar Sahib, the Museum Collection and publish them. We also thank Punjab & Sind Bank for permitting us to publish a few paintings from their collection. We are grateful to Shri P.L. Sodhi who, despite age and bad health, searched many studios and collectors for obtaining for us some unique old photographs. Dr. Jiwan Sodhi, Dr. Pretty Sodhi and the entire family made our stay at Amritsar homelike. We recall with gratitude how Shri S. S. Hitkari was always willing to share with us his lifelong experience and knowledge. We are grateful to Dr. Narinder S. Kapany, Chairman, Sikh Foundation, USA and Dr. Mohindar Singh of Bhai Bir Singh Sadan for providing us with some slides of rare objects. We are also thankful to Dr. Vijay Mathur, Rajeshwari Shah, Deepak Vashistha and Prem Chand who not only helped us in many ways but also boosted our morale. We also thank Shri Rajbir Singh and his wife Paramjit Kaur for their great contribution. We are specially thankful to Shri Atul Anand for his multifarious help, Maa Anand Bharti for her blessings and encouragement, Prem Bharti, Smt. Shashi Prabha Jain, Dr. P. P. Bose, Dr. Mausami Bose, Himani and Vinit Khanna and all our children for their affectionate concern. We thank Suraksha and Yogesh Gajwani for excellently designing the book and Shri Ashwani Sabharwal, his wife Mrs. Pinky Sabharwal and Gaurav Sabharwal, who are always eager to reach the reader with new dimensions of knowledge in the most magnificent way.

Dr. Daljeet and P.C. Jain
Friday, January 14, 2005 *(Makara-Sankranti)*

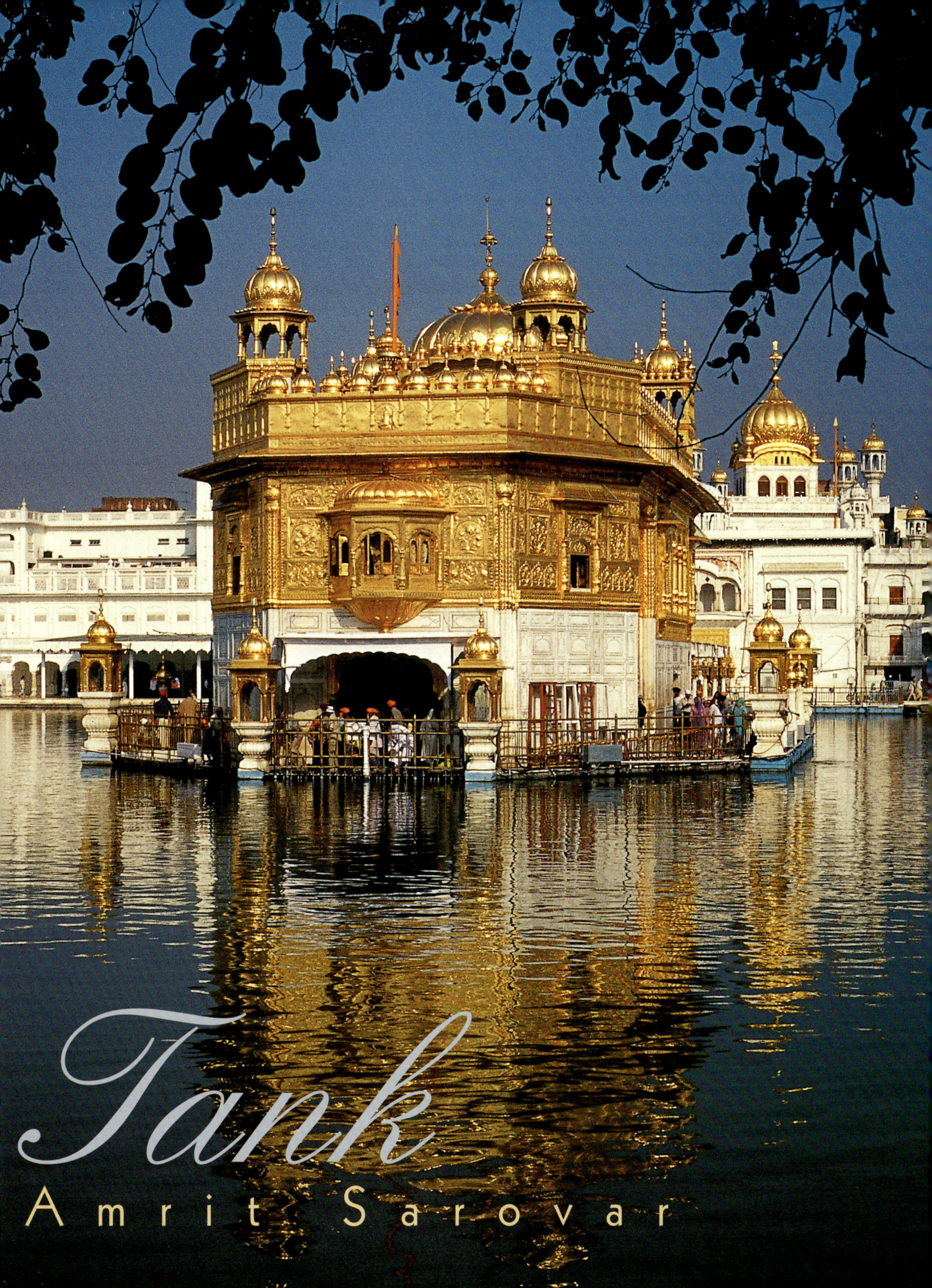

WATER, ABLUTION AND THE SHRINE

The construction of the *Amrit-sarovar*, the pool of nectar, had been accomplished and the Great God had filled it with His grace and benevolence. Now there lay, in the form of a large square tank, a huge mass of transparent blue water. Its banks, paved with fine baked bricks, formed around the tank a deep red frame. This pleasant contrast of blue and brick-red was further enhanced by a number of leafy green beris, which lay scattered all over them. These beris looked like small mounds of emerald rising over a field of coral. The splendour was unsurpassed when the tank cradled upon its bosom crimson dawns ejecting from behind the eastern horizon, warm days made of molten gold, languid evenings treading westward and soothing nights drowsing under the blue canopy inlaid with silver stars.

Moved and overwhelmed by this divine lustre and the unique beauty of the *sarovar*, Sri Guru Arjan Dev, with tears of delight and thankfulness flowing from his eyes, looked towards the sky, the abode of the Benevolent, Who accomplished everything so gracefully, and without a detriment. And, the enrapt saint did not know when and how he began singing:

The Creator, the Great Lord was Himself my support,
And, hence, nothing harmed me.
The Guru hath perfected my Ablution.
I contemplated the Lord, and thus, my sins were washed off.
O Saints, beauteous is the tank of Ram Das;
Yea, whosoever takes a bath in it, his generations are blessed.
He is applauded by all,
And he has all his desires fulfilled.
Bathing, his mind is in peace,
For, he contemplates God, his Lord.
He who bathes in this tank of the Saints
Receiveth the Supreme Bliss.
He dieth not, nor cometh, nor goeth;
For on Lord's Name alone he dwelleth.

As applauded in this verse, the pond of Guru Ram Das, was Sri Guru Arjan Dev's first shrine and the ablution his foremost rite. Sri Guru Arjan Dev perceived in them the power to redeem from the cycle of birth and death. Sri Guru Arjan Dev was not, however, the first Sikh pontificate to discover this unique power of the pond and ablution. In Nanak's tradition, water and ablution always had the same significance. A pond meant to a Sikh what a temple meant to a Brahmin or Jain, a church to a Christian, a mosque to a Muslim, or a gompa or stupa to a Buddhist. Sikh Gurus were not the only ones to realise this significance of water and ablution, but they were certainly different in their approach. In several religious and ritual traditions, rivers and ponds had greater significance. These traditions often deified them and attributed to them the power to redeem and to many of them

(Facing Page) Guru Nanak attended upon by sages of other sects: This early 19th century miniature represents Baba Nanak attended by Bhai Balaji and Mardanaji and the ascetics of different other religious orders. Baba Nanak not only founded the Sikh Panth, but also associated with it in inseparable unity the recitation of *Bani* and water for ablution, both as the most sacred rituals of the Panth, which the *Amrit-sarovar* and Sri Harimandar Sahib finally instituionalised.
Courtesy: State Museum, Shimla.

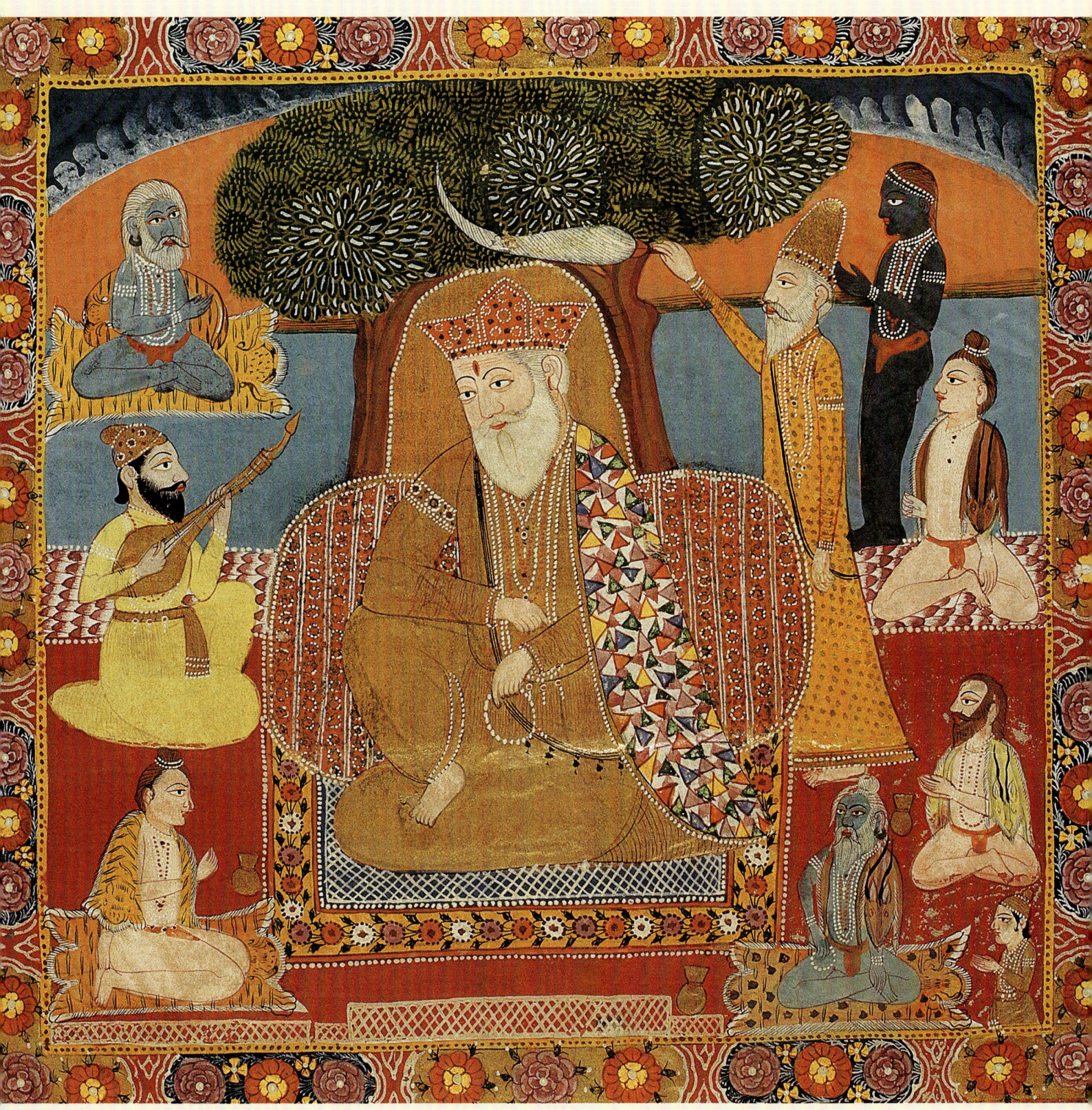

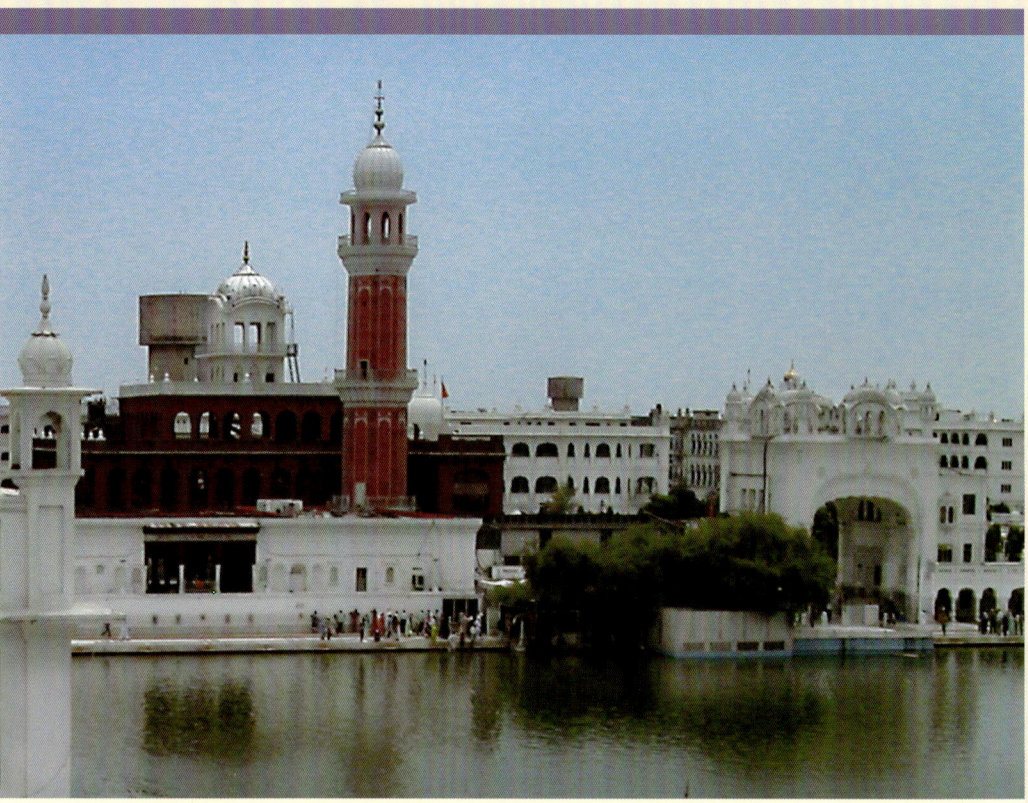

Dukh-Bhanjani Ber and the Eastern Gate: Though a simple puritan gateway, the Eastern Gate has exceptional significance in the Sikh tradition. It was on this side that the ancient trade route passed and the Dukh-Bhanjani Ber was discovered with its charismatic power to heal. To a great extent, Dukh-Bhanjani Ber caused first the construction of the *Amrit-sarovar* and then of the Sri Harimandar Sahib. The panoramic view includes the towering Bungas, Langar-ghar, various yatri-niwas and the administrative building complex.

independent shrines and seats. But it was not the same in the Sikh tradition. The Sikh Gurus neither deified them nor attributed to them an independent or even a subordinate shrine. The significance they attached to a tank was nonetheless far more. They conceived the tank as temple's essential component. They could think of a tank without a temple but not of a temple without a tank. The tank and the temple, thus, stood in Sikh tradition in inseparable unity and the tank was as much the essence of Sikhism as was the temple. This inter-relationship of the tank and the temple is the unique feature of Sikhism.

In Nanak's path, this inter-relationship of the tank and the temple, or rather tank's priority over the temple, is deep rooted. Since the inception of this tradition, water and ablution emerged as two most significant essentials of Sikhism, and not without sound reasons. It was while bathing in river Vahi at Sultanpur that Guru Nanak was enlightened. He chose to establish the township of Kartarpur, the first seat of the Sikh doctrine, on the bank of river Ravi. The doctrine of *Nam-simaran* emerged, thus, not by way of penance, performed on a hilltop, or in a deep forest, but from around the water and in the course of ablution. Guru Amar Das, the third pontificate of the Sikhs, is known for his absolute dedication and service. Despite that his Guru was twenty-five years younger to him, Guru Amar Das, before he ascended the *Gurugaddi*, fetched water for twelve years from river Beas for his Guru's ablution. River Beas was several miles away from his Guru's seat. The significance of water, both as the means of physical purity and as the ladder of spiritual sublimation, was, thus, well known to Guru Amar Das. Hence, when he ascended the *Gurugaddi*, the first thing, which he did, was the construction of a huge *baoli*, a reservoir, at Goindwal.

The Goindwal *baoli* had a flight of eighty-four steps. One could reach its water by descending down these eighty-four steps, but Guru Amar Das

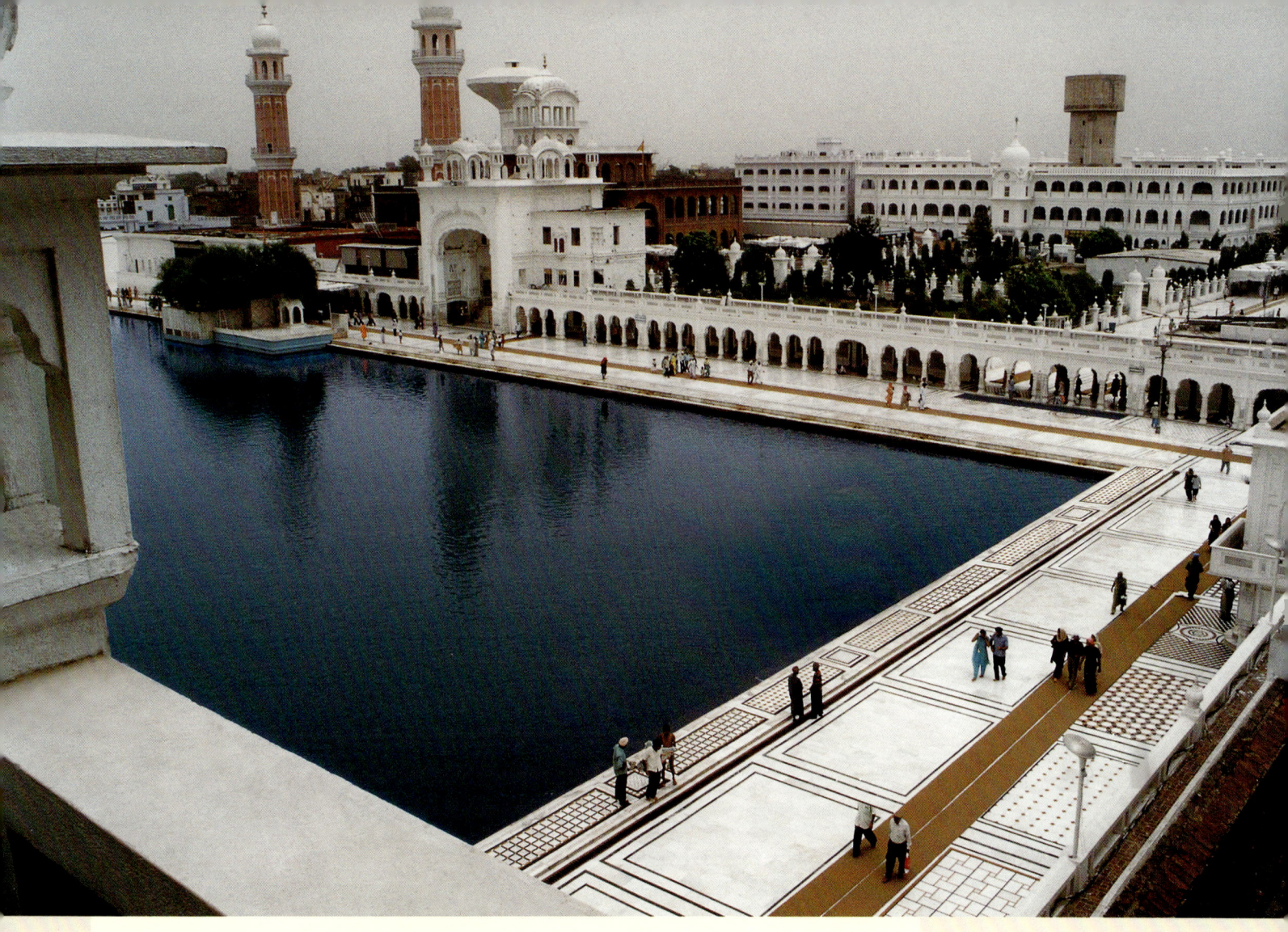

declared that he who commemorated *Japuji Sahib* once on each step was redeemed from the cycle of life and death and was no more required to ascend or descend those steps. Guru Amar Das, it seems, when conceiving a *baoli* with eighty-four steps, had in mind the Indian tradition of thought, which believed that the self had to pass through a cycle of eighty-four crore births and deaths before it attained salvation. He believed that commemoration of *Japuji Sahib* eighty-four times, that is, once on each step of the *baoli*, redeemed the self from this cycle of eighty-four crore births and deaths. Guru Amar Das had discovered in the *baoli* his sanctum sanctorum wherein enshrined the redeeming power of the Supreme, and with this was born the temple in the Sikh tradition. The *baoli* of Guru Amar Das was Sikhs' first manifestation of a temple, the body visible of the invisible Supreme.

The Tank: Holy Amrit Sarovar

Baba Nanak's association with water could be casual, but in the case of Guru Amar Das it was born of a conscious mind and determined hands. The *baoli* was the first materially present entity wherein Guru Amar Das perceived and enshrined the redeeming power of Nanak's *Karta-Purukh*. A pond, river, or *baoli*, thus, had for him a different kind of significance and the service rendered at any of them was at par with the service rendered to the Supreme. The water, far more than a material necessity, was for him a ladder of transcendence.

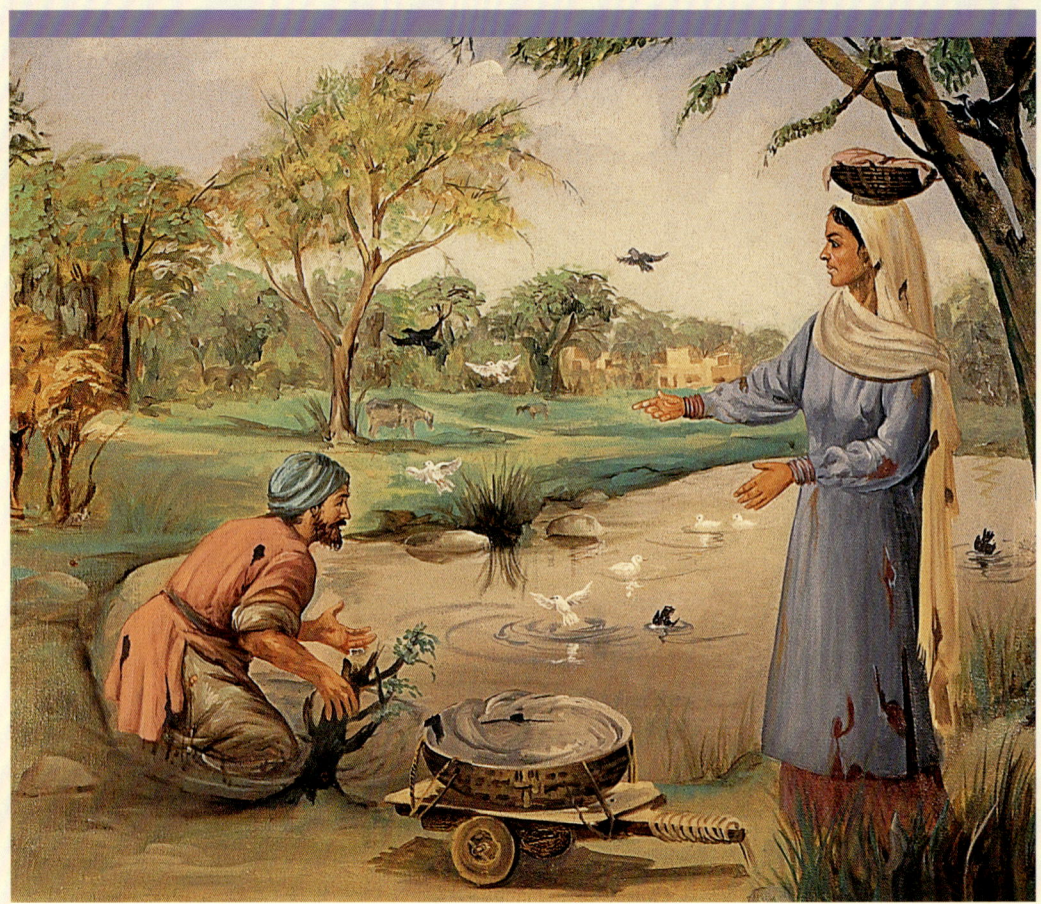

The Rajani legend: The legend of Rajani, the wife of a leper husband who was cured of leprosy after a dip in water under the Dukh-Bhanjani Ber, has great significance in the Sikh tradition. It is said, Guru Ram Das decided to construct the tank around Dukh-Bhanjani Ber after he heard of the Rajani episode. This painting renders the episode beautifully and appropriately.
Courtesy: Central Sikh Museum, Golden Temple, Amritsar.

(Facing Page) Sri Guru Ram Das: This early eighteenth-century miniature portrays Guru Ram Das who created the *Amrit-sarovar* and founded Ramdaspur, now known as the city of Amritsar.
Courtesy: State Museum, Shimla.

He, hence, believed that a Sikh Guru could most aptly have his seat around a reservoir, a pond or river. With such frame of mind, when Guru Amar Das was looking for a suitable seat for his successor, his attention was caught by the pond lying amidst the villages named Tung, Gilwali, Sultanwind and Gumtala. This pond, known subsequently as Amritsar, fell on the trade route connecting India with Afghanistan and the world beyond. Maybe, Guru Amar Das foresaw in the place, in addition to its spiritual significance, potentials to develop as the axis of the new faith. The pond had around its banks shady and fruit-bearing trees, the beris, or jujubes, in particular. It could provide to the caravan, passing across, shade to relax and water to quench their thirst. Guru Amar Das felt that Baba Nanak's message, if transmitted from here, would reach far and wide within and beyond the boundaries of the subcontinent.

The pond had a great legendary past. It seems, Guru Amar Das was immensely influenced by it and it was, perhaps, the foremost reason for his choice of the site. Guru Amar Das, even before he turned a Sikh, was a devout theist attending to prevalent religious activities including recitations of *Puranas* and other holy texts. They alluded to legends relating to a divine *Amrit-kund*, the pool of nectar, for obtaining the possession of which there occurred a number of *devasura-sangrams*, or a series of wars between gods and demons. Guru Amar Das had learnt from local traditions that the pond he was attracted to was the same legendary *Amrit-kund*. There prevailed numerous other myths. One linked it with the Great War, *Mahabharata*, and the other with the great epic *Ramayana*. The *Ramayana*-related tradition asserted that it was around this tank that

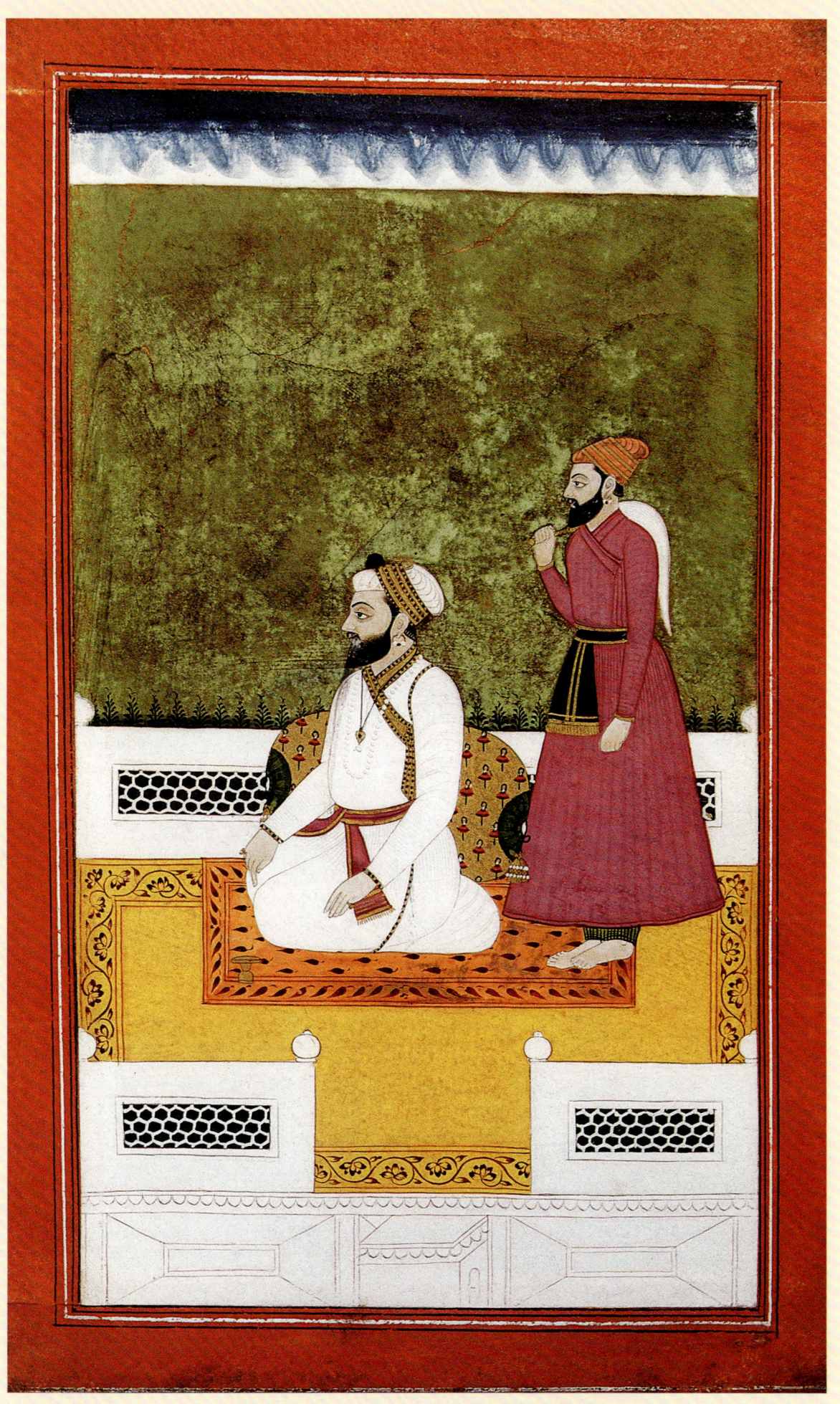

the *ashrama* or the seat of the great sage Valmiki lay. The great epic *Ramayana* was composed here; Sita, when exiled by Rama, bore here her two sons, Lava and Kusa; and it was here that Lava and Kusa defeated the army of their father Rama, killing thousands of his soldiers. Yet another tradition claimed further that the soldiers so killed in the battle were brought back to life and the wounded healed by the water of this pond. This belief as much prevailed during the lifetime of Guru Amar Das. He not only believed it but also put it to trial. Guru Angad, the second pontificate of the *Panth*, was suffering from some kind of skin disease. Guru Amar Das, before he had ascended the *Gurugaddi*, carried to Guru Angad its water and some herbs growing around it, which on being applied cured him completely. Guru Amar Das resolved that he would develop

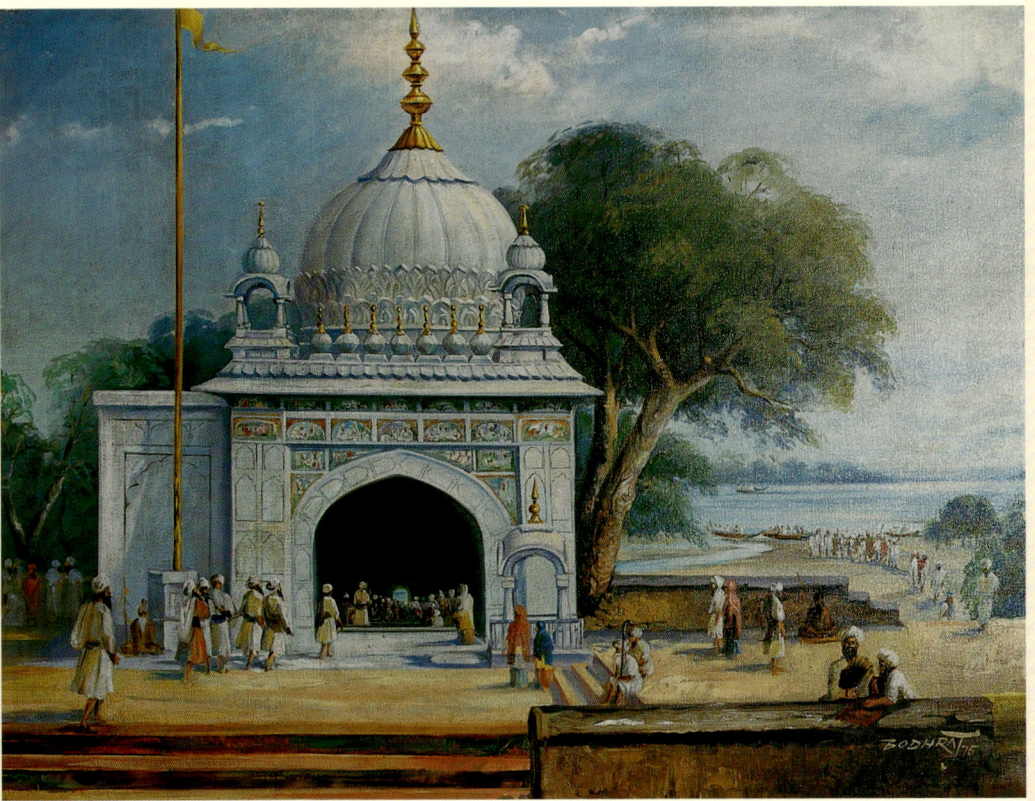

The Baoli at Goindwal:
The Goindwal Baoli, constructed by the Third Sikh Guru Amar Das, is the earliest structure constructed by any Sikh Guru. Besides, it is also shouded in a kind of mysticism. Guru Amar Das built it with eighty-four steps and propounded that recitation of *Japuji Sahib* on each, step while descending the Baoli would redeem from the cycle of birth and death. In Indian tradition, the self is believed to transmigrate through eighty-four crore births and deaths before it is redeemed, that is, one-time recitation of *Japuji Sahib* is equivalent to one crore births and deaths.
Courtesy: Bhai Matidas Museum, Delhi.

the pond and the area around as the seat of Baba Nanak's doctrine, as and when he found opportunity to do so.

Guru Amar Das was 73-74, when he was nominated the third Guru of the *Panth*. He had made up his mind to retain the Guruship within his family and his son-in-law Bhai Jetha, who ascended the *Gurugaddi* as Guru Ram Das, was his chosen successor. He wished Bhai Jetha established his own independent seat before he was nominated the Fourth Guru of the sect. Perhaps, Guru Amar Das could foresee some kind of confrontation between his sons and his son-in-law over the issue of inheritance. He felt that the legendary *Amrit-kund* could be the most appropriate site for his seat and for the seat of the *Panth*. Bhai Jetha only bowed humbly to what his Guru commanded and left for his new abode. It is said that Guru Amar Das gave him some funds and commanded Baba Buddhaji and a few other senior Sikhs to accompany and assist him in developing the

pond and the site. It is almost unanimously held that the construction of the pond commenced around 1572. After about two years, in 1574, Guru Amar Das passed away and Bhai Jetha, as Guru Ram Das, ascended the *Gurugaddi*. Now the tank-site was his permanent abode. The construction of the tank ended by 1577, but that of the township, which Guru Ram Das had begun simultaneously continued for the rest of his life. The town that evolved came to be known variously, as Ramdaspur, Chak Ram Das, Chak Guru, Guru ka chak and so on.

There is in prevalence another tradition, which confines all pond-related events to Guru Ram Das. According to this tradition, it was Guru Ram Das who was highly impressed with *sarovar's* legendary past and felt that a place with such spiritual magnanimity alone could have the potentials to develop as the

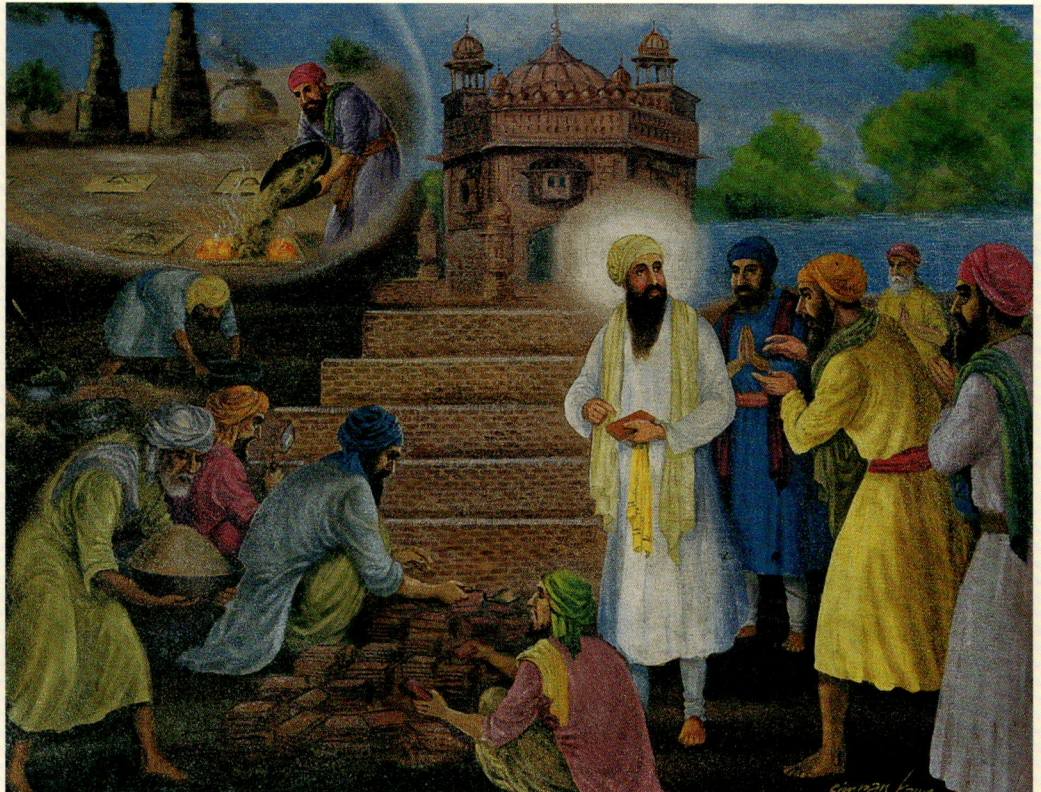

Sri Guru Arjan Dev supervising construction of Sri Harimandar Sahib:
Sri Guru Arjan Dev, with the divine halo around his face, is supervising the construction of Sri Harimandar Sahib. In the course of checking the supply of material, particularly bricks, Sri Guru Arjan Dev finds that bricks piled at the site have gold-like glaze. When asked, he was told that once when clay fell short, Bhai Bahlo collected debris and waste and put it into his kiln and what came out were these bricks. Suggestively, the artist Simaran Kaur has painted the Sri Harimandar Sahib and the chimneys of Bhai Bahlo's kiln in the background.
Courtesy: Bhai Matidas Museum, New Delhi.

epicentre of the Sikh faith. Some scholars assert that it was during an itinerary that Guru Ram Das saw the pond and was so much impressed by its location and over-all beauty that he decided to make it his seat. The highly dramatised and variously narrated legend of Rajani, the daughter of Rai Duni Chand, the revenue collector of Patti, is, however, more popular in this regard. Rajani, a Godloving maiden, being asked by her father as to whom she considered the most benevolent, said it was none else but God. Her vain father, who thought it was him, the father who fed his children, was annoyed by her answer and as a challenge to let her try her fate and God's benevolence with a leprous husband married her to a leper. The poor girl, carrying her disabled husband in a basket, wandered from one place to the other. One day, while passing by this pond, she learnt that a bounteous saint, engaged in digging the tank, had his *dera* and *langar* around there.

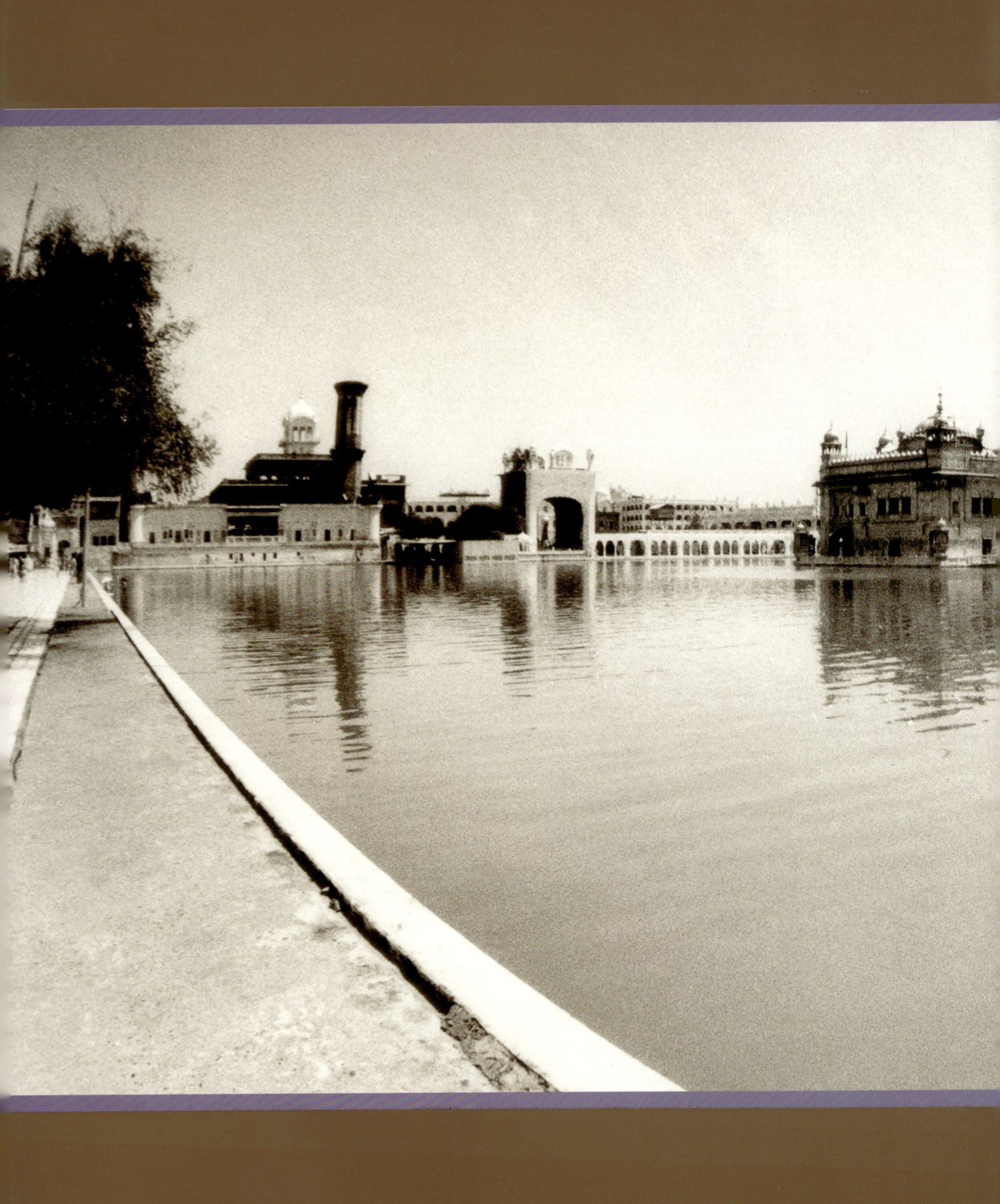

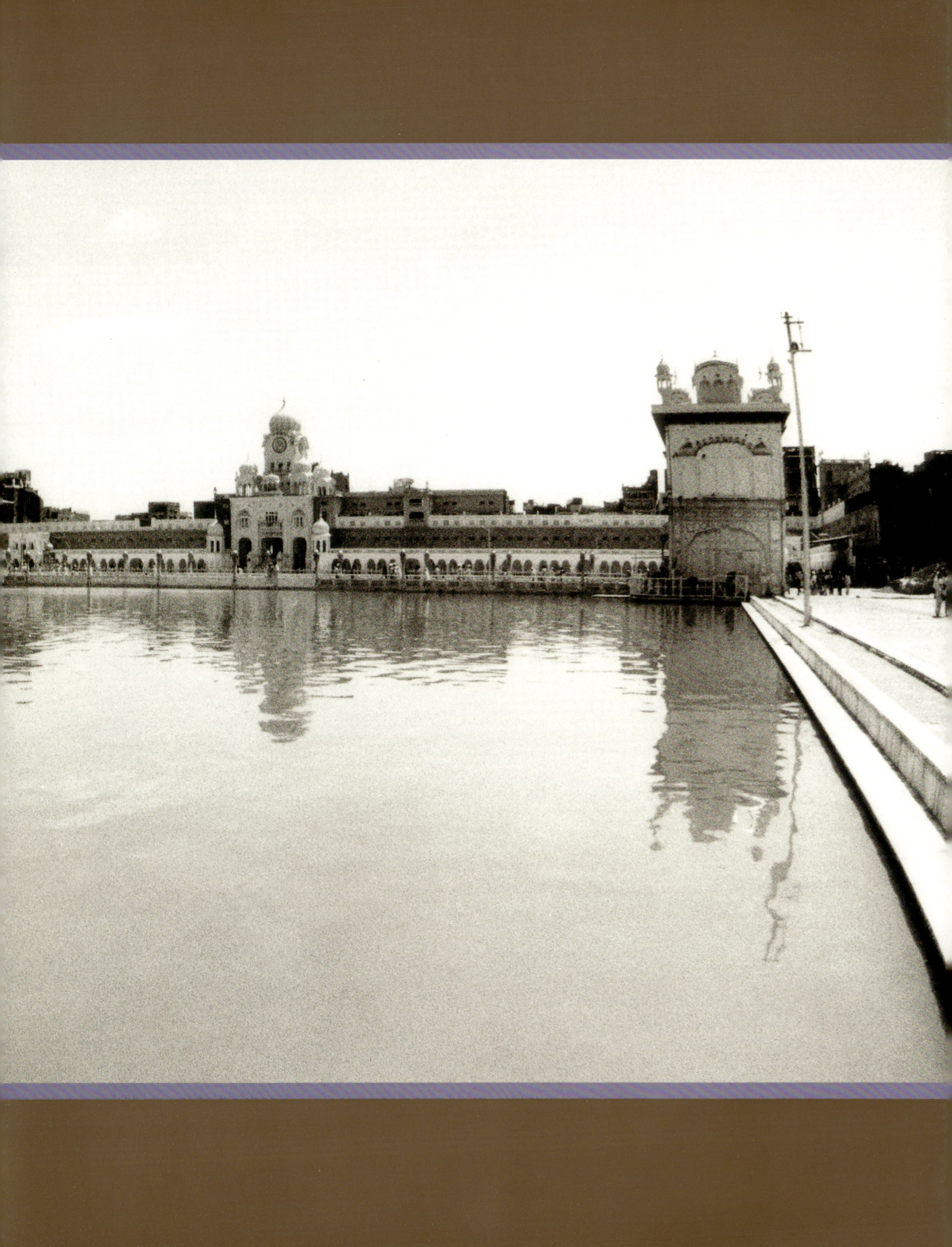

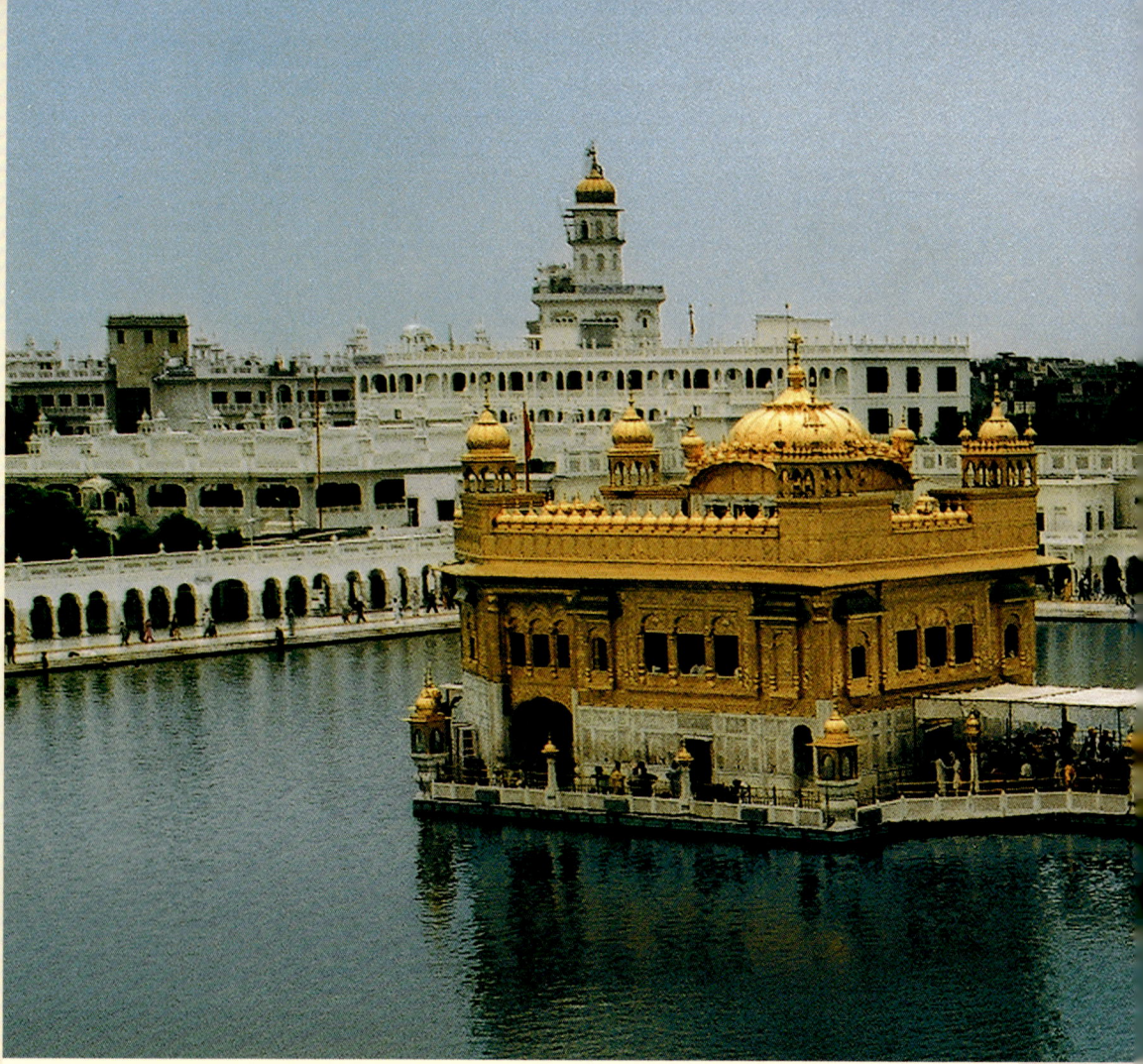

(Preceding Pages) The sublimity at large: This 1972 photograph has captured Sri Harimandar Sahib in its most sublime and widespread dimensions. Shot from the northwest corner, it mirrors, besides Sri Harimandar Sahib and the *sarovar*, also the *Darshani Deorhi*, Southern and Eastern Gates and one of the two historical bungas in the shape as they were before recent reconstruction.

She left her husband on its bank and went to the saint's *dera* in hope of getting some food for her hungry husband. Rajani's husband, left to himself, gazed emptily above him into the sky and then around him over and across the blue waters of the *Amrit-kund*. And, to his utter dismay he noticed that the crows that were born black turned milk-white after they dipped into the water of the pond. He leapt out of his basket, crawled towards the pond and supporting himself upon a creeper descended into pond's water for a dip, and, what a miracle, he was cured of leprosy. When back with food, Rajani saw the miracle and melted into tears of thankfulness for His benevolence. As regards Guru Ram Das, the fable concludes in two different ways. The overwhelmed Rajani rushed back to the holy saint and narrated the miracle to him. He thereupon visited the site and decided to develop it. According to the second version, in the course of one of his itineraries, Guru Ram Das was in a nearby village, where he heard of the episode. He later visited the place and was so impressed that he decided to make it his seat.

Broadly, it appears unlikely that Guru Ram Das learnt about the pond during an itinerary or from the Rajani legend. As the myth itself has it, Guru Ram Das was already engaged in digging the tank when the Rajani episode took place. The Itinerary theory also would not work. In Sikh tradition, it was the Guru of the *Panth* who ordinarily performed itineraries, that is, Guru Ram Das was already *Panth's* pontificate before he heard of the Rajani episode and chose the site for his seat. But, different from it, there is unanimity as to the fact that he had begun the construction of the tank when he was yet a disciple of Guru Amar Das.

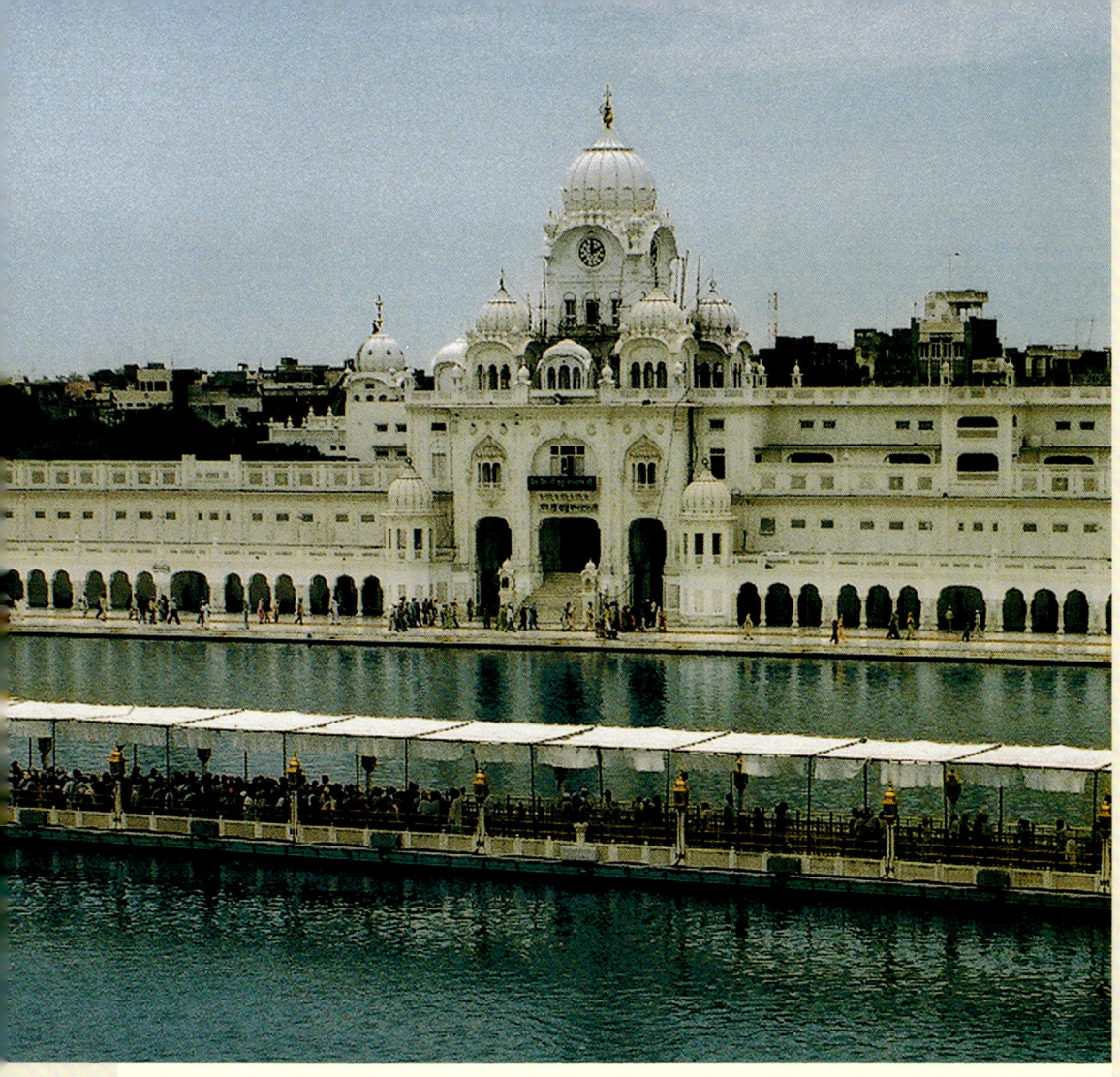

Sri Harimandar Sahib: The axis of faith of millions: Sri Harimandar Sahib, couched in the centre of the *sarovar*, draws to it thousands of devotees every day but on Sundays the number of visitors increases enormously. On such crowded days, the narrow causeway, packed with colourful devotees queuing with bowed heads, seems to move towards its Supreme Lord breaking the monotony of the wide-stretched waters.

Maybe, he had some idea of the tank and its legendary past, but under the Sikh norms, during the lifetime of his Guru, he could initiate tank's construction only at the behest of his Guru and more so under his authority. Hence, it is more likely that the choice of the place was that of Guru Amar Das and he was the one who provided preliminary means to develop it. And, whatever the related legends, its potentials as a location falling on the main trade route, mythological and spiritual status in public mind, general significance of a tank in the Sikh tradition and the healing properties of its water were perhaps stronger reasons for choosing the place for Sikhs' supreme seat. It is not unlikely that Guru Amar Das also perceived it as an effective safeguard against any likely confrontation over the issue of the inheritance of the *Gurugaddi*.

The Title of the Sarovar

The construction of tanks, *baolis*, *dharmashalas* and so on was always a benevolent public service. Therefore, questions related to their ownership scarcely arose. It seems that the issue of land's ownership was not given, any thought at the time when the construction of the tank had begun, nor the landowners objected to it. But, after it evolved as a magnificent site, landowners' attitude might have changed and there arose demand for land's cost. It is likely that there upon Guru Ram Das paid to them, in 1577, after the construction had been accomplished, a sum of rupees seven hundred as the cost of the tank and the land lying around, and obtained its legal title.

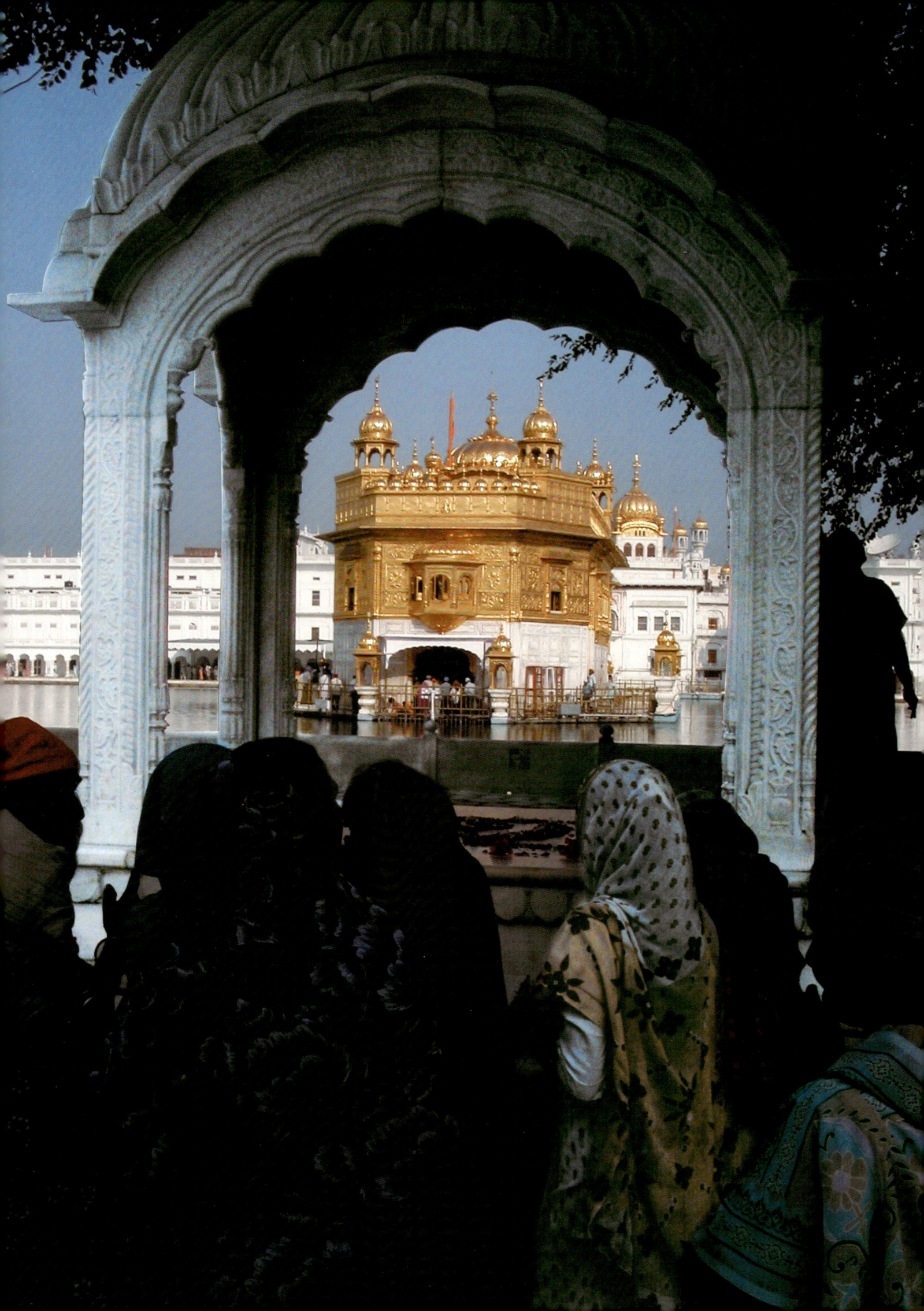

According to some scholars, the tank and its surrounding land, along with a *jagir* comprising of some villages of Jhabal *pargana*, were presented to Guru Amar Das by the Mughal emperor Akbar, when on his way to Lahore, he visited him at Goindwal. The Mughal emperor had shoun his gratitude towards the holy saint by whose blessings he was able to conquer the invincible fortress of Chittor. Guru Amar Das initially declined but finally accepted it for the benefit of his *sangat*. A division of such scholars emphasises that the grant of the land and *jagir* was made to Bibi Bhani, the daughter of Guru Amar Das, after her father did not accept the offer. But, neither Akbar's court record, which was meticulously maintained with details of each grant, nor his biography, the *Ain-i-Akbari* by his court biographer Abul-Fazl, which is packed with minute details, contains any reference to a grant made by the Mughal

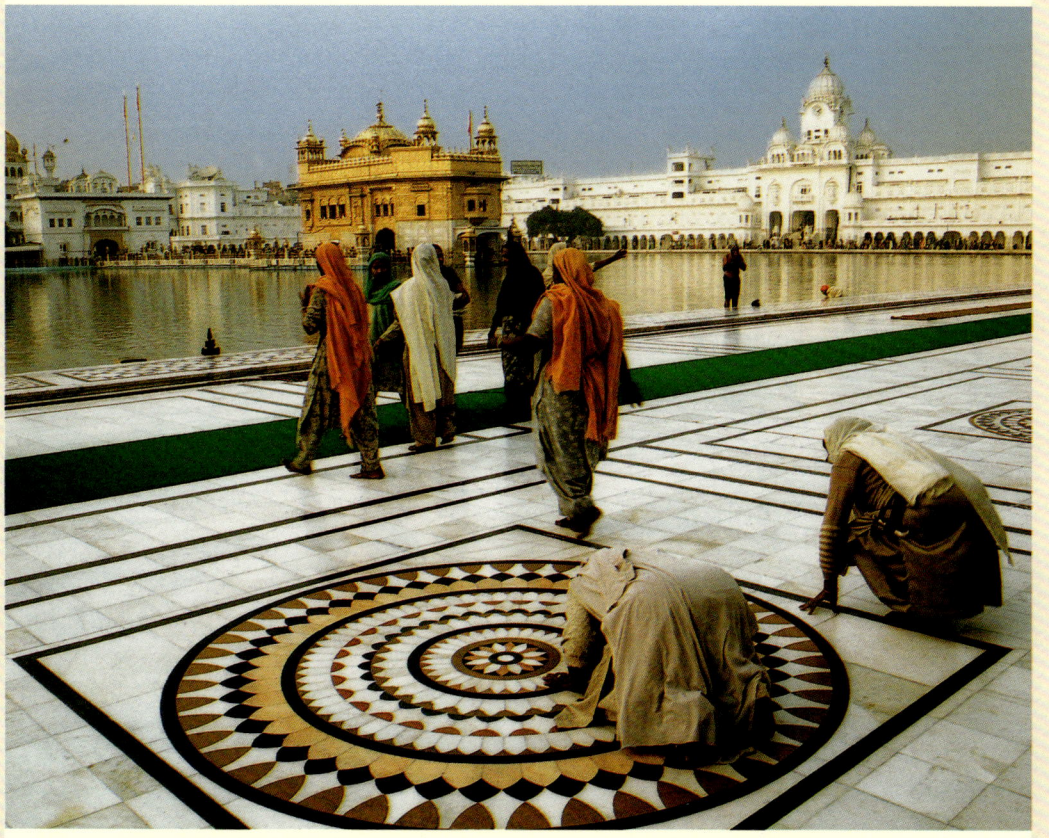

Parkarma and devotees:
Parkarma, providing frame to the *sarovar* and breathing space to the entire complex, is one of the most beautiful components of Sri Harimandar Sahib premises. Paved with beautiful marble and inlaid with various colourful designing patterns, the *Parkarma* is so mystic in its bearing that the moment one enters it, you bow your head.

(Facing Page) Athsath Tirath:
Adjacent to Gurdwara Dukh-Bhanjani Ber and in straight line to the Eastern Gate, there stands a small but highly sacred domed kiosk known as the Athsath Tirath. As the tradition has it, Sri Guru Arjan Dev, while supervising construction of Sri Harimandar Sahib had his seat here and also that the *Bani-Pothi*, brought from Baba Mohanji, was first consecrated here. It is believed that bowing head at Athsath Tirath is equivalent to pilgrimage of sixty-eight pilgrimage centres. Athsath Tirath is always thronged by visitors. Its pillars and arches provide a brilliant frame to Sri Harimandar Sahib.

emperor to either Guru Amar Das or Bibi Bhani. In all probability, it is fiction, which seeks to link with each other the two great personalities of the time. Maybe, and it is more likely and also logical, that Akbar exempted the land, purchased by the Sikh Guru, from land revenue, which a land-holder was required to pay to the Mughal empire. The 1865 land records of the British Government, which is the earliest available record in the matter, enters the land of Darbar Sahib as a revenue-free grant, a kind of *abadi* land exempt of all revenue fees. Akbar perhaps knew that Guru Amar Das would not accept any favour, if offered. And, such exemption, as of land revenue, Akbar could grant without requiring the Sikh Guru to make a formal request or say 'yes' or 'no' to it.

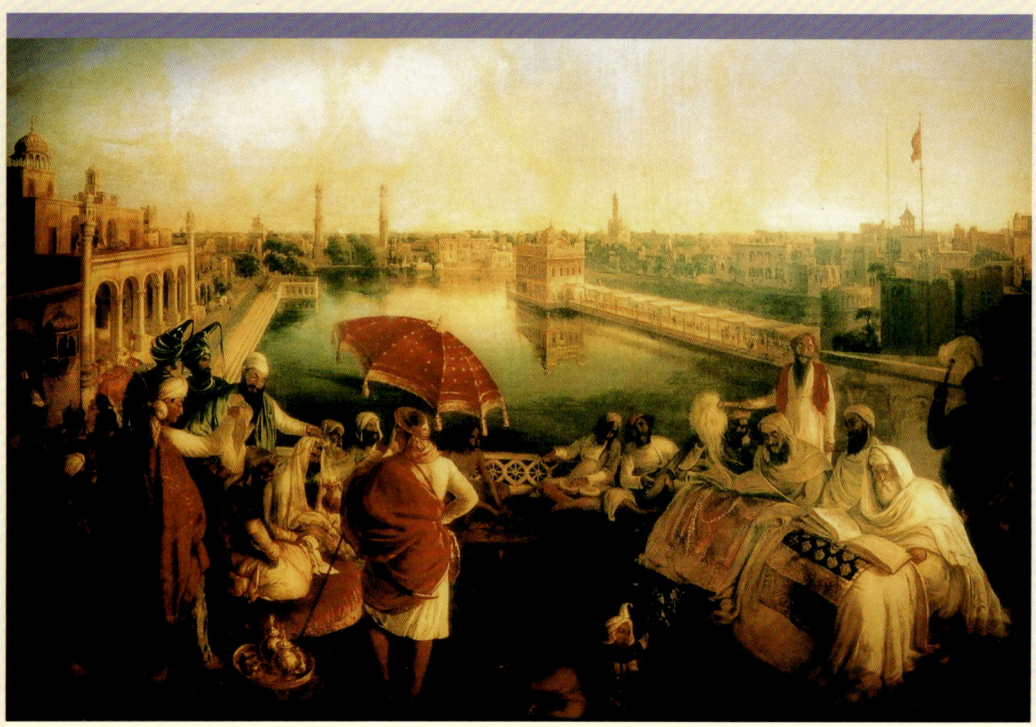

Maharaja Ranjit Singh attending recitation of Sri Guru-Granth Sahib:
A painted copy by an unknown Indian artist from the original oil painting of 1841, by the European painter A. Schoefft, now in the Princess Bamba Collection, Directorate of Archaeology, Government of Pakistan, Lahore. It represents Maharaja Ranjit Singh listening to the recitation of Sri Guru Granth Sahib in open outside Sri Harimandar Sahib. Behind him is painted the Sukracharia Bunga, his camp at Sri Harimandar Sahib and in far east is seen Sri Harimandar Sahib. The superstructures of the two towering minarets comprise kiosks, though in 1973 photographs, they comprise flat terraces. It seems, the recently constructed towers follow this early pattern.

The Sarovar before it was developed

There is no doubt that the construction of the tank or *sarovar* preceded the construction of the temple, but it is the temple, which by its various constructed members, their location, direction and altitude etc., defines and denotes the dimensions of the original tank, various phases of its construction, its catchment, up and down streams and the status during different seasons. The south-north direction of the aqueduct, which constitutes the structural base of the causeway, as well as that of the temple, suggests that some seasonal stream, or small river, which originally fed the tank, streamed from south to north. The situation of the Kaulsar further conforms this south-north character of the feeding channel. Constructed subsequently, the Kaulsar was an upstream storage tank. Whatever the related myths and legends, or facts on record, the construction of the Kaulsar was as much a technical need. It was meant to store as well as control surplus rainwater, which, if allowed to flow in, could endanger the temple which lay exactly on tank's normal water level, and if stored, could help maintain such level during lean summer months. The Kaulsar continued to enjoy the status of the upstream storage tank even when the canal system was introduced for filling the Darbar Sahib tank. The supply of canal water was also made through the Kaulsar. These up and down stream levels could not be ignored even in the 2004 augmentation of the supply system created to fill the Darbar Sahib tank with purified, treated water. The treatment plant, which now supplies treated water to the *sarovar* through a concealed pipeline, has been installed in the vicinity of the Kaulsar, which has an altitude naturally higher to the *sarovar*.

As becomes evident from myths and legends prevalent in the Sikh tradition, the original reservoir was not initially a *pakka* masonry tank, and least a square formation as it is now.

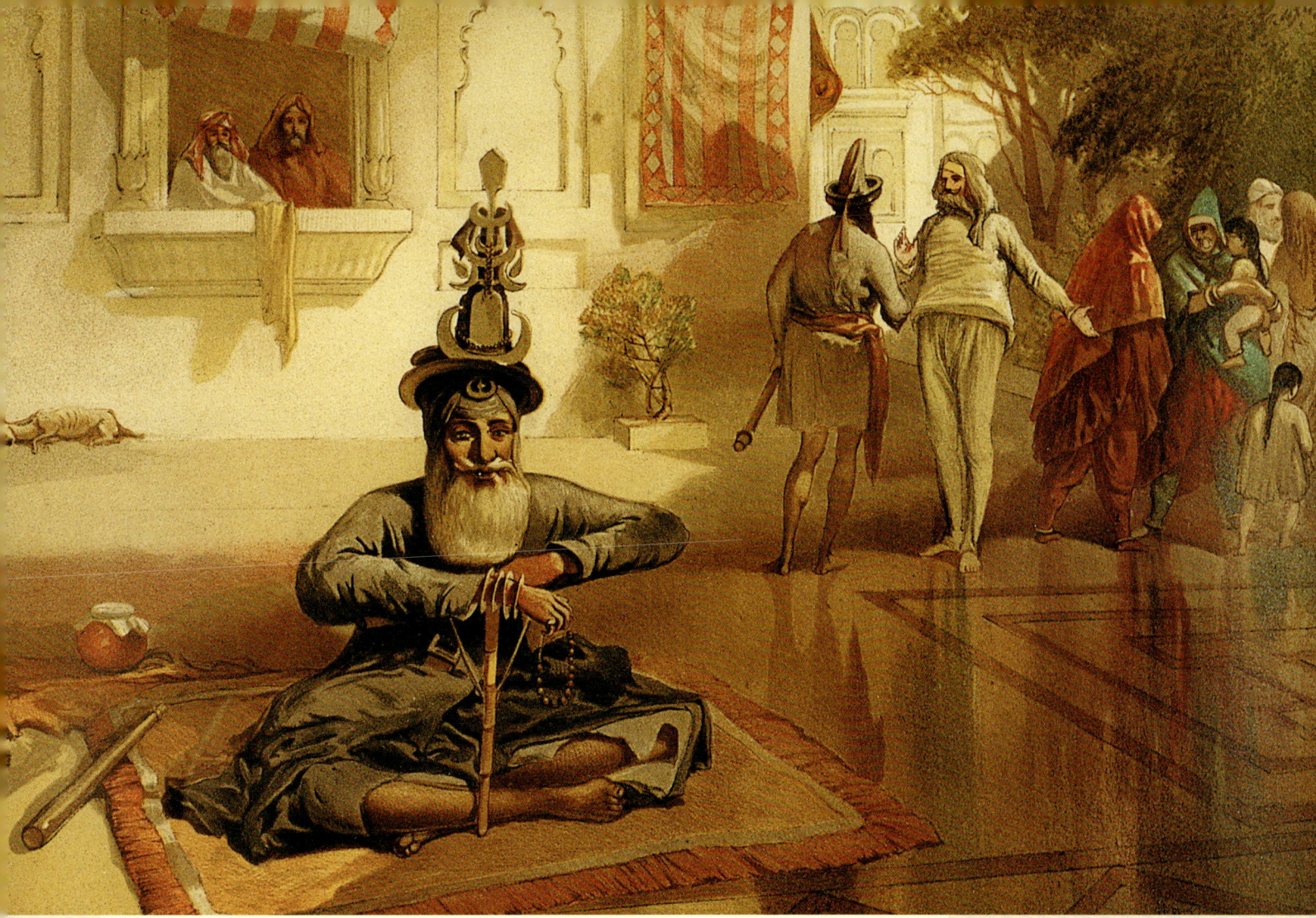

Even the *sarovar* of Guru Ram Das was a *kachcha* tank and was so till 1581, when Sri Guru Arjan Dev ascended the *Gurugaddi*. Sri Guru Arjan Dev recommenced the digging of the tank. The prior earthen *ghats*, such as had been created under Guru Ram Das by cutting tank's planks, were paved with bricks and converted into a semi-*pakka* construction, but in all likeliness not into a square masonry tank. Obviously, when on the first day of *Magh Samvat* 1645, that is, the 14th January 1588, the foundation of Sri Harimandar Sahib was laid, the tank was a semi-*pakka* construction with an irregular format. Its square form appears to have evolved later. In a number of paintings rendered for Maharaja Ranjit Singh by European artists visiting his court, the *sarovar* appears to have west-east rectangular thrust.

Obviously, before the *sarovar* reached its present magnificent square format it had numerous phases of additions and alterations. Hence, it would be erroneous to think that Sri Harimandar Sahib was built in the centre, or that there was any such thing as a centre of the tank. Rather, the tank, which was subsequently deepened and extended to its present form and status, was constructed around the temple keeping it in its centre. Obviously, the tank discovered its dimensions, its length, width and depth, in relation to the temple, which is the axis of the entire creation, the body manifest of the invisible Supreme. A profound philosopher as he was, Sri Guru Arjan Dev would not conceive his temple, his vision of the Supreme, in subordination to a man-built structure, howsoever sacred it was. As all forms and all dimensions were born of Him, in the analogy of Sri Guru Arjan Dev, all forms and all dimensions of the tank were born of the temple.

As for the original tank, it seems, it lay towards the northeast edge of the

A Nihang engaged in rituals:
The lithograph prepared from the design by William Simpson drawn by him between 1859 to 1863, when he was in India, represents a true picture of how Nihangs performed penance like a Shaivite Yogi, though their adherence to Khalsa, as becomes evident from the head-dress of the main Nihang figure comprising solely of the Khalsa emblem, was stronger than ever. In features, kind of dress, body gestures, etc., the European effect is quite apparent.
Courtesy: Hotel Imperial, New Delhi.

present tank, that is, around the Dukh-bhanjani ber. There collected, against a natural, or an old embankment, a mass of rainwater conducted to it through a seasonal stream, or small river, streaming from the southern side. Tank's bottom, which might be as deep as it is at present, that is, about 17 feet, was in all probability around here. The tank stretched length wise from north to south and width-wise lay close to the eastern side and extended to its west, during monsoons, up to the place where now stands the *Darshani Deorhi*. It appears, during summers, it receded down to the place where now stands the *Har ki Paudi*, or a little more to its eastern side. The tank might have, on its northeast corner, a semi-circular formation as most of the natural tanks had.

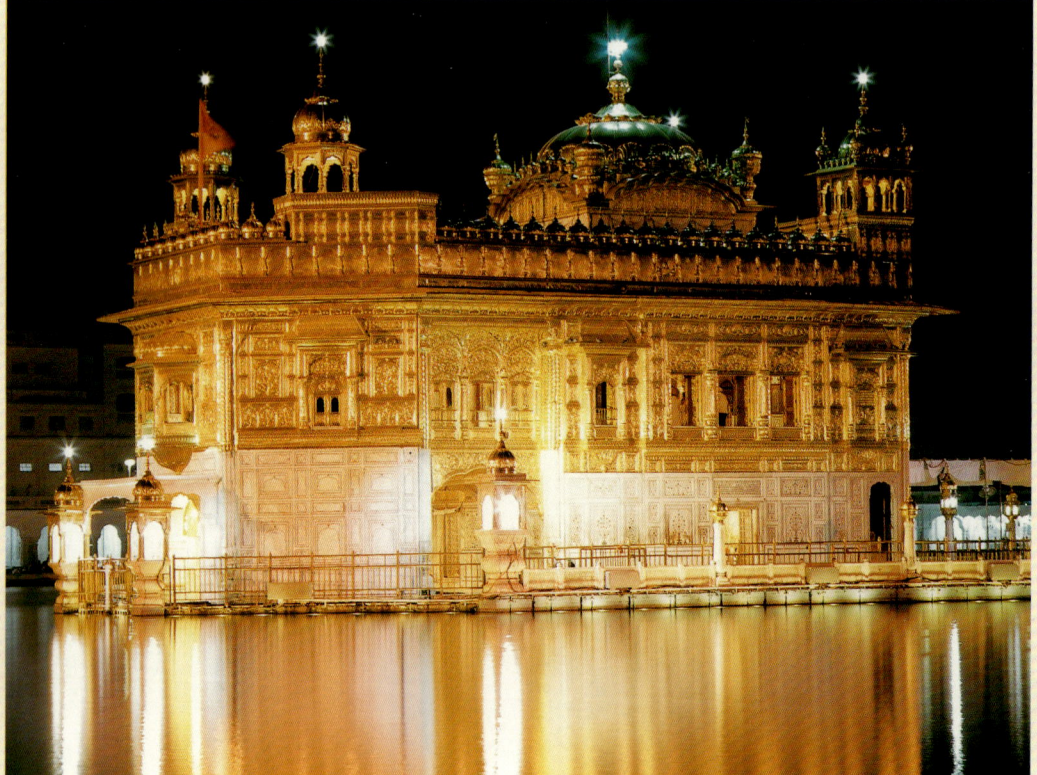

(Above) Painted Ivory:
This ivory piece, from the period of Maharaja Ranjit Singh, represents the beautiful tiny image of Sri Harimandar Sahib in all its glow and glory. The soft milky touch of ivory visually enhances the sublimity of the Golden Monarch. Courtesy: Maharaja Ranjit Singh Museum, Amritsar.

(Right) That which glorifies light:
The light is God's glory, but it is further glorified when Sri Harimandar Sahib allows it to fall upon it's being. It not only magnifies its brilliance but also imparts to it multiplicity of colours.

(Facing Page) Kar-sewa, 2004:
The service is in Sikh Panth, the prayer as well as worship, and *kar-sewa*, the service rendered by one's own hands at a sacred place, is its absolute accomplishment. Hence, when in March 2004, the *kar-sewa* of the holy *sarovar* was announced, people from far and wide and from beyond India thronged Sri Harimandar Sahib. Here every head was eager to bow and every hand to serve.
The object of this *kar-sewa* was to clean the *sarovar* so that its water supply system could be augmented. For laying pipeline for this system, a trench is being dug towards the left. The trench has yielded from below the bottom a mass of blue-grey dry sand characteristic of Himalayan rivers. It suggests that beneath the bottom of the *sarovar* there lay buried some extinct Himalayan river.

Such seems to have been the original tank, which Guru Ram Das undertook to develop with the help of Baba Buddhaji and other devout Sikhs. Quite likely that Guru Ram Das extended tank's area, removed silt deposits, added flight of stairs, obviously on tank's eastern and northern planks by cutting horizontal and vertical sections, strengthened its semi-circular embankment and provided some routine facilities for bathers and travellers. The land towards the west, where now stands the Akal Takht, had a higher altitude and a graded slope towards the east.

A huge river buried below Sarovar's bottom

The *sarovar* seems to have some two to three feet below its bottom a massive river of Himalayan origin, which in the course of time dried due to excessive inflow of sand, water seepage and other geological reasons. Maybe, some geo-

logical phenomenon, a kind of landslide, caused land shifting over the belt of this river, and with its feeble current it could not wipe off the encroaching earthen mass. It seems, after such geological changes, most of this river belt was covered under mounds of earth and what of it had remained depressed was later occupied by some subsequent rain water based local river, or *nala*. There is every possibility that such geological changes might have created some kind of natural embankment towards the northeast corner causing the rainwater conducted by the subsequent local river or *nala* to collect here and form a natural pond.

The signs of the existence of this buried river revealed from under the bottom of the *sarovar* during March 2004 *kar-sewa*. This *kar-sewa* was carried out for accomplishing two objectives. Firstly, it aimed at de-silting and cleaning the *sarovar* and secondly, to install a water treatment plant that fed the *sarovar* with treated purified water. The *sarovar* was emptied by March 25 and major de-silting was effected in about two days. Strange, though it sounds, within less than 72 hours the *sarovar* had a bottom as dry as a cemented floor. It comprised brown clay. Now, four-five feet deep trenches were excavated over *sarovar's* bottom for laying the concealed pipeline to conduct purified water from the treatment plant to the *sarovar*. Some two feet below, it revealed a thick layer of blue-black silvery sand, which continued to spill as deep as the trench was dug and

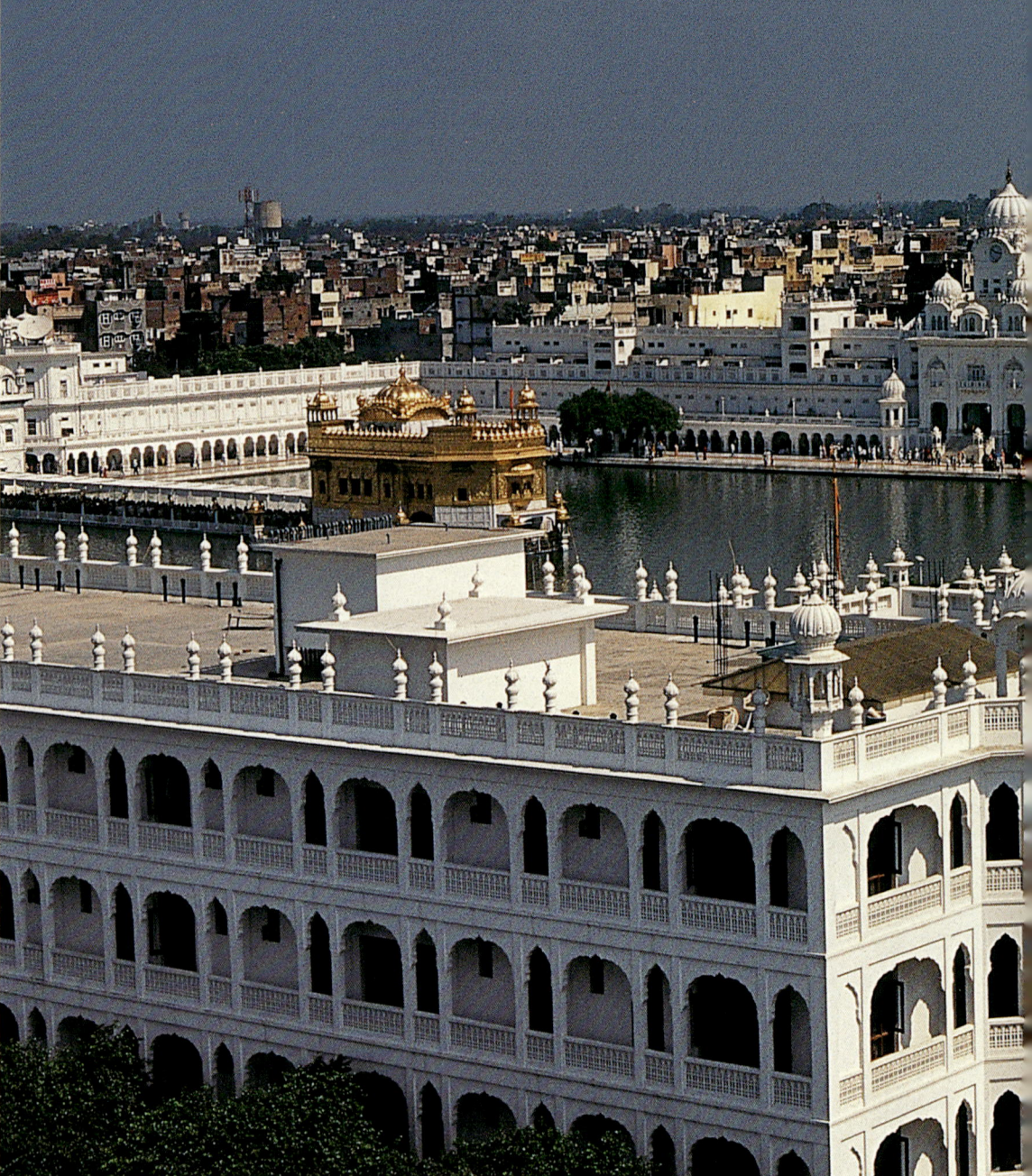

Sri Harimandar Sahib complex:
The entire Sri Harimandar Sahib complex acquires a different look when seen from the terrace of the tower of Baba Atal. Besides the wide, stretched township and various shrines in the complex, the columns of light and darkness emerge the most beautifully, perspectives of heights with rhythmic rise and fall and geometry discovering its role and forms.
In greater focus are Mata Ganga Niwas, Manji Sahib and the Eastern Gate, but as much significant are the two towers, the Bungas as they are commonly known, and the Gothic style northern gate.

appeared to be thicker. In the same uniform thickness, this sand layer extended across the entire *sarovar* from east to west and north to south. This is the same sort of sand as one finds in river Yamuna and was characteristic to a river, which had Himalayan origin. The thickness and the expanse of the sand layer suggest that the buried river had a massive width.

There are factors that further testify the existence of this buried river. It is almost unanimously held that there was a natural pond, whatever its size, at the site of the *sarovar* before Guru Ram Das undertook to excavate and develop it further. It seems the prior pond could retain a good deal of water round the year. Later it was excavated to its present 17-feet depth. Soon after, it was realised that the pond had serious seepage problem, and in 1783, it even completely dried. As the tradition has it, several measures including laying a thick layer of the finely graded clay of Santokh-sar upon its bottom were taken from time to time for avoiding the seepage. However, the problem was never fully resolved. It indicates that before it was excavated the pond had a thick layer of earth strong enough to hold accumulated water, but after its bottom was dug 17-feet deep reducing its

thickness to near minimum, it lost its strength to do so. Even now the *sarovar* seems to have only some two feet thick clay layer and below it is only a voluminous layer of sand. Hence, it is least surprising if within three days of emptying the *sarovar*, the bottom dries like a cemented floor, obviously underneath lies a thick blotting paper, meters thick layer of sand.

Could this river be the legendary Saraswati, which is said to have descended beneath the bottom of the earth somewhere upon the land of Punjab? As the local tradition has it, the *Amrit-kund* was the site of one of the many rounds of *devasura-sangram*, the battle between gods and demons. It was fought for obtaining the possession of this *Amrit-kund*. Almost on similar lines the *Rigveda* alludes to a *devasura-sangram* to have taken place for obtaining the possession of the river Saraswati. Local tradition claims that it was the seat of sage Valmiki. Vedic literature and various *Puranas* do not name Valmiki but allude to many sages who had their seats around the bank of Saraswati. How close are these two traditions, the local tradition of faith and the classical tradition of scriptures! *Tetreya-samhita* and other *Puranas* maintain

variously that many sages had their seats on the banks of river Saraswati but when the region had a twelve-year long famine, all sages, except the sage Saraswata, abandoned Saraswati. It is said sage Saraswata was born of Saraswati by sage Dadhichi, the teacher of Raja Dilip, who was Lord Rama's great grandfather. Obviously, sage Valmiki too was in the line of sage Dadhichi. The descendants of sage Saraswata are now the Brahmins of highest order. Incidentally, all Saraswata Brahmins, wherever they are, hail from *Doaba*, the region around Amritsar. Could one derive from above that before the legendary river Saraswati disappeared from the earth, it had its course across Amritsar?

Archaeologists say a big 'no' to this notion. They affirm that the ancient Saraswati had its course across Punjab, but they hold that such region of Punjab was far away from Amritsar. It streamed across the southern region of the land of Punjab. They, however, concede to the possibility of a big river to have been buried below the bottom of the Golden Temple tank. They agree that the signs revealed from under the tank bottom strongly denote the presence of a buried river there. They feel it could be river Ravi before it changed its course to deep northwest. According to them, among all the rivers of Punjab, Ravi changed its course more often. Many a time, geological phenomena shifted or rather uprooted a mighty river from one course and threw it to the other and often miles away. Ravi might have been subjected to such geological shift and more so because it is not that far from Amritsar.

The Sarovar when fully evolved

The tank, when fully evolved, almost as it is now, acquired a square form with minor deviations. Its two sides measured 510 feet while the other two only 490 feet. The flight of stairs narrowed its bottom by 40 feet. The bottom, thus, measured 470 feet by 450 feet. A five-feet thick wall bound the tank on all four sides. From this retaining wall there ensues, all around the tank, a flight of variedly sized ten stairs. The uppermost stair has been built on a level even with that of the tank water. Next four stairs have a one foot four inches rise and a two feet one and a half inches width. The sixth step has about a six feet four inch span and about four feet five inch height. For protecting the bathers from drowning, the edge of this sixth stair has fixed on it a four feet tall and four inch thick railing. The seventh stair has a one feet four inch rise and about one feet seven inch span. Other stairs are as variedly designed. The last one, that is, the tenth, has a four feet rise above the bottom of the tank. The water of the tank had medicinal character. Its *kachcha* bottom was not, hence, paved or interfered with, to let its water remain in touch with its soil, which probably contained minerals endowed with curing power.

Problem of feeding the Sarovar

Till at least 1783, the tank depended solely on monsoons and usually suffered from shortage of rainfall. The tank's area, as well as its depth, had been multiplied, whereas the rainfall average was the same as before. It was observed that

(Facing Page) Candle lighting: a glowing ritual: Light has special significance in the Sikh Panth. From the first-time installation of the Holy Adigranth to its daily installation, the ceremony is called *Prakash-utsava*, that is, the celebration of the emergence of light. Hence, every special occasion, a Gurpurab, Diwali or Sharbat-Khalsa, is celebrated by lighting candles. Here devotees are lighting candles on the occasion of Guru Nanak's birthday on 26th November, 2004.

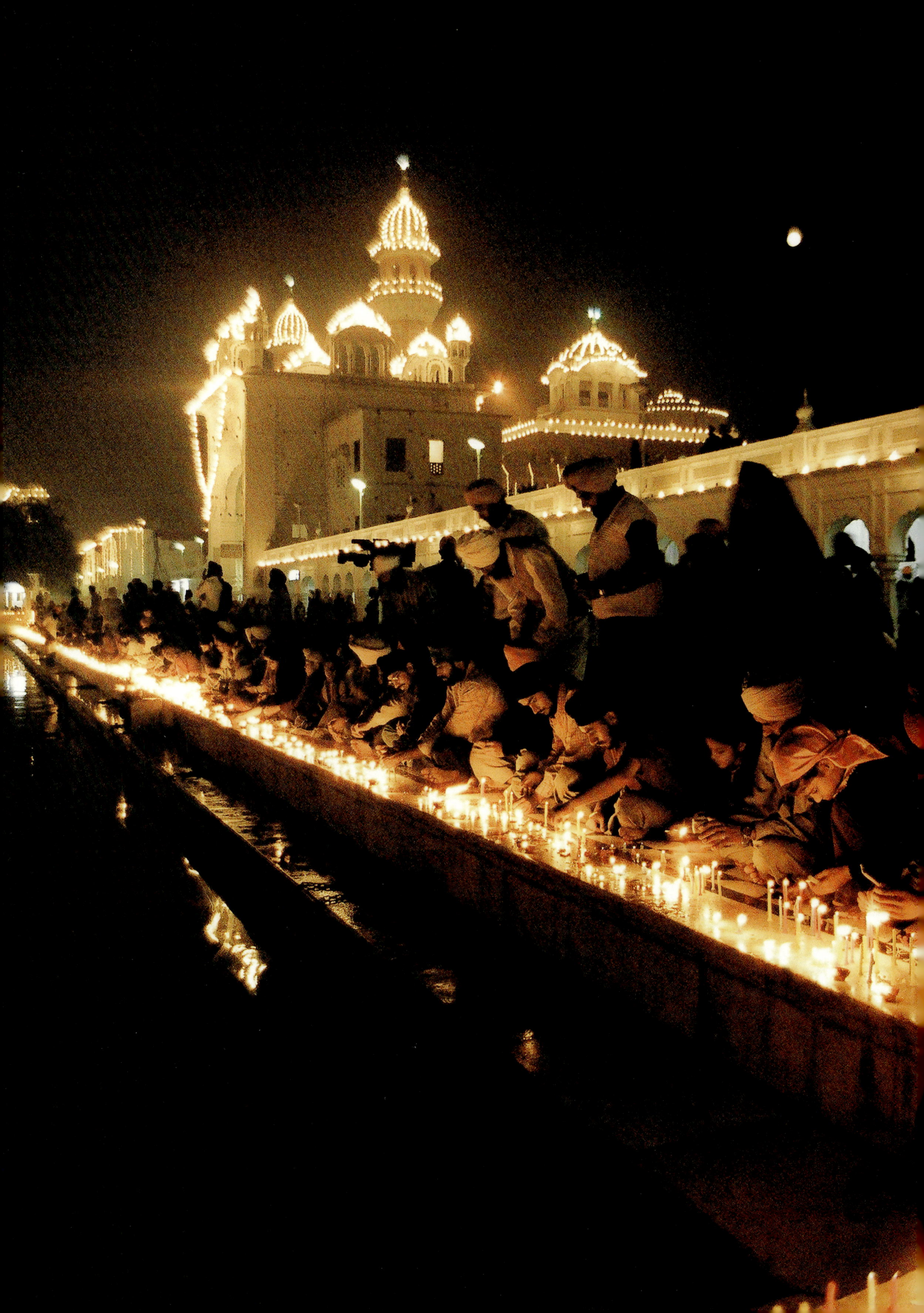

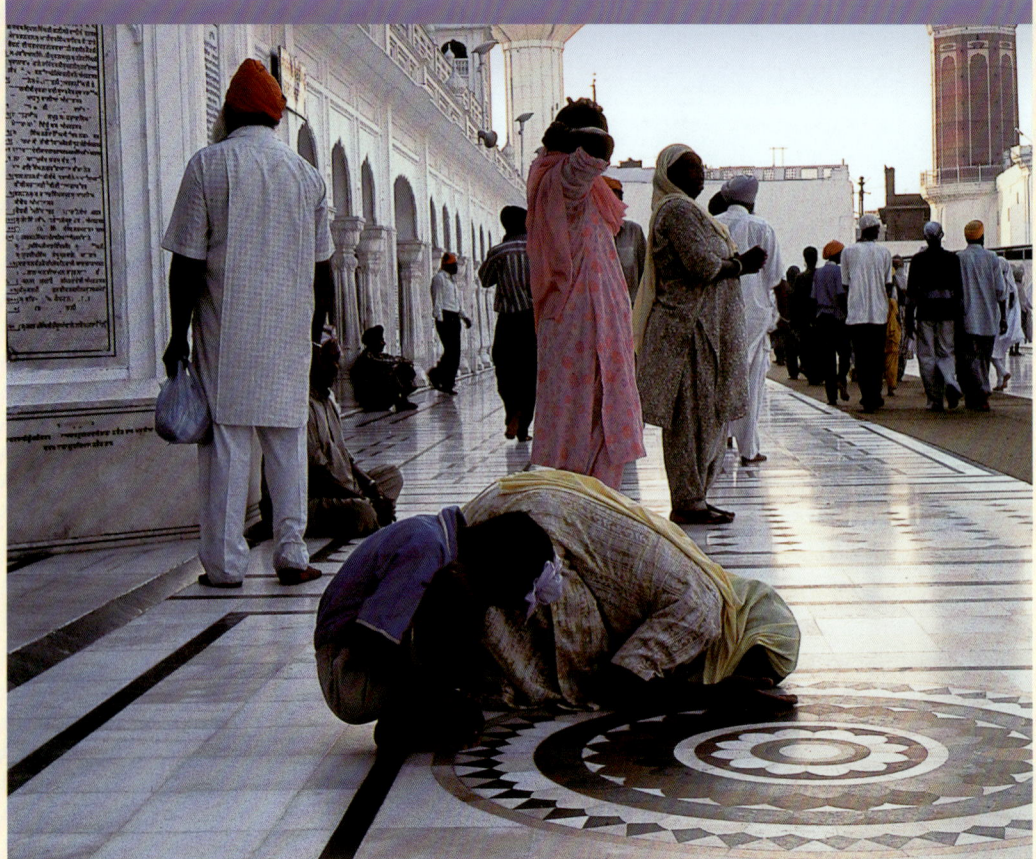

Devotees in Parkarma:
The glory of the gold-clad Supreme mesmerises a person the moment he or she enters the *Parkarma*. Such is His glory that here every head bows in prayer and every heart fills with a sense of gratitude towards Him, Who allowed him or her to be the witness of His grace.

(Facing Page) Sri Guru Hargobind:
This early 19th century miniature represents the sixth Guru Sri Guru Hargobind riding his horse like a warrior. Like a monarch, he is carrying on his right hand a falcon, the emblem of regality. He is known in the Sikh tradition to emphasise the need of arms for protecting piety. After his father, the Fifth Guru Sri Guru Arjan Dev was subjected to unprovoked torture and sacrifice, he announced that henceforth the piety should be protected by the power of arms and the Pir would attire like Mir and gave to Sikh Panth the Piri and Miri concept and established the seat of Miri as Akal Bunga facing Sri Harimandar Sahib.
Courtesy: Shri Harish Chander, Chamba.

even when a good monsoon filled it fully, it began drying by winter and dried almost completely by summer. Seepage was considered to be one of the reasons and measures were undertaken but with no effective result. Extra stock of water, stored during monsoons, could be another measure. The tank could be fed by it during lean summer months. Guru Hargobind, after he succeeded his father, began working on this line and as soon as he had required resources, whether provided by Mai Kaulan as claim some sources, or otherwise, he built an upstream reservoir, essentially a storage tank, named Kaulsar.

During good monsoon years, Kaulsar-scheme was quite helpful, but during short rainfall it did not work. In 1783, during *misl* period, both tanks dried almost completely killing thousands of fish and polluting the entire atmosphere. Finally, the known Udasi saints, *Mahant* Santokhdas and Pritamdas Nirban came forward and resolved to make permanent arrangements to bring the river Ravi water to the *Amrit-sarovar*. They decided to construct a canal from Ravi to the tank. With a batch of five hundred strong *sadhus*, *Mahant* Santokhdas went to Pathankot. On *Mahant's* persuasion the Sardar of the *Bhangi misl* was the first to donate the land across which the proposed canal had to pass. He also constructed as much part of the canal as fell on his land. Under persuasion by *Mahant* Santokhdas other Sikh Sardars followed the example set by the *Bhangi misl* and constructed such part of the canal as passed across their territories. *Mahant* Pritamdas constructed about a mile-long part with his own resources. The construction of the canal, called Hansali in local dialect, was accomplished by 1785, and with this the *Amrit-sarovar* had an assured constant supply of water. During the British period, using Hansali's base, the British Government constructed two more channels,

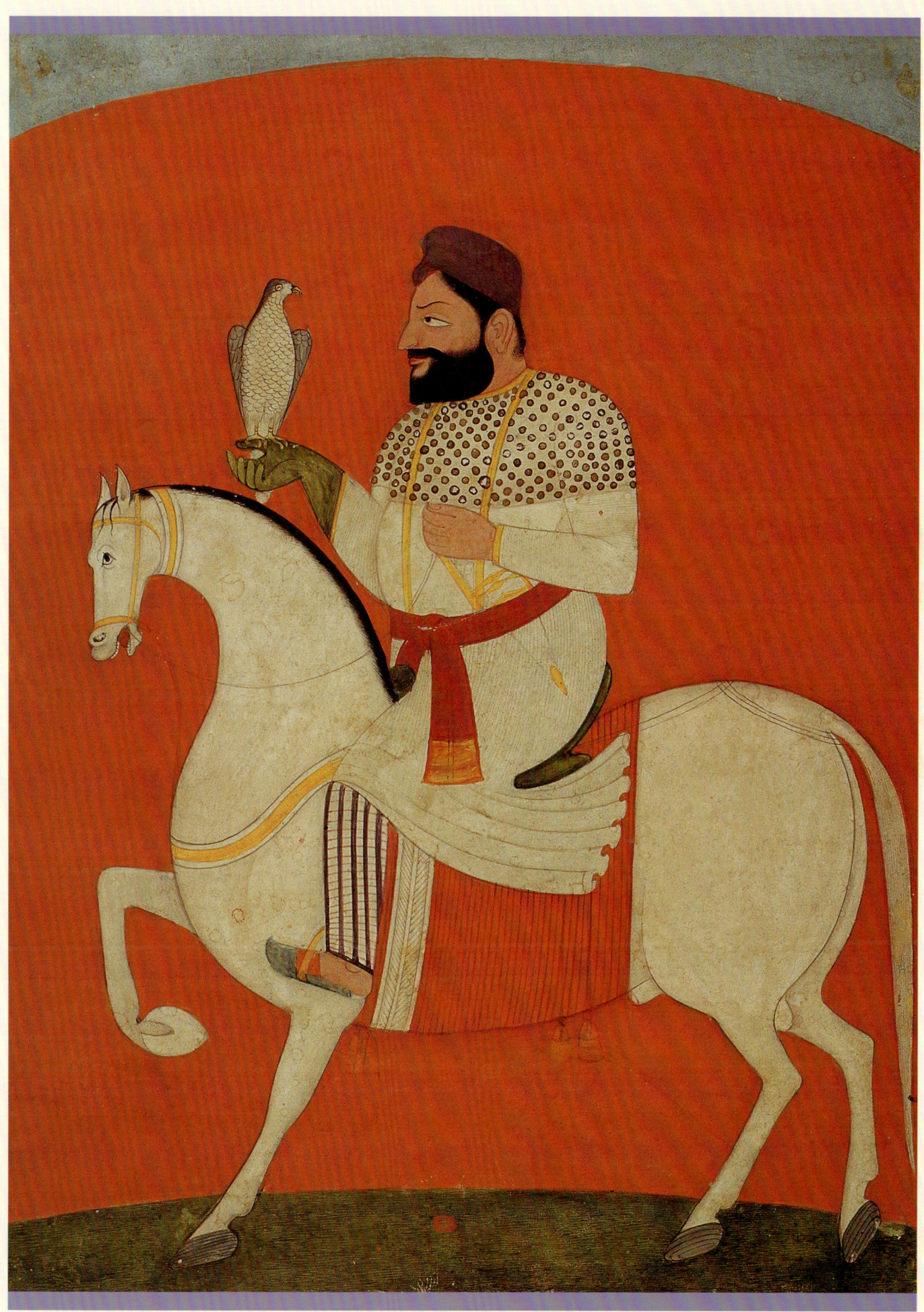

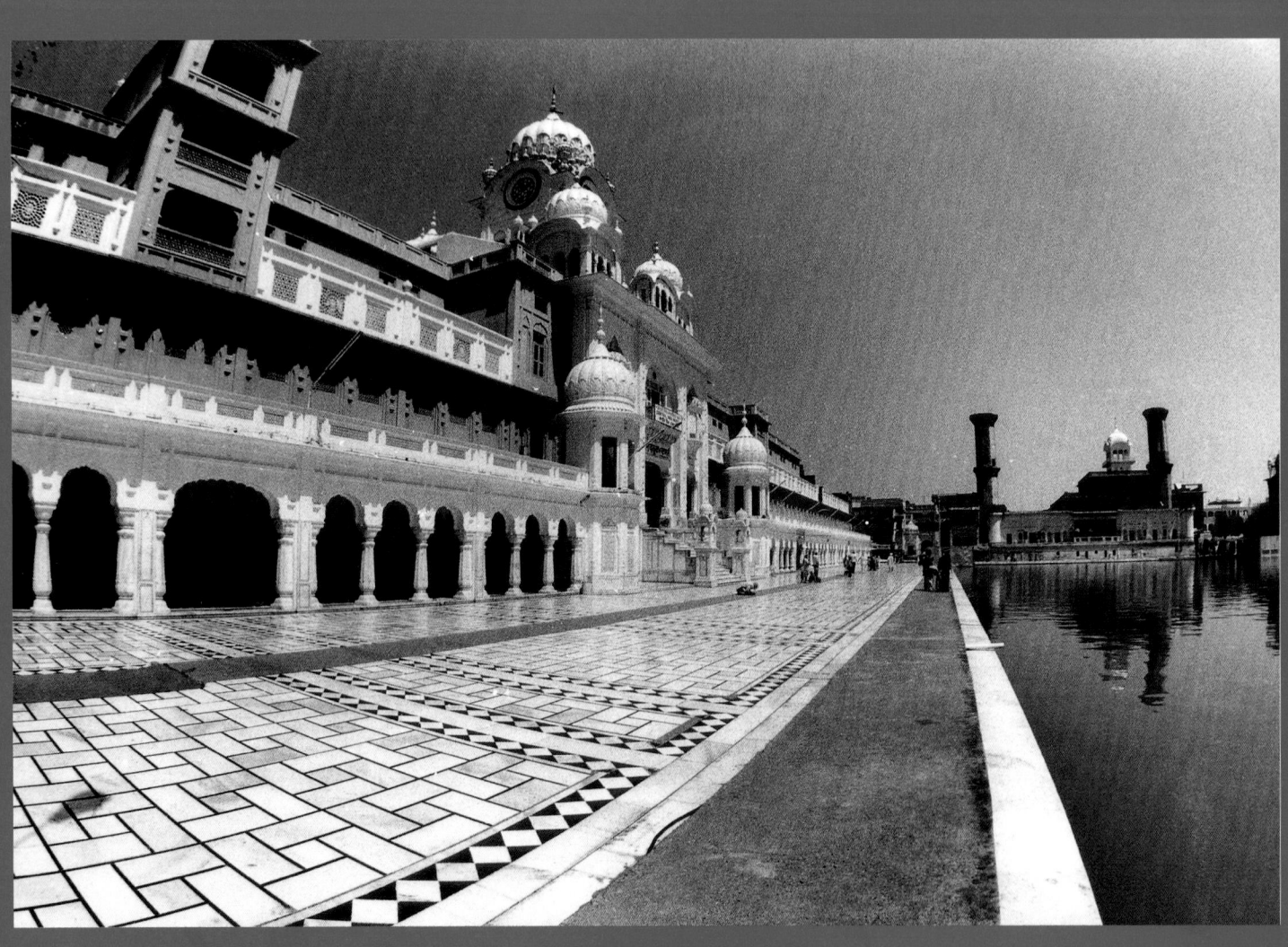

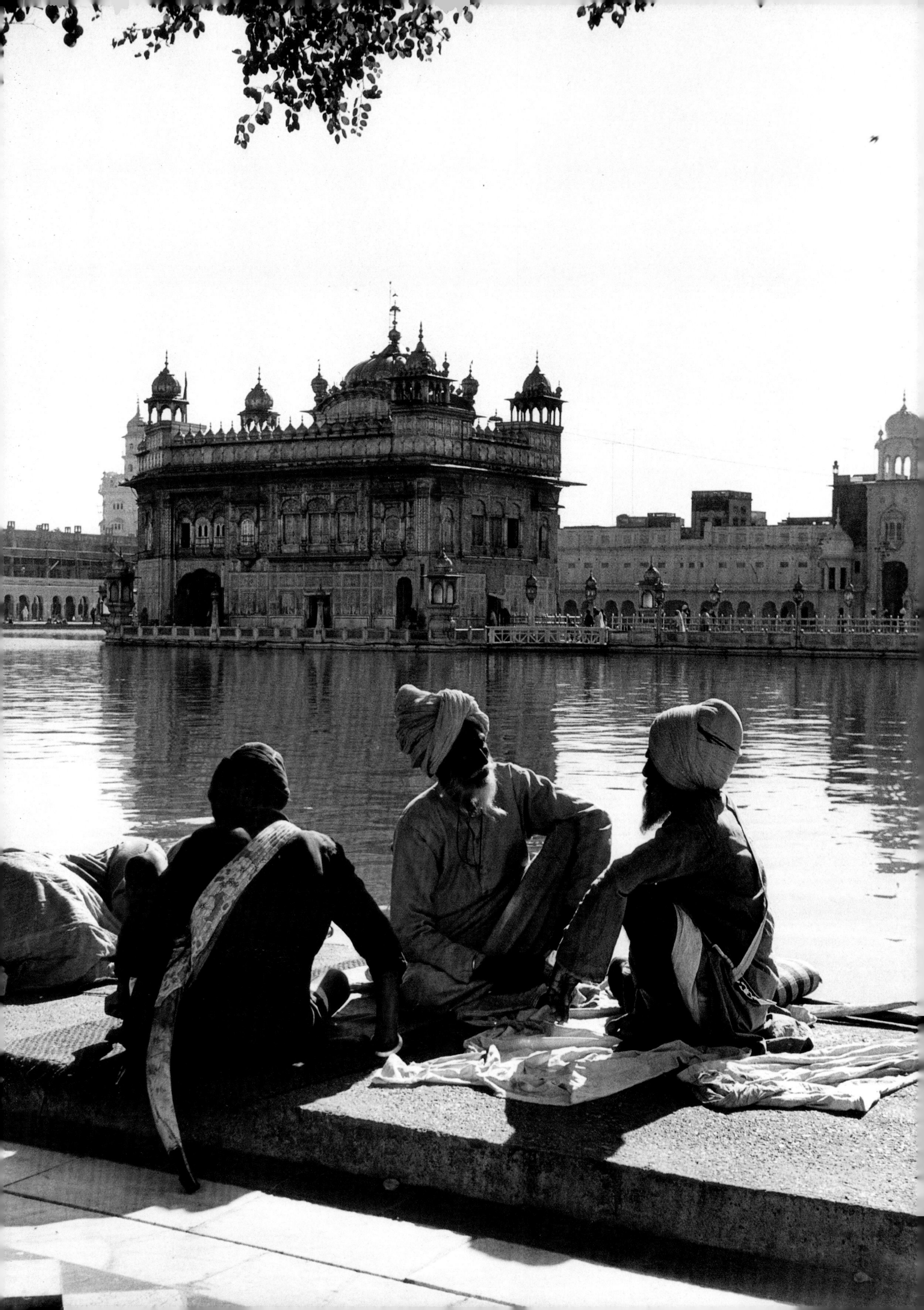

(Facing Page) Northern Gateway and Parkarma: The northern Gateway, surmounted by a Gothic style clock tower with fluted dome, is the main entrance to Sri Harimandar Sahib complex. The entrance leads on to the northern arm of the *Parkarma*, which has towards its western end Ber Baba Buddhaji. Circumambulating clockwise and passing across Dukh-Bhanjani Ber, Athsath Tirath, Samadhi Baba Deep Singh, Lachi Ber, etc., the devotee reaches the ultimate, the *Darshani Deorhi*, entering which he has before him the Invisible Supreme with His visible presence.

(Preceding Page Left) Parkarma: Northern arm: The mysticism that seems to envelop Sri Harimandar Sahib complex reveals here in this 1973 photograph of the northern arm of the Parkarma, which, though only a measured distance, seems to distance itself from eye and from all measurements. From sunny brilliance it recedes into an invisible dark end where one may detect two *bungas* and the *Langar-ghar* but only as columns of darkness, which further multiplies by their reflections in *sarovar's* water.
Bungas are topped by open octagonal terrace and not by domed kiosks as they had around 1850, or have now.

(Preceding Page Right) Discourses and dialogues: People believe that Sri Harimandar Sahib discourses even when the recitation of the *Bani* stops. It is a dialogue between the being and the Supreme Being and neither the ear is capable of hearing it nor a script to transcribe. But, this divine act often materially manifests when the spirited ones discourse on religious matters. Symbolically, Sri Harimandar Sahib premises is not only the venue of *Sharbat-Khalsa* and decision-taking Diwans, but also for the ordinary Sikhs to meet and discuss matters related to the *Panth*, community or society or decide even personal issues. It is perhaps in this sense also that Sri Harimandar Sahib discourses even when recitation of the *Bani* stops.
A 1973 photograph.

one Amritsar-Lahore branch and the other Kasur-Sabraon branch and with this the original Hansali became practically non-existent. Since 1866, the tank is fed by Jethuwal distributory of the Upper Bari Doab, that is, the region that fell between river Beas and Ravi, the 'B' of Bari being derived from Beas and the 'R' from Ravi. Initially the canal was *kachcha* but subsequently it was lined and covered. The feeding branch is connected with the *Amrit-sarovar* through Kaulsar.

This canal system not only fed the *sarovar* and maintained its water level but it also provided for its cleanliness. It was so arranged that its inflow pushed and drained out the surface layer of *sarovar's* water, which dust, etc. could contaminate, and replaced such quantum with fresh supply. A recent augmentation scheme, effected just in 2004, has largely changed this system of water supply. It provides for feeding the *sarovar* with treated water instead of the erstwhile direct raw water of the river. Now, a water treatment plant with a capacity to treat many thousand litre water in a minute has been set up in the vicinity of the Kaulsar. The treated water is stored in a tank for the needful supply. The *sarovar*, along with the Kaulsar, has been connected with this tank of treated water by a mesh of concealed pipeline laid below the *sarovar* bottom. To evade erosion, the retaining walls on all four sides have been lined with beautiful blue synthetic sheets. Expenses for the entire system to include water treatment plant, laying the pipeline and lining of side walls are met reportedly by Tut Brothers, the Non-resident Indians from United States of America. After the recent March 2004 *kar-sewa*, the *sarovar*, filled to the brim with the treated water, was ready for the holy dip on Baisakhi, that is, the 13th April, 2004. The *sarovar*, surging with its ripples of gold against a magnificent mass of blue, wears a divine look, so characteristic to the *sarovar* of Guru Ram Das.

Parkarma or Parikrama

Parkarma, or perambulating path, covered with the finest kind of marble set in variedly designed patterns, consists practically of the flattened bank of the tank and is, thus, its another significant component. Except in front of the *Darshani Deorhi* on the western side, the entire perambulatory path is sixty-feet wide, the fifty-feet being uncovered and the rest ten-feet covered by a long *verandah*. Initially, it seems, these banks were narrow except in front of the *Darshani Deorhi*, where the space was used, since the days of Guru Hargobind, for holding daily, as well as special, congregations. In all likelihood, the eastern side also had some ghats around the *Dukh bhanjani ber*. As old records reveal, there stood, quite close to its bank, private mansions, known as *bungas*, and the guesthouses of various *misldars*. The *bunga* of Sukracharia *misl* covered almost the entire northern side. This, along with some other *bungas*, was demolished in 1862, when the British Government wanted to raise a clock tower here. It was after the Shiromani Gurdwara Prabandhaka Committee took over the management of the Golden Temple that a serious effort towards improving the *Parkarma* was made. In its budget for the year 1928-29, the Shiromani Gurdwara Prabandhaka Committee allocated Rs. 20,000.00 for the development, including widening, of the Parkarma. Encroachments were removed and Parkarma was given its present width.

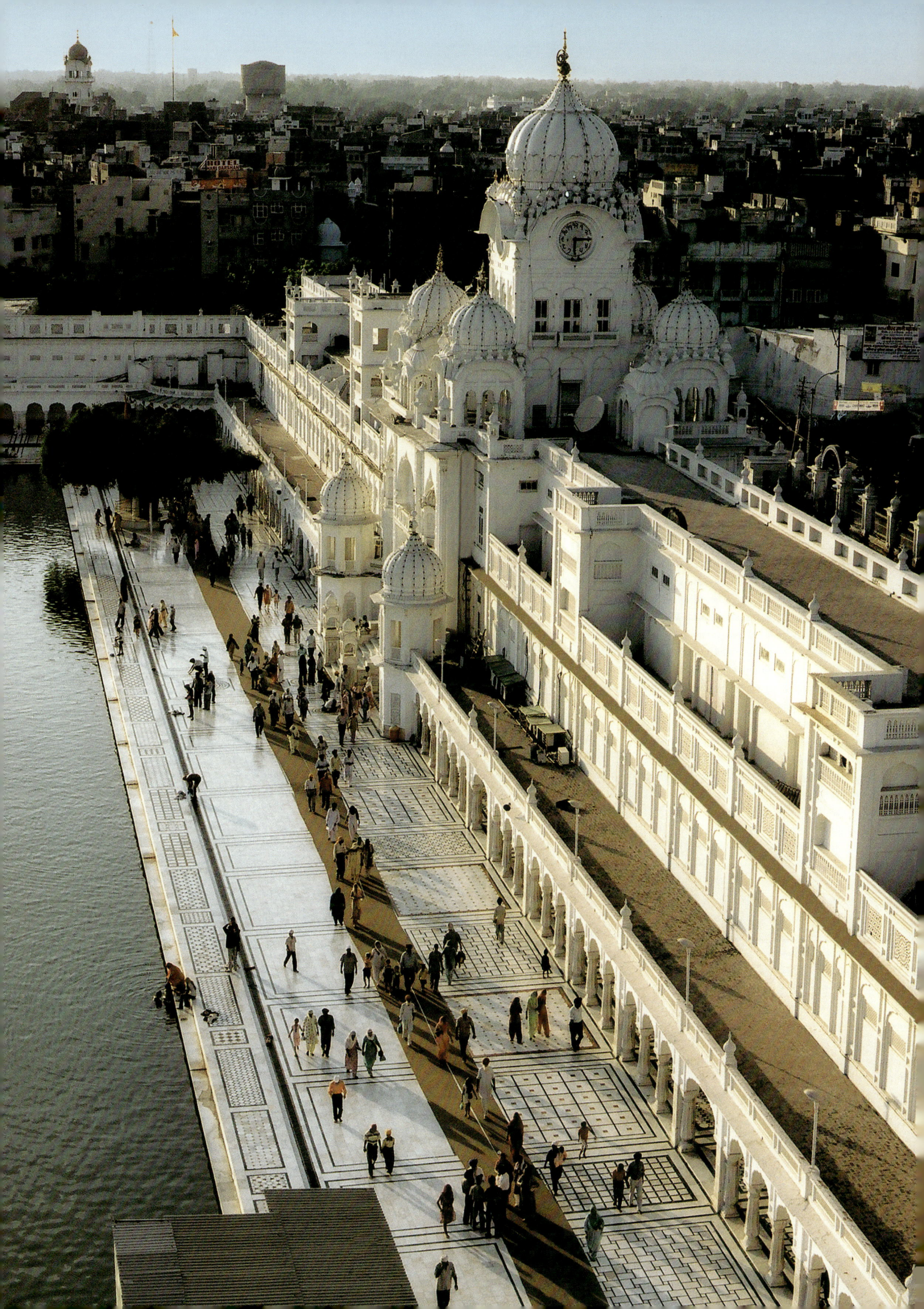

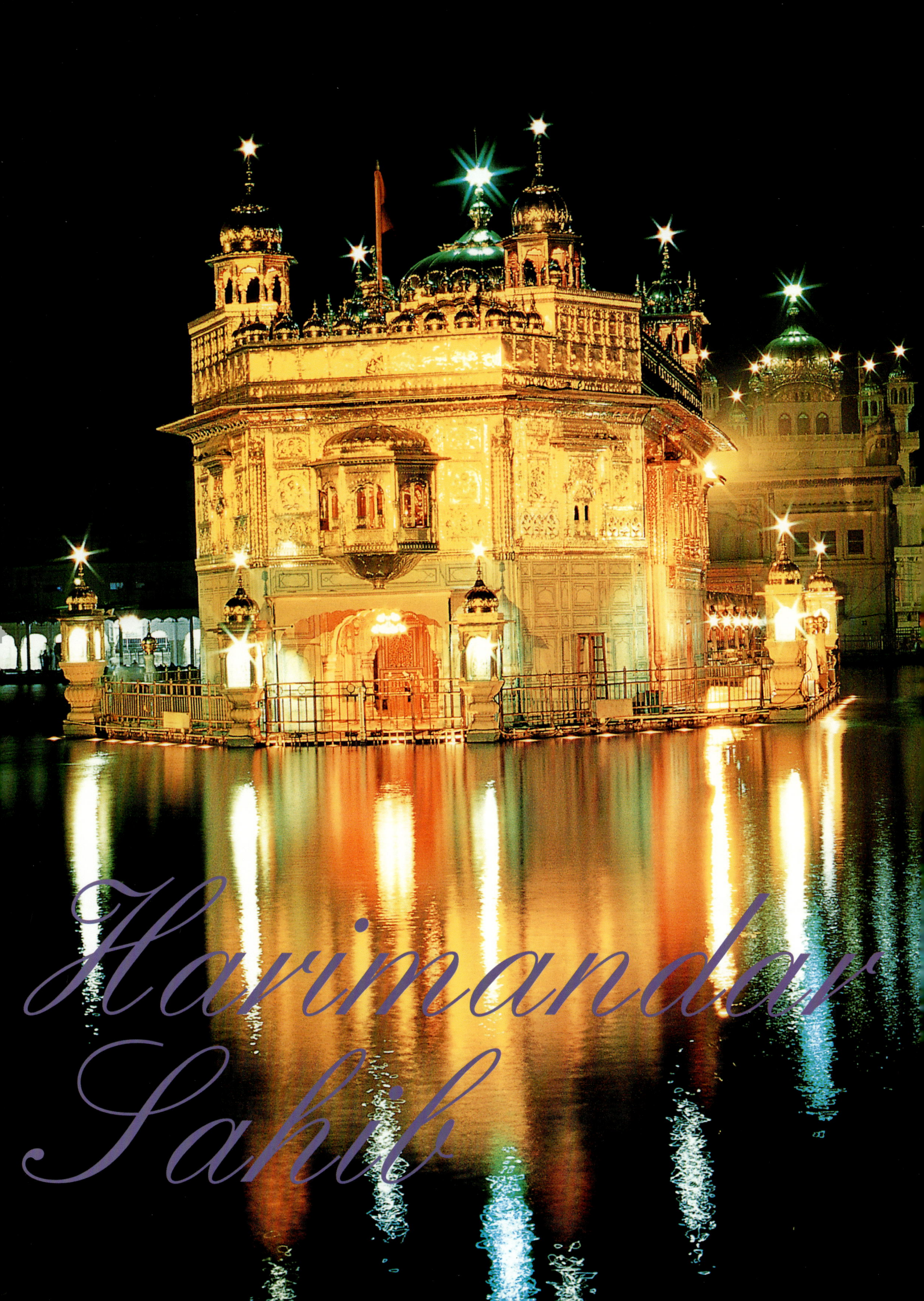

Postal stamp on Golden Temple:
This postal stamp on the Golden Temple for the twelve paisa is about fifty-year-old and now a rare item for collection. It renders the Golden Temple and the *sarovar* in blue tint.

(Facing Page) Sri Guru Arjan Dev
with Bani-pothi:
This late 18th century Guler
miniature represents Sri Guru Arjan Dev
with *Bani-pothi* before him. He conceived,
designed and built Sri Harimandar Sahib, the
temporal seat of spiritual elevation and divine
realisation. Designed with four gates in all the four
directions, Sri Harimandar Sahib was for all castes
and all faiths. For visually symbolising this character
of his thought, the artist has painted with him
an ascetic of other faith.
He is in a mood
of contemplation, as if pondering over the
correctness of the collected *Bani* before including
it in the Adi Granth, or discovering for it the
appropriate *raga* form.
Courtesy: Lahore Museum, Lahore, Pakistan.

(Preceding Page Right) Sri Harimandar Sahib:
When piety breathes light, even the
deep recesses of darkness are illumined.
Sri Harimandar Sahib was not hence the birth
of a building structure, or even of a shrine,
but rather that of the light,
which not only enshrined 'Hari', the Supreme,
but also illuminated darkness.

Sri Guru Arjan Dev's concept of the Temple

In the physical entity of his temple, Sri Guru Arjan Dev discovered its spiritual being. What he designed and built was not hence a building structure but rather an idea transformed into a visible form. It could be quite an easy feat of masonry to construct a strong, solid, rock-like podium with a towering height and create the temple on its base. Sri Guru Arjan Dev thought differently. He carried the structure of his temple deep into the water, placed its floor along the tank's water level and raised it into the sky to whatever height. His temple, like Him, like Baba Nanak's *Karta Purukh,* whose manifestation the temple was, pervaded all three worlds, this world, the world below and the world above. Placed on a rock, or a rock-like solid base, his temple would not have roots in the world below. And, placed on a towering high plinth, it would have lost the touch of this world. His temple was as much a part of the water, the earth and the sky.

Maybe, when planning his temple with the tank, Sri Guru Arjan Dev had in his mind what *Braht-Samhita*, the known treatise on sculpture and architecture, prescribed: *Kratva prabhutam salilmaraman vinivaishya cha, Devata yatanam kuryadyasodharmabhi vradhye* (56/1), that is, let a big tank with abundant water be excavated and a garden laid and the temple be built there. It will bring fame and expand religion. The tank, temple and the subsequently laid *Guru ka Bagh* are too close to this prescription but Sri Guru Arjan Dev used the union of the tank and the temple for a more profound philosophical meaning rather than for fame or mere beauty. In his concept, the tank was not his temple's landscape setting, or a natural frame, but its essential component, and this was also the essence of the Sikh doctrine and subsequently of the Sikh architecture. If he perceived any duality to exist in between the tank and the temple, it was that of the Creator and the created. Hence, a temple, away from the tank, or even above its water level, would have been incomplete and, perhaps, inauspicious. The tank and the temple were to Sri Guru Arjan Dev an integral whole, one and indivisible, and not mere two co-existents. Temple's low plinth was not thus the manifestation of just humility but the core of Sri Guru Arjan Dev's cosmic vision realised in Sri Harimandar.

Besides such spiritual vision, an excellent and unique kind of engineering, which marked a complete departure from all prior traditions of lake-temples or lake-castles, whether inspired by *Braht-Samhita* or otherwise, was another unique feature of his temple and again it was born of his own mind. There prevailed three types of lake-buildings. The most usual kind was a building constructed around the bank of a lake. It had a part of it submerged into lake-water. Another kind used a natural rock, or mound, emerged in the basin of a lake, and erected on it a building structure. The third kind was a building constructed on the normal ground level and, subsequently, a tank excavated around excluding the built-up site. The excluded site naturally gained a height perspective against the tank's excavated bottom. The temple that Sri Guru Arjan Dev designed was altogether different. It was designed to lay in the middle of a natural or prior tank, but not on a natural mound or rock. The tank was excavated and

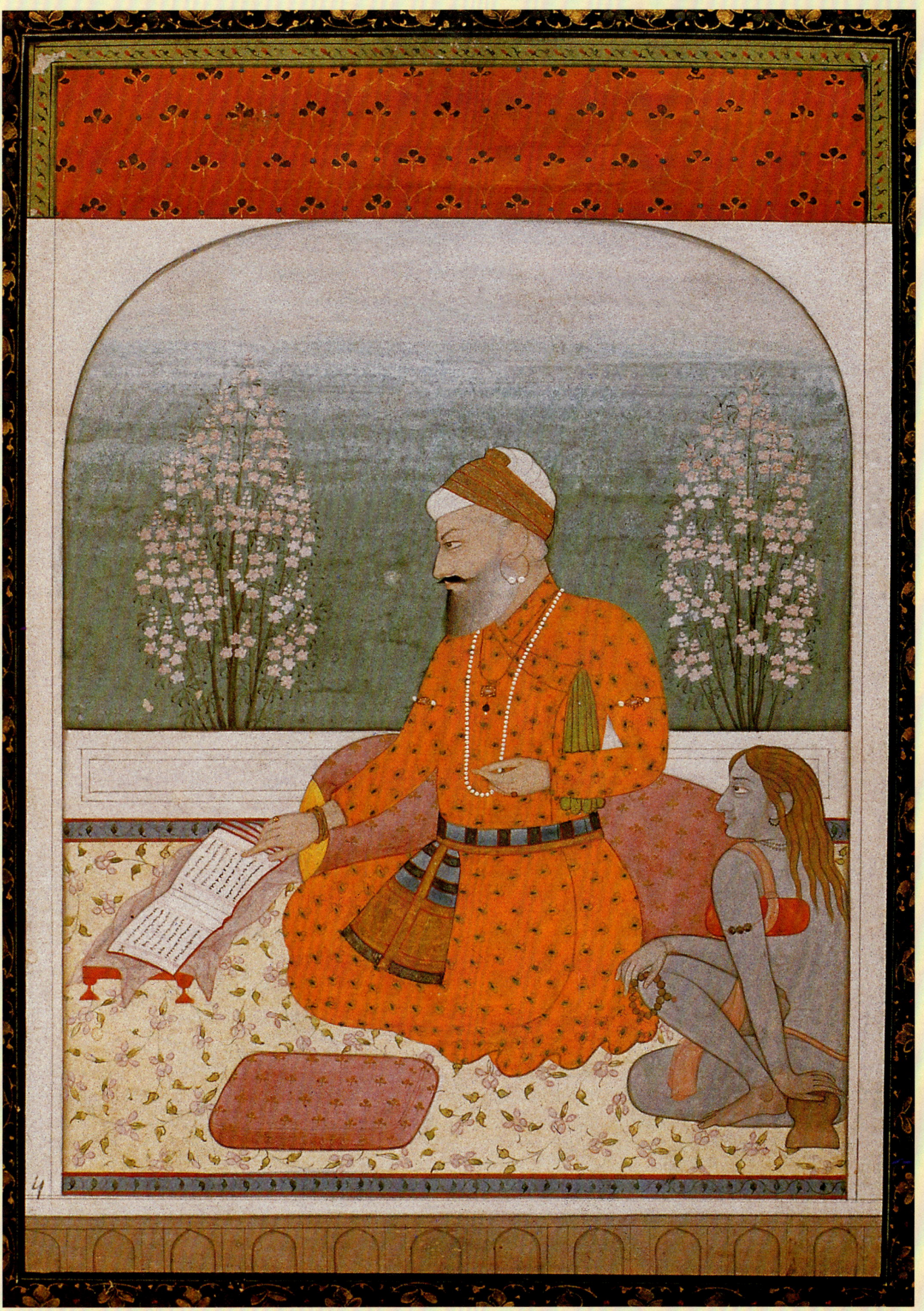

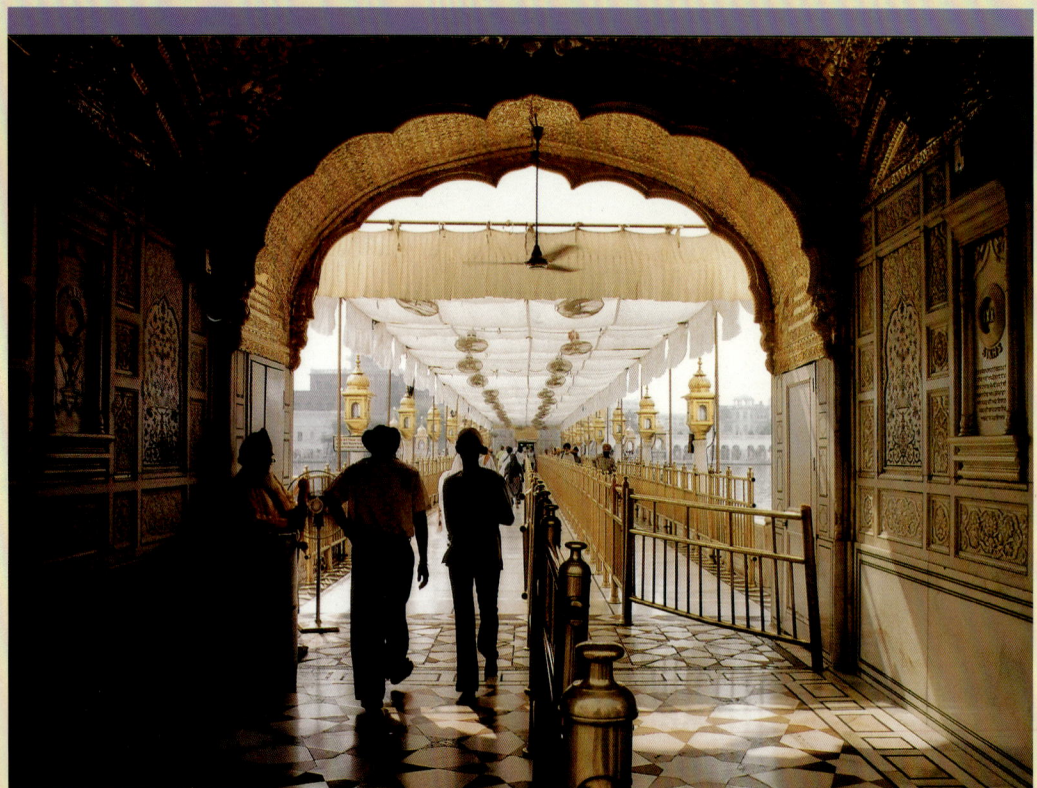

Darshani Deorhi and Causeway:
Darshani Deorhi, an obvious late addition, is one of the finest works of architecture and craftsmanship and adds further aesthetic dimensions to the beauty of Sri Harimandar Sahib. Across *Darshani Deorhi*, the Causeway acquires a lyrical perspective and exceptional splendour. From its doors to arches, *Darshani Deorhi* has elaborate designs carved both in gold leafs and marble and elegant inlayed patterns.

(Facing Page) Baba Nanak, Bhai Mardanaji and Balaji:
Besides the opening for the entrance to the Causeway, the *Darshani Deorhi* has on its side planks, door motifs with concealed columns, arches and other components covered with carved gold leafs. This gold-clad left plank has below the arch-motif Baba Nanak, Bhai Balaji and Bhai Mardanaji seated under a tree. Below them is an elaborate *Gurmukhi* inscription embossed in gold.

developed into a masonry tank but not to give the constructed site a natural height. The temple had to seek by itself its height and other dimensions, obviously, above the level of the tank-water, and this objective Sri Guru Arjan Dev accomplished by designing and constructing the temple in a very special way.

Temple's site and initial planning

The model of the temple that Sri Guru Arjan Dev had in his mind was, thus, an essential synthesis of the tank and the temple, requiring one to merge with the other, or both to emerge mutually. It not only represented his unique cosmic vision and spiritual perception but also required a very special kind of engineering and building skill. Temple's location was as much significant. Though it sounds strange, Sri Guru Arjan Dev discovered, in the first day of the month of *Magh*, that is the 14th of January, the key to his temple plan. This first day of *Magh* provided him with a time schedule for construction as well as an idea of what could be an ideal location for his temple. He had been observing for a few years that by *Magh*, or mid-January, tank's water receded, obviously from west to east, to almost half of its width, remaining confined to its eastern arm. Thus, the month of *Magh* demarcated the geographical mean of tank's width. This determined the central point on the east-west axis line. An equal distance from tank's northern plank determined tank's over-all centre. This was to Sri Guru Arjan Dev the ideal location, for raised in the centre of the tank the temple fully accomplished his vision. Besides, this location had a natural altitude higher to tank's bottom by some seven to eight feet but as much below tank's water level when it was full.

It appears that a plot with an area larger than temple's ground-plan, say, about a 100 feet square, was demarcated and leveled. The level so arrived at was deemed to be the standard ground level for the erection of the temple and other

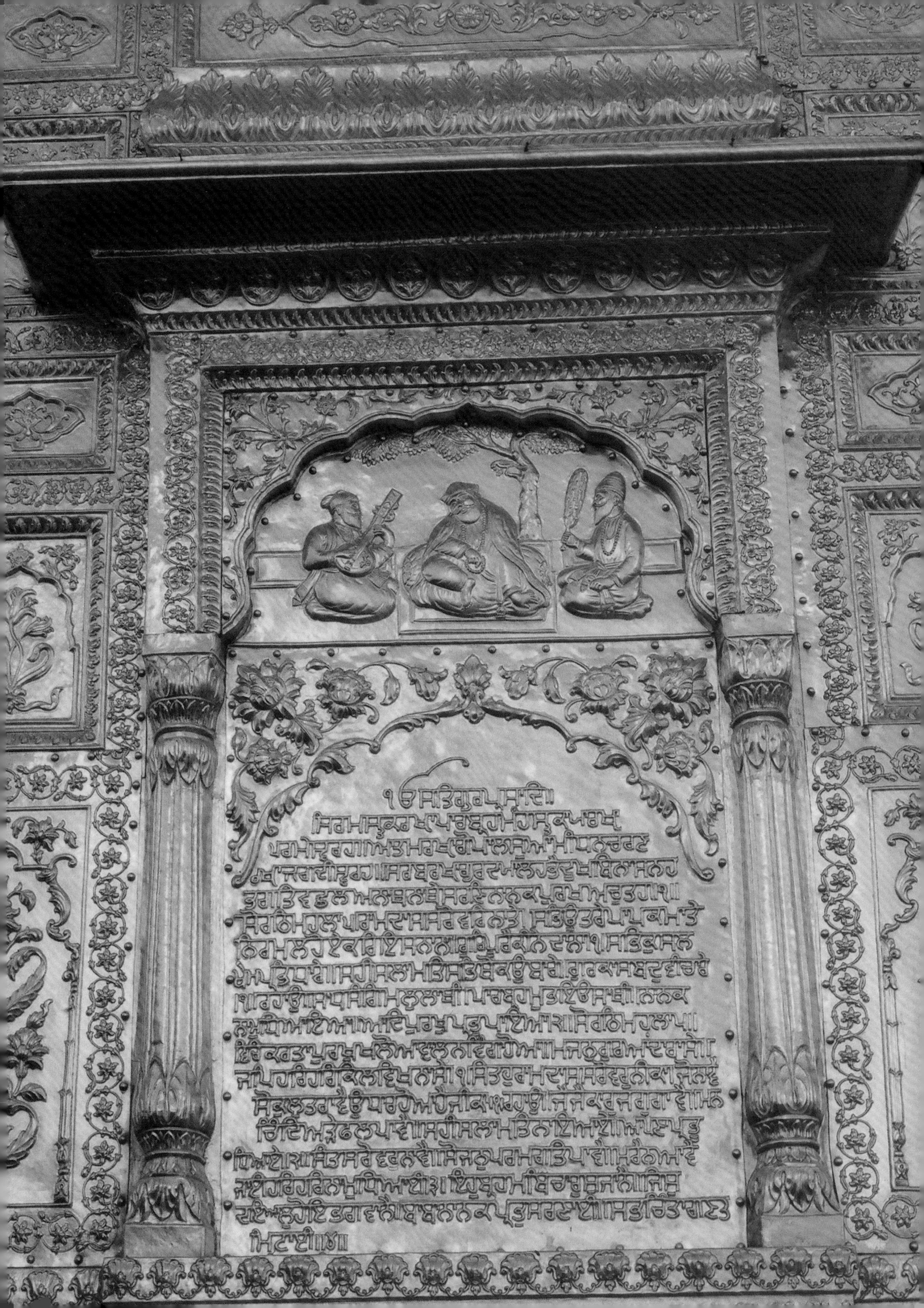

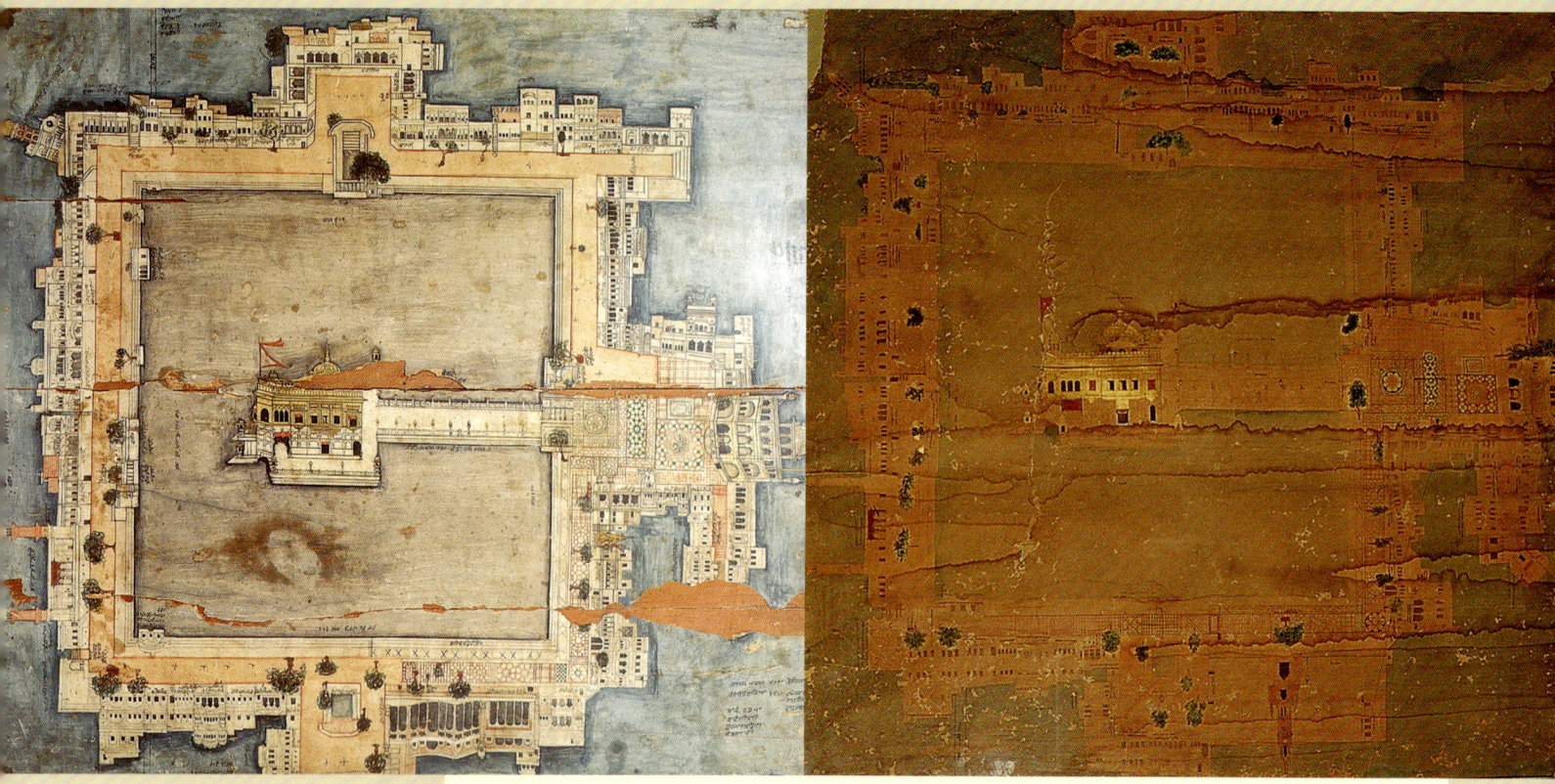

Old drawings of Sri Harimandar Sahib:
Two old drawings of the period from 1850 to 1870, depict Sri Harimandar Sahib complex in almost identical measures except that the drawing, which is somewhat more defaced, has on its north a clock tower, a work of British rulers. The clock tower was built in 1862, after the British rulers had grabbed, though indirectly, the management of the Temple in their hands. The other drawing, which is less damaged, depicts the prior stage, as it does not show any such tower. The clock tower was built by demolishing some Bungas, the Sukracharia Bunga of the descendants of Maharaja Ranjit Singh in particular. This earlier drawing shows these Bungas instead of the British tower. Obviously the drawing without tower could be of around 1850, while the other of any time after 1862. Both show *Darshani Deorhi*, two spiral tall towers on northeast corner, the western gateway and a number of green trees, perhaps the jujubes as per the Sikh tradition.
Courtesy: Central Sikh Museum,
Sri Harimandar Sahib, Amritsar.

subordinate structures. From the centre of its western arm, a 202 feet long and about 36 feet wide strip, from east to west, was further demarcated for the passage to the temple. This 202 feet long strip had an ascending character. It was hence excavated to become even with the main shrine's ground level. This broadly distinguished the plan area of the temple complex including the main shrine and the causeway leading to it. As the total western side had a graded rise, the excavation of the tank, which might have been taken up in simultaneity to the construction of the temple, must have begun from this side. The reports that there lay over its western side, where now stands the Akal Takht, a huge mound of excavated earthen mass conform that major digging was conducted in the tank's western basin. The Akal Takht, initially an open-air theatre-type platform, was created on this mound.

Except the area marked for the construction of the temple and the causeway, the rest of the surrounding land, which was demarcated for the expansion of the *sarovar*, was excavated as deep as was the bottom of the original tank, that is, around 17-feet deep. Now, the entire tank had alike depth all over and it began acquiring simultaneously the character of a masonry tank, now the holy *sarovar*. Contrarily, the temple plan area, which included the landstrip demarcated for the construction of the causeway, gained against tank's bottom a natural height of about seven to eight feet, although it was yet nine to ten feet below the normal ground level. It seems that at the initial stage itself this natural earthen base was lined and paved as measures for its fortification. The construction of the temple and the causeway and the excavation of the *sarovar* might have begun simultaneously, but it appears from the verses of Sri Guru Arjan Dev, which he composed on the completion of the holy *sarovar*, that the excavation of the *sarovar* had been accomplished before the construction of the temple.

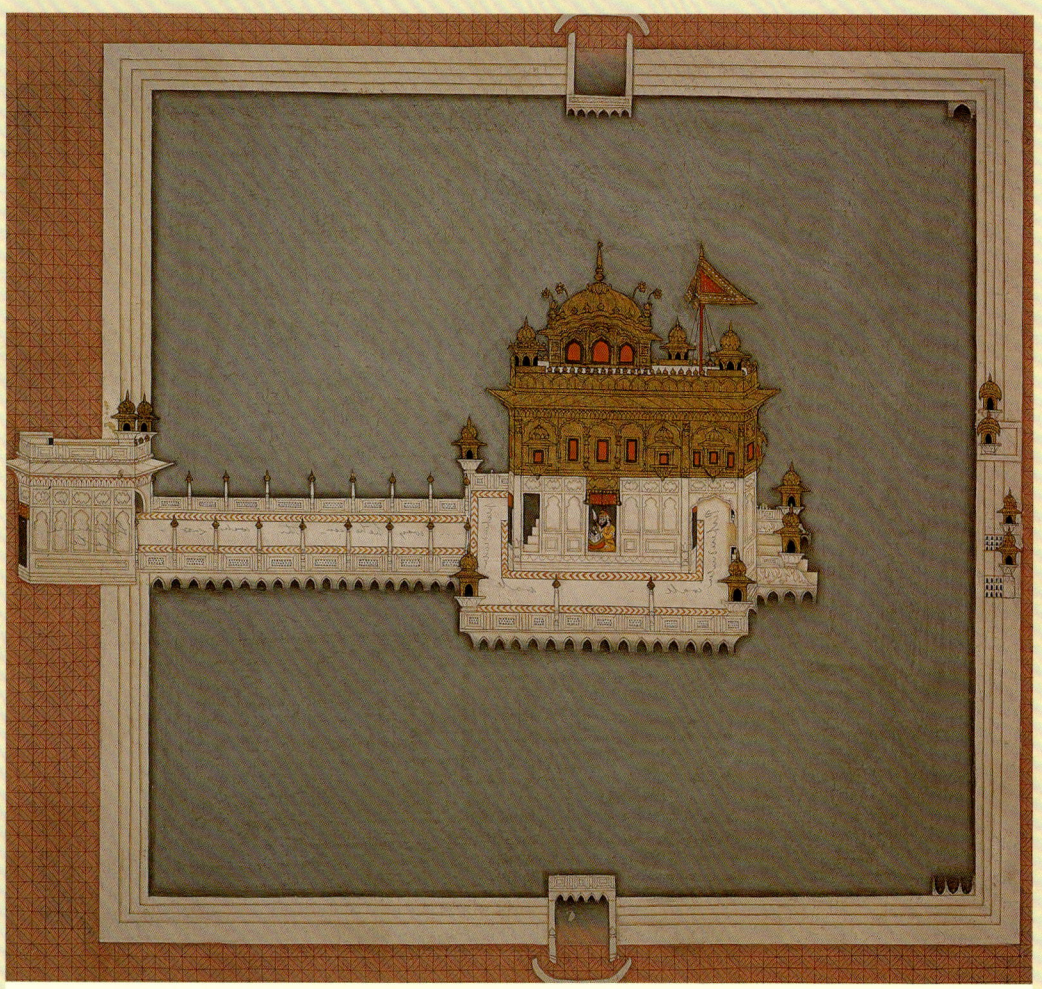

Sri Harimandar Sahib: A late 19th century painting, rendered using water colours, gold and paper as its medium, represents the image of Sri Harimandar Sahib in its great spiritual sublimity and as great aesthetic beauty. This well preserved miniature paints the spiritual marvel not only in its accurate dimensions but also in all its splendour and with its unique spiritual strength.
Courtesy: Narinder S. Kapany, USA.

The foundation of the temple was laid over the demarcated site by digging it four to five feet deep to reach the dry sand level, although it was yet about three feet above the bottom of the tank. Indian *vastu-shashtra*, the ancient canonical norms of architecture, prohibited a westward entrance to a temple. Though Sri Guru Arjan Dev was not unacquainted with such norms or prohibitions, but despite his awareness, he planned his temple with a front towards west. It was not his revolt against the establishment but rather a technical necessity. The immediate approach to the site, selected for the temple, was available only on its west. The southern side, which fed the tank by a stream, or river, must have been a marshy land. On its north and east, there lay the main body of the tank with 9 to 10 feet deep water even during the summers. No other side could provide, thus, a natural approach, such as provided the western side. The construction of an approach, on either of the east, north or south, would have consumed more time, more labour and, of course, more money than would have the construction of the temple itself. Thus, an approach on any side, other than the western, could not have been technically feasible.

The foundation of Sri Harimandar

The temple's foundation was laid by the Fifth Guru on the first day of the month of *Magh*, *Samvat* 1645, that is, AD 1588, but before it had consolidated, a mason, by sheer error, pulled the ritual-founding brick. It was inauspicious,

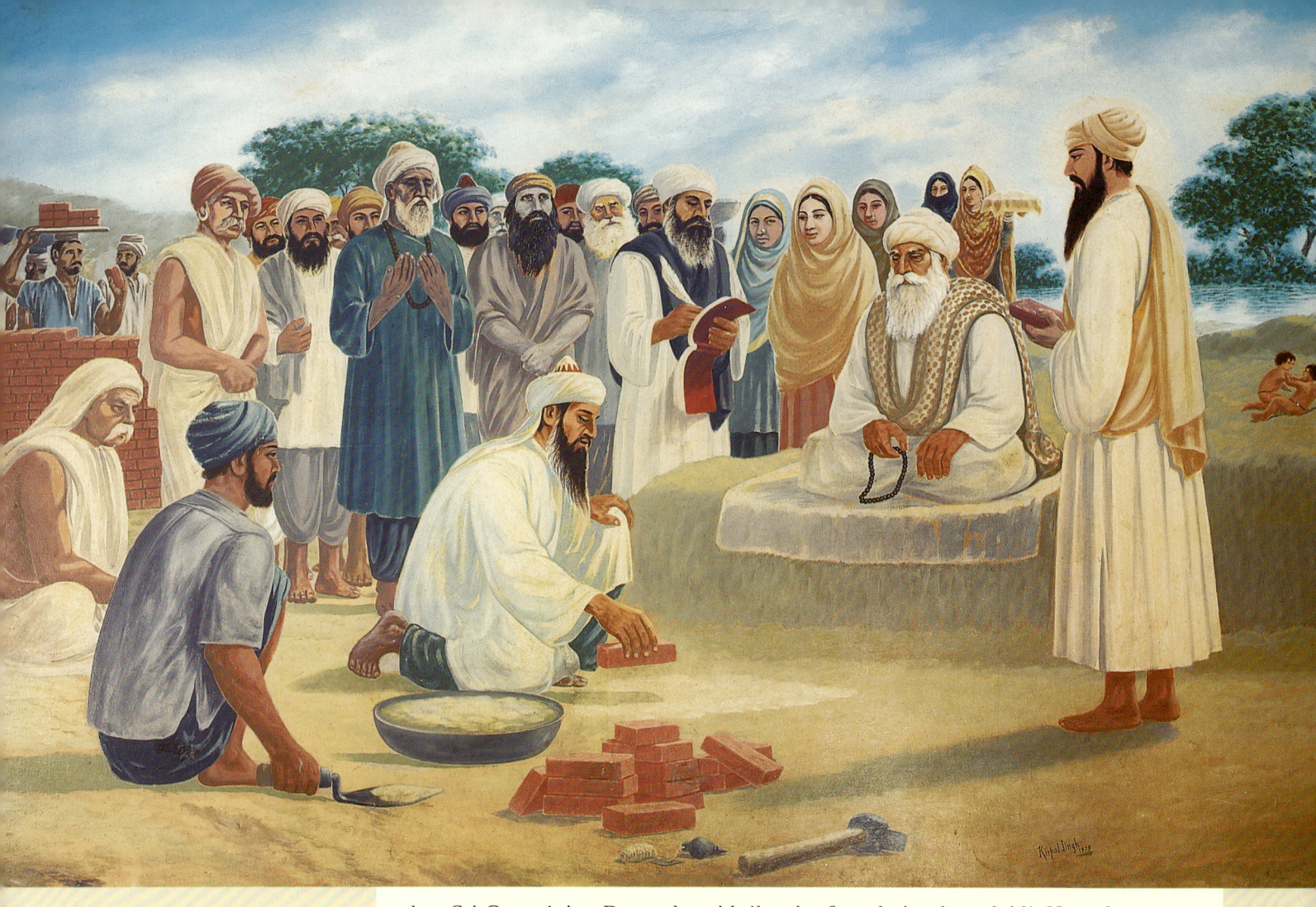

but Sri Guru Arjan Dev only said, 'let the foundation be relaid'. Now the great *Sufi* saint Hazrat Mian Mir was invited and he relaid the foundation and thus began the construction of the Harimandar Sahib. This is how, in the popular mind, the foundation of the first shrine of the new faith was laid.

Scholars turn pages of history and bow over debris of the past attempting at discovering who actually laid the foundation, the Guru, the *Sufi*, or both and whether it was laid and then relaid. Ego, mostly of sectarian kind, is often their problem. One section claims that the foundation was laid by Sri Guru Arjan Dev himself and everything related to the *Sufi* saint is a mere myth. Such section is satiated most when it discovers that even Mian Mir's biography does not contain a word as to his laying the foundation of the Sikh shrine. The other one, with sarcastic smile on lips, rejects it. This frame of mind not only asserts that it was Mian Mir who laid the foundation of the shrine but also that it was after the design of Mian Mir's tomb that the design of the Sikh shrine was conceived.

The popular mind rejects both. Its truth is what it perceived across centuries, or what Sri Guru Arjan Dev had foreseen when the founding brick was erroneously pulled. Time and again, this popular mind saw erroneous hands trying to uproot the very basis of Nanak's faith and Sri Guru Arjan Dev's shrine and the 'faithful' saintly hands as often coming forward to lay it again. Whether what has been narrated in the myth actually occurred or not is not that significant as is its truth. And, this truth is that the 'faithful' rebuilt what the erroneous hands had pulled down. Sri Guru Arjan Dev's prophecy depicted by analogy the truth of the future. He read the omen and foresaw that attempts to uproot the shrine would continue. And, hence, he commanded 'let the foundation be relaid'. Scholars

question, 'Did he say so?' But the community of Sikhs never questioned its truth. They saw it widely writ on the countenance of the sky. They perceived in it an all-time commandment, and rebuilt, and always with added vigour, whatever, the shrine or the faith, the cruel hands defiled or demolished, and the sacred brick, which the erring hands had pulled, was relaid.

Construction begun: First evolved Temple's sub-structure

From the date of laying the foundation to the arrival of monsoons, there was about a six-month period to work. Assisted by Baba Buddhaji and Bhai Gurdas, Sri Guru Arjan Dev began the construction of Sri Harimandar. Bhai Salo, Bhai Bhagtu, Bhai Paira, Bhai Bahlo and Bhai Kalyan were some of the prominent Sikhs looking after various aspects of the work. Bhai Bahlo, an expert in brick manufacturing, was given the responsibility of arranging bricks. For a regular inflow of funds and material, the system of *masands* was regularised and strengthened. They were commanded to gather twice a year, that is, on Diwali and Baisakhi and deposit all their collections with the central authority. Farmans were issued to various *sangats* for contributing means, material and money and for arranging voluntary manual service, the *kar-sewa*.

The temple had a square plan. As per the plan, the land-base lay about nine to ten feet below the estimated water level. Obviously, the temple had to gain this height with the help of a sub-structure. Hence, a sub-structure, 66 feet square, was planned to initiate the construction of the temple. For this sub-structure a 5 x 4 feet deep and wide raft foundation was laid in the centre of the plan area. The foundation had a 12-inch thick base layer of perfectly baked *Nanakshahi* bricks contained in finely ground lime mortar reinforced with *gur*, jute, pieces of alloy and other ingredients. Though with layer thickness varying, this was the kind of mortar used everywhere in Sri Harimandar complex for laying foundations, to include the causeway and the *sarovar*'s retaining walls, etcetera.

The outer foundation of the sub-structure was laid across the entire length on all four sides of the plot area demarcated for construction. The four courses so laid met each other on right angles and formed a perfect square. Then on interior, the foundation was repeated in parallel courses from north to south and east to west. The distance between any two strips was equal and perfectly measured. The courses laid from east to west crossed those laid from north to south at right angles, which divided the entire interior into small squares or cubes. These north to south and east to west courses of foundation created on each cross-point a kind of architectural interlocking and an over-all fortification. Thus, a well connected and strongly fabricated mesh lay and bound the entire plan area.

The height from the foundation to the roof level was covered by a sub-structure. It consisted of three components, a plinth with a good height of about two-and-a-half feet on lower side, a thickly built wall pierced by trefoil arched openings after about every two-and-a-half feet in the middle and about a three feet high blind wall on the top. This walled structure, built uniformly

Laying the foundation of Sri Harimandar Sahib: This 1979 large size oil painting by Kirpal Singh portrays Mian Mir, the known Sufi saint of those days, laying the foundation of Sri Harimandar Sahib. Sri Guru Arjan Dev, with the auspicious brick in hand, is standing opposite him and Bhai Gurdas, the scribe of the *Adigranth*, with a notebook in hand, is standing on Mian Mir's left. An elderly Sikh, in all probability Baba Buddhaji, who was subsequently nominated by Sri Guru Arjan Dev the first *Granthi* of the Sri Harimandar Sahib, is seated on a platform reciting hymns. Behind Mian Mir is seated a Brahmin pandit wearing *yajnopavit*. Courtesy: Central Sikh Museum, Amritsar.

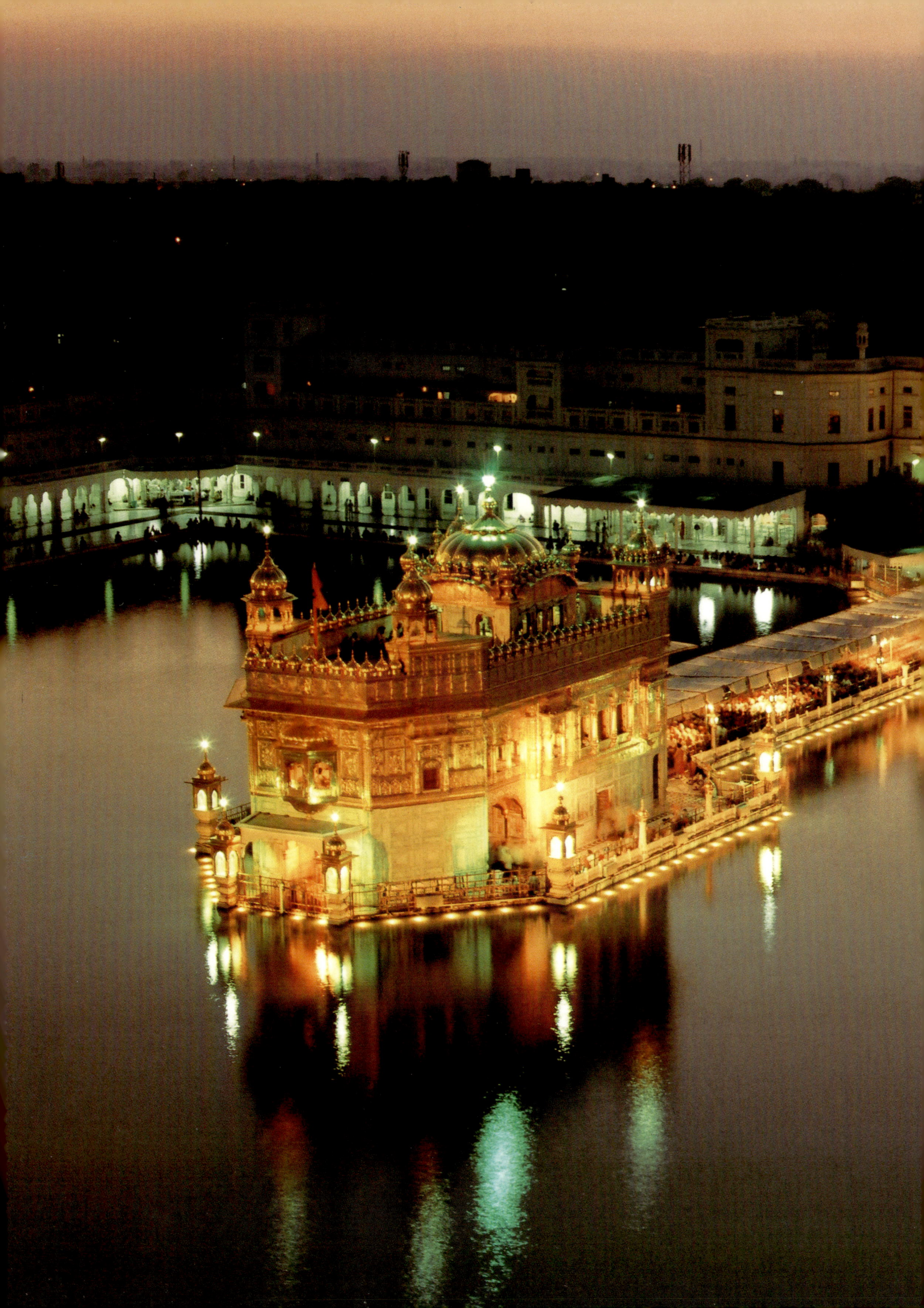

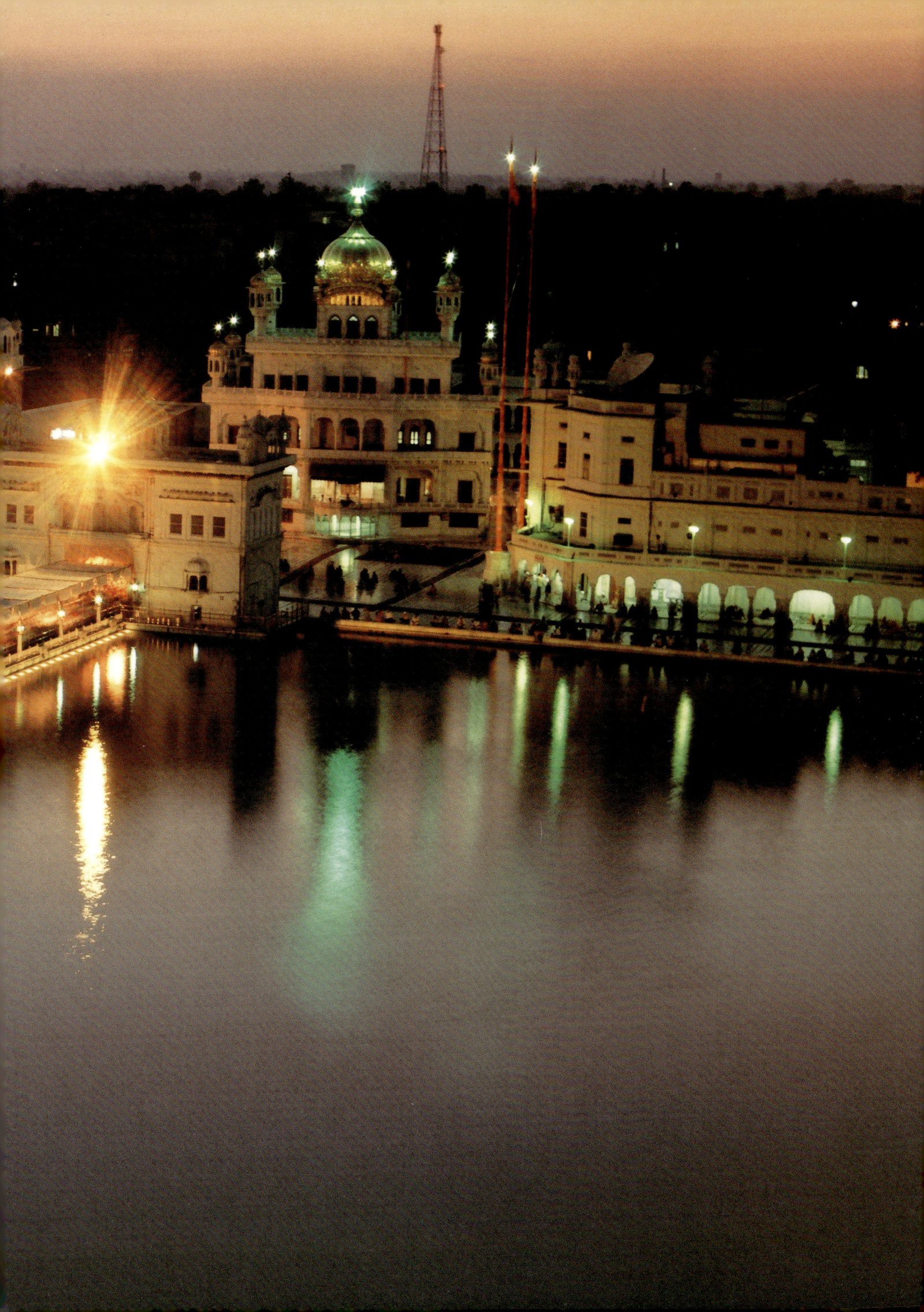

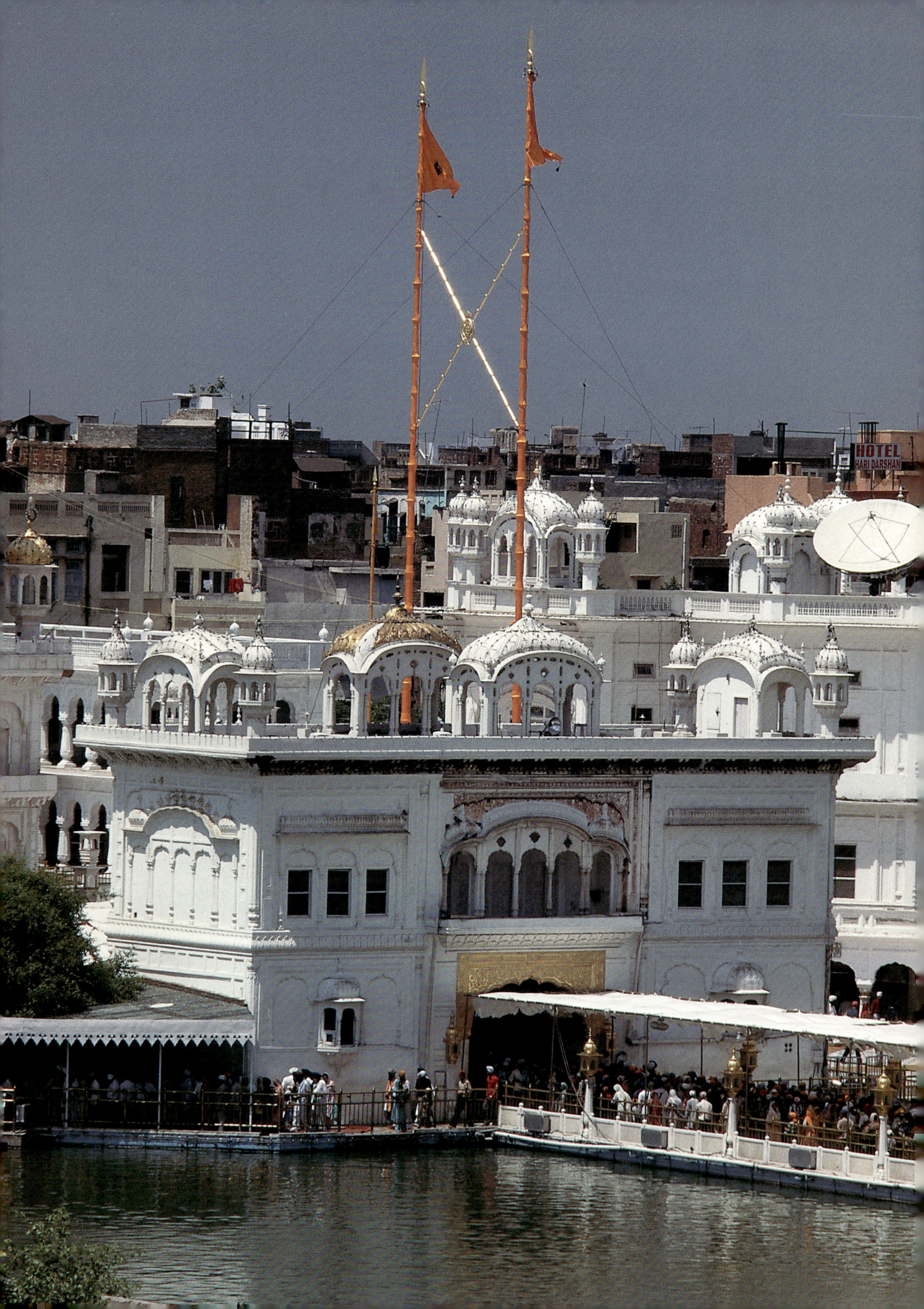

all over the foundation, carried over it the roof that lay on the estimated water level of the *sarovar* and served as the ground floor for the main shrine. The roof follows vaulting technique used uniformly in the construction of the entire Sri Harimandar complex. This was the initial structural pattern for the entire substructure, though, it seems, the arched openings, which pierced the walls that fell under the four outer walls of the main shrine, were later blinded probably for security reasons. The sub-structure was, thus, designed to emerge as a self-reinforced and self-contained unified whole able to withstand surging water, or evil meaning winds from whatever direction they stormed.

The foundation of the causeway was also laid on the same raft technique but, being narrow in width, just 21 feet, in comparison to its 202-feet length, it was not self-sustaining and mutually fortifying. This length and width proportion required extra strengthening. Hence, its foundation was laid five to six feet deeper to the foundation of the main shrine and about two feet below the tank's bottom level. The thickness of its base layer was also doubled. Besides, for strengthening it, it was designed like a spinal net, one long spine stretching from west to east and several arms, branching from it on its right and left, giving it support and fortification. This did not leave any of its parts isolated. The spinal *surangdwari*, the tunnel constructed lengthwise, ran straight and across the entire sub-structure from the *Darshani Deorhi* to the *Har ki Paudi*.

Like the sub-structure of the main shrine, the causeway was also erected on the same seven to eight-feet high natural base. Sri Guru Arjan Dev knew that a 17-feet deep tank usually had at its bottom at least seven-eight feet deep dead water and against it even a natural earthen base could sustain. This might have prompted him to retain this natural base, which gave to the entire Sri Harimandar complex a considerable altitude and also helped reduce construction. As for the causeway, it was laid over a chain of 35 *surangdwaris* consisting of trefoil arched openings with passage from south to north. A series of two feet and six inch thick 36 walls divided the entire length of the causeway. These walls were constructed at a distance of three feet from each other. This three feet gap was spanned by arched roof constructed using vaulting technique. Thus the gap between each two walls was converted into a tunnel-type arched passage, the openings of which on both northern and southern sides stood perfectly aligned with each other.

These arched tunnels, known as *surangdwaris*, are about five-feet high. The two-feet six-inch thickness of walls was the distance between two *surangdwaris* and the three-feet gap between two walls defined their width. Two kinds of arch-forms, one with two curves and the other with four, alternate each other. Besides these 35 south-north *surangdwaris*, there is also a long tunnel running from *Darshani Deorhi* on the west to the *Har ki Paudi* on the east. A chain of arched openings, which pierce all 36 walls in perfect alignment, constitute the west-east tunnel. These openings consist of pointed arches and have a two-feet six-inch length and width. About a three-feet thick roof, with a dry brick upper layer, has been laid over this sub-structure, and over it stands the causeway.

(Facing Page) Darshani Deorhi from inside: *Darshani Deorhi* has two meanings, one, the gate, which by its beauty is worth seeing, and the second, a gate that leads to the Him Who alone is the object of '*darshan*'. *Darshani Deorhi*, a unique blend of architectural styles, justifies both. It is unusual in beauty and is the only path that leads to Him.

(Preceding Pages) The darkness descends to let light have its role:
If there was no darkness, there would be no light, or at least the light would have no role, no lustre, no colours and no significance. Whether it is the darkness of ignorance or invisibility, it gives light, as knowledge or as visibility, its true meaning. Sri Harimandar Sahib is the eternal light as there is darkness all around. The darkness covers the sky but Sri Harimandar Sahib has light enough to let the sky have some of its glow. Its light pierces as deeply the recesses of dark waters.

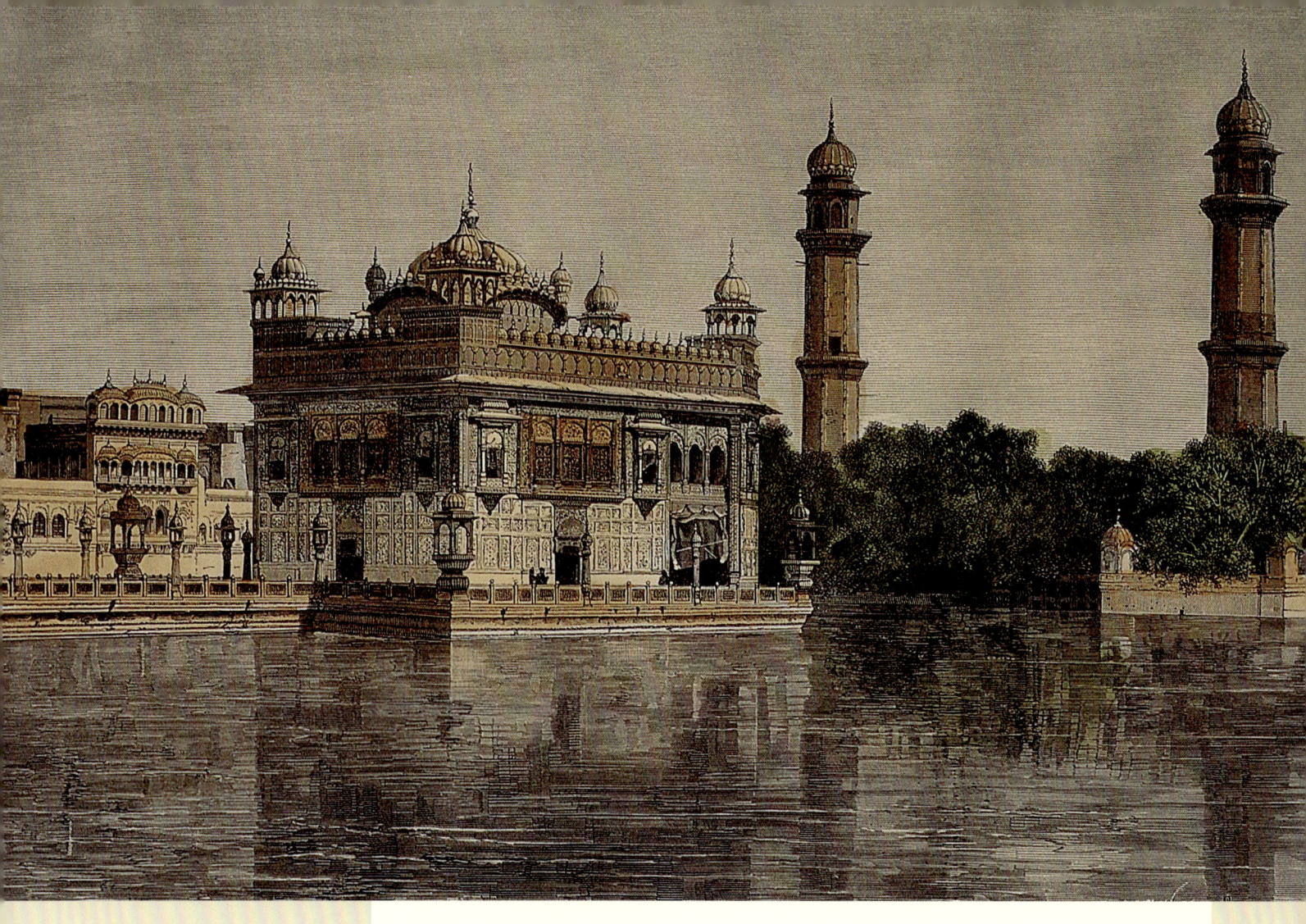

The extended eastern side

Apparently, the original ground-plan was square and did not provide for a semi-hexagonal projection on the eastern side, as it has now. The eastern side had, in Sri Guru Arjan Dev's design, the same width as had other three sides. In all likeliness, the initial structure was provided with only flights of simple stairs to reach the *sarovar*. These stairs defined what is known as the *Har ki Paudi.* The sub-structure, a large round arch, which extends the temple's floor area on its east into a half hexagon, obviously for providing to the *Har ki Paudi* an additional space, seems to be a later addition. The arch type used here is not only different but also considerably late. The outer arch-frame has a circular formation with shallow corbels defining it. There is inside it another shallow or semi-concealed arch with a pointed apex and plain sides. The third arch is deeper but again a blind one. It also has the same circular thrust with an angular apex. It is this third arched formation that the two narrower arched openings pierce. Again, these two arched openings have no regular arch format. This architecture kind has little in common with the simple puritan and largely conventionalised earlier arch forms used in the construction of Sri Harimandar. The use of rail-pole in the construction of this part is yet more conspicuous.

In all probability, the significance of this eastern part, which is obviously greater than a part of the mere circumambulatory, was subsequently realised. Here devotees were required to stay for a longer moment, as this was the sacred site for the *sarovar*-related rites. As such, the extension could alone ease the

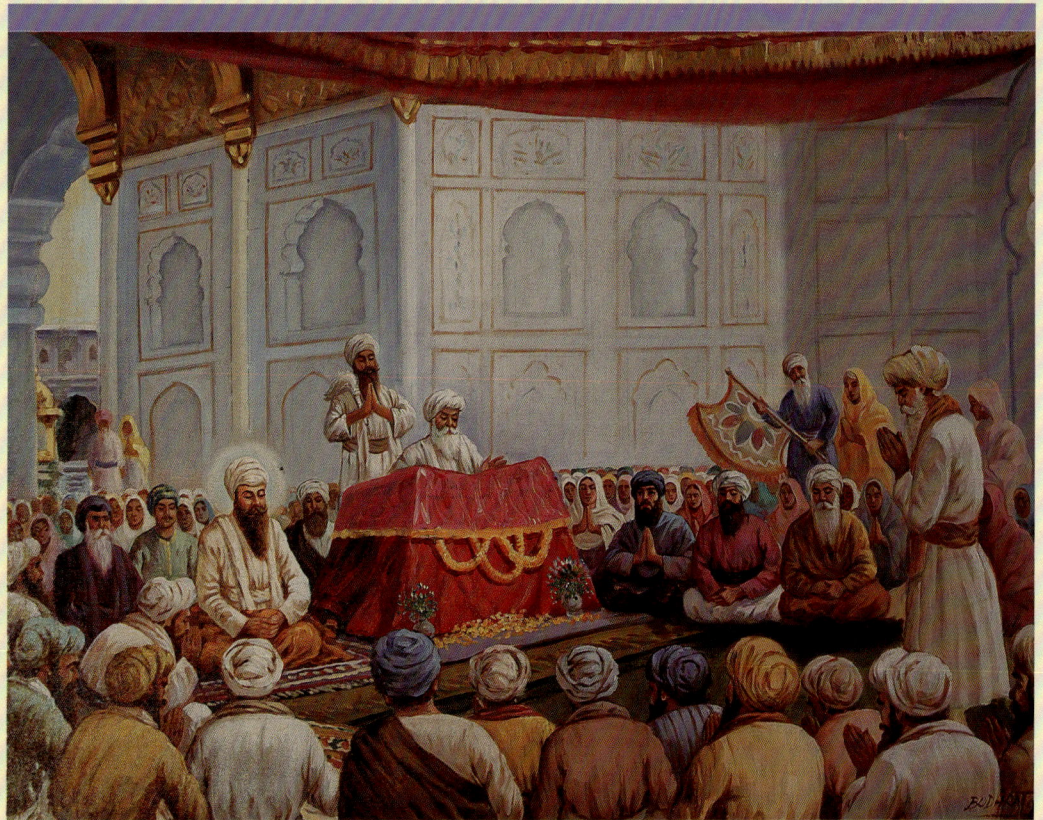

Installation of the Adigranth:
This 1990 painting by artist Bodhraj depicts the first time *Prakash-utsava* of the Adigranth, which had taken place on the first day of second-half of the month of *Bhadaun, Samvat* 1661, that is, 1604 A.D. The Holy Granth is installed on an elevated *Manji* covered with colourful *rumalas*. Baba Buddhaji occupies the seat of the Granthi and on the left is seated Sri Guru Arjan Dev in deep meditation.
Courtesy: Bhai Matidas Museum, Delhi.

(Facing page) Sri Harimandar Sahib:
This old lithograph represents Sri Harimandar Sahib along with Dukh-Bhanjani Ber, two watch towers and other surrounding structures as they were around 1850-60. Towards the east, where now stands the Athsath Tirath, there is a terrace type structure with kiosks on corners. This side is covered largely with Ber trees. On the north is visible a castle type structure, probably the Bunga of Naunihal Singh or the Atari of Rani Sada Kaur.
Courtesy: Government Museum and Art Gallery, Chandigarh.

pressure. Reportedly, in initial days *sarovar's* water used to recede away from the Temple during summers. It is likely that such extension was seen as helpful in reaching *sarovar's* water during such summer days. Two of the *surangdwaris*, which run across the sub-structure under the main shrine, open under this large arch of *Har ki Paudi*. Had this large arch been the part of the initial architecture, the provision for the discharge of *surangdwaris* would have been different. The forearm of this half hexagon has a flight of 14 stairs, which lead to the bottom of the *sarovar*. Thirteen of these stairs are designed to remain under water, while the upper-most to be above it.

The construction accomplished and Hari installed

After a long period of about 14 years, in 1601, the construction of the temple was completed. Sri Guru Arjan Dev had built Sri Harimandar, the abode or the temple of Hari, or God. It was not a Gurdwara, or a Guru's seat. The humble saint, as Sri Guru Arjan Dev was, would not think of building his own temple. It were the Sikhs who conceived, as they perceived the Ultimate in their Guru, a temple of the Guru, namely, the Gurdwara, a concept which had yet to evolve in the Sikh tradition. Besides, Sri Guru Arjan Dev or any of his successors never used it as a residence, or even for holding Sikhs' *sangat* there. Sri Guru Arjan Dev usually sat under the Lachi Ber and performed from here all functions of his office as *Panth's* pontificate. It must have been a very difficult and exceptional situation before Sri Guru Arjan Dev who wished to create the temple as an axis, a centralised seat of Sikhism, which bound all Sikhs in a single thread, but at the same time could not give to his concept either a Hindu temple's form or that of a mosque. Idol worship stood prohibited in Sikhism from its very inception, but

Sri Guru Arjan Dev and the assembly of saints and bhaktas: The central portion of a wall painting from the first floor of the tower of Baba Atal. The full wall painting represents Sri Guru Arjan Dev with nimbus seated against a bolster as the central figure and saints Raidas, Sheikh Farid and Pipaji on his right and Bhai Gurdas, a chauri-bearer, Kabirdas, Ramanand, Jaideva and one more *bhakta* on his left. Bhai Gurdas has before him the large size manuscript of the *Adigranth* consecrated on a richly dressed *chawki*. He seems to be reading out from the Holy Scripture. An oriel window in the centre symbolises Sri Harimandar Sahib.

(Facing page) Prakash of Sri Guru Granth Sahib in the sanctum-sanctorum: The most elaborate view of Sri Darbar Sahib. Under the *Chandani* lay on the sacred Manji Sahib, the Holy Sri Guru Granth Sahib. The Granthis are in attendance and the ragis reciting Sabad. It also allows a rare view of the architectural specialties of the interior of the Darbar Sahib – pendentives, massive columns, amazing long spans of arches, etc.

despite that He was, to Baba Nanak and other Sikh Gurus, the *Nirakara*, or the formless, the abstraction, such as the Islam propounded, was also not the part of Sikh practices. The Sikh Gurus saw Him manifest in His *Nam*. To them, He was not beyond manifestation. Obviously, Sri Guru Arjan Dev planned neither an idol to occupy his temple nor to leave it unoccupied. *Nam* alone was to Sri Guru Arjan Dev the manifest form of Hari and this same *Nam* he had in mind to install in the Harimandar.

Hence, as soon as the construction of the Sri Harimandar had been accomplished, Sri Guru Arjan Dev devoted next three years to the compilation of the *Bani* of the earlier Sikh Gurus, *vaishnava* and *Sufi* saints and devotional poets. His *Nam* was His manifest form. Thus, only in *Bani*, wherein reverberated His *Nam*, one could realise Him. The *Bani* so compiled was to Sri Guru Arjan Dev the light of the Supreme Being. On the sixteenth day of the month of *Bhaduan*, *Samvat* 1661, that is August, 1604, this collection of the *Bani*, subsequently named the *Adigranth*, or the First Book, was installed at Sri Harimandar Sahib in full ceremony and with this *pran-pritishtha* the structure of bricks and mortar turned into the abode of the Supreme. Baba Buddhaji was nominated the first *granthi* of the temple.

Sri Guru Arjan Dev's analogy the foundation was first laid by the Sikh Guru and then relaid by a saint, reiterates its truth. It were the Gurus who laid the foundation of the new faith, but it as much sustained in the *Bani* of saints. This defines the truth of the Sikhism, which was dually founded, first by the Gurus and then by saints. Incidentally, Sri Harimandar was greatly instrumental in threading together the entire body of the Sikh dogma. Here *Nam*, Baba Nanak's manifestation of Him, manifests as *Bani*, the *Bani* appears as the Holy Book and, finally, the Holy Book as *Panth's* timeless Guru and His light. And, in this cyclic transition, Sri Harimandar is the axis. In the Sikh tradition, Gurdwaras have been built in abundance, but a Harimandar never again. After the *Nam*, the manifest form of the Hari, had merged in the Guru, His

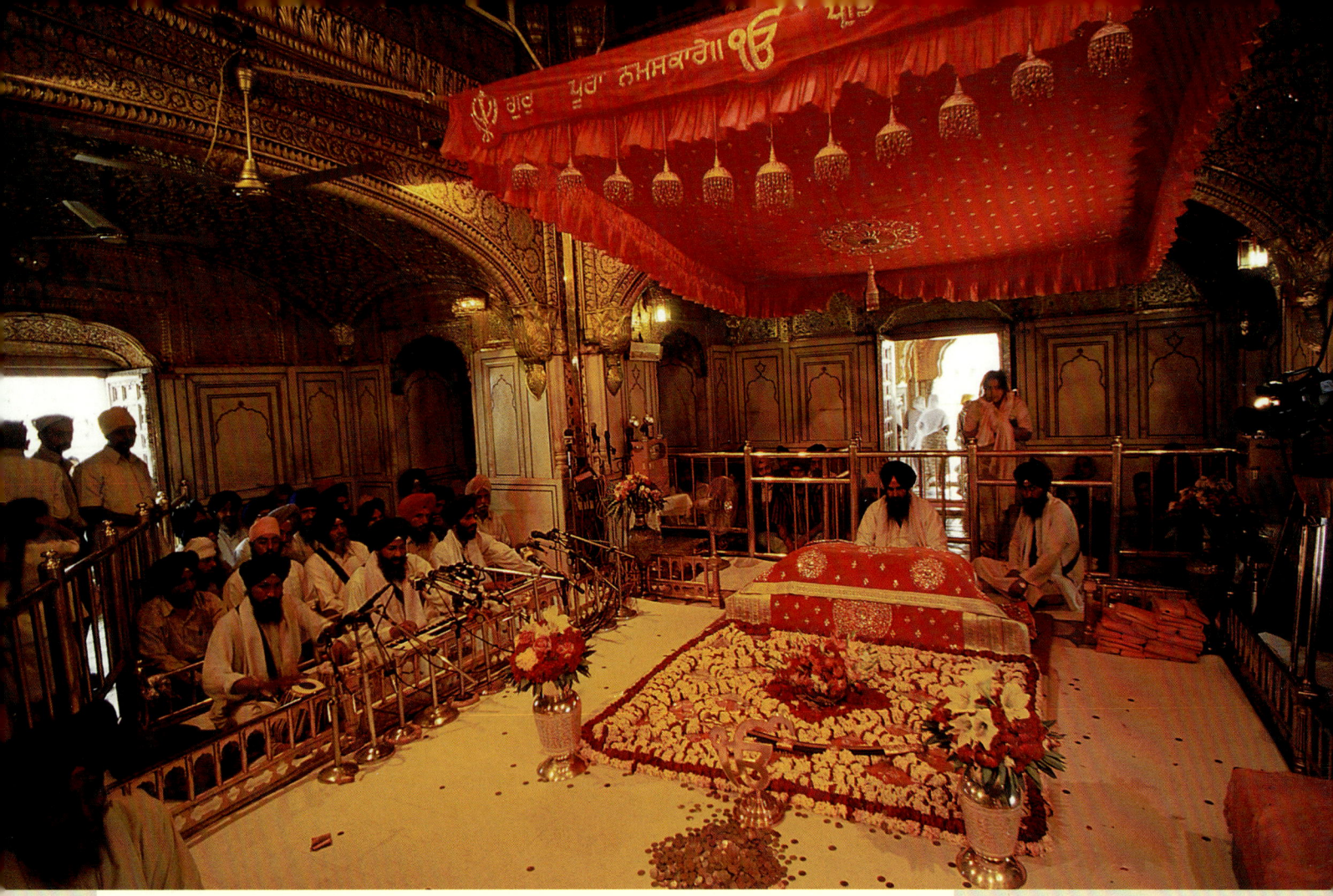

mandir also merged in the Gurdwara, and the two had merged in each other in inseparable unity. Sri Harimandar Sahib is the abode of the Hari. Here He emerged as *Bani*, and finally as Guru. As He is *Ek-Omkar*, the only one, so is His abode, the one, and the only one.

Saintly hands reconstructed what erroneous hands demolished

Sri Harimandar was many more times plundered than any other shrine in India. The temple was constructed during the reign of Mughal emperor Akbar, but due to his liberal policy of religious tolerance its construction was never interfered with. Jahangir was unfriendly with Sikh Gurus. Sri Guru Arjan Dev was assassinated and Guru Hargobind imprisoned by his orders, but even he did not harm the temple. Aurangzeb and his subedars waged a life-long war against Guru Gobind Singh and Aurangzeb's successors treated Sikhs as much cruelly, but despite Sri Harimandar Sahib was not harmed. The temple passed into Mughal occupation after Bhai Mani Singh was executed on 24th June 1734, for his failure to pay the levy of Rs. 10000/- for holding Diwali celebrations at Sri Harimandar. This time the holy shrine was plundered, the tank filled with debris and carcasses of animals and Sikhs subjected to unsurpassed persecution, but despite such cruelty there is nothing on record to suggest that the temple building was harmed.

In 1739, Nadir Shah invaded India and forced Mughals to evict Punjab. Nadir Shah did not harm Sri Harimandar, although before he left, he cautioned his ally, Zakariya Khan, the Governor of Lahore,

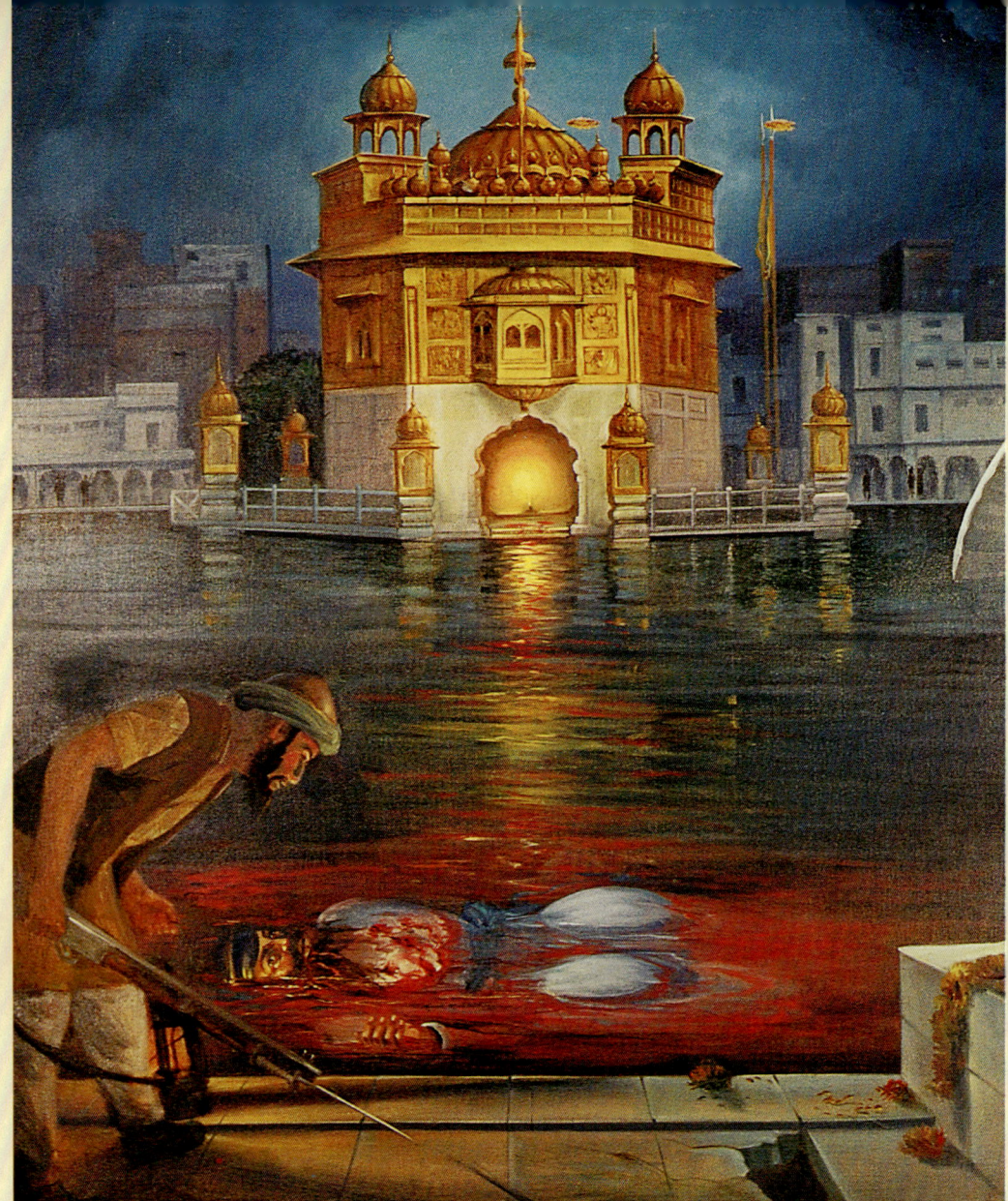

A rare sacrifice:
This painting by Bodhraj portrays
an event of rare sacrifice.
Around 1743, the Mughal Governor of Lahore,
Zakaria Khan, sent to Amritsar a Muslim officer
Massa Ranghar to occupy Sri Harimandar Sahib.
Massa Ranghar stopped all sacred rituals and even
the sacred 'jot' was not allowed to be lit.
A Sikh, Bhai Mansha Singh decided to at least
light the holy 'jot' every day.
He would swim across the *sarovar* and light the
lamp in Darbar Sahib. One day, he was detected
by the Mughal soldiers and the unarmed Mansha
Singh was speared to death. The holy *sarovar*
witnessed this great sacrifice and, as if itself
bleeding, it turned its waters into blood red.
Courtesy: Central Sikh Museum, Amritsar.

against Sikhs. A Muslim officer Massa Ranghar was sent to take charge of Amritsar. He occupied Sri Harimandar Sahib and not only held his court there but also arranged in it nautch parties. The temple was once again defiled but not demolished. Ahmad Shah Abdali attacked Punjab a number of times. In 1751 and 1757, he plundered and desecrated both the temple and the tank and also harmed the building but perhaps to a repairable extent. But, during his 1762 invasion, he gunned down and demolished the entire temple. As suggests a prevalent myth, the temple structure was so powerfully blown that its debris reached tank's bank and a blown brick hit Abdali's nose standing there. As the Sikh tradition has it, the injury sustained ever since and after 11 years Abdali succumbed to it. In 1763, after Abdali had left, a congregation of sixty thousand Sikhs took the responsibility of reconstructing the temple. Sardar Charat Singh, the grandfather of Maharaja Ranjit Singh, was put into the charge of the work. The construction was begun, but in 1764 Abdali again attacked Punjab and demolished whatever portion of the temple had been reconstructed. Abdali's attacks were repeated in 1765 and 1767 also, but without much effect. The reconstruction of the temple was resumed, but, it seems, it geared up only after Abdali's death in 1773. The construction, or reconstruction, of the temple, causeway and the *Darshani Deorhi* was accomplished finally by 1776.

From Sri Harimandar to the Golden Temple

The golden era of Sri Harimandar began after 12th April 1801, the day on which Ranjit Singh was proclaimed the Maharaja of Punjab in a special congregation of Sikhs at Lahore. He rendered multifarious services to the shrine, the more significant being his initiative to clothe the entire structure with gold leaves and marble. Not only that his deputies worked day and night for giving the temple the glow and the glory of His abode but he himself concluded all his achievements, as well as auspices, by presenting himself at the temple's threshold humbly bowing his head at His feet.

There are scholars who claim that the temple was redesigned and reconstructed by Maharaja Ranjit Singh but except in the case of the *Har ki Paudi* the

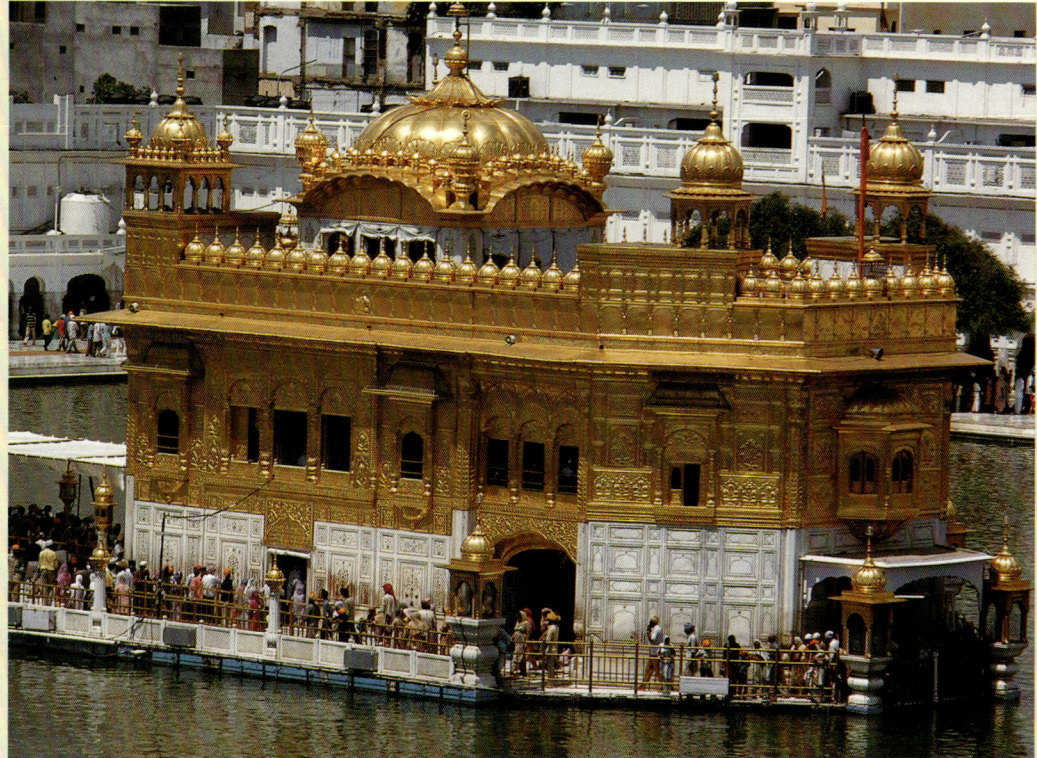

The southeast façade of Sri Harimandar Sahib: Sri Harimandar Sahib, the lyrical perception in architectural art, hums its own tunes, creates its own rhythm and discovers its forms sometimes in waters, sometimes against sky and sometimes against its architectural allies. It rises from the worldly path, above human height, with marble purity and transgressing the golden splendour reaches the apex, where it transforms into multiple spiral turrets, domes, finials, which all lead away from this plane to the plane above.

claim seems to have little substance. As reveal temple's prior paintings, the temple did not have on its eastern side the semi-hexagonal projection as it has now. This portion has a different kind of super as well as sub-structure, which is definitely a later addition. The upper floor of this projected semi-hexagon consisting of the Sheesh Mahal, reflects a Maharaja's grandeur and not a saint's humility. As discussed before, an excessive turnout of devotees at the temple obstructing the circumambulating passage might have necessitated such extension. Thus, it is more likely that Maharaja Ranjit Singh invited designs to suggest temple's embellishment as well as provision to extend the eastern width and the subsequent construction was carried out accordingly with the resources provided by him as well as by other Sikh chiefs on his initiation. But it is unlikely that any substantial change was affected in temple's basic engineering, or architecture. After the shrine had been clad in gold, the outside world began

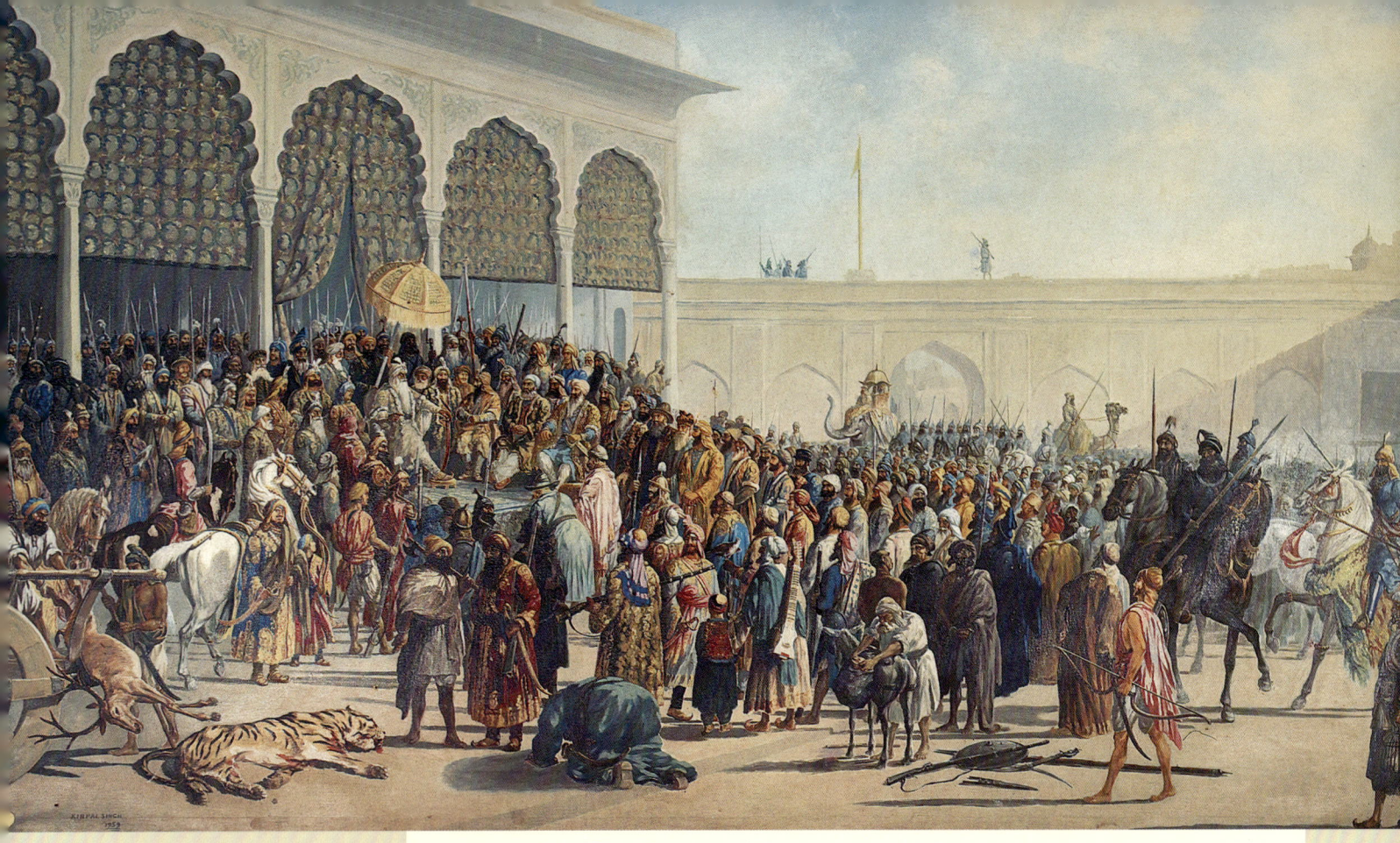

Durbar of Maharaja Ranjit Singh:
This 1979 painting by Kirpal Singh portrays the Durbar of Maharaja Ranjit Singh, who figures in the growth of Sri Harimandar Sahib as one of the milestones. It was him who added to the puritan simplicity of Sri Harimandar Sahib splendour worthy of Him, who was the king of kings. In the painting, Maharaja Ranjit Singh, to whom everyone had access, is seen surrounded by people from cross sections of society. Eager to present him something out of love, they brought with them whatever they could to include even the hunt.
Courtesy: Central Sikh Museum, Sri Harimandar Sahib, Amritsar.

calling it the Golden Temple, but for Sikhs it was yet the same Sri Harimandar, or His Darbar, the Darbar Sahib.

Thus, Sri Harimandar, as it is now, is an entity, physical as well as spiritual, that evolved over centuries and reflects a composite mind of the entire Sikh community. It grew, through Sikhs' collective effort and voluntary service and at the same time by their constant resistance against all oppressions, whatever their kind, into the axis of spiritual inspiration for all Sikhs and as the principal seat of all of their community affairs. Temple's evolutionary growth reflects in many of its aspects and in its subordinate structures. The temple, which Sri Guru Arjan Dev conceived and built, was a puritan structure of pure spiritual kind. Its subsequent gold covering added splendour to its piety. The Sheesh Mahal blended into its form the regal grandeur and the addition of the *Darshani Deorhi* transformed it into a semi-defense structure. Many of the *bungas*, now mostly demolished, were built for securing the shrine from intruders. They were normally used as inns for pilgrims but at times housed defense *jatthas* and served as defense positions. The Akal Takht added to Sri Harimandar an altogether different dimension relevant till date.

The concept that never changed

Many a time, Sri Harimandar was reduced to debris and every time it rose to greater magnificence but despite this its basic concept never changed. It was ever the same, as it was perceived by Sri Guru Arjan Dev, a large square hall with sufficient space to accommodate as many Sikhs as possible. Sri Guru Arjan Dev wished to distinguish his shrine from both, a mosque and a temple and neither designed it with a long colonnaded *verandah* as a mosque usually had, nor on a rectangular temple plan. He, how-

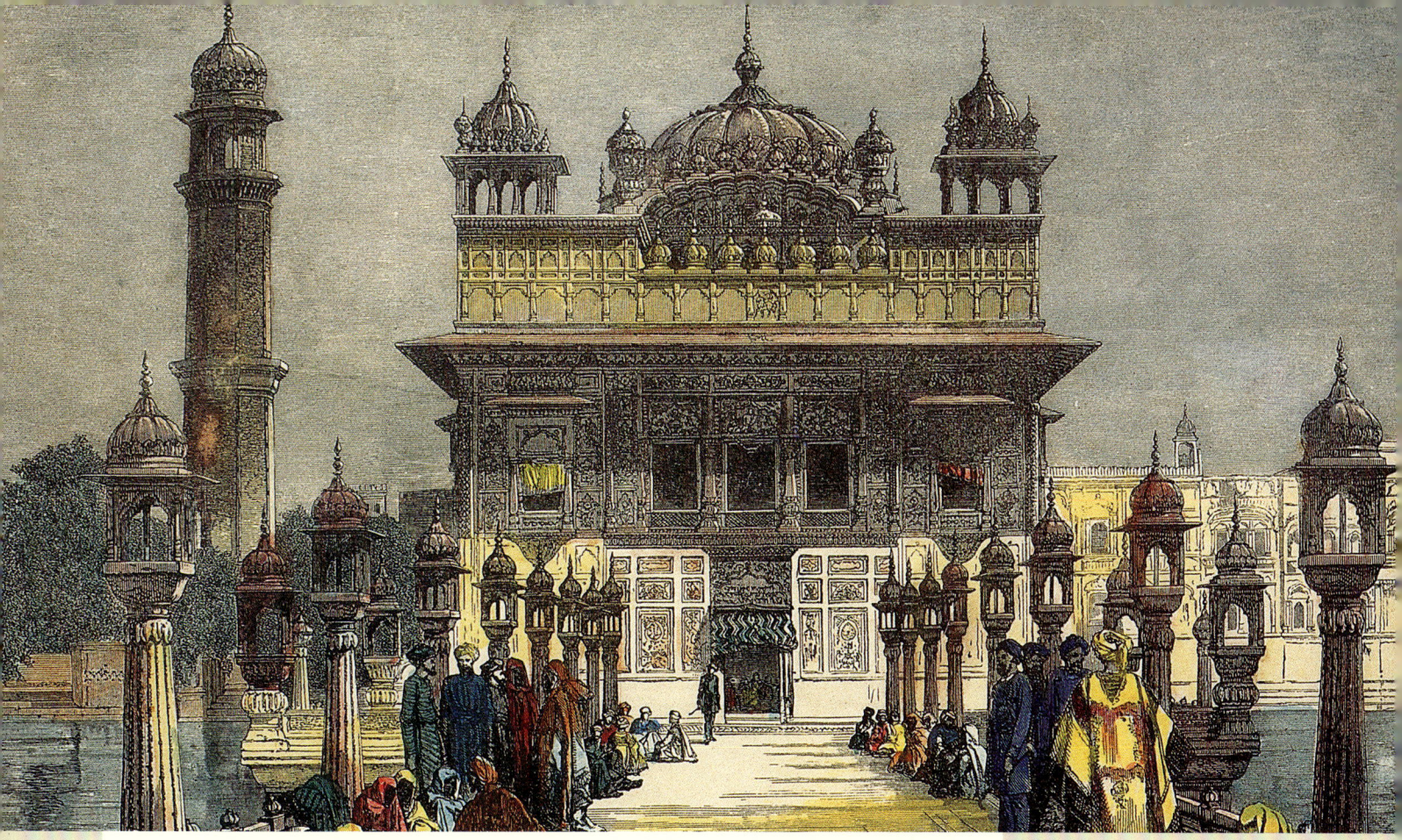

ever, seems to have developed his building structure keeping in mind the *mandapa* and the *garbhagrah* forms of a *Vaishnava* or Jain temple. In a rectangular temple plan, the *mandapa* and the *garbhagraha* essentially had a square format with circumambulating passage around them. Except for the square format, Sri Guru Arjan Dev's shrine made a complete departure from the temple tradition and was conceived with absolutely different dimensions and objectives.

A *mandapa*, or *garbhagraha*, was only a component in a rectangular plan. Sri Guru Arjan Dev's structure was absolute in itself. It was not a small chamber, like a temple's *garbhagraha*, with space only for the idol and the priest and with a single low door. As regarded *mandapa*, it did not have its ornate character. On the contrary, it was a simple puritan structure, a hall for communion, more like a theatrical stage where, he believed, the Divine Light would emerge and he wished, everyone, irrespective of his caste, creed, origin, or status, felt and experienced the Divine Drama from an equidistance. This was obviously something, which a rectangular hall could not afford. His choice for a square format was a technical need as well. In a brick building, as Sri Harimandar was, vaulting alone could be the architectural kind of roofing and spanning doors, gates and tunnels. Using squinches, or similar devices, a square structure was more easily reduced into a dome, or a dome-like apex.

Instead of a *garbhagraha's* single door opening, Sri Guru Arjan Dev preferred the *mandapa*-type openings on all four sides of his shrine. This, however, was not a mere architectural feature, as it was in the case of a *mandapa*. In this multiplicity of door-openings, there reflected the multiplicity of dogmatic sources, wider acceptance, his world view and the all-embracing character of Sikh faith. Scholars have variedly interpreted this option of Sri Guru Arjan Dev. To some of them, the openings on all four sides aimed at letting the light, symbolically the knowledge of Him, pour

An old lithograph of Sri Harimandar Sahib: This late 19th century lithograph represents the western façade of Sri Harimandar Sahib. The causeway appears to be quite spacious and was in use then also for devotees to sit and meditate. Devotees sitting towards its sides are either engaged in meditation or awaiting the door of the Temple to open after some ritual, which might have been in prevalence those days. Courtesy: S. S. Hitkari, New Delhi.

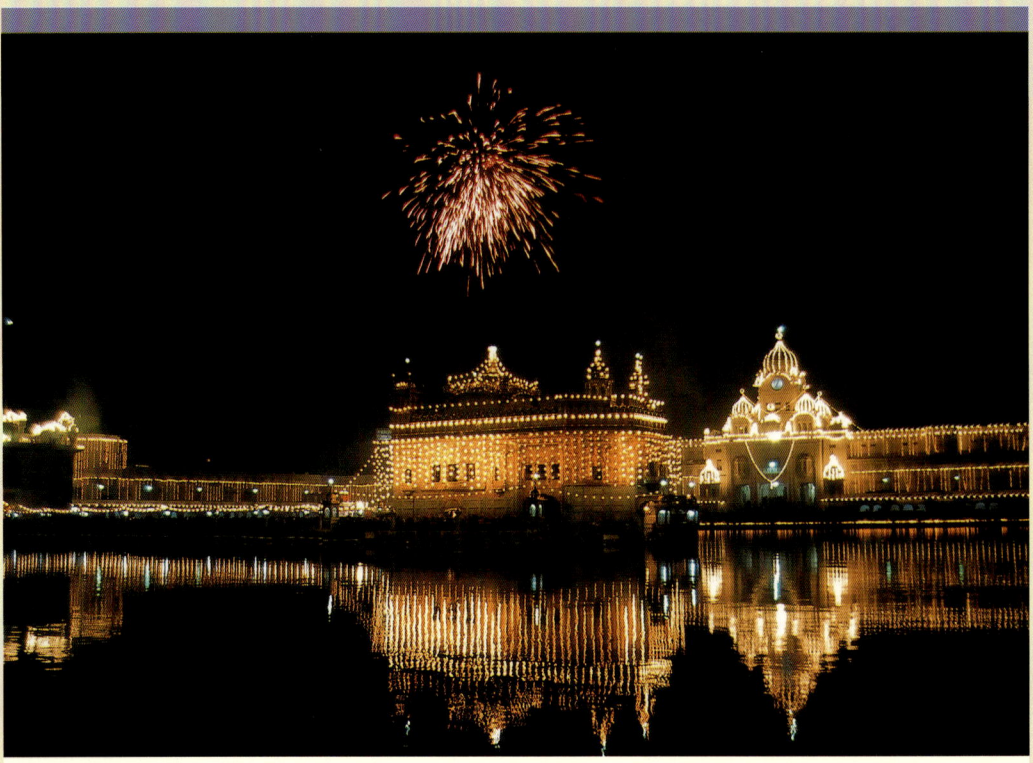

Sparklers in the sky: When so much of light, the light within and light beyond, the light in the sky and the light below waters, where would prevail the darkness? O, Yea! The wanderer of darkness, look, there is for you, too, a handful of light, open the eyes and let it descend into you.

(Facing page)
A bird-eye view of Sri Harimandar: The photo realises Sri Harimandar as the axis of the cosmos – a cloud-laden sky above and surging waters below. Around it are portals to the divine shrine and the circumambulating path.

from all directions. They claim that in the Granth Sahib he compiled the *bani* of both Hindu and Muslim saints and *sufi* and *vaishnava* poets. The other group of scholars interprets it differently. To them, four door openings of the shrine allowed all directions, that is, all sections of mankind, seek from it an alike inspiration and His benevolence.

It appears that Sri Guru Arjan Dev wished his shrine to have a distinction of its own. He hence designed it different from both, the temple and the mosque. The structure that Sri Guru Arjan Dev designed and constructed does not survive any more, but whatever of it survives today suggests that he had designed it more like a castle, with a castle-like multi-windowed facets, flat roof, balconied inner-floor pierced with steps on all corners to reach the terrace and the like. Its landscapic setting in mid-water, which not only provided to the building a unique frame but also enhanced its splendour in its reflections, was an element foreign to both, the temple and the mosque. Such totality was more akin to Mughal buildings, especially their mausoleums, which they set in the centre of a *charbagh*, a garden laid into four equal divisions. It may be doubtful whether his structure had the first floor consisting of the projected balcony or not, but it may as easily be said that the chamber comprising the second floor with the fluted dome over its roof is a later addition. Temple's sub-structures, as well as its ground floor, do not provide for a domed structure. By Sri Guru Arjan Dev's time the concept of hollow domes was in great vogue, followed widely in temples, mosques, mausoleums and other similar structures. If his design provided for a dome, it might have been a hollow one and provisions for it were made in its sub-structure itself. It is more likely that his humble seat of the Supreme Divinity did not provide for a dome's towering majesty.

Thus, it is obvious that whatever its present status, the basic architecture of Sri Harimandar has not deviated much from Sri Guru Arjan Dev's concept and

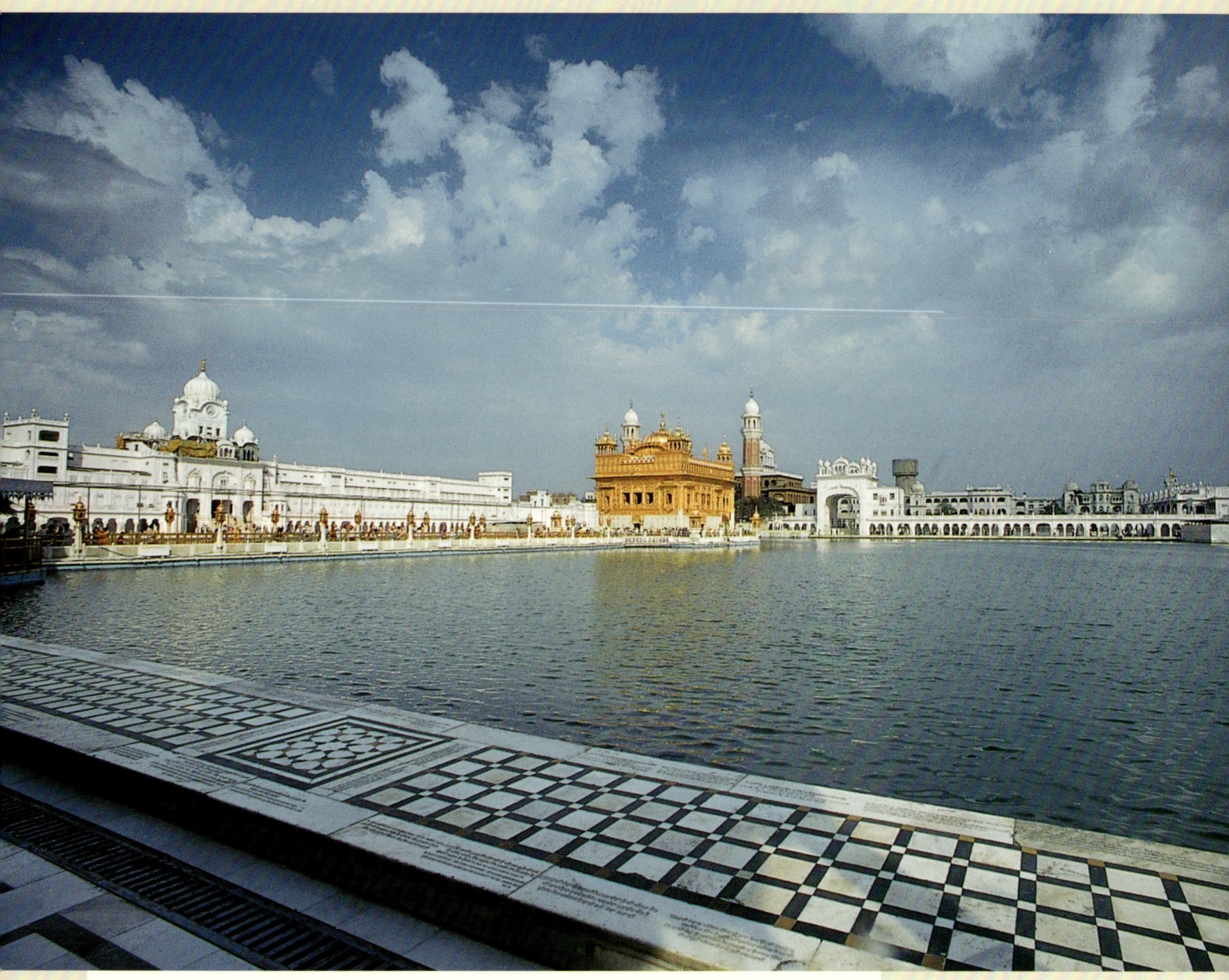

design and the shrine's sub-structure is largely responsible for it. The structural unity and the adherence to the basic concept, which has always prevailed in all subsequent constructions, are born of this sub-structure. This base-structure was so designed by Sri Guru Arjan Dev that the super-structure was bound to seek its form only in relation to it. Sri Guru Arjan Dev knew the significance of this part. He had, hence, especially secured it by constructing it into deep waters and in all likelihood it always stood safe and secured against all intrusions and attacks. Sri Guru Arjan Dev sought the thread of spiritual unity of Sikh *Panth* in the compilation of *Bani*, and that of the architectural unity of Sikhs' principal seat in its foundation and related sub-structure. Thus, two things are obvious; first, that Sri Harimandar kept constantly changing, but its basic concept never changed, and thereby Sri Harimandar is, and always was, a saint's vision and not a monarch's creation, as it is sometimes considered; and secondly, that its sub-structure is the same as it was originally designed and constructed by Sri Guru Arjan Dev.

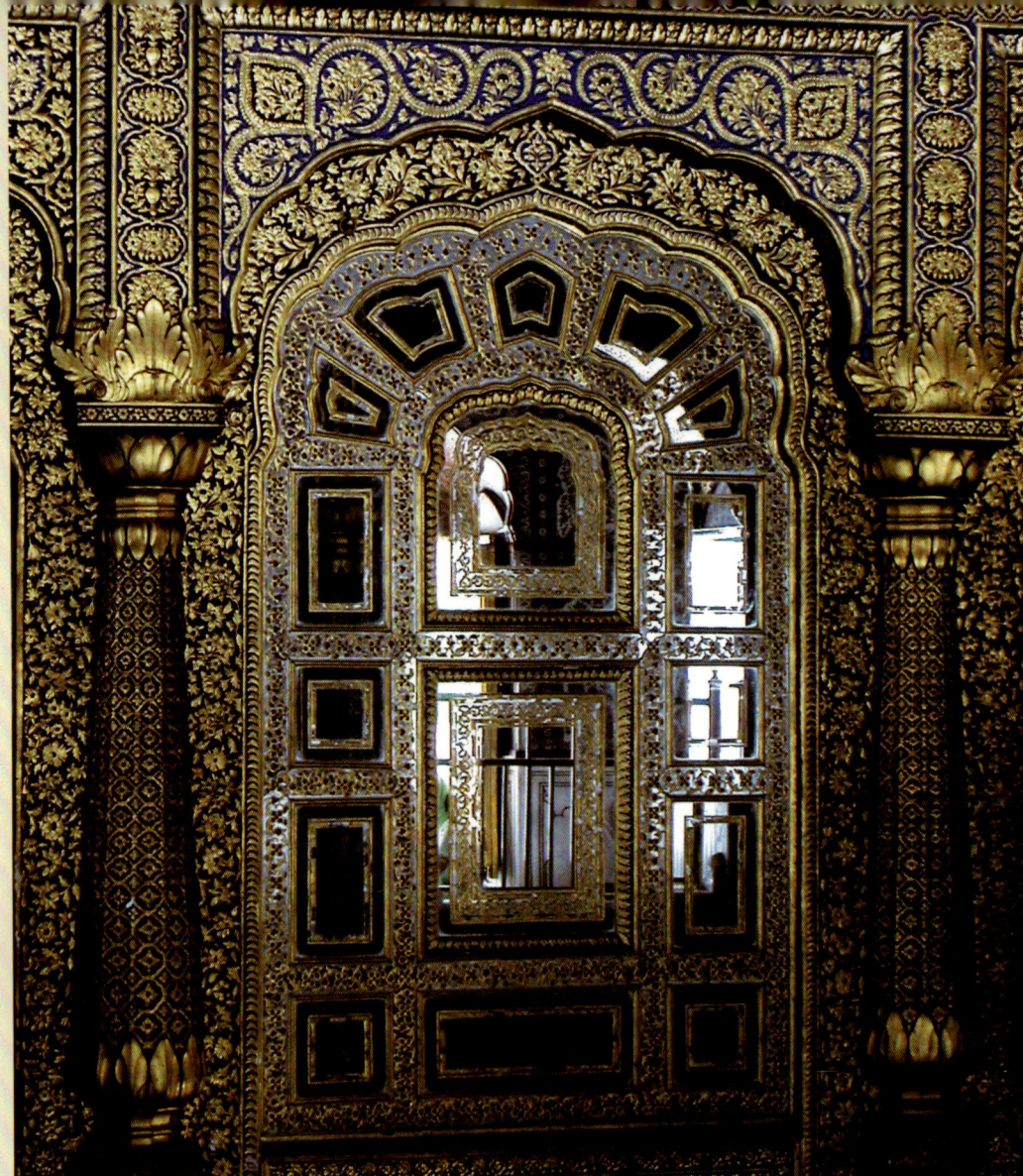

A marvel of art:
An otherwise simple door, comprising the central opening on the eastern arm of the first floor balcony, is a piece of exceptional beauty and a marvel of art. It uses, besides the mirrors and coloured glass pieces, brilliant colours, gold leafs and elaborate and varied designing patterns and motifs for creating effects. To gold, bright Persian blue, deep red with maroon tint and magenta provide befitting contrast.

(Facing page) A portion of the ceiling of the Sheesh Mahal:
Every part of Sri Harimandar Sahib has its own kind of beauty, but the beauty combined with the unique splendour is the sole preserve of the *Sheesh Mahal* on its first floor, and its beauty remains unparalleled, not even in mirror palaces of great kings. Here sobriety characterises the brilliance and the feel of spirituality in the opulent exteriors. It visualises the cosmos but so differently. Here the rotating sun does not vanquish stars, but only adds to their brilliance.

Three phases of the architectural growth of Sri Harimandar

Obviously, there are at least three distinct phases that define the architectural growth of Sri Harimandar. Temple's sub-structure, which also includes the causeway, and its broad basic design and layout are parts of the initial structure, which Sri Guru Arjan Dev had built. The super-structure of the shrine, it seems, was almost fully demolished during 1762 and 1764 invasions by Ahmad Shah Abdali. It was reconstructed by Sikhs' collective effort in 1776. The Sikhs who were put to the charge of the reconstruction must have seen the prior structure constructed by Sri Guru Arjan Dev and had its design in their minds. Hence, by and large, the subsequent structure would not have deviated, except for strategic reasons or embellishment, much from its original form. The likely addition of one more floor consisting of a large square room and a fluted dome over it during reconstruction might have been prompted by security reasons. Whether Sri Guru Arjan Dev's structure had over its parapet kiosks and turrets or not, is difficult to say, but during the reconstruction in 1776, the parapet was adorned, in all likelihood, with four beautiful kiosks on its four corners and 58 as beautiful turrets all around it.

It seems, the *Darshani Deorhi* was added to Sri Harimandar complex as a security measure. The entire wall surface of the shrine was

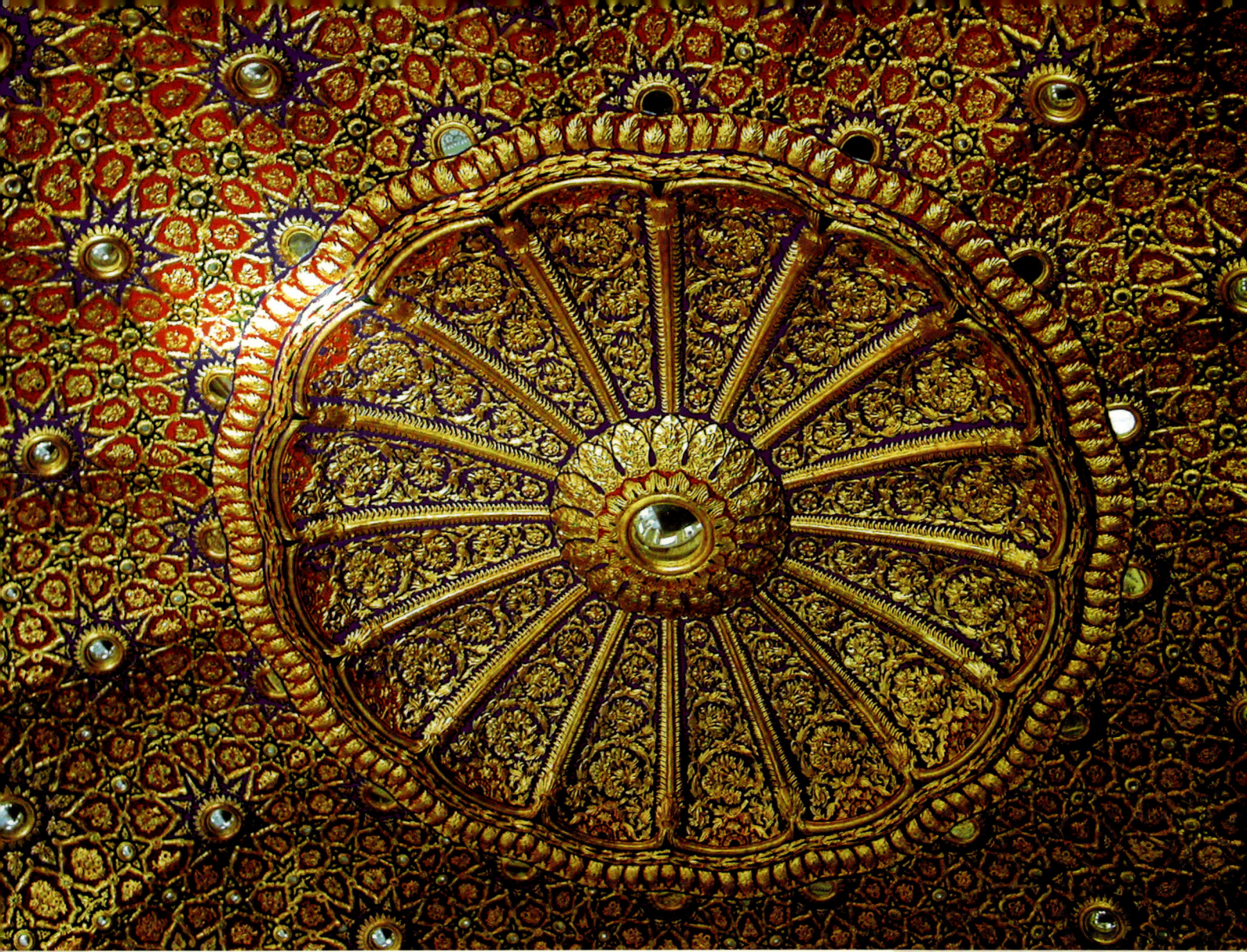

adorned with various kinds of wall paintings. Till covered under gold-plating by Maharaja Ranjit Singh, these wall paintings were the principal means of decorating the wall surface. These murals revealed from under this gold-plating, when for recent relaying of gilded copper leaves the prior gold-plating was removed. During Maharaja Ranjit Singh's regime Sri Harimandar had its third phase, the phase when splendour was added to piety. The entire interior and exterior wall surface was clad with gold-plating and marble and a semi-hexagonal projection and its related part were added towards its east and the causeway was given a new look. The Sheesh Mahal was in all probability a creation of his time. Being in live worship, Sri Harimandar underwent changes and alterations every now and then but architecturally hardly of any significance.

Dr. P. S. Arshi has concluded in his book *The Golden Temple* that the present structure of Sri Harimandar is solely Maharaja Ranjit Singh's contribution. As above, this conclusion of Dr. Arshi may not be endorsed. Maharaja Ranjit Singh embellished the temple to its all-time splendour, but even the concept of embellishing the temple surface was not new. During the recent renovation of the gold-plating the temple surface revealed, from under the earlier gold-plating of Maharaja Ranjit Singh, prior mural paintings that adorned the temple surface before it was gold-plated. It appears illogical that Maharaja Ranjit Singh first built the

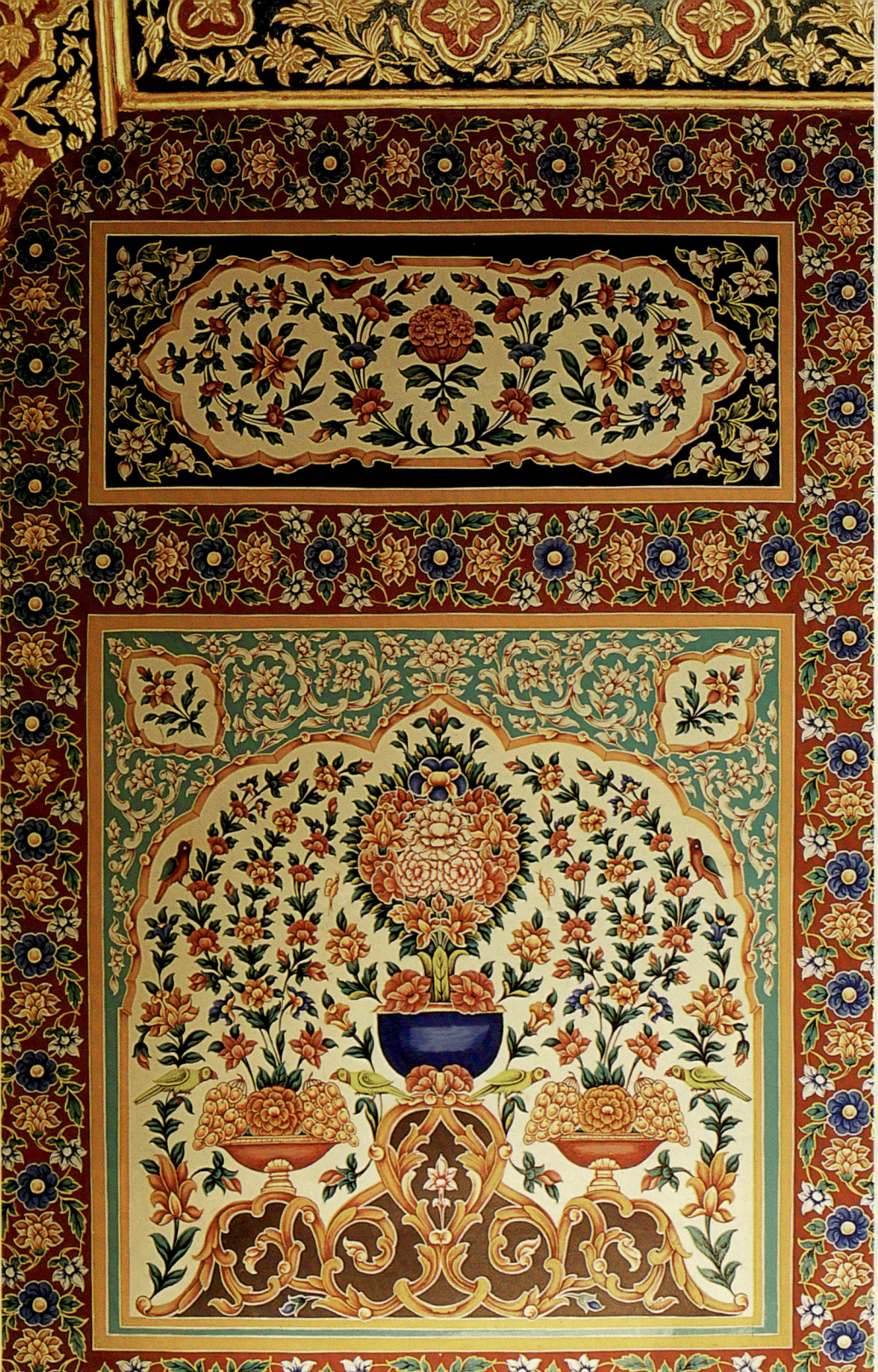

Arabesques and floral designs:
Sri Harimandar Sahib is a picture gallery of arabesques and floral and geometric designs. It is estimated to have more than three hundred types of such designs and patterns and hardly a few use human icons.
These highly rhythmic designs discover their thrust in geometry and amalgamation of varied motifs. If the leaf of a creeper does not aptly negotiate the space, the artist would use a small isolated bird to fill it. Here the verticality is divided into multi-framed squares and horizontal rectangles, which not only break monotony but also create rhythm.

temple, then covered its wall surface with murals and then over these murals laid the gold leaves. Obviously, the architecture of the shrine, along with its wall space painted with murals, existed before Maharaja Ranjit Singh got it gold-plated. Only recently, the prior gold-plating of Sri Harimandar by Maharaja Ranjit Singh was removed for laying fresh gold leaves. The wall space that revealed from under such gilded copper sheets was elaborately painted. The cost of the recent gold-plating, that is the cost of required quantum of gold and that of its laying, has been borne by the collective effort of Sikhs

The inscribed arch-span:
To be constructed in the centre of a huge *sarovar*, Sri Harimandar required a massive architecture and so Sri Guru Arjan Dev conceived and designed it with some three to four feet thick walls and columns, as also the arches spanning in-between. But in the tradition of faith, every inch of the space of its shrine is required to say something and elevate the soul by it, whether by its beauty or by its spiritual message. Sri Harimandar Sahib uses both, the forms of beauty and the extracts of *Bani*. Here this part of the arch-span has inscribed all over it the sacred Bani.

mainly from the U.K. The work was executed under the supervision of Baba Mohindar Singh, the head of the Guru Nanak Nishkam Sewak Jatha, London, U.K. For many months, he camped at the Golden Temple along with a team of devout Sikhs from England.

Fergusson's observation that Sri Harimandar is an example of the form which Hindu temple architecture assumed in the 19th century is also not very sound. *Shikhara*-temple was the prevalent style of the 19th century Hindu temple architecture at least all over the North and the Central India. Besides, the basic architecture of Sri Harimandar, even in its reconstruction, which a disciplined community adherent to its Guru's vision and norms rendered, was always the same as it was conceived by Sri Guru Arjan Dev. Hermann Goetz's opinion is as much misguided. He perceives in Sri Harimandar the Kangra transformation of Oudh architectural style, though both were very late entrants in the arena of architectural styles of India. In the official list of the buildings of the wider interests published in 1875, by the British Government of Punjab, not only that the reconstruction of the temple has been attributed solely to Ranjit Singh but its design has also been attributed to Mian Mir's tomb near Lahore. Such wrong notions which most of the European scholars entertained about the architectural

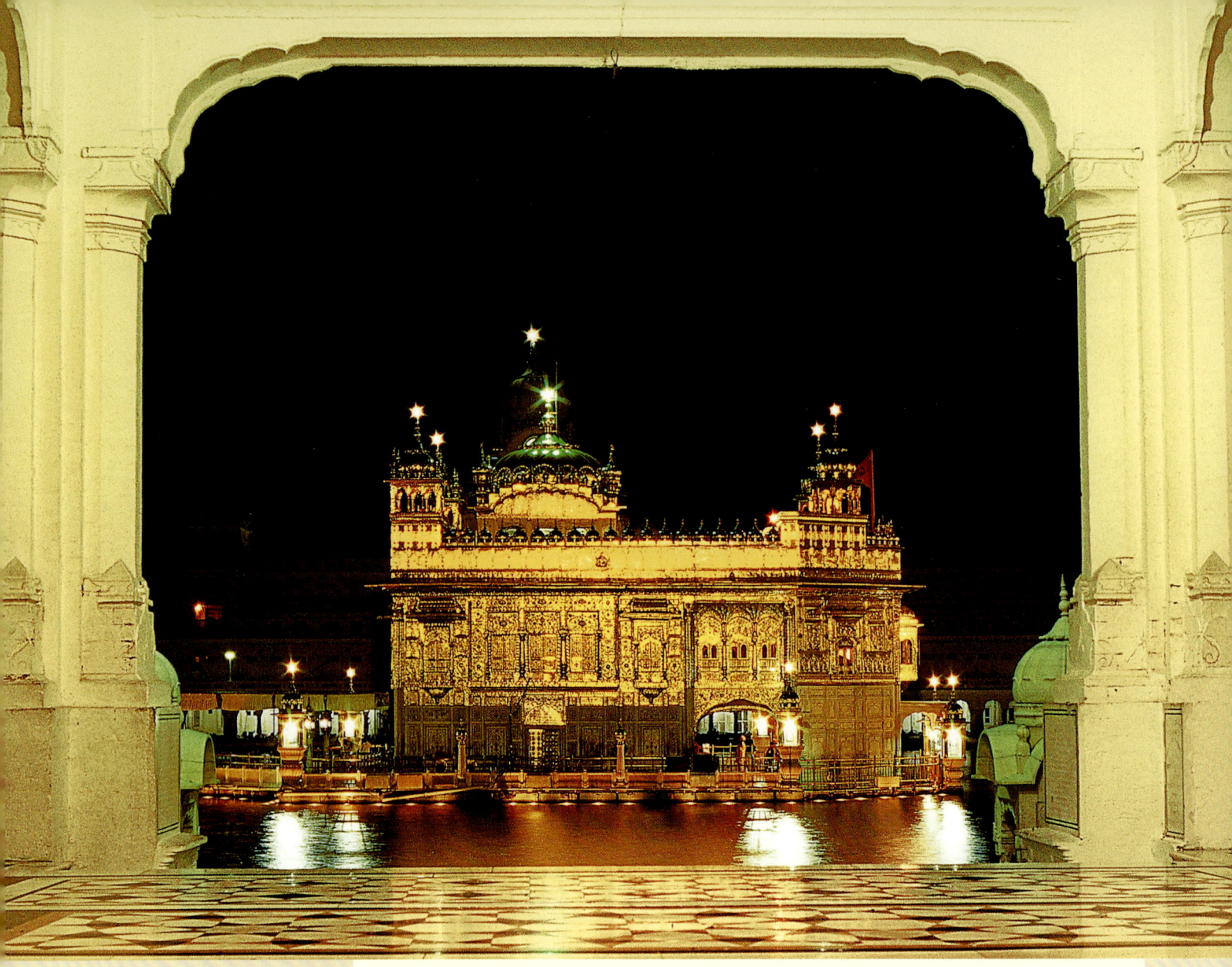

kind of Sri Harimandar were born of their mind-set that believed that the temple, as it stood, was constructed solely by Maharaja Ranjit Singh. Observations of Percy Brown, Major Cole, Louis Rousselet, etc., perceiving in the architecture of Sri Harimandar a synthesis of Hindu and Islamic elements, are wide and generalised.

The design of Sri Harimandar Sahib

Sri Harimandar has some architectural elements common with the tomb of Mian Mir, namely, the location of the shrine in the centre of a tank with access through a causeway, domed kiosks on each corner, square format with painted wall surface and the use of fretted screens. Hence, some scholars conclude that in the construction of Sri Harimandar Sahib the design of the tomb of Mian Mir was followed. Such claim has little substance. It seems the scholars drawing such conclusion did not take into consideration certain points that deserved to be discussed at length.

As discussed above, Sri Harimandar, even in its reconstruction, had adhered to Sri Guru Arjan Dev's original design, barring of course embellishment and some changes in superstructure. Mian Mir died in 1631. His tomb was built after

his death, but the exact date is not known. Sri Harimandar had been constructed by 1601, that is, 30 years before the death of Mian Mir. Obviously, at least the location and the sub-structure of Sri Harimandar could not be borrowed from a building, which was yet not born. Besides, the related dates of the construction of the tomb and the reconstruction of Sri Harimandar have yet not been ascertained. It is, hence, difficult to conclude which of the two buildings borrowed these elements from the other.

Besides, it is also doubtful if Sri Guru Arjan Dev, or his Sikhs after him, would follow for the temple the model of a tomb. Moreover, these are not the exclusive features of either of them. As discussed before, the location in the middle of the tank was considered since ancient days an ideal setting for a temple under classical norms of architecture in India, and texts like the *Braht-Samhita* emphatically recommended for it. The 16th century tomb of Sher Shah Sur at Sahasram in Bihar presented an excellent example of this kind of building. Sur's tomb has been built in the centre of a masonry tank. Akbar's Fatehpur Sikri presented the finest examples of fretted screens and domed kiosks. His tomb at Sikandara, built largely during his lifetime, had excellent domed corner kiosks. Gwalior's Man Mandir, a pre-Akbari castle, subsequently built Orchha's Jahangir Mahal, Datia's Bir Singh palace and a number of pre-Mughal castles in Rajasthan had their corners negotiated with magnificent and diversely designed domed kiosks. In India's architectural tradition square format and painted walls were in great prevalence. Hence, on the basis of these elements any such conclusion would only be erroneous. Maybe, both borrowed these features, independent of each other, or mutually, from a common pool, or from diverse and different sources.

'*Dhithe sabe thawa, nahin tudh jehia*', that is, all places I beheld but none like you I found. Though this *sabad* of Sri Guru Arjan Dev relates to the town of Ramdaspur, yet it defines as much the monumentality of Sri Harimandar. The Harimandar attains this magnanimity as a monument not by borrowing features of this or that building but by assimilating and synthesising the best of all building traditions. It is unique that in Sri Harimandar the architecture of a castle has been transformed into that of a temple, a chamber reflects in myriad of its mirrors, inlaid on its walls, a *granthi* bowed over the Holy Book, or a devotee turning his beads, and not the glimpses of a court-dancer, a royal lady, or a king. Its walls transform into a painter's canvas and the towering *kirti-mahastambha* depicting *samavasharan* of a Jain *tirthankara* condenses here into fretted marble lamps to embellish the causeway and the circumambulating passage around the august shrine. It uses in successive rise, for both, the beauty and the spiritual elevation, the corbelled arches of Mughals and for strength the semi-circular arch forms discovered in the Ajanta caves for door-openings as well as vaulting of roofs and elaborately used in the 7th century rock-cut Jain temples of Karuppanaswami, in Madurai. The fluted dome it takes from Islamic tradition but bases it over Indian lotus. It transforms a garden *baradari*, a gallery with 12 openings, into a domed kiosk and adorns with it the corners of its parapet, and with the interplay of vertical and horizontal recesses and projections, it creates its own music and rhythm and vibrates its entire façade.

Sri Harimandar Sahib a rare vision:
Sri Harimandar Sahib, an entity beyond all frames, submits itself to a frame and in the process the frame derives from it its divine glow.
The space contained in the frame has highly contrasting areas, the abyssal darkness beyond but the brilliant light within.
The waters forsake darkness and borrow light's splendour and golden glow. The floor has its colours but shares also the glory of light.
The semi-visible kiosks on both sides of the framing arch add to it delightful dimensions.

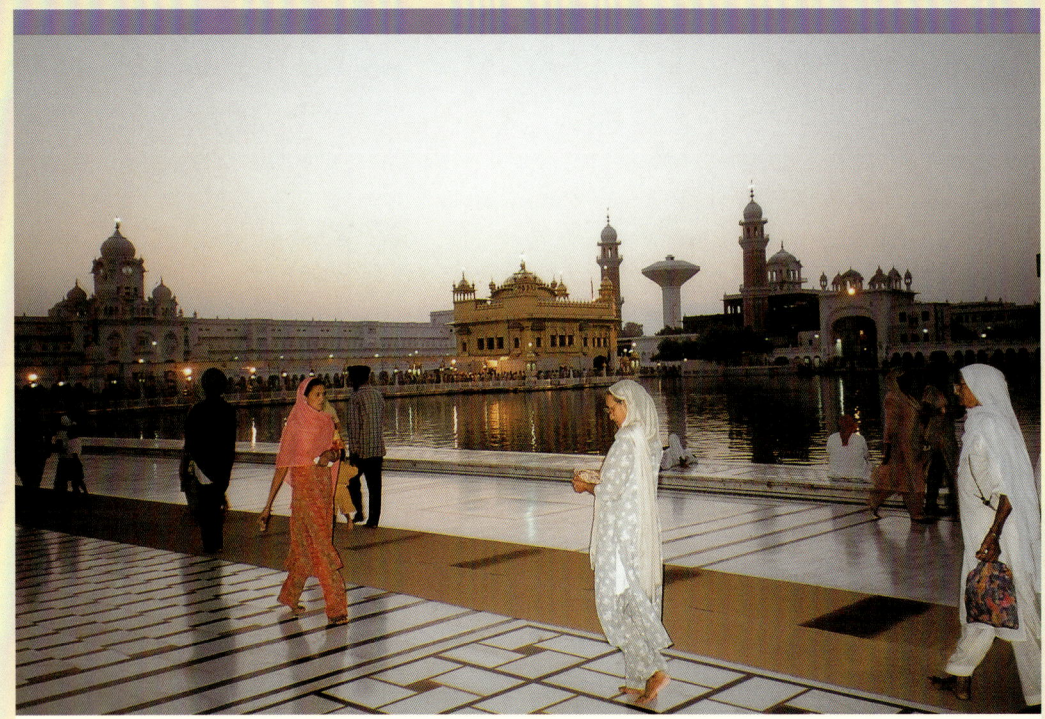

A morning at Sri Harimandar Sahib:
And, Lo! The eastern sky glows with day's brilliance and the man-made lights have been commanded to pack off, as it is now the turn of day's light to take care of His abode.
The dutiful northern clock tower would not put its lights off unless it has assured itself that the Sun is there to relieve it of its charge.
To devotees, nothing is more sacred than the early morning rituals and whatever the hurdles, they are there to attend them.

(Facing page) Sri Harimandar Sahib during the early 20th century:
This photograph represents Sri Harimandar Sahib in actual dimensions with the only exception that some of its windows have curtains on them. As becomes obvious from this version as well as other historical records, the surrounding area had different kind of buildings and habitation. The most towering structure, beyond the Temple, was the Victorian clock tower built by Britishers on Temple's north.
Courtesy: Imperial Hotel, New Delhi.

Diversity, instead of symmetry, is more characteristic of the architecture of Sri Harimandar. It blended and assimilated into its being multiple forms, styles and traditions. The frontage of the holy shrine, or its western facet, is different from the eastern one. The western one has a square format but its opposite, the eastern, a semi-hexagonal. Kiosks surmounting the corners of western façade are square and consist of 12 openings. Around their domes they have four corner turrets. The eastern kiosks are octagonal and stand isolated. Windows have alike diverse forms. Some of them are contained in the walls as routine openings but others are balconied windows thrown out on carved brackets or are bay windows with shallow elliptical cornices. Brackets themselves have a very wide range. Its parapet has been adorned with beautiful gold-plated turrets. Their shape does not change but their number on each facet differs. The northern and southern sides have 19 turrets each, but the eastern side has just 13 and the western side just seven. Arch forms are as much diverse. From the ancient Indian semi-circular arch forms to Mughals' cusped and corbelled arches all arch patterns have been used in Sri Harimandar. Such arches have been used broadly for three purposes. They are usable as openings when they contain doors in them, but they turn into decorative element when they are recessed into a wall. When such arches are contained into a wall, they work as a strengthening agent. All domes are fluted but otherwise they have a very wide range from the dome form of Bengal's Vishnupur temple to the dome pattern of Lahore's Badshahi mosque. The Islamic cult of calligraphy has been effectively used by both, the goldsmiths who engraved gold leaves, and the artists who painted the walls. They have engraved or painted the timeless *Bani* of their Gurus in niches and other framed spaces cast in usual Mughal arch types. Assimilation of diverse forms and traditions and an attempt at synthesising them into a single thread are thus the cardinals of the architecture of Sri Harimandar Sahib.

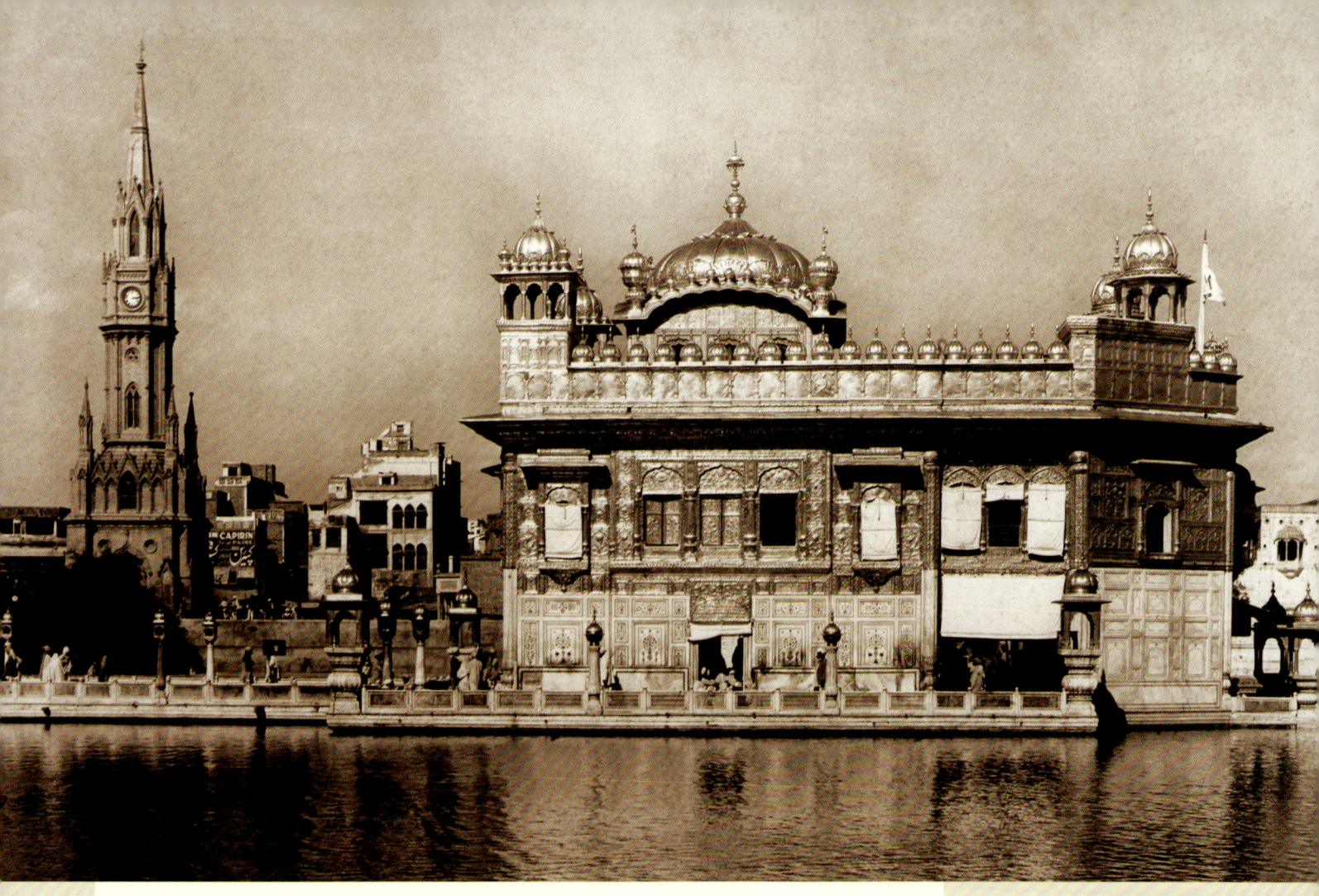

Architecture and embellishment

Sri Harimandar, as it is now, is the result of an evolutionary growth. The present form has been arrived at by repeated reconstruction, interior alterations, renovations and additions. The main body of the temple was square and its founding earthen base, which contains the sub-structure of Sri Harimandar, is yet the same perfect square. Temple's sub-structure, too, except an eastward projected loop comprising of a massive tunnel carrying over it the extended ground floor and an upper floor, has a square format. The semi-hexagonal *Har ki Paudi*, added to it in all likelihood subsequently, endows to the ground floor its hexa-square or irregular quadrangular form. Temple's main body consists of three floors, while its eastern half-hexagon has just two. The temple proper stands in the centre of an approximate 66 feet 4 inch square platform. Temple's main body is about 40 feet 6 inch square. The rest of the platform has been left, in almost equal length and width on all four sides of the temple, for circumambulatory. Its breadth on its western side is few inch less than that on its east, but on its northern and southern sides it is equal. This circumambulating path has been left uncovered on its west, south and north, while on its east, it stands roofed and serves as both, the circumambulating path as well as a vestibule-cum-corridor in-between the temple's main body and the *Har ki Paudi*.

 Length-wise, the eastern side has been extended by 16 feet 4 inch. In width, it reduces from an approximate 43 feet to 23 feet 4 inch and forms a half-hexagon. Hexagon's side-arms measure 17 feet 4 inch. Beyond this 23 feet 4 inch eastern forearm, there is a further extension of about 8 feet 3 inch. The most part

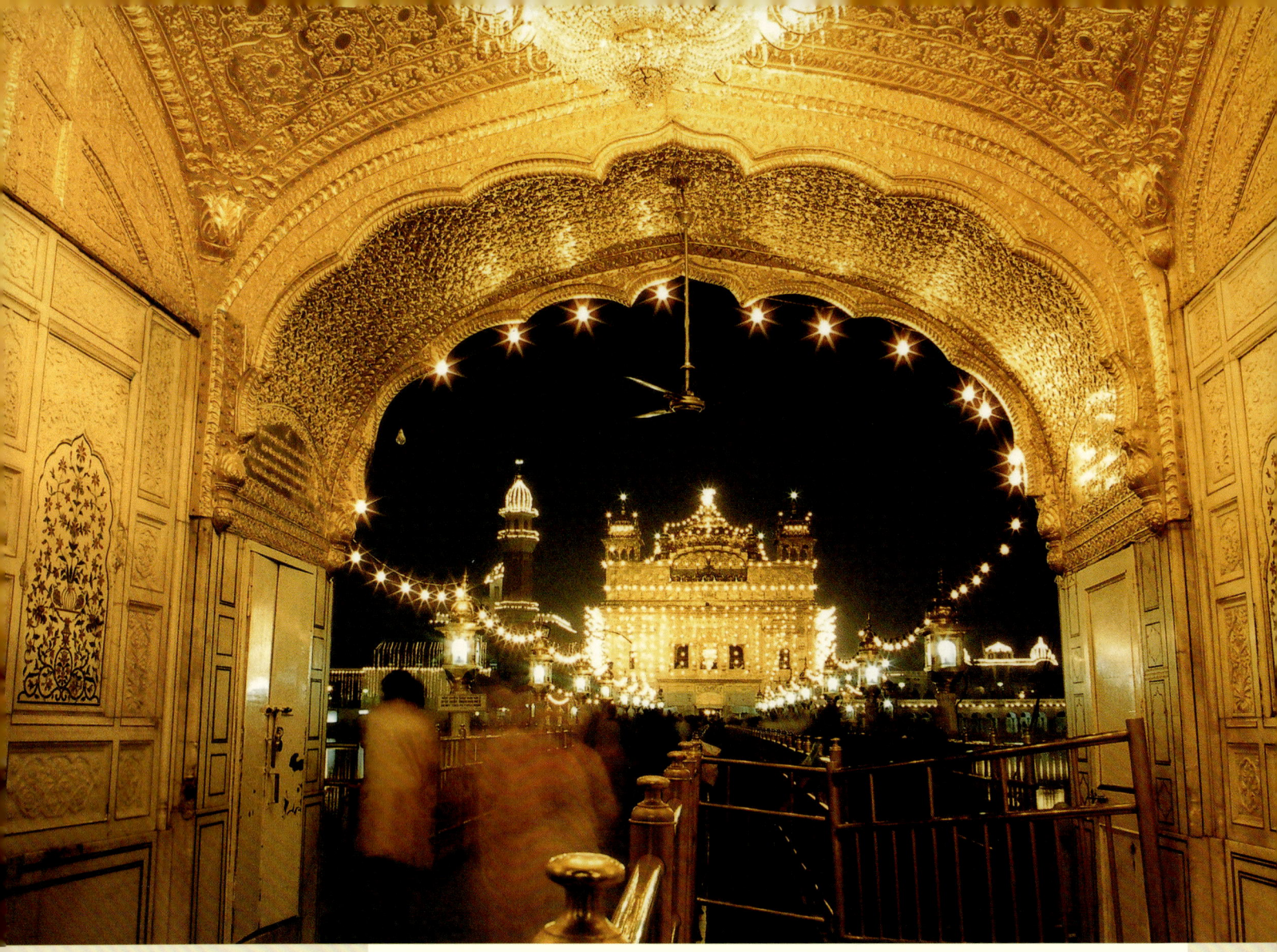

of the extended portion lay over the earlier referred massive tunnel lying on south-north axis line. Beyond this tunnel there is a flight of steps. Construction-wise, the tunnel as well as the flight of steps may be considered as forming part of the sub-structure, but in layout and architecture type they significantly deviate from the rest of it. As mentioned before, not only the arch form and the total engineering used in its construction are different, but different from the rest of the sub-structure, this portion is based in *sarovar's* bottom and not upon the seven to eight-feet high natural earthen base, which contains upon it the rest of the sub-structure. These approximately are the dimensions of the temple's ground plan and floor area.

Har ki Paudi

On ground floor, the eastern arm of the circumambulatory comprises a simple marble-floored corridor. Main shrine's eastern door opens in its centre, while opposite to it there is the 8 feet 10 inch wide arched passage leading to the *Har ki Paudi*. This passage is flanked on both sides by flights of stairs cast with a circular plan. They lead to the first floor and continue up to the terrace as well. The walls conveying these stairs have been beautifully adorned with floral designs. Most of the mural paintings in Sri Harimandar have been retouched, but some of the panels contained on the walls of these stairs have original paintings. One of these panels depicts Guru Gobind Singh on horseback, a rarity in the precinct

of Sri Harimandar. The apexes of the openings on the southern and the northern sides of this corridor have almost similar and alike large elliptical arched formations defined by shallow corbels. The forearm of the half-hexagon is flanked on its corners by fluted marble posts. These marble posts are moulded like a series of pots and are topped by gilded lanterns. The outer walls, up to the first floor level, not only around the *Har ki Paudi,* but also around the entire shrine, are clad with beautifully carved marble facings. Quadrangles, rectangles, niches, string-courses, arch forms, recesses and projections and other geometric patterns, carved on these marble planks, like ripples in a pond of milk, define the beauty of the façade.

The upper storey of the *Har ki Paudi* is a full-fledged floor. The corridor, with over 40 feet length and some 13 feet width, which on the ground floor merges with the circumambulating passage, transforms on this floor into a vast lobby. To make it functional, it has been divided into three distinct cubical parts by using shallow semi-circular arched or elliptical divisions. The northern and the southern cubes have, close to their western walls, the *Prakash-sthan*, that is, the place consecrated for the installation of Sri Guru Granth Sahib. There are, on eastern walls of these chambers, the terminal openings of the circular flights of stairs, which lead from the ground floor to the terrace. In their outer walls each of these northern and the southern chambers has three rectangular windows. From inside they are normal windows, though with beautifully engraved marble side planks, but on the exterior they are contained within beautiful rectangular frames consisting of fluted tapering pilasters and trefoil arch patterns. This part of the facet on both sides, that is, on the north and the south, a depressed one as it is, is contained within a frame comprising tall, fluted, tapering pilasters rising almost up to the eave or *chajja* level. A shallow but elegantly embellished eave-like projection, which these pilasters support on them, forms the lintel-piece. The smaller rectangular frames, which contain the windows, lie within this large frame.

The central chamber is more like a walk-through. It has on its east and west large elliptical arched passages with 8 feet 5 inch width, aligned exactly to each other. The eastern one leads into the Sheesh Mahal, while the western one into the projected balcony, which comprises the first floor of the main shrine. The Sheesh Mahal is broadly a square chamber with 11 feet 2 inch width and 11 feet 4 inch length. There is on the centre of its eastern arm the *Prakash-sthan* where the Holy Sri Guru Granth Sahib is regularly recited. Two highly esteemed hymns of the Sikh *Panth*, Baba Nanak's *Japuji Sahib* and Guru Gobind Singh's *Jap-sahib*, are calligraphed in gold letters on its walls. The entire wall space and the ceiling are exquisitely adorned with beautiful geometric designs and floral patterns, which are rendered in gold and inlaid with variedly sized and shaped mirrors. In the centre of its eastern arm, there is a magnificent oriel window, thrown out of the facet like a domed balcony. Shaped like a half-hexagon, it has, on its three arms, three openings formed by tapering, fluted pillars and cusped arches. The dome, which surmounts it, is of fluted kind and is topped by a *kalasha* finial. This window is one of the most beautiful members in the architecture of Sri Harimandar. Each of the southern and northern arms of the Sheesh Mahal has, on

(Facing page) Sri Harimandar Sahib on Gurpurab:
On November 26, 2004, that is,
the birthday of Baba Nanak, every inch of
Sri Harimandar Sahib complex bathed in celestial
glow immeasurable by any human scale.
Not only the main shrine but even its other components had divine lustre.
Exceptionally glowing-the gold-clad
Darshani Deorhi, when the light burst also from
its massive chandelier and bathed even the milky
marble into golden hue.

(Following Page Left) Har ki Paudi:
For kar-sewa, during the last
week of March 2004, the seventeen-feet deep
sarovar was emptied. The temple,
now with a seventeen-feet added height, which it
gained against the ground level, appeared as if
floating into air. Its sub-structure, with a massive
crowd of devotees thronging around all the time,
was hardly ever visible. This gave the impression
that it was the crowd and not any masonry that
carried the gold chariot on its head.

(Following Page Right) Har ki Paudi:
Har ki Paudi, the most sacred
point of the *sarovar,* which Sri Guru Arjan Dev
himself consecrated, comprises the eastern façade
of Sri Harimandar Sahib. It is as unique in its
architectural beauty. The semi-hexagonal window
aligning with the similar architecture of the façade
is the most beautiful architectural member in the
entire Sri Harimandar Sahib complex.

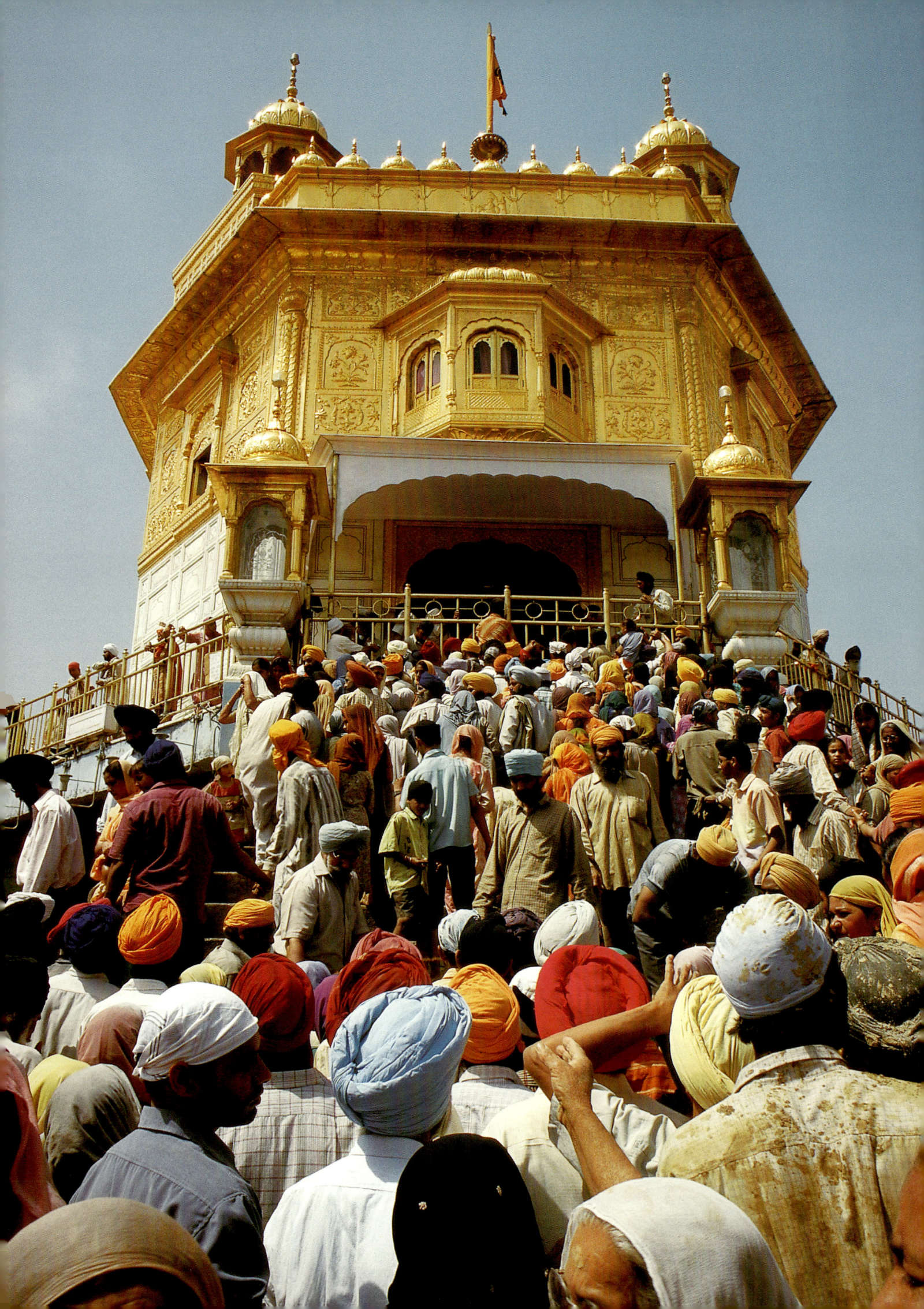

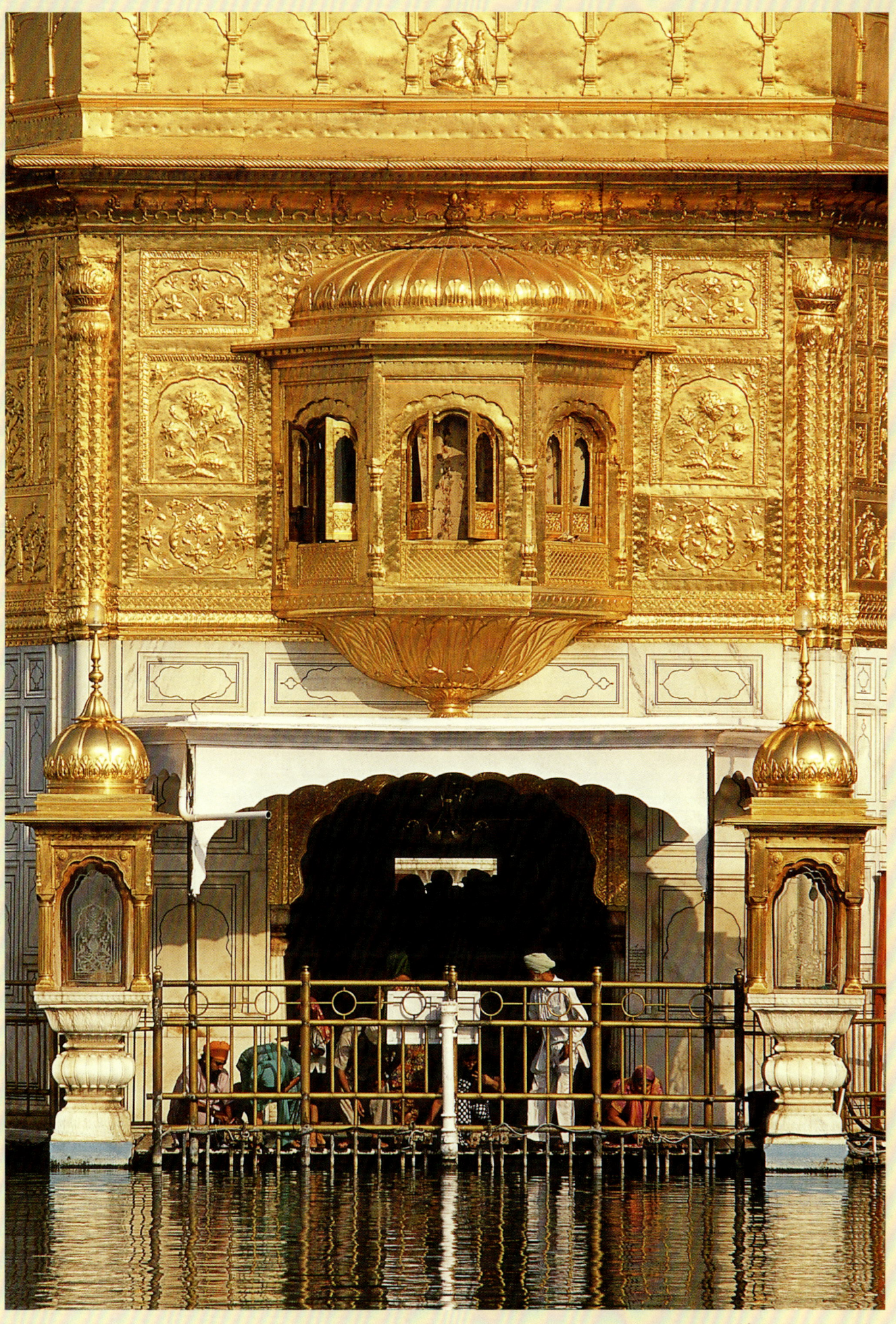

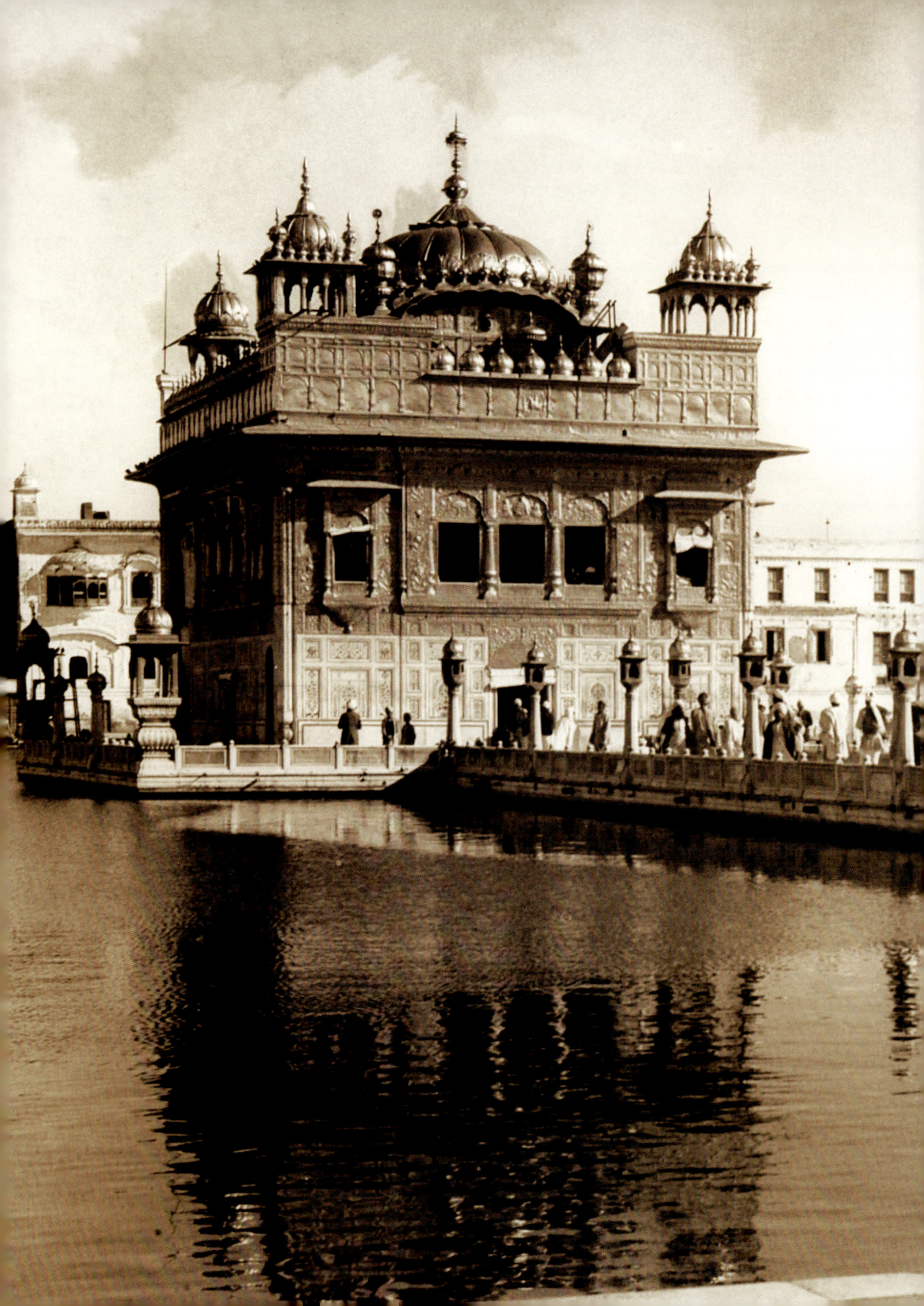

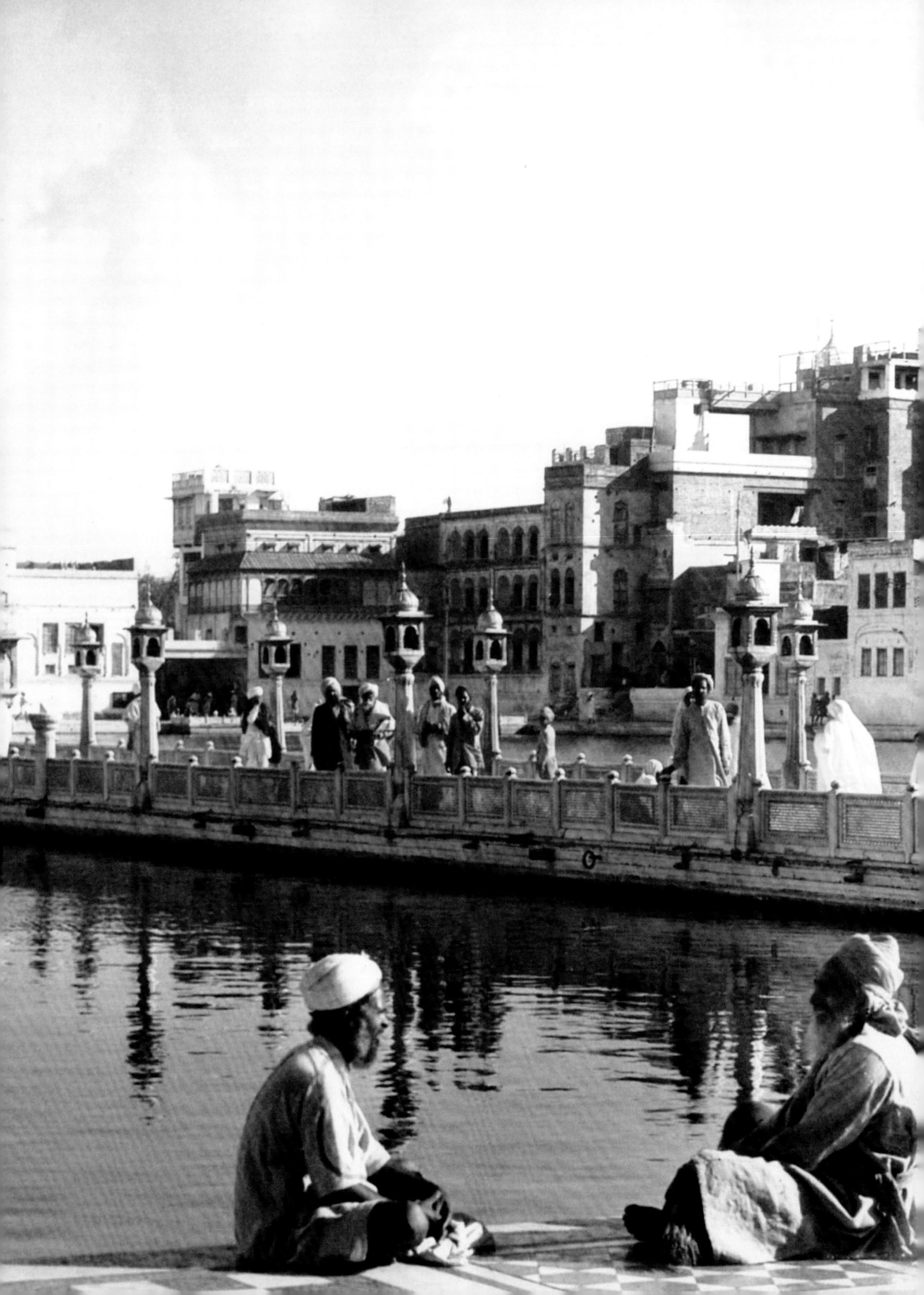

the same level, one balconied window. Both of these windows open into the stairs leading to the terrace. They are crowned with shallow elliptical roofs and are supported on beautifully cast brackets.

Main Shrine

The main shrine, a 40 feet 6 inch square, externally a two-storeyed building but functionally and in its interior structure three-storeyed, is a wondrous example of a harmonious blend of multi-media and multi-styles. The interior floor divisions are not allowed to break the building's external unity. In their interior structure all three floors have been constructed for almost a similar kind of function but the character of the one is completely different from that of the other. This unity of 'the diverse', the prime thrust of its architecture, seems to depict the very pith of the Sikh faith also. Everyone in the community seeks his Sahib, the Supreme, singly and by himself. The community, like the exterior of his shrine, is thus, his outer frame, his unity, but intrinsically in his search of the Supreme he is single, and this defines his diversity. On the ground floor, the central hall with *Prakash-sthan*, is its essence. On the first floor level, this square does not have a roof and is a physical non entity. Here, the balconies constructed over the lobbies, which, on the ground floor, surround the central hall, and the extended part comprising the Sheesh Mahal, gain prime significance. The second floor has nothing in common either with the ground or the first floor.

The ground floor

The ground floor is a large square. Broadly, it is a simple structure of four outer walls and four pillars. The outer walls make the interior a big hall and the four massive pillars divide it into various parts with different dimensions. On ground floor, these pillars effect these divisions and on roof level elliptical arched divisions enhance their effect. The main functional area on this floor is the 17 feet 10 inch central square contained within the four pillars. These pillars do not have simple four sides, but on each effective side they protrude by about 12 inch acquiring a perfect right angle recess which accommodates into it the respective corner of the central square hall and diagonally on the other side. An elliptical arch, aligned to this protruded part, rises from one pillar and joins with the other and thus spans the gap. Such four arches define the central square. From the other two sides of each pillar, there rise similar arches and join the half-pillars contained in the walls opposite them. Thus, from all four sides of each pillar there rise four arches and span the entire floor area dividing it into nine parts, the central hall being their axis.

On all its four sides, a foyer-type lobby flanks this central hall with some 16 feet length and 8 feet 6 inch width. There evolve in the process on all four corners four small chambers. Such chambers on southwest, southeast and east–north corners are open ones, while that on the northwest corner, has been converted into a room, which is used as-temporary Toshakhana – a treasury for storing day-to-day collection. A flight of stairs, to the upper floor,

(Facing Page Top) A full view of the eastern wall of the first floor inner balcony: The central part, that is, the square that opens over the sanctum sanctorum, has around it a four-sided balcony. In the Baradari tradition, that is, a structure with twelve openings, all four walls are divided into three openings each. Their doors beautifully adorned but those on the eastern side are exceptional.

(Facing Page Bottom) The Holy Bir enshrined in sanctum sanctorum: It is the partial view of the Darbar Sahib. The Holy Bir is contained in blue *rumala* and of the same is the *chandani* above. Towards the left are ragis and on right are devotees.

(Preceding Pages) Sri Harimandar Sahib: The late 19th century view of Sri Harimandar Sahib and the causeway. As suggest the two discoursing Sikhs, Sri Harimandar Sahib was also always the venue where Sikhs met, discussed and resolved issues, sectarian, social, personal or whatever. Courtesy: Hotel Imperial, New Delhi.

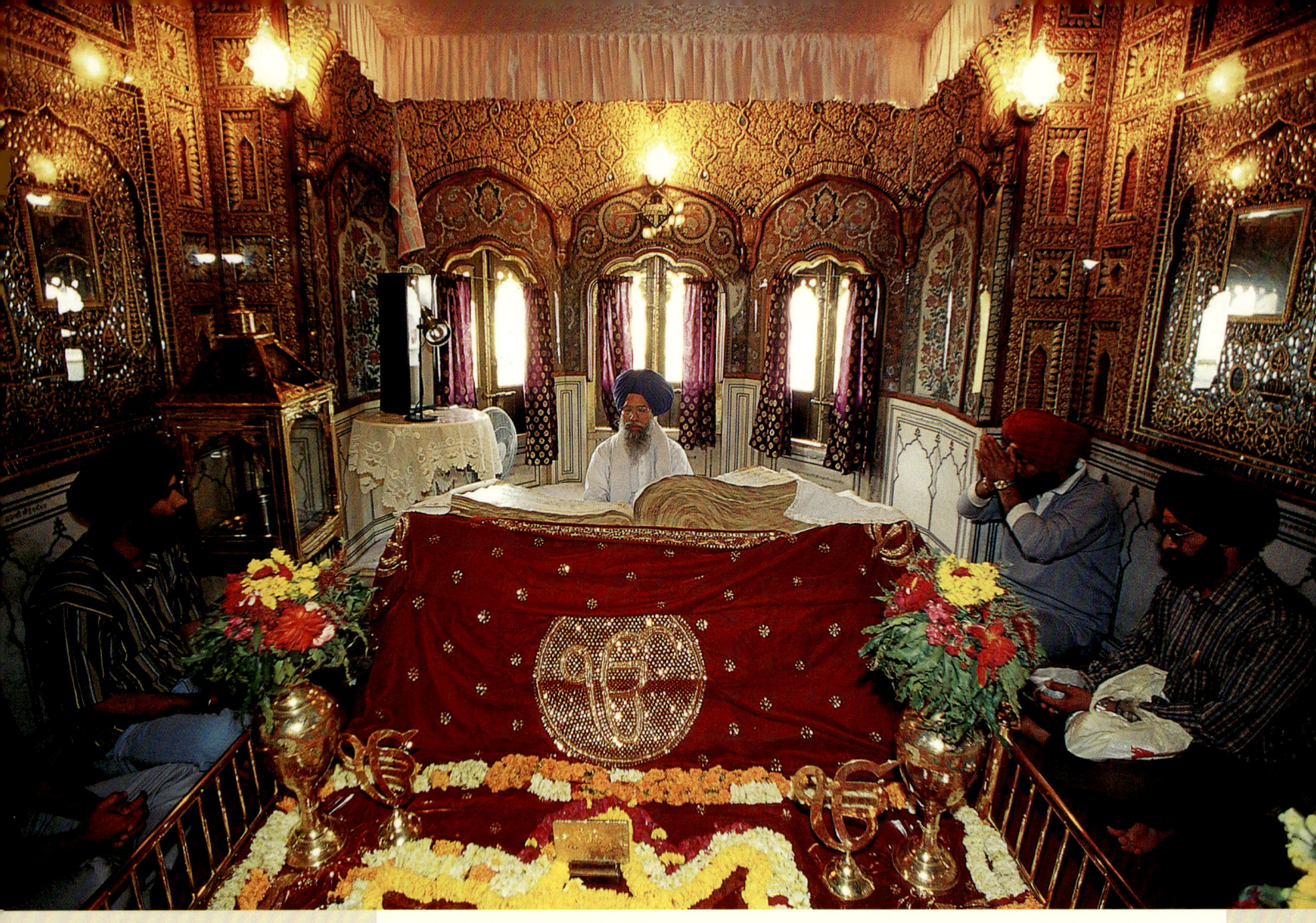

Recitation of Holi Bir in Sheesh Mahal:
Besides the Darbar Sahib on the ground floor, the two other chambers in Sri Harimandar Sahib have Holy Birs and their continuous recitation. One of them is the *Sheesh Mahal* on the first floor and the second is the chamber on the second floor.
The *Sheesh Mahal* is known for the exceptionally beautiful glasswork, inlay and filigree.
The Bir enshrining *Sheesh Mahal* comprises of hand-written large size folios.

has been provided on this northwest corner also. These stairs pierce the northern wall from the outside and reduce the size of this corner chamber. The central square has not been roofed. The roof-space between the outer walls and the four pillars on all four sides has been vaulted with elliptical roofs. The arch-ends have been beautifully negotiated with pendentives of stalactite type, one of the most beautiful architectural elements used in Sri Harimandar. Walls and pillars, up to a height of about four feet, are clad with finest marble, usually wrought with floral designs rendered in coloured semi-precious stones and beads. The wall space above marble cladding, along with ceiling, arches and arch-soffits has been adorned with gold leaves splendidly designed with various patterns.

The central square has towards its eastern arm the *Prakash-sthan*, the seat of the Holy Book, which enlightens the world from here. With the help of a railing a part of this central hall has been separated from the rest of it and under a canopy or *Chandani*, the Holy Book, Sri Guru Granth Sahib, is installed. The Holy Book remains installed since early morning to late in the evening as per time schedule varying seasonally. The colour of the *rumala* laid over the Holy Book and that of the canopy is always one and the same. In a separate closet towards its north, there sits a team of *ragis*, the singers and the instrumentalists, who uninterrupted recite *sabads* from the Holy Book. This northern closet has been recently extended right up to the northern wall. It is again divided on west-east axis line providing behind the *ragis* a similar closed space for devotees. A devotee who enters from the main door on the west exits from the northern door, though

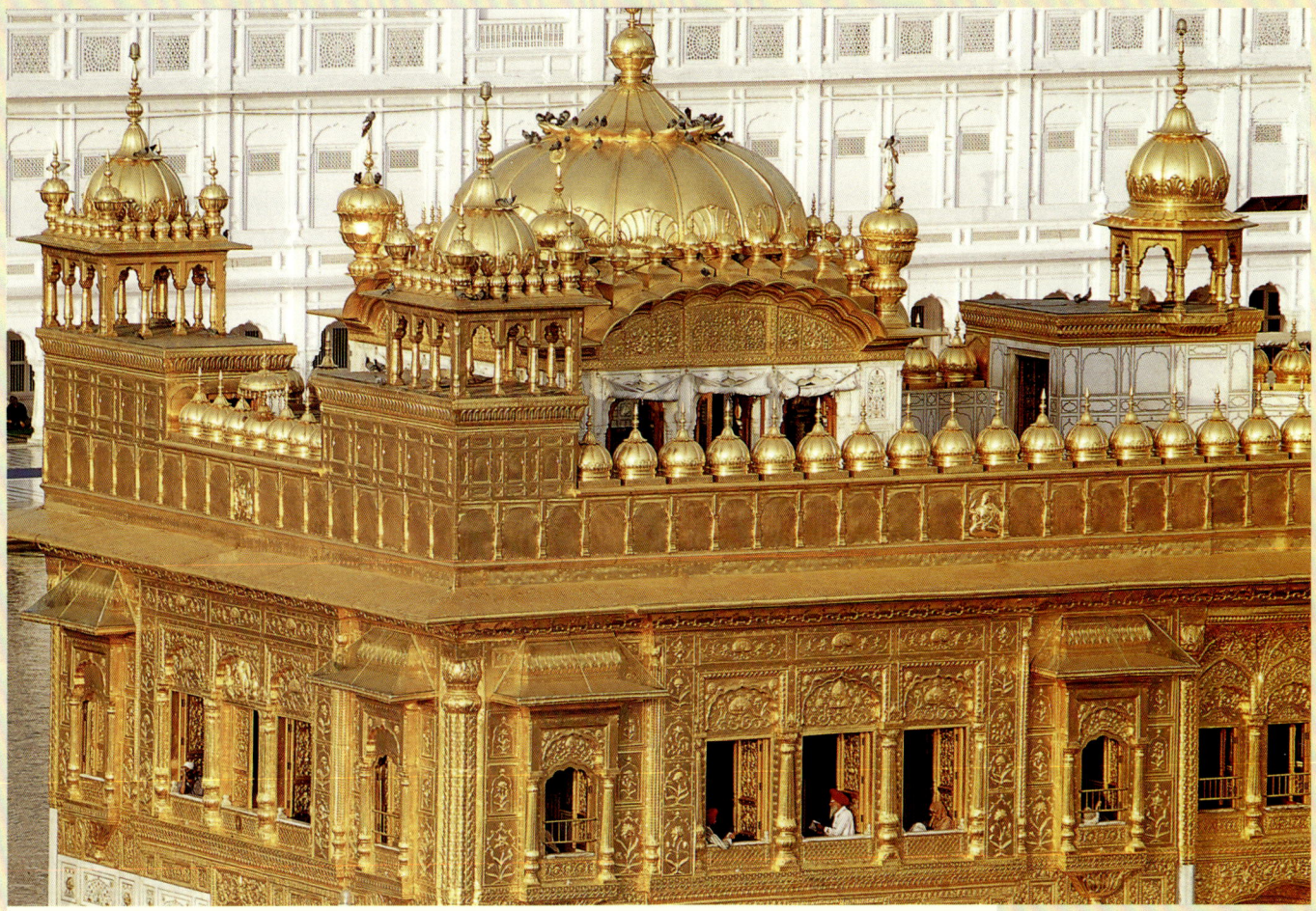

from the eastern one he may re-enter, offer his *ardas* or prayer and leave either from the same door or from the southern one.

The first floor

The first floor consists of the projected balcony type galleries constructed over the lobbies, which on the ground floor flank the central square hall on all its four sides. It is reachable from three sides, the northern and the southern wings of the *Har ki Paudi* and the stairs provided into the northern wall of the main shrine. These first floor galleries, except the western one, are about 19 feet 10 inch long and 6 feet 2 inch wide. The corner chambers on southwest, southeast and northeast are 6 feet 2 inch square. The northwest corner contains up and down stairs, hence part of the corner chamber and a little length of the western gallery have merged with it. Each gallery has three arched openings overlooking the central square hall on the ground floor. One of these openings on eastern gallery has been closed for providing functional space. It is decorated with beautiful mirrors of various sizes. Mild decorative corbels define the arch forms. These arch openings are carried over heavy rectangular piers, but towards the central hall each opening is contained within a rectangular frame consisting of tapering fluted columns rising from pot base and terminating into rectangular projection. Lotus motifs define both ends of these columns.

The southern gallery has on its outer wall five rectangular windows. Three in the middle form

The upper floors of Sri Harimandar Sahib: Unlike a temple or sectarian building, at least this first floor of the Temple, with diversely designed and decorated windows, has the look of a castle. This western façade alone has five windows and they follow at least two construction patterns. All corners negotiated with kiosks, parapet defined by turrets and similar other architectural members suggest that Sri Guru Arjan Dev wished that his Harimandar Sahib looked different from a conventionalised temple, or any religious building.

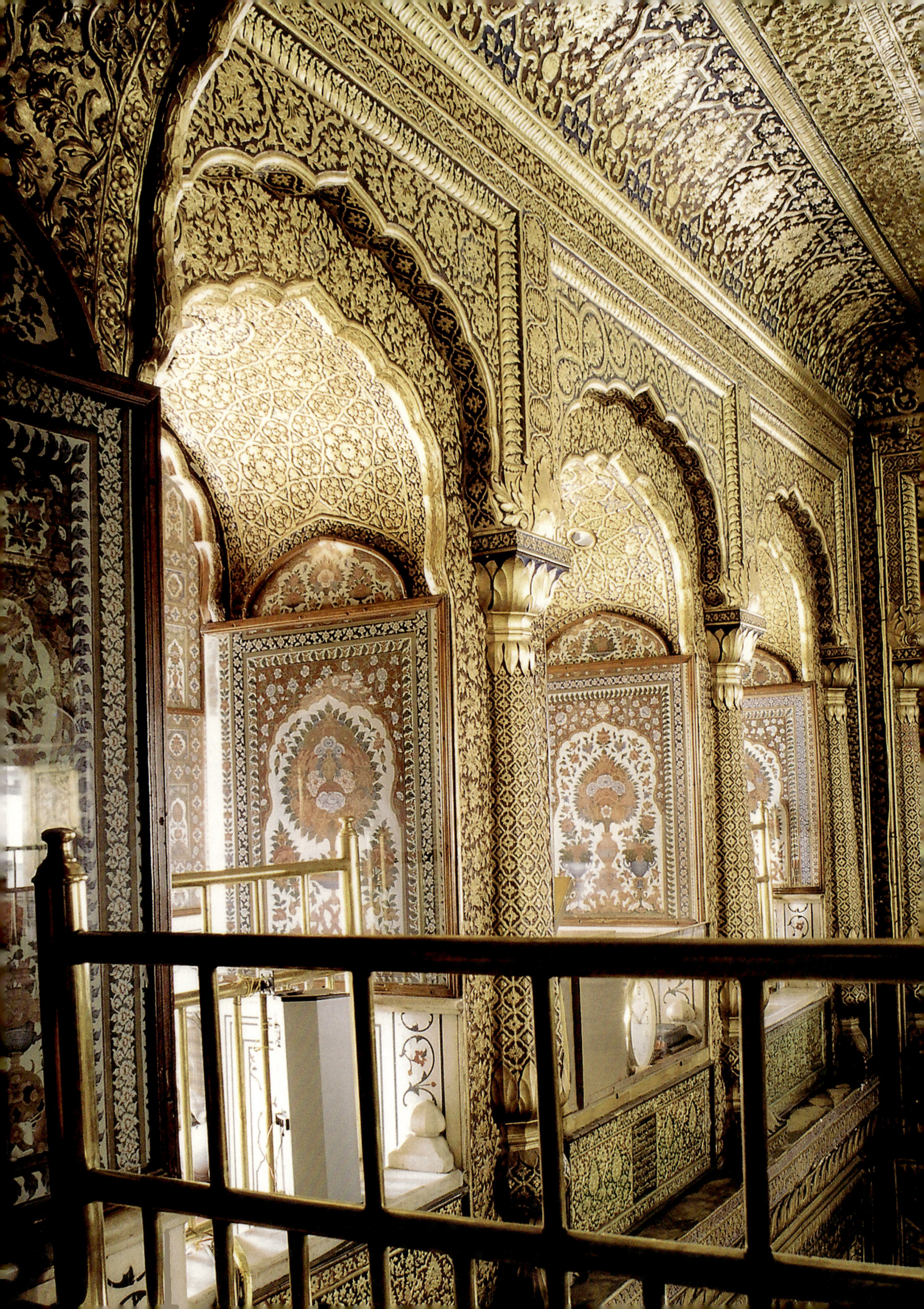

The first floor:
This other view of the first floor interior shows how artistically one wall has been negotiated with the other, how unnoticed align the roof with the walls carrying it and how the pilasters merge with the walls and yet retain their identity. The arches are not so much the architectural units, as they are the delightful frames for the designing patterns rendered inside them.

(Facing Page) Interior of the first floor:
One may hardly believe that Sri Harimandar Sahib has been able to retain the brilliance of its colours, finesse of designs and an over-all aesthetic continuity despite that forty to fifty thousand people visit this august shrine every day. Being a shrine in live worship, erection of various structures sometimes becomes necessary, but tuned to its holistic aesthetic cult, even such structures add to its beauty, or at least do not interfere with it.

an architectural group and are similar in style and are built in close vicinity. The two flanking them are variedly distanced but are shaped alike. They are of oriel kind thrown out of the wall supported on elegant brackets, which are shaped like a lotus. Shallow elliptical domes top them. The northern gallery has a similar build, but instead a window opening towards its western corner it has only a blind window form created in the wall, obviously for symmetry with its northern counterpart. The western gallery has the same kind of window openings as has the southern side. Internally, each of the galleries and corner chambers have a separate elliptical roof which rising from its four arms negotiate into a well-moulded apex, but externally, that is on the terrace level, it is a plain three-feet

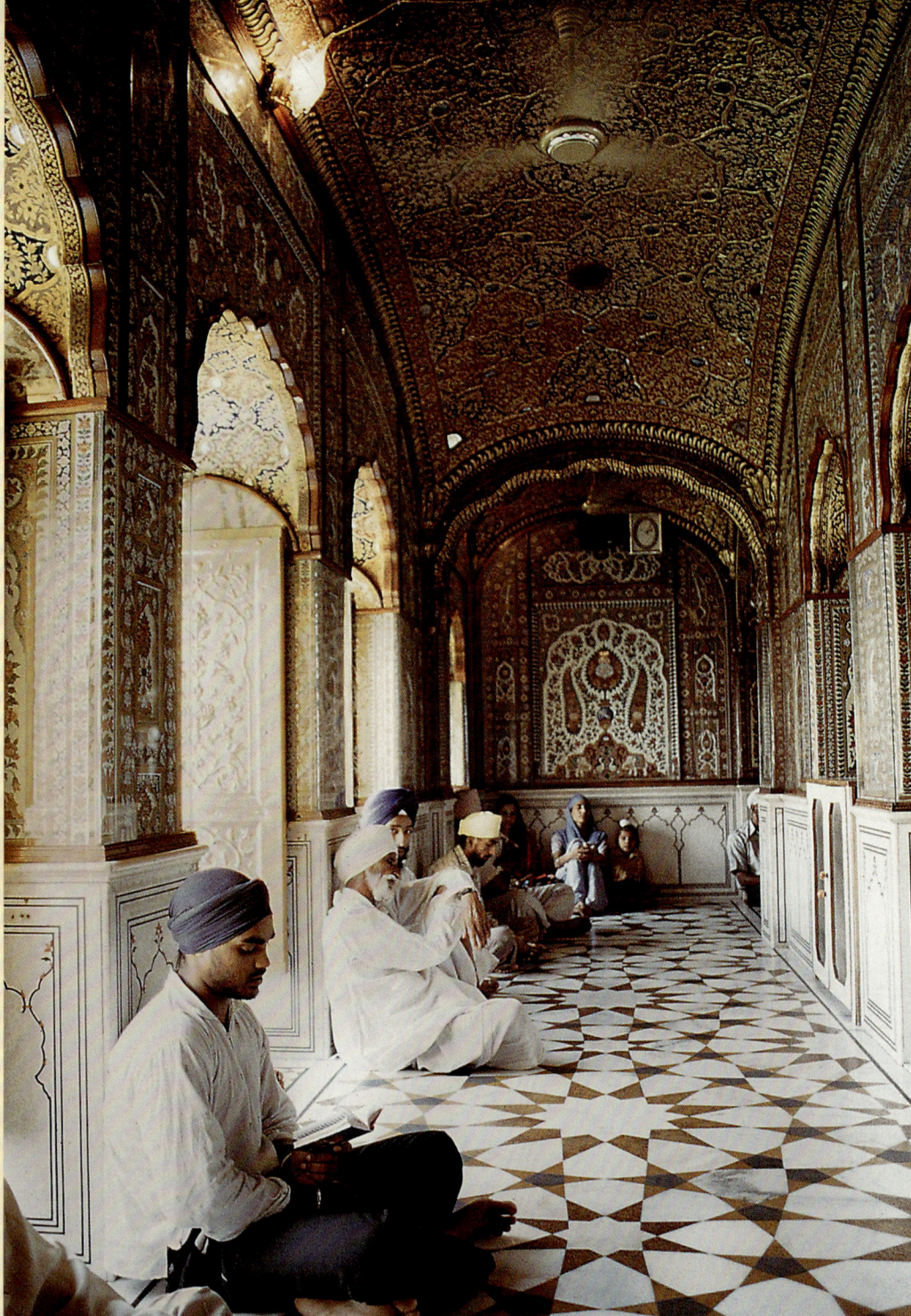

The devotees commemorating Nam: Bowing to the Holy Sri Guru-Granth Sahib is in itself the highest kind of worship in Sikh *Panth*, though meditating on *'Nam'* is its further stage and they who have greater commitment of mind commemorate *'Nam'* also. Most of the devotees, visiting Sri Harimandar Sahib, prefer to also meditate and the first floor corridors are best suited for the purpose.

(Facing page) The Sarovar and the Temple: The Sun has set leaving behind it the world to bloom with its radiance. The waters of the *sarovar*, forsaking their blue, have turned saffron. The darkness is gradually engulfing the far-off expanse of the town. If there is any entity beyond the darkness, it is Sri Harimandar Sahib and whatever it brightens by its glow.

thick level roof with upper layer cast of dry bricks. It is a curious architectural device used for evading all kinds of leakage. Walls are clad with marble planks up to a certain height and beyond that each wall is a piece of canvas painted exquisitely with gold and in brilliant colours. All angles on this floor have been negotiated with elegant pilasters.

The second floor

A tall 4 feet high parapet with 58 turrets adorning it, a square pavilion measuring about 15 feet 4 inch with a fluted low dome surmounting it and four corner kiosks define the second floor. It may also be defined as the terrace pavilion. This

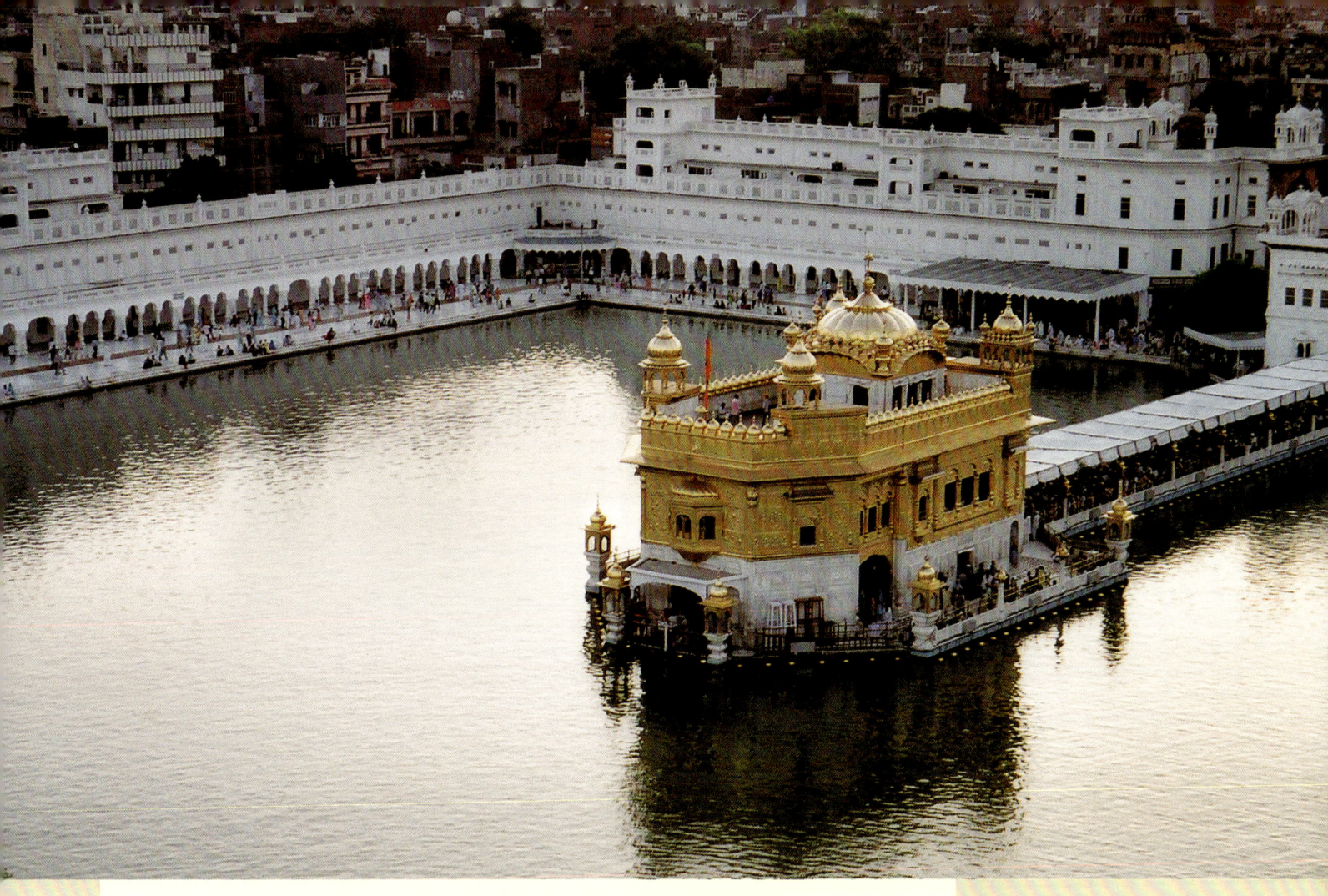

square pavilion is built over the central square hall. On each of the four sides it has three door openings fitted with exquisitely carved wooden doors. Marble sheets, which clothe the interior and exterior walls, are inlaid with beautiful floral designs and plant motifs. An elliptical eave or *chajja*, rising on each side in shallow arch curves, carries on each of its corbels a beautiful turret. The number of these corbels and correspondingly of the turrets on each side is nine. On four corners, it turns into a flat projected eave carrying a larger turret on each one. The semi-circular tympanum just below the projected cusped eave and above the door level on all four sides is a curious element in the architecture of Sri Harimandar. This tympanum has been divided into rectangular areas by beautiful pilasters. The wall space above door level, to include dome, eave and all turrets is covered with gilded copper. The terrace has four small chambers, two on its west and the other two on the side-wings of the *Har ki Paudi*. Three of them consist of openings of stairways and the fourth is a small chamber. The eastern side has in its centre the Nishan Sahib consisting of gilded iron.

The kiosks on the front side are 6 feet 6 inch square. In *baradari* style they have 12 openings, three on each side. The fluted dome is topped by inverted lotus motif and *kalash* finial. Their dome-base has on each side five small but beautiful turrets and four big ones on four corners. The parapet height in the centre has been reduced to a half. Beautiful seven turrets adorn this part, the central one having a magnificent *chhatra* suspending over it. The corners on the eastern side carry over them two octagonal domed kiosks. The southern and northern parapets have 19 turrets each, while the semi-hexagonal arms of the eastern side have 13 turrets.

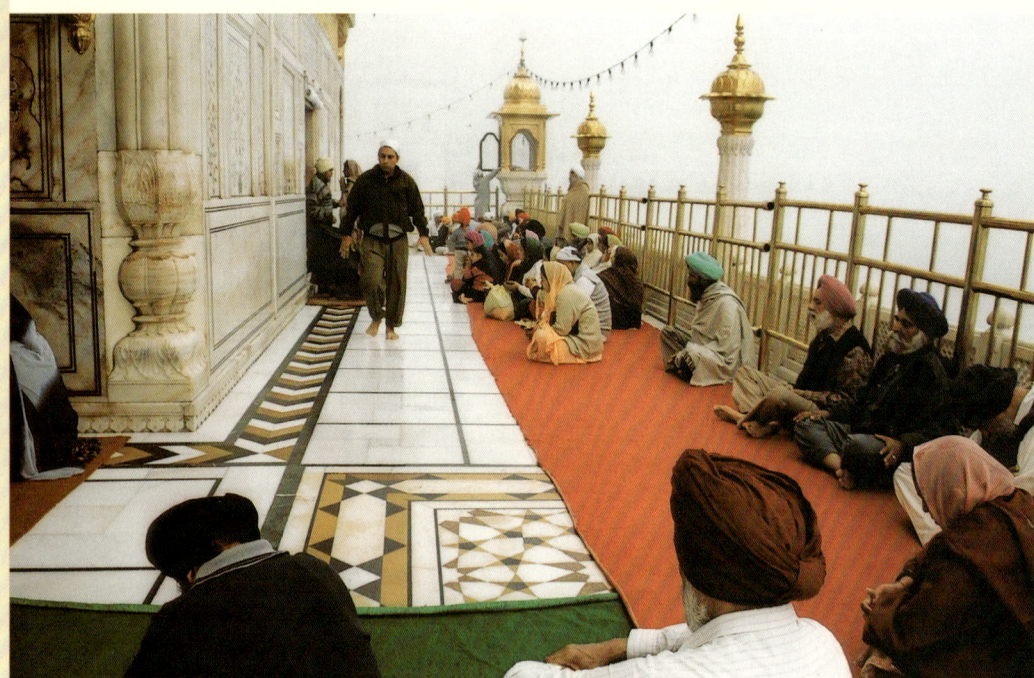

(Top) Terrace with the row of gold turrets: The terrace of Sri Harimandar Sahib has its own music and rhythm. With the rows of gold turrets on all four sides surmounting the parapet, it creates dazzling effect. The southern and the northern parapets have nineteen turrets each, while the eastern side have thirteen and the western seven.

(Bottom) The Temple Circumambulatory: The circumambulatory around the Temple with elegantly laid floral designs and colourful carpets and brilliant brass barricades is in itself a beauty. Here visitors come and go but the devoted ones have enough quietude for reciting the *Bani* and commemorating the *'Nam'*.

(Facing Page Top) Three brothers: The camera has clubbed together three brothers, two domes surmounting the corner kiosks over *Har ki Paudi* and the larger one surmounting the clock tower over the southern gateway. All three fluted alike, topped by similar finials and inverted lotuses and rising alike from lotus ring look so much like three brothers.

(Facing Page Bottom) Circumambulatory: Another view of inner circumambulatory. The oriel window, thrown out over a lotus bracket and flanked by beautiful floral designs embossed in gold plating, imparts to it exceptional beauty.

These numerous gilded domes of varied sizes, large, medium and mini, create unique rhythm and dazzling effect.

Parkarma: the Circumambulatory of Sri Harimandar

The main shrine has on each of its four sides a circumambulatory with 13 feet width and 66 feet 4 inch length. It is open on three sides, while on the eastern side it is roofed along with the first floor of the main shrine and the *Har ki Paudi*. The entire circumambulatory has been floored with fine marble. This part of the shrine was paved first by Maharaja Ranjit Singh with marble brought from Makarana in

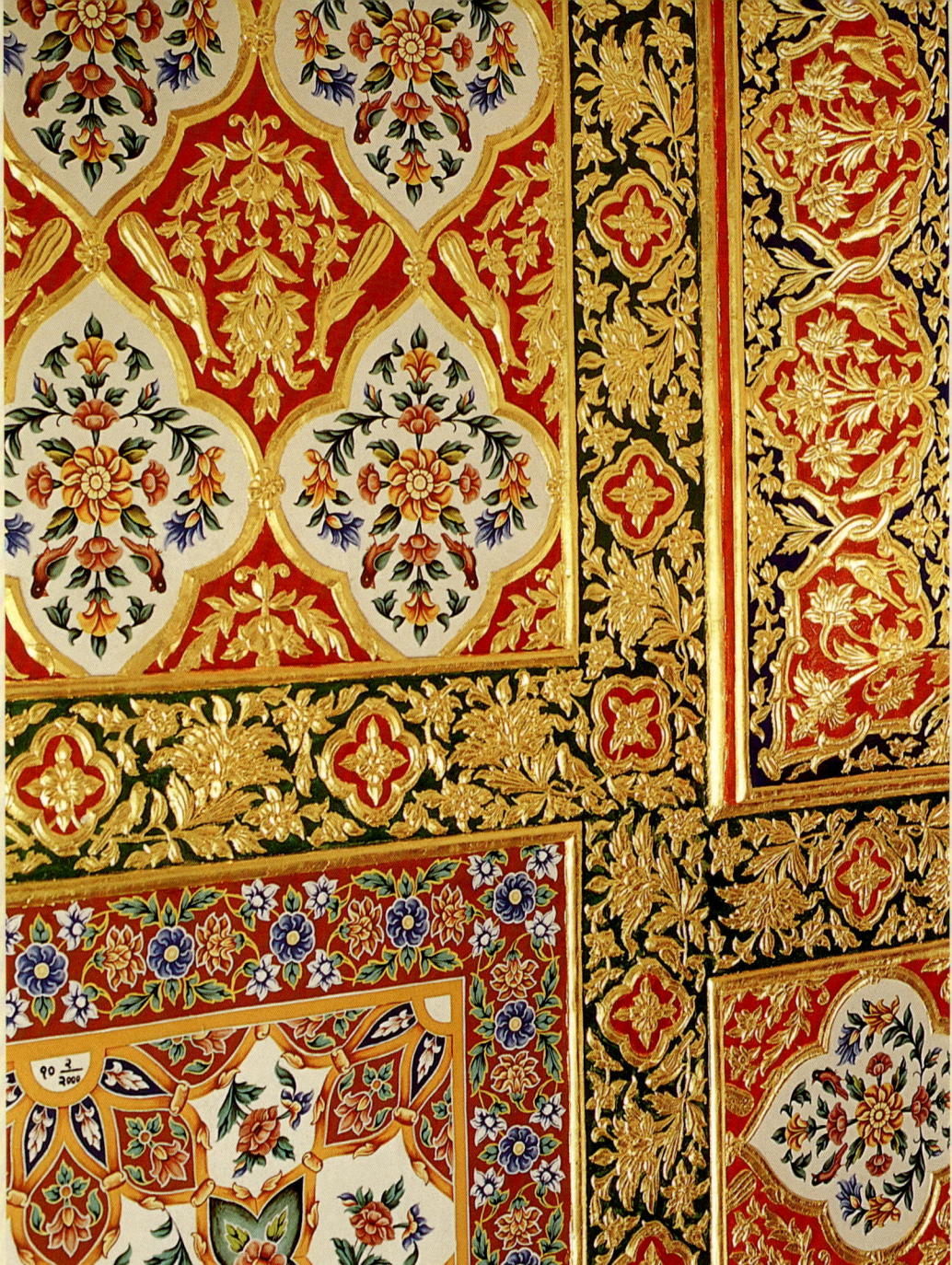

Floral designs in Sri Harimandar: The entire wall space on the first floor of Sri Harimandar Sahib has been embellished with arabesques, floral designs, graphics and bird motifs. The frames of various sizes created using variedly patterned designs break the entire wall space with rhythmic vitality. It afforded ample scope to the painter for ingenuity and to the viewer a variety of forms. Bold patterns rendered with great symmetry using bright colours and the gold laid in contrast to the scarlet red and deep maroon are simply splendid and unique.

Rajasthan. The circumambulatory has on its four corners four standard lamps. The forearm of the *Har ki Paudi* is flanked on both ends by two other similar lamps. All the six lamps were clad with gilded copper in 1835 by Maharaja Ranjit Singh.

Embellishment of Sri Harimandar Sahib

The walls, the interior as well as exterior, arches, ceilings, niches, etc., are adorned by various forms of murals, inlay, *gachkari* and other decorative techniques. A larger surface has been gold-plated, which adds to its puritan simplicity unique splendour and brilliance. Various designing patterns, both floral and architectural, embossed on these gilded copper leaves, add to this splendour an artist's vision and a goldsmith's minuteness. Idols stood prohibited in Sikhism. The artists, however, were tempted to relieve here and there their walls with figures of various Sikh Gurus. Pediments, the pyramidal space over

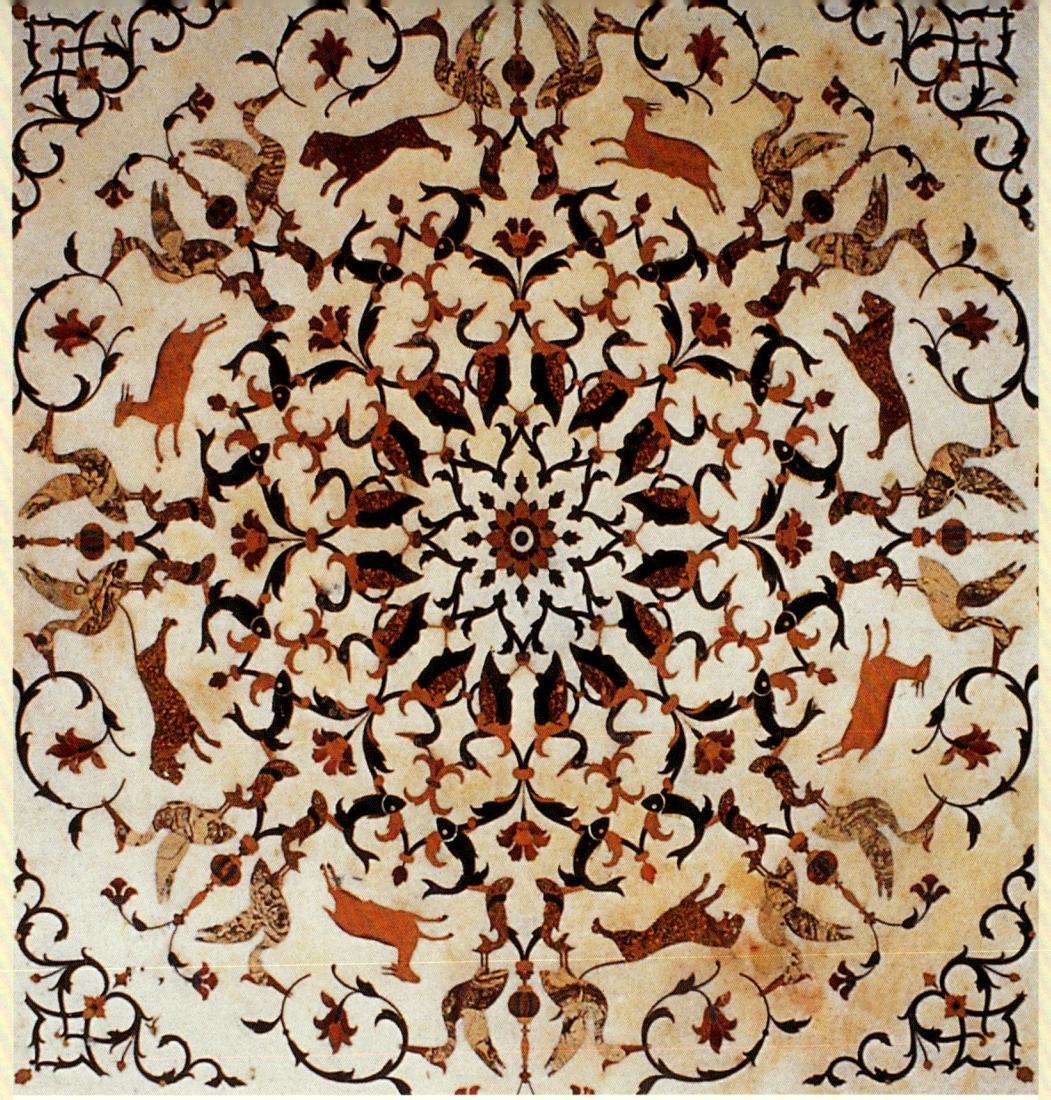

This medallion, the central part of the floor decoration in the chamber on the upper floor enshrining the Holy Bir, is of unusual interest, as it seems to comprise the floral arabesques but in reality it largely comprises birds, fish, lions and deers, that is, the creatures of the sky, water and the earth. Suggestively, the medallion, the rounded space, symbolises the universe with inhabitants of the three worlds. The ring radiates from a flower with eight petals, which in the first ring transform into sixteen mythical birds and beyond it as many fish. The circle above them has four deer and four lions and beyond them sixteen fowls. The corners have been negotiated with floral arabesques. These patterns inlaid in marble using coloured marble motifs are unique in elegance and versatility.
Courtesy: Guru Nanak Nishkham Sewak Jattha.

door-lintels, have been largely used for calligraphic representations of *Bani* and sometimes for recording the *sewa*, the service rendered by someone, but also for illustrating parts of *Jamam-sakhi*. Baba Nanak with Bhai Bala and Mardana prominently figure in these relief carvings. Quite interestingly, the western parapet has in its centre the horse-riding image of Guru Gobind Singh. Attended by a *chauri*-bearer and standard-holder, Guru Gobind Singh is in full regalia. The eastern parapet represents Sri Guru Arjan Dev with the *Adigranth*. Seated against a bolster he is attended by a *chauri*-bearer. The southern parapet represents Guru Hargobind with falcon and the northern Guru Ram Das. H. H. Cole, in his 1884 monograph on the Golden Temple, refers to have seen, in the Golden Temple, panels depicting Hindu mythology but except a few in Baba Atal, now there are none such in existence.

Architectural elements, recesses and projections, repeated arches or arch-patterns, pilasters, niches, alcoves, pendentives, eaves, turrets, string-courses, both when moulded in marble or cast in gold, create their own songs and rhythm. They impart to the façade unique variety and relieve it against any likely monotony. The marble facing is further relieved by inlay, or *jaratkari*, using both, the pietre-dure technique and otherwise. Some marble panels are inlaid with semi-precious stones, lapis lazuli, onyx, etc., and are examples of magnificent pietre-dure craft, but others are inlaid with ordinary coloured stones cut to various sizes. Most of the designing patterns cast in marble-inlay have a Mughal character but, by introducing human figures in their composition, the Sikh artists have attempted to establish a distinction of their own.

ਗੁਰਦੁਆਰਾ ਸ੍ਰੀ ਕੇਸਗੜ੍ਹ ਸਾਹਿਬ

Gachkari, a kind of stucco, wherein various designing patterns are carved on wall surface by cutting semi-dried plaster made of gypsum paste, and *tukri*, wherein *gach* work is further adorned by laying coloured glass-pieces into it, are other kinds of techniques used in adorning Sri Harimandar. The Sheesh Mahal part of the shrine is a fine example of *gach* and *tukri* work. Ceilings of the first floor are also adorned with *gachkari*. Ivory inlay is yet another kind of embellishment used in Sri Harimandar, though its use is restricted to only the back of the doors of *Darshani Deorhi.* The entire door space is divided into square and rectangular panels, which contain geometrical and floral designs and figures of birds, tigers, lions, deer and other animals. Some parts of the ivory-inlay are coloured and in the words of H. H. Cole are "extremely harmonious".

The murals that adorn the larger part of the interior of Sri Harimandar exhibit an exceptionally great variety of designing patterns. Scholars have discerned over 300 floral designing patterns, interspersed with animal motifs and sometimes human figures, adorning the walls of the main shrine. These imaginative and largely conventionalised studies, tying up human figures and animal motifs with plants and flowers, known in the terminology of art as *dehin* and *gharwanjh*, are exemplary works of the *naqqashee* of those days. The decorative device of *gharwanjh*, involving knotted grapples between various animals, has been more widely used in these murals. Cobras, lions, elephants, peacocks, one clutching the other, carrying flower bases over them are a characteristic feature of the murals in Sri Harimandar. *Pattas*, the decorative borders consisting of various floral designs rendered around *dehin*, are yet another outstanding element of the murals in Sri Harimandar. In the diversity of designing patterns, design-

Embellishment on the first floor ceiling:
The interior of the first floor with its splendid mirror palace, the *Sheesh Mahal*, is unparalleled in its beauty. It uses diverse designing skills and as many techniques and mediums. The basic patterns are arabesques, floral and geometric, rendered in light relief using stucco. They use bright colours, bold flowers and knotted chains and inlay and filigree. Artists have adopted filigree technique from Mughals and bold patterns from Iranian tradition.

(Facing Page) Three floral designs and column decoration on the first floor:
The design on the top is a simple flower arabesque, but its base with the design of the Gurdwara Sri Keshgarh Sahib at Anandpur Sahib is exceptional. Most of the wall paintings in Sri Harimandar Sahib complex have been retouched, but some are yet untouched and have their original brilliance. The two designs below are their examples. They are in their original colours and form. The design on the left is a painted pillar and the other on its right is the traditional flower creeper with pot-base.

ing techniques, material used, brilliance and variety and spiritual thrust, Sri Harimandar outstands most other religious shrines.

Electrification of the premises of Sri Harimandar

It was on June 22, 1897, that the premises of Sri Harimandar glowed for the first time during the dark hours of night. With the collective efforts of Sikhs and a meagre amount of Rs. 20,000, which had been so collected, the premises were electrified and a generator set was employed to produce required light. After a few weeks, Maharaja Vikram Singh of Faridkot visited the temple and offered Rs. 100,000 for its augmentation and further expansion and then the newly constructed Guru Ram Das Langar-ghar was also covered under electrification programme. As every change is unacceptable to conservative minds, this step was also opposed by a section of Sikhs. *The Khalsa*, a newspaper highly popular amongst Sikhs, considered it as anti-Sikh act, as such a step reduced the prestige of the Sikh shrine to a mere museum. Others argued that after the shrine had the light of Gurus' *sabads* how artificial light could be allowed to over-ride it. But, the reformists did not concede. They felt that even the worldly light could not be the antithesis of the divine light but only its reflection and glow. Ultimately the change for the better prevailed and as planned by Guru Singh Sabha in its 23rd annual convention at Amritsar in 1896, the electrification of the temple premises was accomplished.

Darshani Deorhi

Darshani Deorhi, the main entrance to Sri Harimandar, is an edifice raised subsequently to Sri Harimandar. Giani Gian Singh is of the opinion that *Darshani Deorhi* was constructed in 1776 along with Sri Harimandar and the causeway. On the basis of an unpublished manuscript, Udham Singh quotes 1769 as the year of its construction. Giani Gian Singh's observation appears to be a generalised one. The causeway, at least its sub-structure, was always there after it was built in 1601. This sub-structure has the same character as has the sub-structure of the main shrine. The long tunnel that runs straight from the *Darshani Deorhi* to the *Har ki Paudi* fully aligns with its counterpart under the main shrine. The tunnels under it and under the main shrine are of similar kind. It is not likely that both sub-structures, the one under the main temple and the other under the causeway, were reconstructed in 1776 or 1769. Had it been so, the building kind would have been quite different, as by the late 18th century, India's architectural scenario had completely changed.

There is no doubt that the *Darshani Deorhi* is a subsequent structure, which was built in all likelihood as a security measure for protecting the shrine from plunderers and invaders, as also to add to the shrine an appropriate entrance. Though the temple was not substantially damaged during the lifetime of Guru Hargobind, yet after the assassination of Sri Guru Arjan Dev threats to its security were seen often surfacing. Thus, it is also likely that the deeply hurt saint Guru Hargobind, who decided to guard *Piri* by *Miri*, thought

(Facing Page) The gold-plated door of Sri Harimandar Sahib: The gold-plated door donated to Sri Harimandar Sahib by Maharaja Ranjit Singh is one of the rare possessions of the *Toshakhana*. This is the reverse side of the door. It is said Bhai Sant Singh Giani of Chiniot, now in Pakistan, was entrusted the responsibility of preparing the doors, for accomplishing which he engaged Muslim artists of Chiniot. The door is hence a mix of Sikh and Iranian traditions.

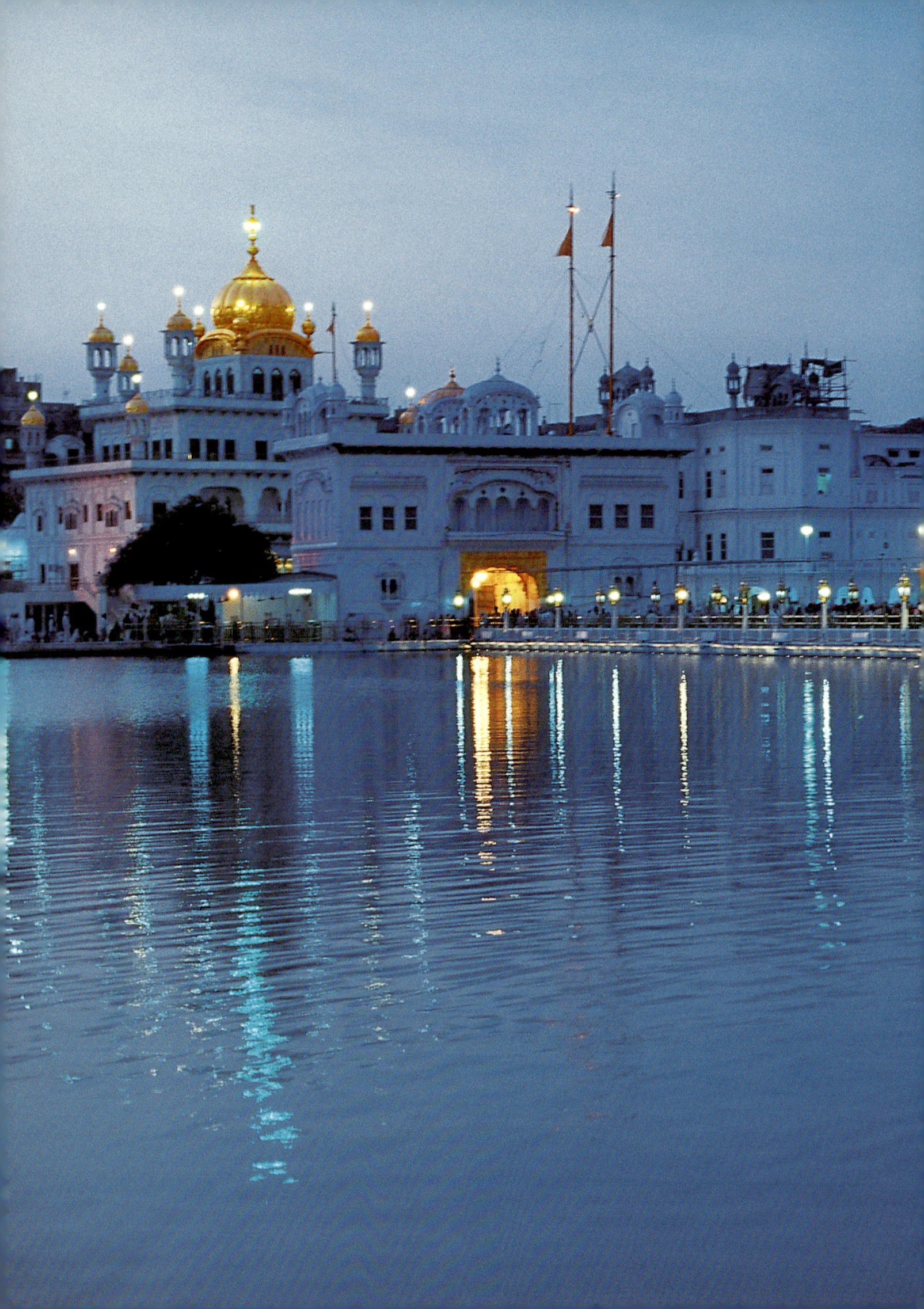

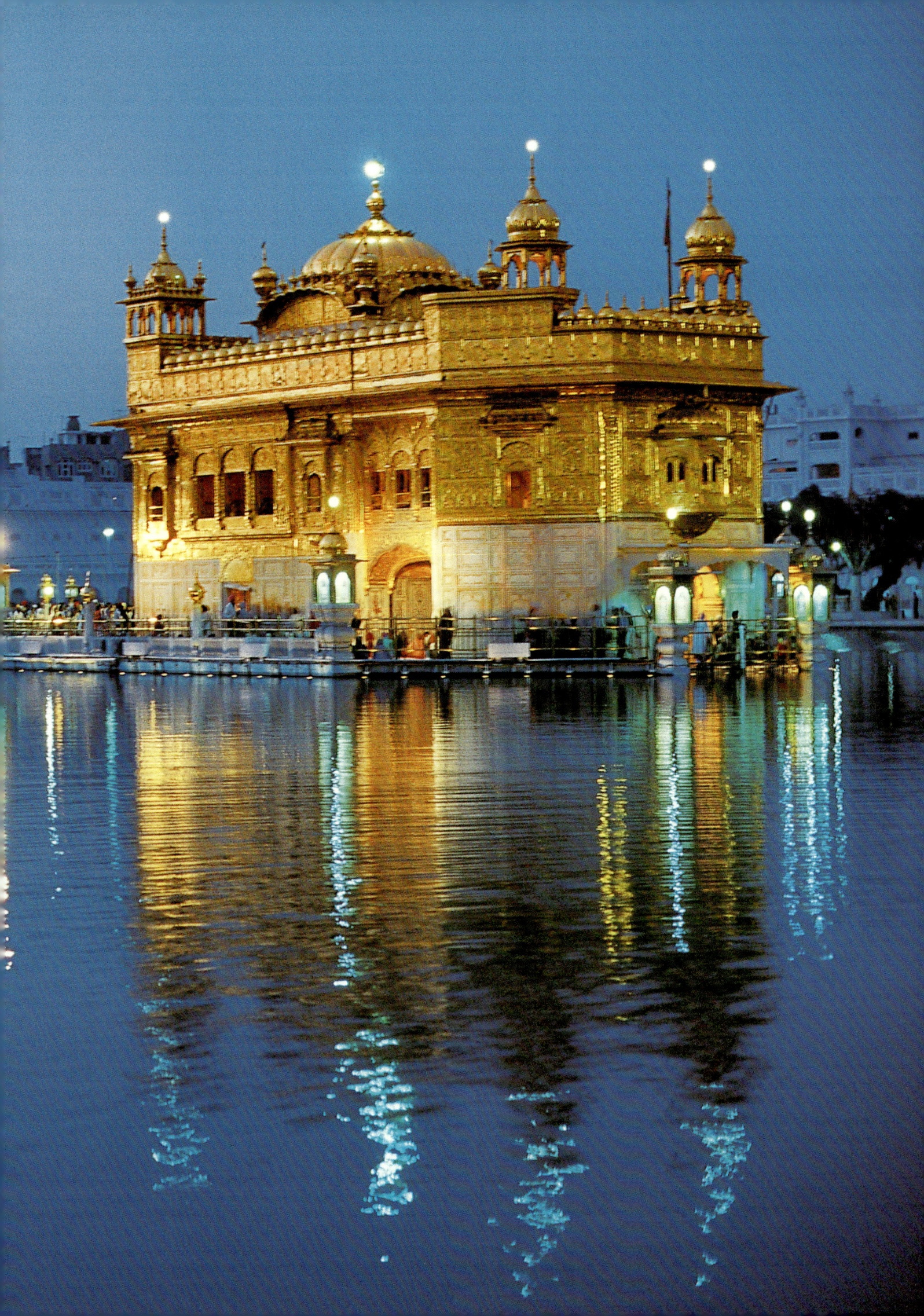

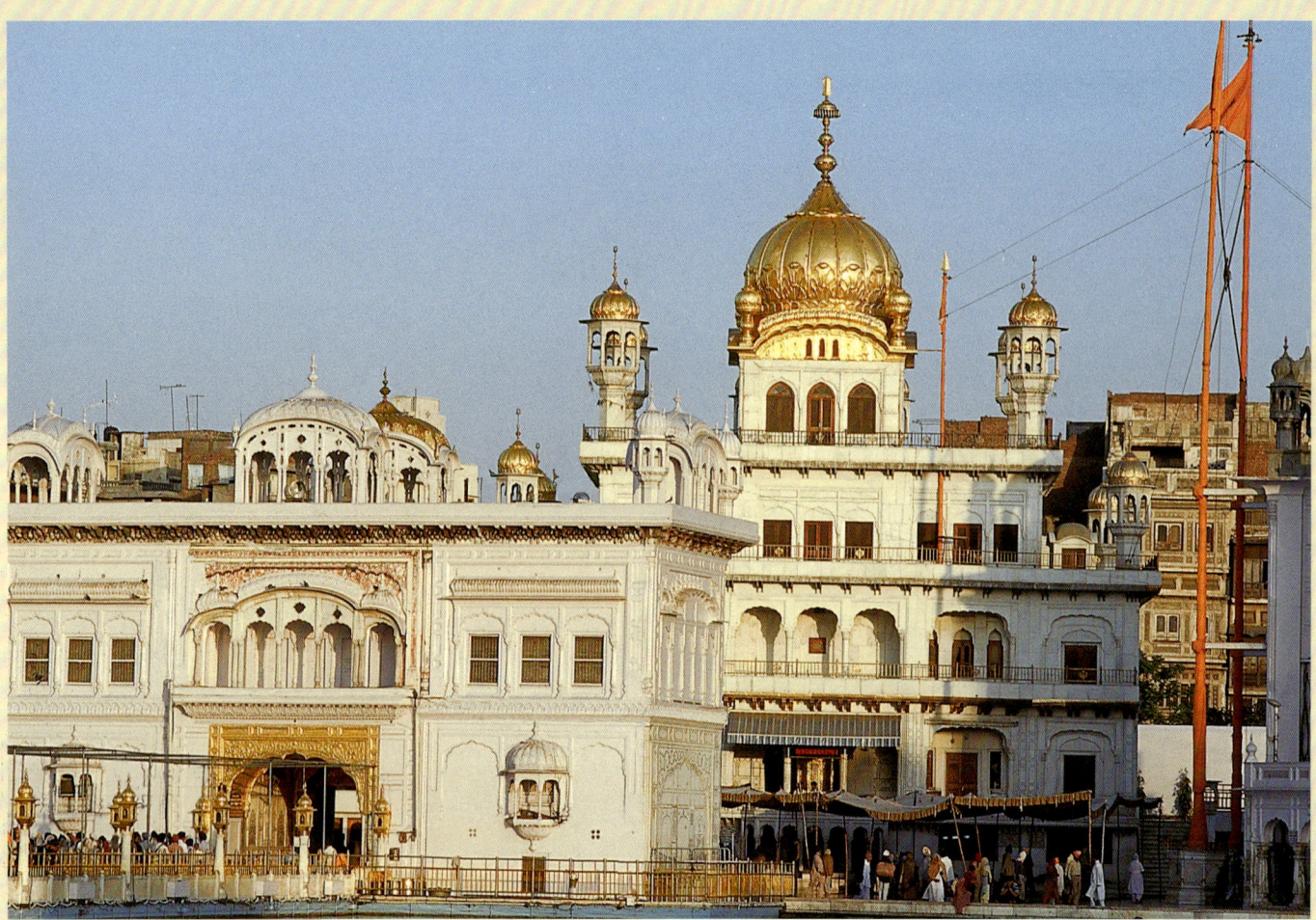

The eastern façade of the Darshani Deorhi: Though a simple building structure, *Darshani Deorhi* is unique in its variety of architectural forms inherent in Bengal, Mughal and Rajput traditions. With the towering Akal Takht in the background, *Darshani Deorhi* gains the look of a huge castle.

(Preceding Pages) The evening at Sri Harimandar Sahib:
The day is to leave and the night has taken over. The sacred shrine, however, comes out with its own light and illuminates, beyond itself, the sky above and the waters below.
It sends piercing columns of light but the entire illumination that zigzags the waters seem to inscribe upon its bosom a script in gold, which only those in His constant service may decipher. Sri Harimandar Sahib is in the commanding view, but the *Darshani Deorhi* and the Akal Takht also make their presence felt.

of guarding the holy shrine by a protective and fortified entrance and built it along with the Akal Takht in whatever form. Maybe, what Guru Hargobind built was a single storey structure with accommodation for gate-protecting *jatthas* of Sikhs, or also built along with a watch-tower rising to multi-storey height on one of its corners. This reconciles to some extent what various scholars assert, some of them claiming that initially *Darshani Deorhi* was a single-storey structure, while the other claiming its three-storey status. It is quite likely that this same structure was pulled down and reconstructed along with the main shrine in 1776 or 1769.

Darshani Deorhi, a rectangular two-storey structure, lies length-wise on south-north axis line. It has a 66 feet length and 36 feet width. The antechamber where the gate opens has a 25 feet length and 14 feet 6 inch width. The three-fourth or a little more part of the building stands in the tank's basin submerged in water, while its western façade is connected with *Parkarma*. *Darshani Deorhi* consists of three parts. A massive archway, the 10 feet high and 8 feet 6 inch wide recessed rectangular marble opening, forms its central part while two wings, one each on north and south, flank it. The two wings differ slightly from each other in their measurements, hence the archway is not in the exact centre of the building. Though both wings have largely a similar designing pattern, yet there also surface some deviations. The northern wing has three openings while the southern one has just one. The northern wing has nine rectangular ventilators, three each over one of the three door openings. The door opening on the southern side is flanked by door motifs and it has over it a rectangular recess.

The main opening, which consists of a rectangular marble frame, is contained within a beautifully adorned arcaded superstructure comprising nine cusps. The arch ends of the superstructure terminate into beautiful pendentives of the stalactite variety. A pair of subsidiary blind doors gouging out of the front wall flanks this archway on sides. These blind doors are also contained within an arched frame consisting of the same nine cusps. Above these blind doors there are similar blind window motifs. A projected *chhajja*, supported on pilasters that rise from floral base, surmount these blind windows. These window motifs are profusely ornamented and contain large gurmukhi inscriptions, neatly embossed on gold leaves used for adorning the wall surface. The northern tympanum contains the conventionalised plant motif, while that on the southern window has reliefs of Baba Nanak, Bhai Bala and Mardana.

Lavish ornamentation consisting of various decorative motifs, both floral and architectural, plants and creepers, beautiful carvings, calligraphy and interplay of marble and gold, colours and marble and the like, exceptionally elevate the façade of the *Darshani Deorhi*. Corners, all four, stand negotiated with round fluted pillars which rise from the ground up to the roof level. The marble doorjambs are adorned with strings of leaves, which after the mid-height are repeated in gold, obviously the gold-plating. Running in parallel courses these milky white and golden string courses, like a duet, create their own music and the façade seems to thrill with their humming tunes. A shallow eave over the archway demarcates the upper floor. Above the eave level, on both sides and both façades, there are large projected

The embellished ceiling of the Darshani Deorhi: The curved ceiling and the arch spans of the *Darshani Deorhi* present the outstanding examples of embellishing a wall space using stucco, inlay, filigree, glass and gold-work, relief and marble-inlay. The chandelier suspending from its centre immensely magnifies its lustre. As per record, it is the work of Kehar Singh and his nephew, who had acquired great expertise in filigree work from a master craftsman of Jaipur. They worked at the *Darshani Deorhi* around 1810-15.

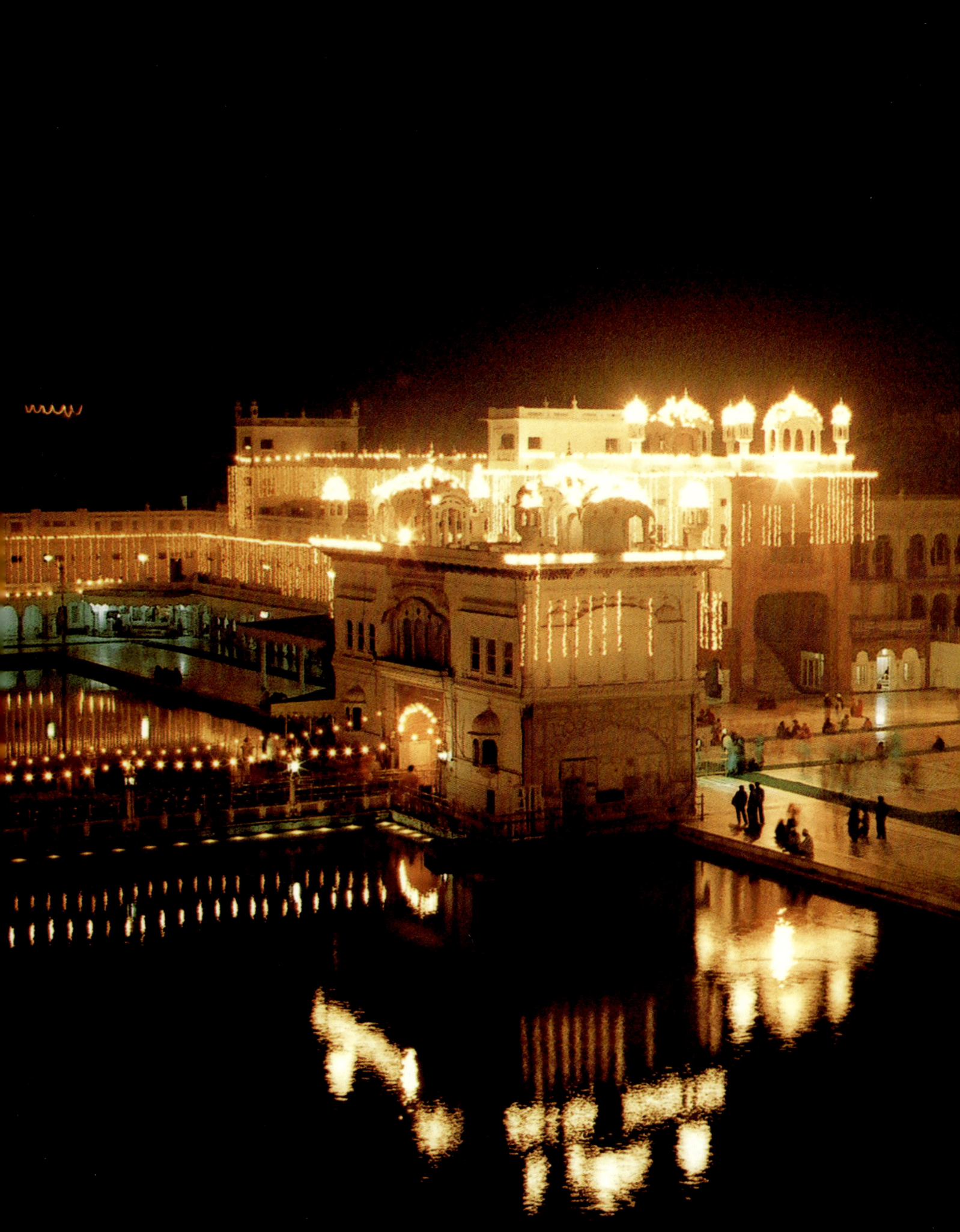

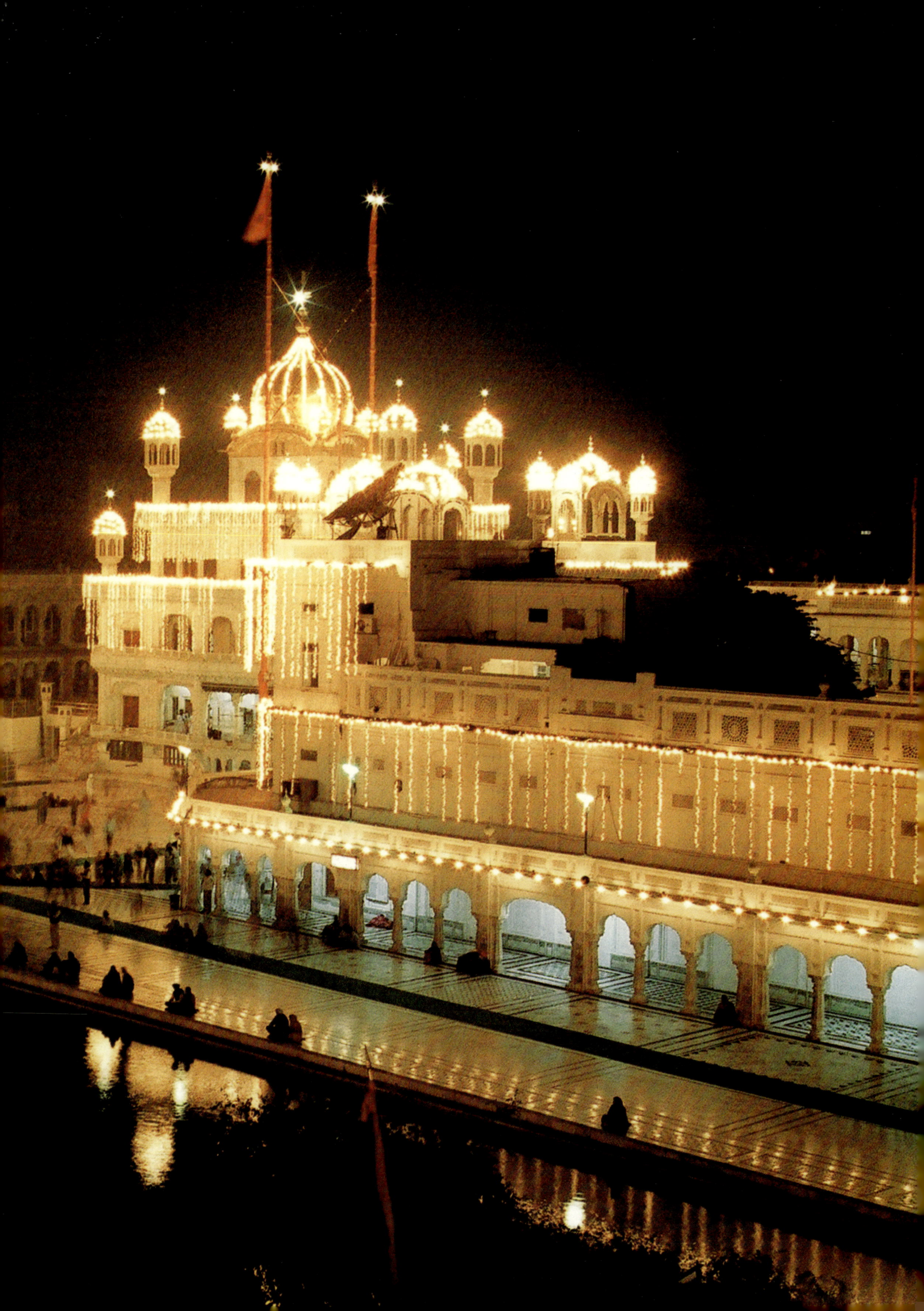

balconies. This part consists of five window openings, three contained under one elliptical shallow *chhajja* comprising the central group and the other two, contained under independent domical eaves, flank this central group. The side wings, on north and south, have a group of three identical windows on each side. These rectangular windows are contained within arcaded frames and have over them decorative shallow eaves, one on each side. These eaves are carried on pilasters, four in number, which also create separate frames for each window. A large projected eave running around the entire edifice defines the roof level.

The terrace does not have any building on it save the non-functional four rectangular *chhatris* or air pavilions in the centre of all four facets and four marble minarets on all four corners. The octagonal minarets with eight openings, each topped by a small fluted dome and *kalasha* finial, are reminiscent of India's old tradition of *kirti-stambha*, or *vijaya-stambha*. All four *chhatris* have an identical appearance, however, the one towards the north is slightly different from the other three. These *chhatris* present a fine blend of Bengal, Mughal and Rajput architectural styles. Bengal's cottage, like slanting domes, largely followed subsequently by Rajasthani architects in constructing garden pavilions and oriel windows, surmount these air-houses at *Darshani Deorhi*.

Structurally, the upper floor, roof level and the terrace, on the eastern façade are identical with the western one. On ground floor level, this façade deviates from its western counterpart. The nine cusps of the arcade on the eastern side are better defined than are those on the western side. The northern and southern wings, which flank the central opening, do not have any door openings. They have instead, on each side, one oriel semi-hexagonal window thrown out of the facet. These windows are supported on floral brackets and are topped by fluted, flat half-domes surmounted by usual *kalasha* finials. Two arched window motifs, one on each side, flank these oriel windows.

On the ground floor, the northern wing is now used for office purposes while the southern wing is the depository of the Holy palanquin, which carries every morning the Holy Book from Akal Takht to Sri Harimandar Sahib and back in the evening. The central antechamber has on both of its wings, the northern and the southern, stairways leading to the upper floor. This floor houses the celebrated *Toshakhana*, or the temple treasury, which includes many invaluable articles, both of great antique as well as art value, and are put to display only during *jalao*.

The doors of *Darshani Deorhi*, made of *shisham* wood, front overlaid with silver and back inlaid with ivory, have always been in popular controversies, as to whether these are the old doors of the famous Somanath temple of Gujarat taken away from there to Kabul by Mehmud Ghazni or not. It is more fiction and less of truth. The only direct evidence in the matter is the proclamation, dated 1842, made by the British Governor General of India, announcing to have procured from Mehmud's tomb the celebrated doors of Somanath temple and restoring them back to the Holy

(Facing Page) Devotees at Darshani Deorhi: Sikhs, now an international community, are scattered over the entire globe but the epicentre of their faith is only Sri Harimandar Sahib. Here one finds an American Sikh as also the English or Iranian. Whatever their land and status, and irrespective of whatever the weather, the parching sun or the freezing cold, bare-footed, maybe with sun glasses, they enter the premises, and humbly bow their heads on the threshold of the Supreme in reverence and gratitude.

(Preceding Pages) Darshani Deorhi. Akal Takht, Parkarma:
Here is *Darshani Deorhi*, Akal Takht and *Parkarma* wrapped in multi-hued light. Darkness vanquishes all forms but here they are reborn—arches so well defined, domes so distinct, towers so effectively countering the darkness and the two Nishan Sahib not only rise high in the sky but also penetrate deep into *sarovar's* waters. Even dark waters have acquired shapes and forms and the *Parkarma* turns into a lustrous stream of melt gold.

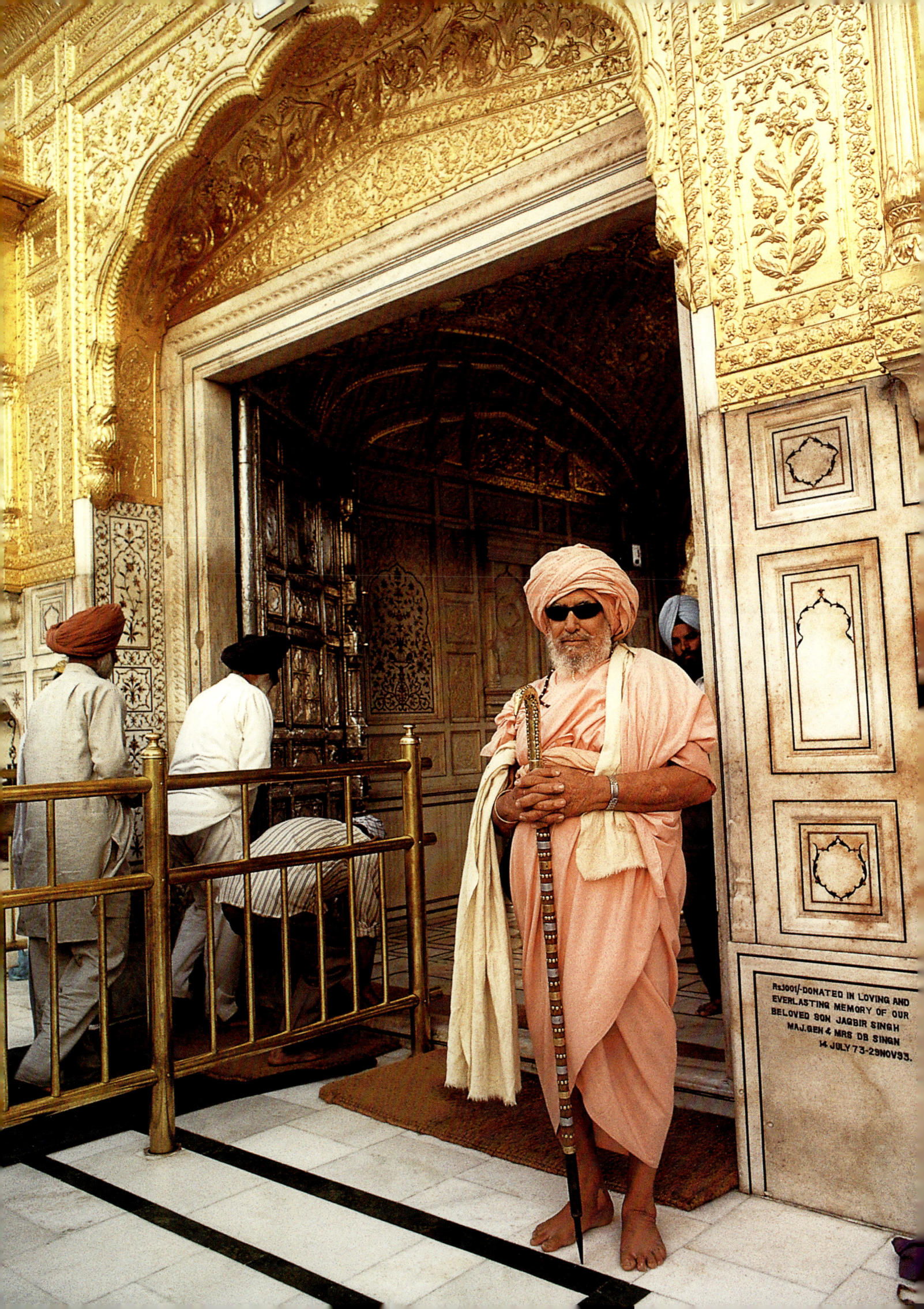

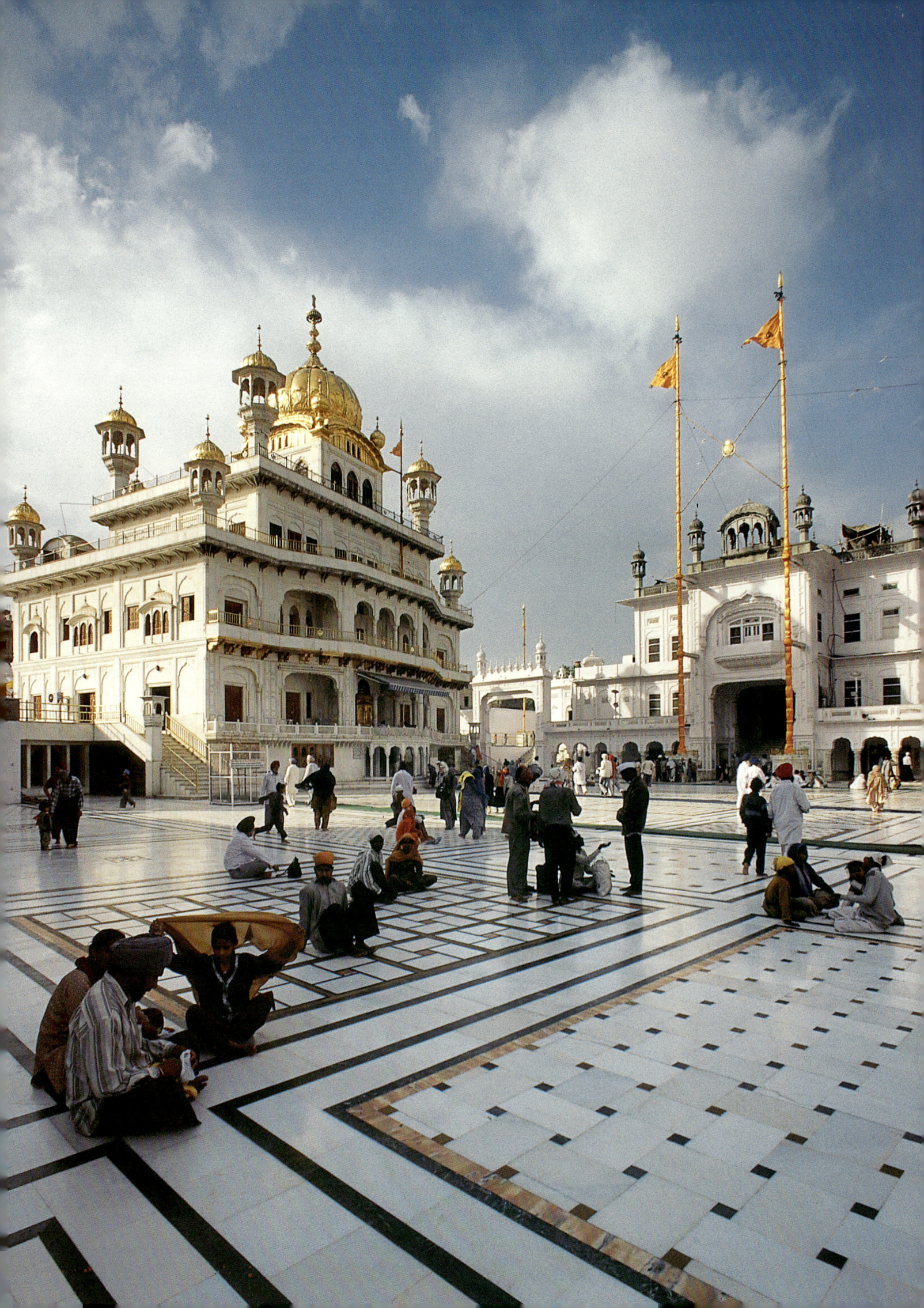

The marble inlay:
Plain and flat marble slabs are a rarity in
Sri Harimandar Sahib. Whether a marble slab used
for cladding the wall space or a floor, it has some
kind of designing pattern laid in it.
The marble slab on wall spaces, as here,
has delicate designs, usually floral patterns,
creepers, vines and flower bases. In finely carved
grooves, these designing patterns are set.
Elegant designs created by using delicate colours
characterise this class of marble work in
Sri Harimandar Sahib.

(Facing Page) Marble mosaic:
The designing patterns, defining marble floors,
are usually bold, as the delicate fine marble strings,
such as define a creeper or a flower stem,
would not sustain against the pressure of
visiting crowds. Geometric patterns, or bold floral
designs and arabesques have been preferred in
paving *Parkarma* and other floor areas.
At some places, the simple marble slabs
of different colours have been used
to create variegating effect.

(Preceding Page Left)
Courtyard in front of the Akal Takht:
Besides the *Parkarma's* width, the open space in
front of the Akal Takht is large and wide.
It is the venue of periodical *Diwans*,
different congregations and *Sharbat Khalsa*.
The Akal Takht has as its frontispiece a
quasi-pentagonal projected marble portico,
which is an essential part of this congregational
venue, as it is here that whenever required, the
supreme Sikh authority is installed to guide the
course of the *Panth*.

(Preceding Page Right) Devotees from far off:
Simple peasants as also the Sikhs with cadre and
ranks, one, two, or many in groups,
flock around Sri Harimandar Sahib. They come out
of gratitude for a good crop as also to pray so
that a crop does not fail. When marrying a
daughter, they come with the first invitation card
and with it invite the most Auspicious One
to preside over all marriage rites. Their smiles and
tears, their woes and victories, their good and
bad, all are pledged with Sri Harimandar Sahib,
their sole spiritual recourse.

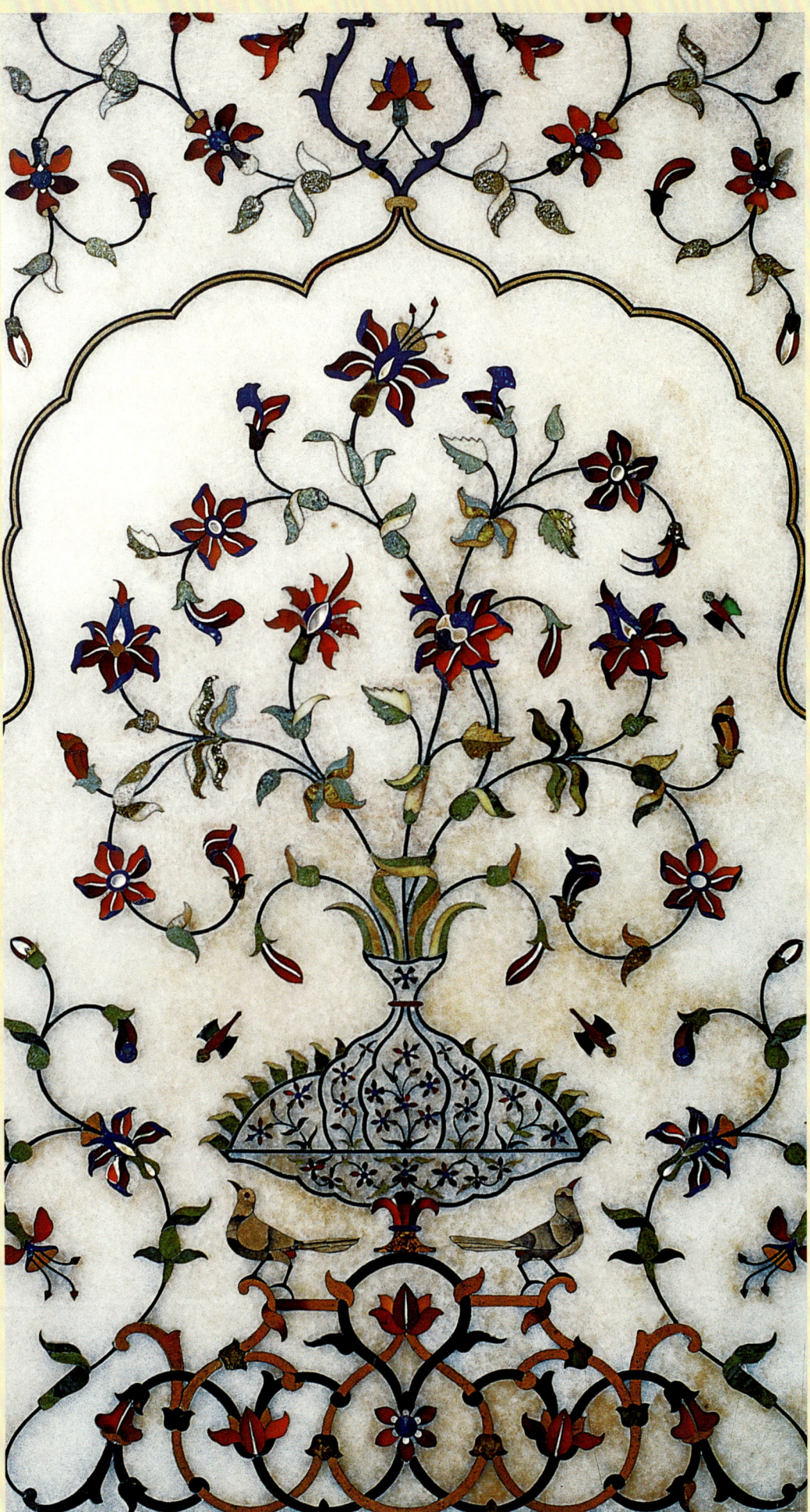

temple. The proclamation has been quoted in John William Kay's book, *History of the War in Afghanistan*. This proclamation refers to the doors as made of sandalwood, something which most other sources affirm.

Evidently, the doors of the *Darshani Deorhi* are not made of sandalwood. They are made instead of *shisham*, perhaps the only kind of timber, which grew in abundance in the belt around and was almost universally used in defense structures due to its steel-like strength. *Shisham* is still the most widely used timber in the area. This above proclamation renders it further doubtful whether these doors, as the popular myth has it, were brought by Maharaja Ranjit Singh, or by British army. H. H. Cole, V. N. More and many other scholars claim that the doors brought back from Kabul lie in the Agra fort. There are others who assert that the door-set, preserved in the British Museum, London, is actually the original door-set of Somanath temple. The doors preserved at the Agra fort are characteristically Islamic in their inlay. Besides, Giani Gian Singh and Udham Singh give even details of expenditure incurred on silver-plating of the *Darshani Deorhi* door-set. If brought from Kabul, silver-plating was not required. The inlaid designs on these doors have largely the same patterns as in the main temple. Obviously, the doors of *Darshani Deorhi* were made locally, from local timber and by local carpenters.

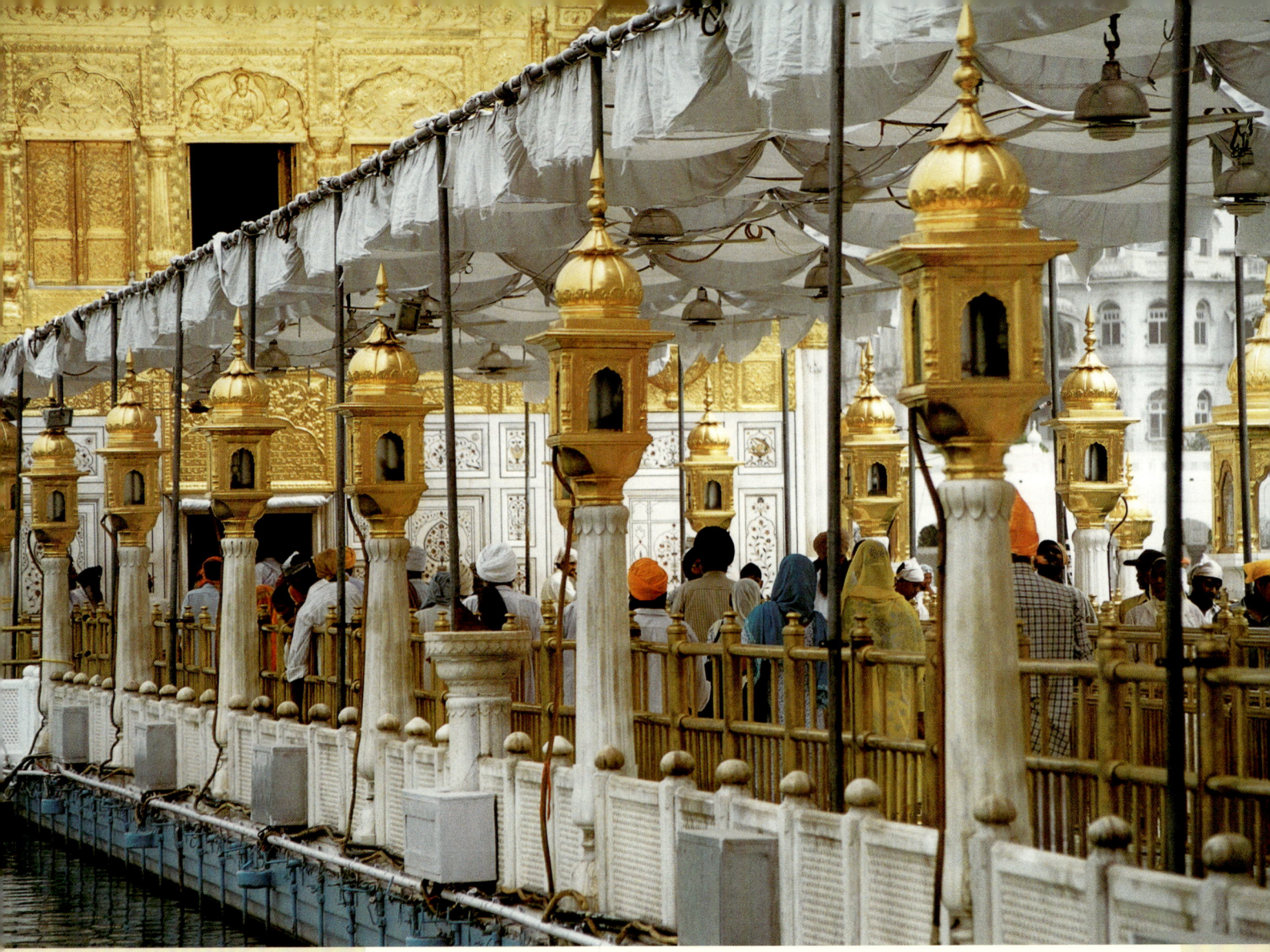

Causeway

The 202 feet long and 21 feet wide causeway connects the *Darshani Deorhi* with the main shrine. The balustrades of fretted marble, intercepted by ten marble pillars supporting on them golden lanterns on each side, border and guard the causeway. The beautiful marble pillars represent India's age-old architectural tradition of *kirti-stambha*, *vijay-stambha*, *Garuda-dwaja* or Jains' *samavasharana-stambha*. On its northern side, a small marble pillar, ahead of the fifth one from the *Darshani Deorhi*, bears on it a sun-dial. The entire causeway is floored with colourfully laid marble and is divided by brass railing for up and down passages. It is said the fretted marble balustrades were brought by Maharaja Ranjit Singh from the tomb of Jahangir at Shahadra near Lahore. Another tradition attributes it to Sardar Jodh Singh Ramgarhia, the son of Jassa Singh Ramgarhia. Some scholars claim that the causeway, its sub-structure as well as its upper structure, was built by Muhammad Yar and his brother, the masons and craftsmen of Maharaja Ranjit Singh, a claim which may not be accepted. Maybe, they renovated and embellished its upper part. Whatever, the causeway, with all its glitter and gold, its colourful carpets and devotees with bright costumes moving to and fro and above all, the widespread sheet of holy blue waters leading it across from the mundane to the spiritual is one of the most splendid members of Sri Harimandar Sahib.

The Causeway in all its splendour: The Causeway is not only an amazing piece of architecture but also so splendid in appearance. It is delightful to see how from a row of balustrades, comprising fretted marble, there rise marble pillars, ten on one side, supporting on them golden lanterns. This unique and glaring architecture guards the Causeway. The entire Causeway is covered with a milky white chandani, floored with colourfully laid marble and bifurcated into two up-and-down sections by brass railing.

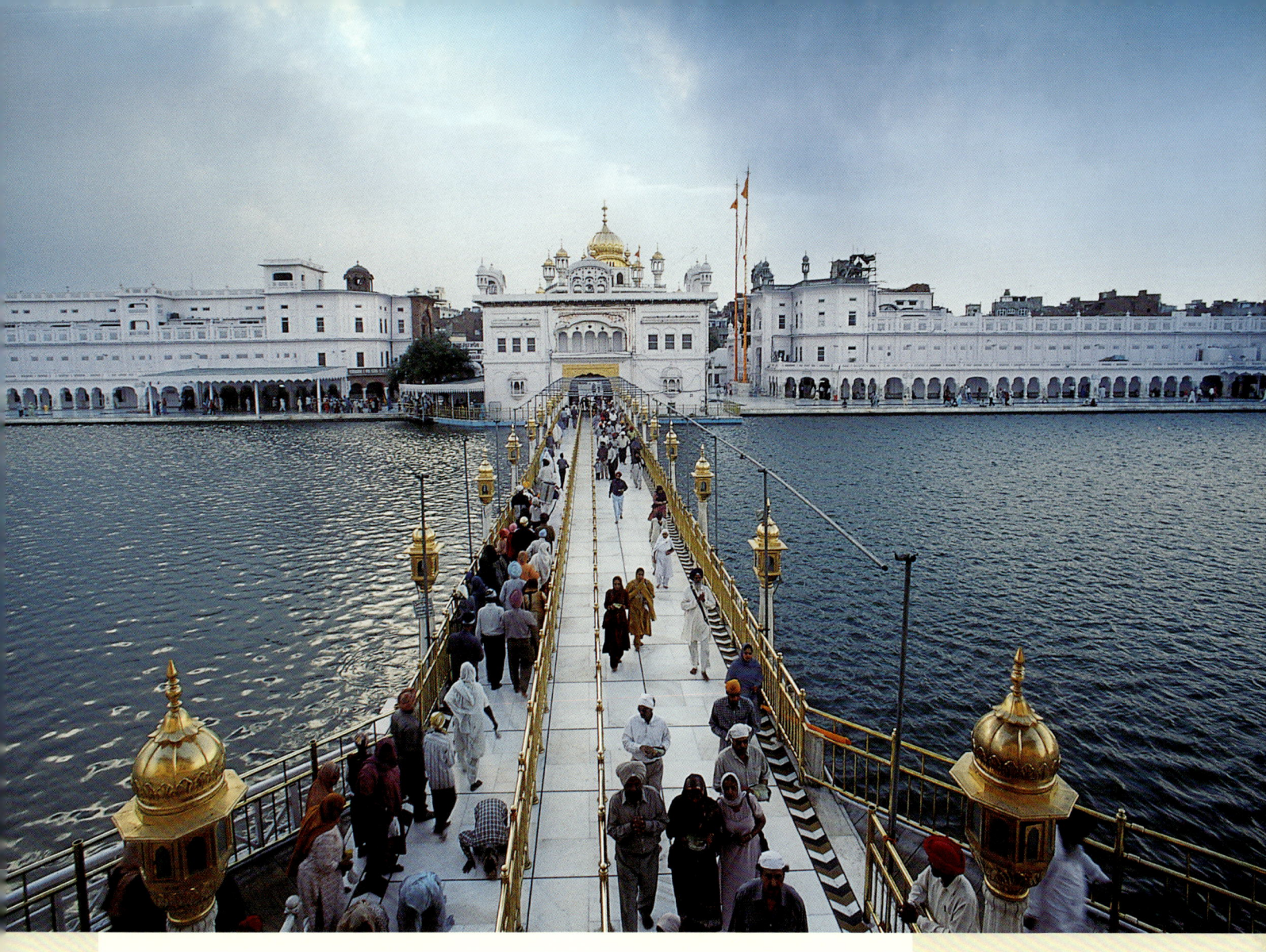

Sri Harimandar assimilates, or has rather assimilated across these 400 years, and quite stoically, not only elements of various styles of art and architecture, designing patterns, or motifs, but also varied traditions, cults and bodies of thought, though essentially such ones as suited the taste, life-mode, dogma and the religious practices of the newly-born man, the Sikh. Far more than a mere form of architecture, Sri Harimandar, with an "animated and picturesque appearance", as the known art historian Percy Brown calls it, represents the beliefs and convictions of this new man as also the cardinals of his faith. The all-embracing catholicity and egalitarianism of Islam and the transcendental wisdom of Hindu thought, which constitute the essence of Sikhism, also characterise its shrine, both in spirit and form. The Sikh tradition, as Sikhs perceived it across these 400 years, representing an indivisible unity of polity and religion, was physically realised in Sri Harimandar, when with it evolved the Akal Takht facing it. With its strongly laid base, Sri Harimandar, the epicentre of the Sikh faith, reassures that its base, and correspondingly that of the faith, would never shake, howsoever strong a turmoil it has on its surface. The creation of the divine hands and a concept of the fully enlightened mind, Sri Harimandar and the path that leads to it define eternity and the timeless quality of the mind.

The Causeway across the Sarovar: The 202' long and 21' wide Causeway is the sole course that connects the *Darshani Deorhi* with the main shrine. Lying across the *sarovar* one has, from the Causeway, *sarovar*'s more elaborate and fascinating view. Both sides have ten marble columns topped by golden lanterns, but its northern side has, ahead of the fifth column from the *Darshani Deorhi*, besides these columns, a small marble pillar with a sundial.

(Following Page) The Temple complex and the town beyond: The Tank and the town were the vision of Guru Ram Das who created the *sarovar* and founded the township of Ramdaspur. Sri Guru Arjan Dev added to it the Temple and, then, the *Panth* had the Temple, Tank and the Town. Guru Hargobind realised that without authority, he could neither sustain the Temple, nor Tank, nor Town. He created *Takht*, the Authority of *Akal* and brought to the Temple, Tank and Town eternity, the timeless existence. The camera has captured them all — the Temple, the Tank, the Town and the *Takht* of *Akal*, together in one shot.

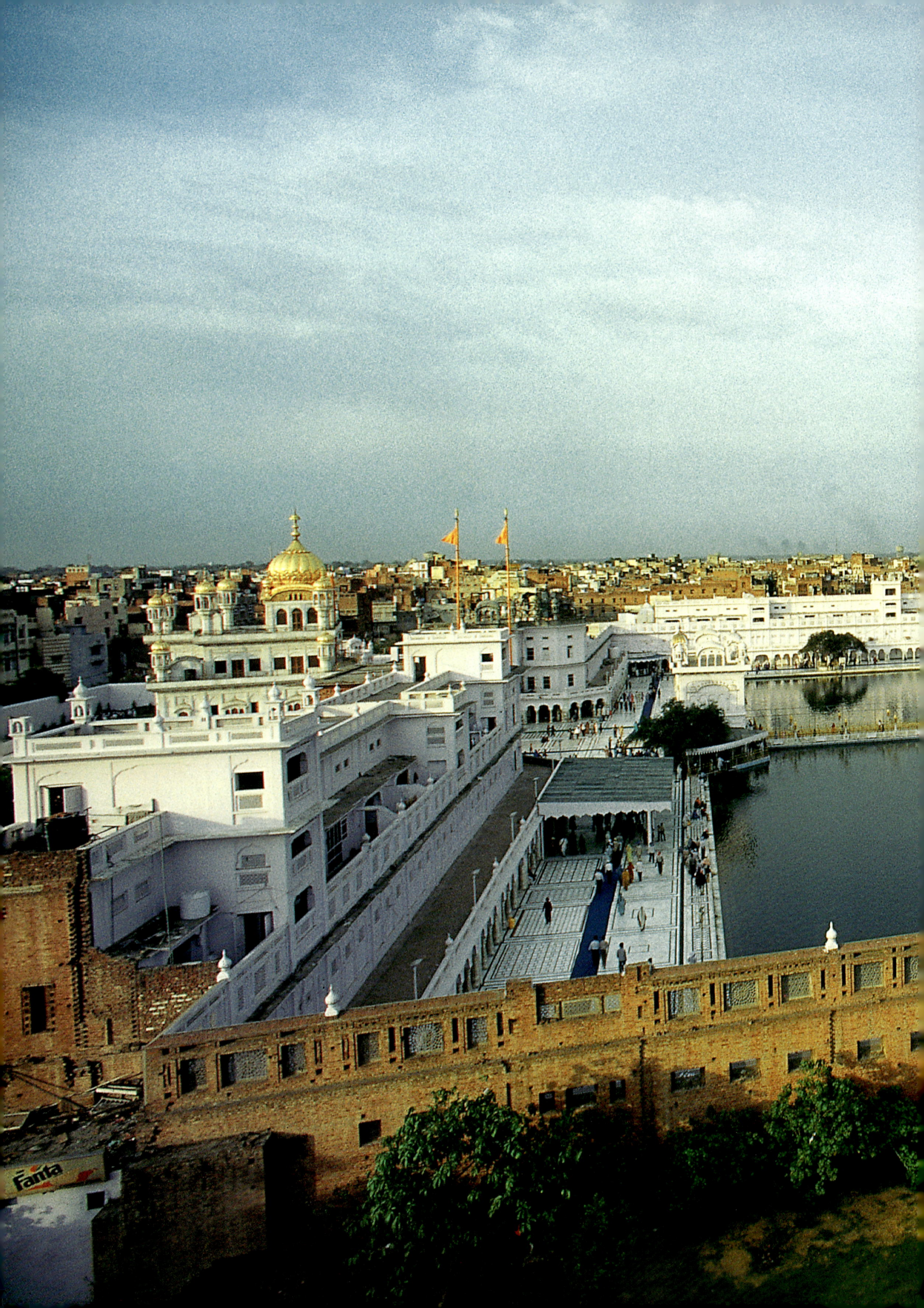

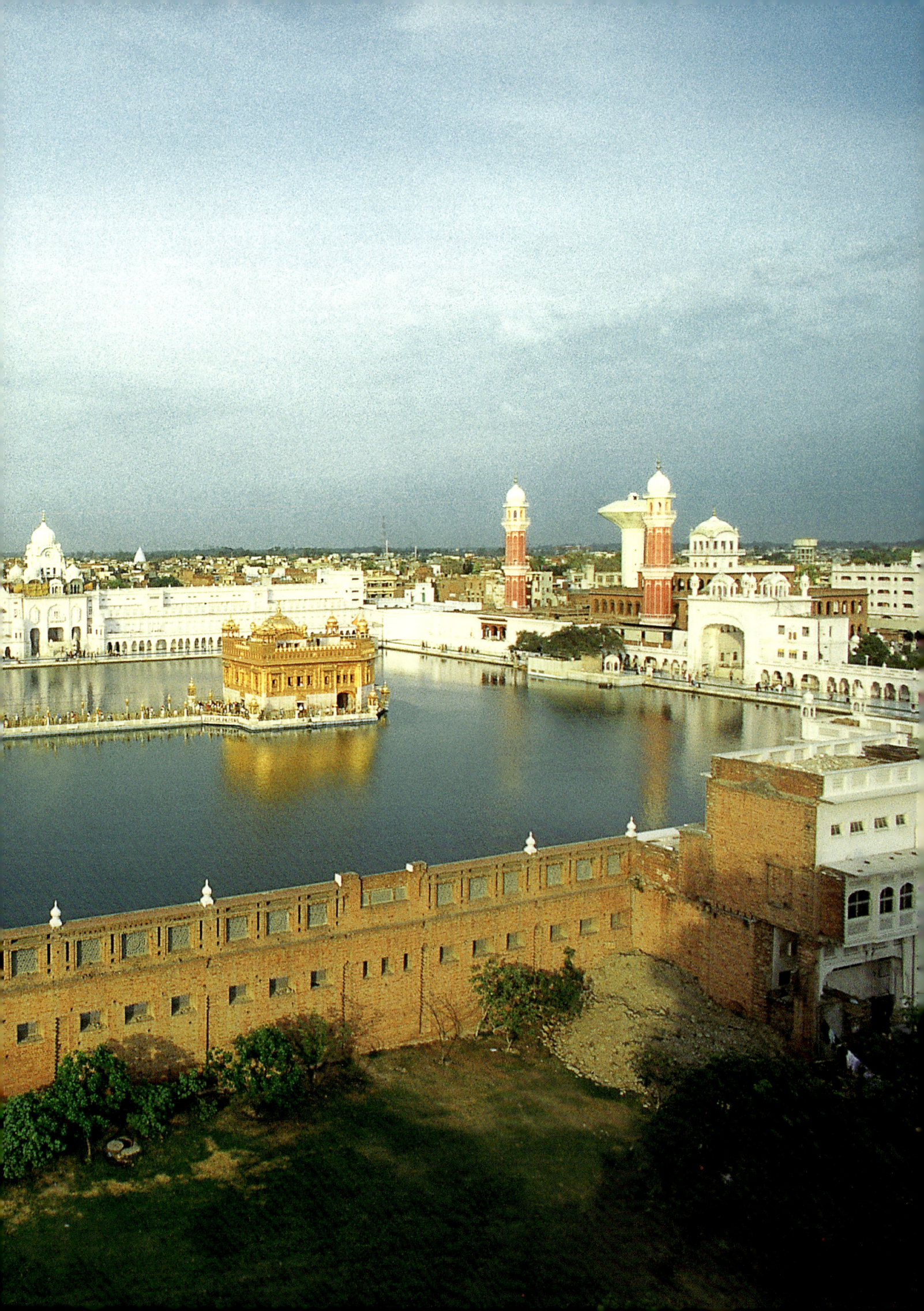

Rituals,

Practices
and Celebrations

Sabad-Kirtan, or Recitation of Bani

Recitation of the *Bani*, for an individual as well as for the community and at a personal dwelling as well as at a shrine, is the first and the holiest of all Sikh rituals. The *Bani* is His manifest form, the recitation of which amounts to realising Him. It is the subtlest means of redemption from the cycle of death and birth. By the time of Sri Guru Arjan Dev, the *Nam-simaran* of Baba Nanak had widened to include the recitation of *Bani*. Sri Guru Arjan Dev ordained that the *Bani* must be sung correctly and under strict musical discipline. He hence not only got the *Bani* collected and corrected but also set it to various *ragas* and *raginis*, or the musical modes, as propounded in the classical tradition of ancient India. This, however, did not mean that the one who did not know *ragas* was deprived of commemorating the *Bani*. Sikhism, moderate as it has been across centuries, commands a *ragi*, when he recites the *Bani*, to strictly follow the discipline, but allows a common Sikh to even commemorate it within him, unheard and unsung.

Installation of the Adigranth: Let the light be born

The recitation of *Bani*, as a proper rite, or religious practice, in the form and manner prescribed under the authority of Guruship, began on *Bhadon sudi ekam*, *Samvat* 1661, that is, sometime in August 1604, when in the early hours of the morning, Sikhs' first book the *Adigranth* was installed in Sri Harimandar. The installation was scheduled to take place before dawn. Scheduling this hour before daybreak was neither in pursuance to the usual convention nor it was at random. It was rather Sri Guru Arjan Dev's analogy. He perceived that God's creation lay enshrouded in darkness, and the *Bani* of the Holy Gurus alone could bring light to it. He believed that the darkness would go but let the light be born first. Maybe, it is in accordance to his perception that the installation of the Holy Book is named as *Prakash*, as if while installing the Holy Book, Sri Guru Arjan Dev said 'let the light spread'. It was the same as was perceived in India's cosmic vision when it ordained, *Tamaso ma jyotirgamaya*, or in Biblical tradition when it pronounced 'let there be light and there was light'.

After years of the collective effort of Sri Guru Arjan Dev and his Sikhs, the *Bani*, which lay scattered sometimes in the pages of a *pothi*, or a modi's account-book and sometimes only in a singer's throat, was collected. Each word, or *sabad* and each page was brought to Mata Ganga, the consort of Sri Guru Arjan Dev, who was its custodian. A team of senior Sikhs, since morning till late in night, worked on the collected material, corrected errors, deleted superfluities and supplemented what either the collectors had left, or the singers had omitted. Sri Guru Arjan Dev supervised everything. But, after the construction of the temple had completed in 1601, he devoted himself solely to the compilation of the *Bani* and in editing it. He dictated to Bhai Gurdas, the first ever scribe of the Holy Book, the corrected *Bani*

(Facing Page) The first folio from Sri Guru Granth Sahib manuscript: This is the content page of a beautifully illuminated copy of Sri Guru Granth Sahib, now in the collection of the National Museum, New Delhi. It has its three sides illuminated by a fine border. The upper part of the usable space has been divided into two cubes. The cube towards the left contains *Ek-Omkar* while the other one on the right portrays Sri Guru Arjan Dev seated in a chair with disciples before him. The lower portion has been inscribed with the broad contents of Sri Guru Granth Sahib.

(Preceding Page Left) The Birds' Tower: The Birds' Tower is one of forms of arabesques prevalent in Iranian tradition. It is only a part of it. The full design is contained inside a niche type frame. The twig rising from a multi-petal lotus is its centre. The inner ring comprises birds, five on each side and the outer one of floral creepers visible only partially.

(Preceding Page Right) Path or reciting Bani: Reciting *Bani*, listening to the recitation of the *Bani*, or commemorating *Bani* is the highest ritual in Sikh Panth. Hence, most of the devotees, who visit Sri Harimandar Sahib for *Darshan*, also read a part of the *Bani* every day. The first floor balconies not only have space for *pathis*, but also several copies of the Holy Scripture, known as *Gutkas*. A devotee may take out a copy by himself and after having read whatever quantum of the *Bani* he wishes to read, he shall place it back. He shall bow to it his head both times, while taking it out and placing it back.

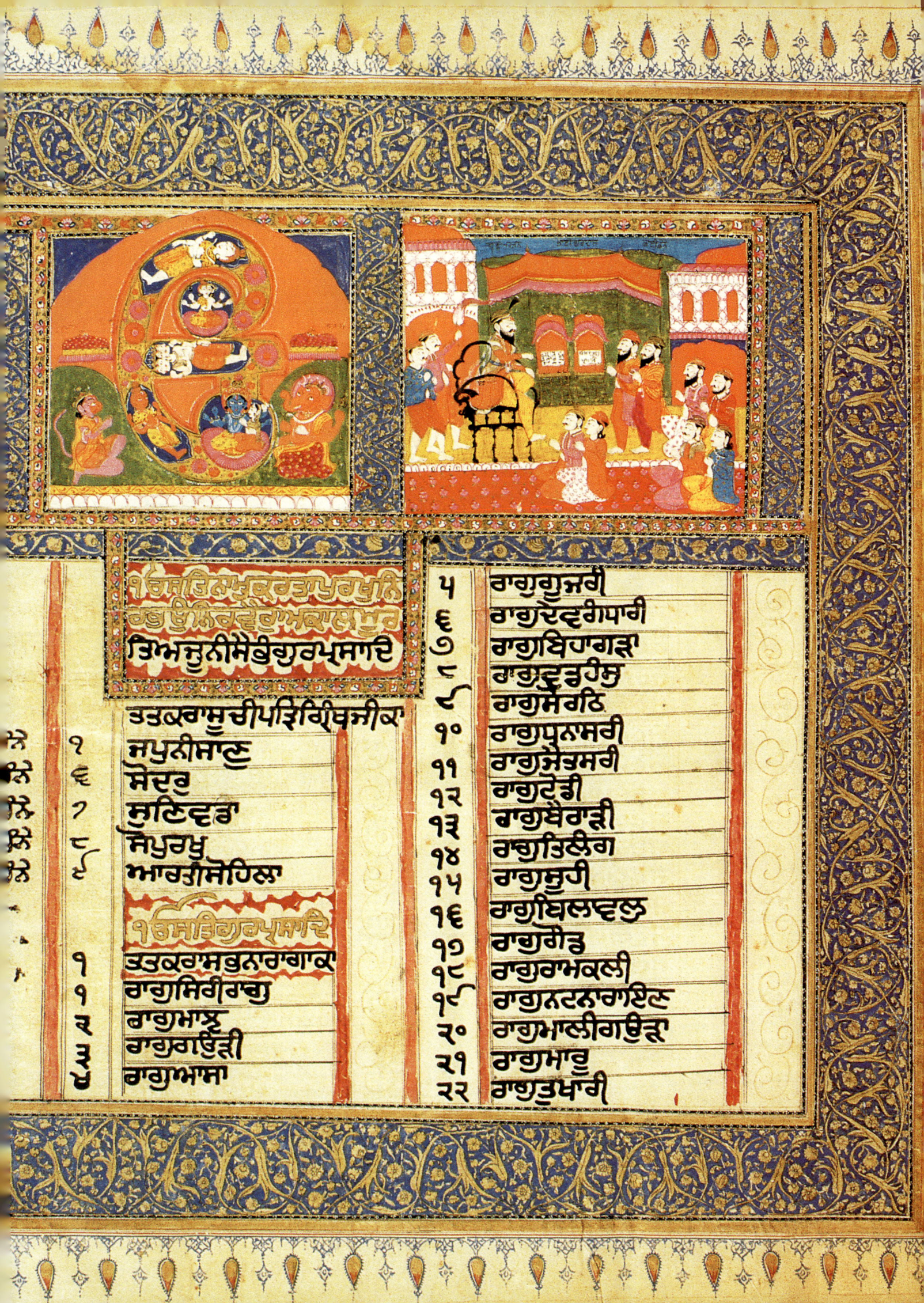

and what evolved after three years of untiring effort and unflinching devotion was the Holy *Adigranth*, the first book of the *Panth*. The Holy Book lay consecrated in a chamber at the Guru ke Mahal. Greatly sensitive as he was, Sri Guru Arjan Dev perceived in all existing things, whether dead or alive, a living mechanism and had for them all an alike reverence. As regarded the Holy Book, in which Sri Guru Arjan Dev perceived the manifest form of the Supreme, the cause of all life and the entire cosmic mechanism, he was exceptionally sensitive. To him the Holy Book was the highest form of life and hence accorded to it the status, which the highest living one deserved. He hence ordained that during the night the Holy Book would rest undisturbed in its resting-place, which the tradition named as its *sukhasan*, and would wake in the morning to its full splendour and glory.

Elaborate arrangement had been made to install the Holy Book in Sri Harimandar. The Sikh *sangat* gathered at the Guru ke Mahal much before the daybreak. Sri Guru Arjan Dev, enthused and filled with devotion, opened the doors of the sacred chamber where the Holy Book lay during the night. The reverend Baba Buddhaji lifted the Holy Book on his head and brought it out. Sri Guru

Sri Guru Granth Sahib:
This is a large size manuscript of
Sri Guru Granth Sahib richly illuminated using
massive quantity of gold. The manuscript
comprises 673 folios, of which all are lavishly
illuminated and elegantly calligraphed.
It is an early 19th century work.

Arjan Dev was waving a flywhisk all the time. The Holy Book was thereafter placed in a *palki*, or the palanquin. Baba Buddhaji led the *palki*-bearers and the barefooted Sri Guru Arjan Dev, waving the flywhisk, followed it. The singers, or the *ragis*, who accompanied the procession, were chanting hymns, obviously the *sabad* from the Holy Book itself, and just behind them there was a large *sangat* following the procession. After the procession reached Sri Harimandar, the Holy Book was again lifted by Baba Buddha on his head and carried into the Temple where in its central hall it was laid on the *manji*, or the *chowki*. The *sangat* sat on the ground around the *manji*. The *ragis* then sang the *Asa di var* and after it was over, Sri Guru Arjan Dev asked Baba Buddhaji to open the Holy Book at random and read out to the *sangat* a hymn and with this was born not only Sikhs' Holy Scripture but also their scriptural tradition.

Observance of the Bani ritual in historical perspective

The *Bani* ritual, barring some intermittent interruptions, was since then, both in form and spirit, the prime religious activity at Sri Harimandar.

Ragas, the musical modes personified in Sri Guru Granth Sahib: It is one of the initial folios of a large size richly illuminated manuscript of Sri Guru Granth Sahib. In reverence to Sikh Gurus' adherence to ragas, the modes of classical music, in reciting the *Bani*, the manuscript devotes two of its folios depicting various ragas. The manuscript acknowledges that it was prepared for some Sodhi Bhan Singh around 1839, just before the death of Maharaja Ranjit Singh. It appears that Sodhi Bhan Singh wished to present it to Maharaja Ranjit Singh, but he passed away before the manuscript was completed.

Everything, a religious practice or whatever, which Sri Guru Arjan Dev had begun, had utmost thrust during the lifetime of Guru Hargobind. But after Guru Hargobind passed away in 1644, deterioration began setting in. The Seventh Guru Har Rai, the grandson of Guru Hargobind, who succeeded him, was a saint of a kind different from his grandfather. Instead of involving in warfare, he preferred touring for spreading Nanak's message. The descendants of Sri Guru Arjan Dev's elder brother Prithi Chand, taking advantage of Guru Hargobind's absence from Sri Harimandar, even in Guru Hargobind's lifetime, had usurped the control of the temple. For about six decades, Prithi Chand's son Sodhi Mihrban and grandson Sodhi Harji used the temple as their personal property. The greedy and ambitious *mahants* and *masands* joined hands with them in exploiting the situation to their utmost advantage and made Sri Harimandar a tool of their greed. The observance of sacred rituals and religious practices was given up and the focus of the religious authority of Sri Harimandar had been shifted to

Japuji Sahib:
This is another as finely illuminated folio of Sri Guru Granth Sahib prepared for Sodhi Bhan Singh. This folio-design has an epicentre, a circle in the centre, which contains a part of *Japuji Sahib*. This central circle has around it twelve lotus petals representing the twelve zodiac divisions suggesting that not only the entire cosmos, but also all traditions of faith rotate around the great hymns of Baba Nanak. The space around has delightful arabesques.

collecting and grabbing the *dashamansha*, the one-tenth of one's earning, which Sri Guru Arjan Dev had asked every Sikh to contribute to the temple for constructing and managing it and for running the affairs of the Sikh *sangat*.

Guru Har Rai, when the *sangat* earnestly prayed him, visited the temple on Diwali in the year 1651, and was there for about six months. During this brief span, the life seemed to have returned to Sri Harimandar, but after he left it was the same as before. Guru Har Kishan, the eighth pontificate of Sikhs, died very young and had no occasion to visit Harimandar. There are contradictory versions as to whether Guru Teg Bahadur visited Sri Harimandar or not, but it is certain that Sodhi Harji, the then custodian of the temple, was against his visit whether under fear or out of rivalry. As for Guru Gobind Singh, he never visited the temple. Broadly, after Guru Hargobind's death in 1644, till the death of Sodhi Harji in 1696, Sri Harimandar was under the control of the descendants of Prithi Chand, known as Mine-Sodhis. To them, the temple was more a fief than a shrine. The term Mine, due to its

association with Prithi Chand's descendants, is colloquially used in Punjab for a person who is mean. After the death of Sodhi Harji, his three sons quarreled over succession and got divided. The *masands*, engaged in the service of the temple, grabbed power and began pocketing every penny, which reached the temple as offerings or from whatever sources.

On the Baisakhi in 1699, Guru Gobind Singh had held a special congregation of Sikhs at Anandpur Sahib. Aggrieved by the deterioration of the Sikhs' supreme shrine, several Sikh *sangats*, which assembled there, jointly prayed Guru Gobind Singh for taking into his hands the control of Sri Harimandar and to revive its past glory. The otherwise engrossed Guru Gobind Singh had no time but he spared Bhai Mani Singh to take the temple's charge. He also deputed five of his trusted Sikhs to assist Bhai Mani Singh in performing his duties towards the temple. He had reports that even the enshrining Holy Book was removed from the temple. He hence gave to Bhai Mani Singh a copy of the *Adigranth*, which Bhai Mani Singh carried to Amritsar and after he had taken the possession of the temple installed the Holy Book there in full ceremony. The recitation of the *Bani* recommenced and with this the temple premises began reverberating with the sacred music. Bhai Mani Singh regularised all rituals and customary services, which Sri Guru Arjan Dev had initiated. The Akal Takht was also revived to its past glory. The *diwans*, or congregations, were now a regular feature but more for baptising the non-Sikhs and Sikhs to the Khalsa and for propagating the codes of conduct, which Guru Gobind Singh had prescribed for every Sikh. This was a new dimension added to the authority of Sri Harimandar.

This, however, did not sustain for long. Guru Gobind Singh passed away in 1708. Before his death, he nominated Banda Bahadur as Khalsa's new leader. Banda Bahadur began serving the community ably but circumstances took a disastrous turn forcing most of the Sikhs to evict Amritsar. Bhai Mani Singh was still at Sri Harimandar braving all horrors that the concurrent circumstances posed, but most of the *musaddis*, or temple staff had left and the number of pilgrims reduced to a near-zero level. The temple still continued with its rituals and religious practices, but they lost their glow and thrust and the financial resources had almost dried. At this juncture, Bhai Mani Singh got unexpected assistance from Udasi sadhus in keeping the temple's custody. Not baptized to the Khalsa, these Udasi sadhus did not have a noticeable identity. This largely helped them, as they could serve the temple without being noticed by the Mughal authority. With their assistance and temple's meagre resources, Bhai Mani Singh maintained the shrine and its activities. In 1717, Mata Sundari, the consort of Guru Gobind Singh, summoned him to Delhi. Before he left, he nominated the Udasi sadhu Gopal Das as the temple priest. The enthused Gopal Das did not let the light extinguish but his enthusiasm was only short-lived.

There erupted bloody factionalism amongst the Sikhs which endangered the Sikhs' unity, as well as the sanctity of their principal shrine and once again the foremost question was, who held temple's control rather than who served it. In the precincts of the holy temple itself, their different camps

(Facing Page) Guru Gobind Singh riding a horse: This lively image of the Tenth Guru, Sri Guru Gobind Singh, is a folio of *Zafarnama*, manuscripted in 1872. As the record has it, Guru Gobind Singh never visited Sri Harimandar Sahib, but when the Sikh Sangat prayed to him at Anandpur Sahib to take over its charge, he sent Bhai Mani Singh to Amritsar to look after the shrine and revive its previous glory. Guru Gobind Singh not only replaced the personal Guru by Sri Guru Granth Sahib but also revised the *Adigranth* by adding the *Bani* of Guru Teg Bahadur before giving it the status of *Panth's* Supreme Entity. Sri Guru Granth Sahib, as installed subsequently, was the same Holy Scripture, which Sri Guru Arjan Dev had dictated to Bhai Gurdas.

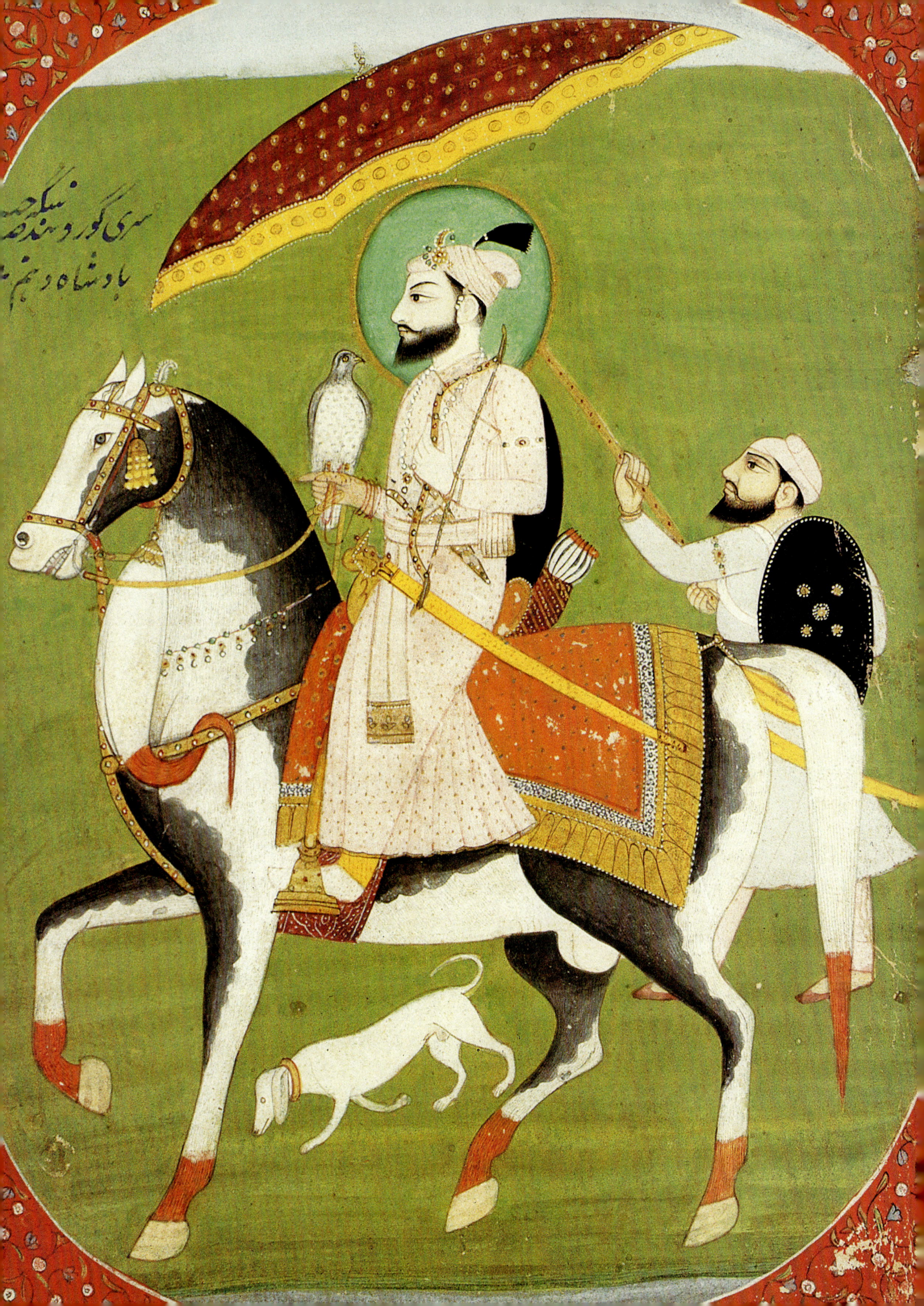

Recitation of *Bani* at Akal Takht:
Akal Takht, though the seat of Miri, that is,
of Sikh authority and power, managing the
polity-related affairs of Sikhs, has its
round-the-clock rituals and is thus also the spiritual
seat. It is in Kotha Sahib at the Akal Takht that
the Holy Sri Guru Granth Sahib rests during the
night. It has its own timings for the recitation of
the *Bani* and *sabad-kirtan*.
On its first floor hall, inside a barricaded area,
Sri Guru Granth Sahib has its seat where devotees
bow their heads in as much reverence as they do
in the Darbar Sahib.

(Facing page) The Ceiling of the Akal Takht:
In the gachkari and jaratkari, used to adorn the
ceiling of the Akal Takht, the glimpses of
the *Sheesh Mahal* part of Sri Harimandar Sahib
may well be seen. From the central medallion radi-
ates all its glow and splendour. Elaborate designing
laid with minute details and fine gold work are
examples of marvellous craftsmanship.

often resorted to arms on petty issues. Under such mounting tension, the observance of the rituals and other customary services had been thrown into the background. Mata Sundari, after the reports reached her, sent Bhai Mani Singh back to Amritsar to restore peace, settle disputes of warring factions and take charge of the temple. Guru Gobind Singh's maternal Uncle Sardar Kirpal Singh accompanied him. Within a short while, Bhai Mani Singh was able to restore Sikhs' unity and temple's sanctity and all its rituals and services. He also revived the community kitchen and held regular congregations. Enthused by Sikhs' response he decided to hold Diwali celebrations. He obtained the required permission on condition to pay a levy of Rs. 10,000 from out of the offerings received, but pilgrims' turnout was far less than

expected and Bhai Mani Singh could not pay the amount. In 1734, he was summoned to Lahore and put to death. After his death, Mughals occupied Sri Harimandar. They not only stopped all rituals and religious practices, but also defiled and derogated it. Since 1734 to almost 1776, the year when the temple was reconstructed by the federation of Sikh *misldars*, the temple had only brief intermittent phases when it had its rituals and religious services.

As regards the observance of rituals, religious practices, receipt of offerings, or contributions and the exercise of its authority, Sri Harimandar had its most glorious, if not its most spiritual phase from 1776 to 1849. In 1849, the Punjab was annexed to the British dominion. Consequently, the control of Sri Harimandar also passed into the British hands. Initially, the shrine was not deprived of its land revenue, which it collected from the *jagirs* allotted to it. Its pensions also continued as before. The prior manager was also retained. The Britishers, on the contrary, earmarked, for salaries and other kind of allowances to *granthis*, *pujaris*, *ragis* and *rababis* and other staff serving the Darbar Sahib, the Akal Bunga, the Shahid Bunga, the Jhanda Bunga and the Baba Atal, a grant of Rs. 29,787, which was several times more than temple's regular annual collection from the land revenue. By making such a grant, the British rule aimed at three goals. This helped them buy out the persons who manned the holy shrines, earn the gratitude of common Sikhs, as well as their upper strata, and pave the way for its direct intervention into the management and the affairs of the shrine and the Sikh community.

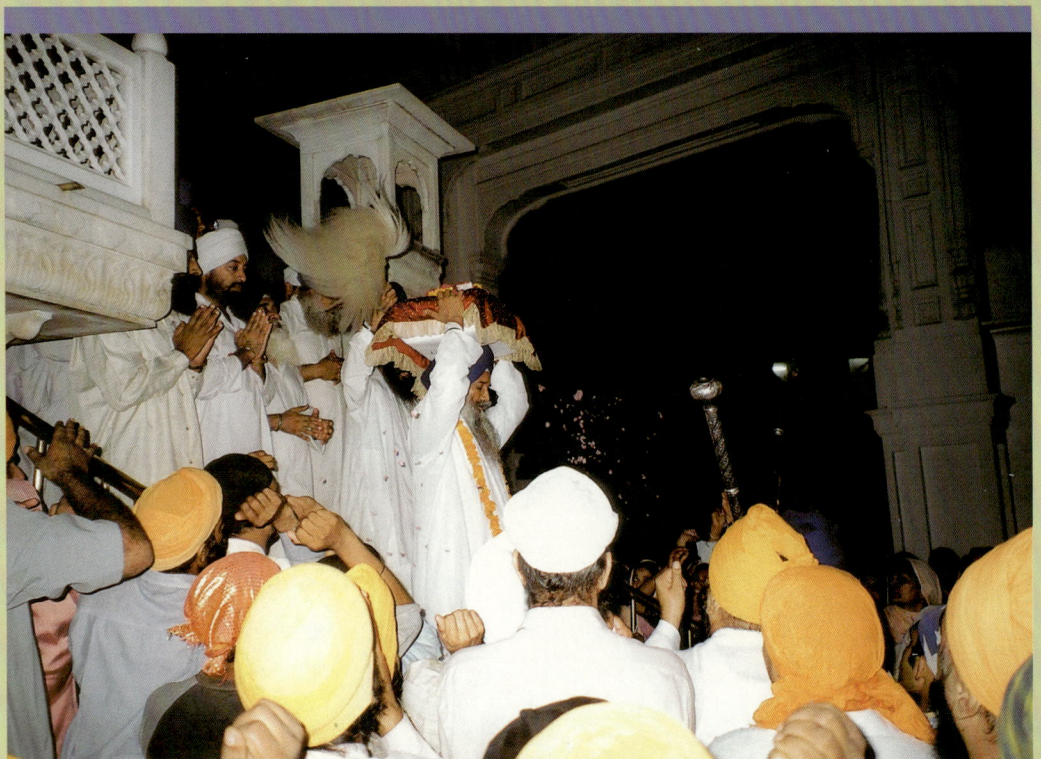

Sri Guru Granth Sahib proceeding from the Akal Takht for Prakash:
In Sikh *Panth*, Sri Guru Granth Sahib is a living entity and hence all related rituals comprise life routine of the living deity. During the night, at the scheduled hour, Sri Guru Granth Sahib retires and rests in the *Kotha Sahib* at the Akal Takht. In the early hours of morning, with the morning hymns and music, it awakes. After the morning rites have been accomplished, the *Aswari* proceeds for *Prakash* in Sri Harimandar Sahib. From the *Kotha Sahib* the head or *granthi* in-charge carries the *Aswari* on his head and brings it down stairs and places there in Palki Sahib to proceed further.

But the Sikhs did not fail to read 'the motive'. Consequently, there arose loud protests, which compelled the British rule to refrain from its direct involvement in Sikhs' religious matters. The charge of the temple was withdrawn from the British Resident and entrusted to the Amritsar's Deputy Commissioner and the management was handed over to a committee of Sikh Sardars and *raees*. The situation, however, only worsened, and much as the British desired and planned. The committee was a mere formal body while the reins were more or less in the hands of *pujaris*, *granthis*, *mahants* and *ragis-rababis*, who received their salaries from the British grant and were British loyalists. The power to deal with all internal matters vested in them. Thus, British hands indirectly controlled the Temple management. British patronage and their power bred arrogance in these Temple functionaries. In their bid to grab the utmost of temple's income, which ran in several lakhs of rupees, there erupted amongst them faction fighting with disputes often reaching the British courts, and one who was able to win the confidence of the British rule got it decided in his favour. This infused more and more servility into the ranks of the Temple staff. The committee of Sikhs, with no powers to intervene, remained disinterested. Rituals, religious practices and services were thrown into background and the appeasement of the British was the prime concern of the temple staff.

Heaps of protests and complaints compelled the British rule to review the situation. Consequently, in consultation with a ten-member team of senior Sikhs, the British government framed a set of rules and regulations, called the *Dastur-ul-Amal,* for temple's appropriate administration, but again only to further strengthen its hold on the affairs of the temple. Under the new arrangement, *pujaris*, *granthis*, *mahants* and *ragis-rababis*, who were merely the instruments of British interests, had a final say in all

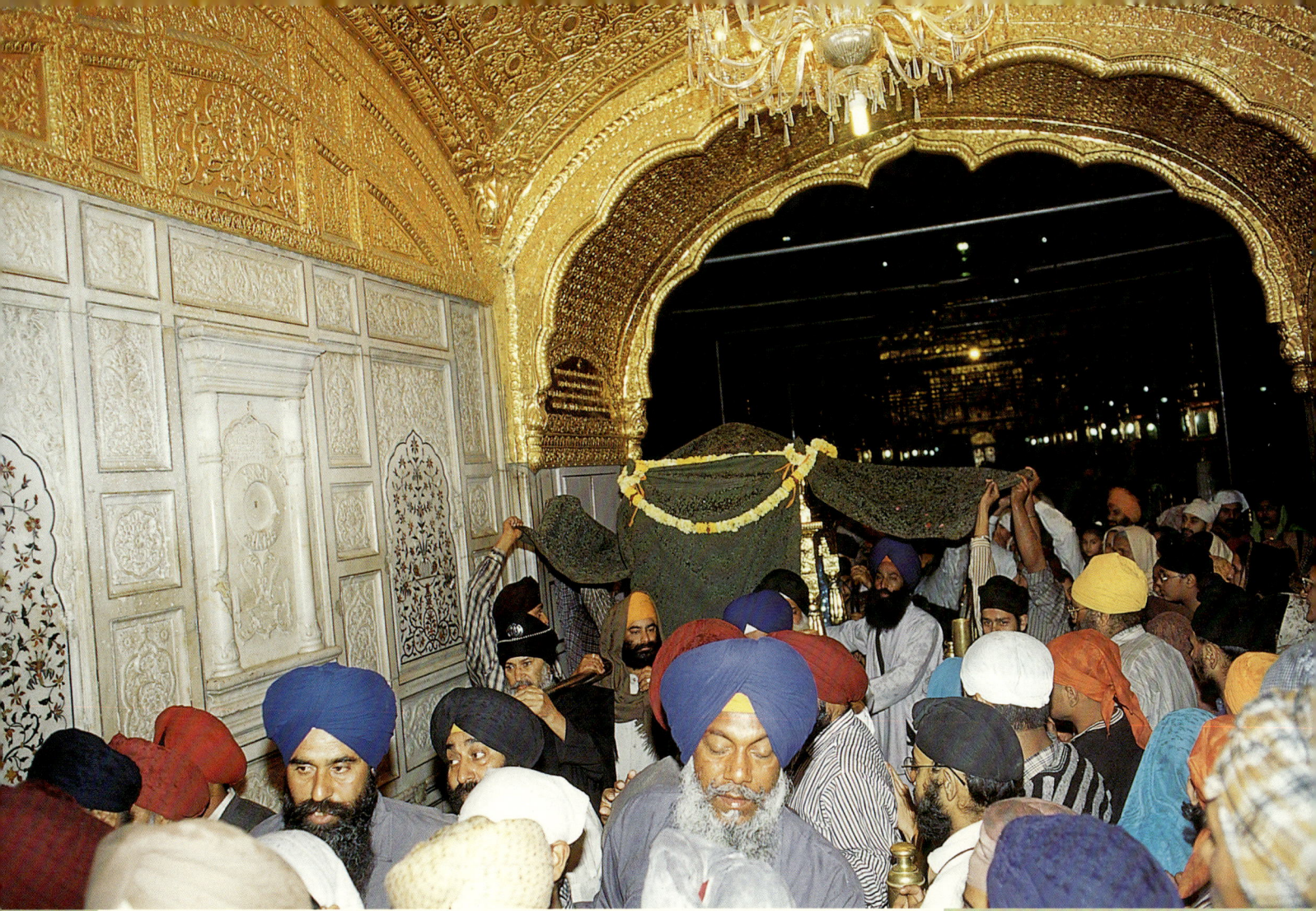

religious matters, while all financial rights and administrative powers vested solely in the *Sarabarah*, or the manager, whose appointment was the prerogative of the British Government. A formal committee by the name of the Golden Temple Committee was also constituted but it had only advisory role and status. Thus, practically, the British Government obtained control of all temple-related activities, the religious as well as the financial. In the hands of these British loyalists the shrine not only lost its sacred rituals, but had its sanctity often defiled and desecrated.

With such a set-up the British were able to often use for British interests the religious authority of Sikhs' supreme shrine. In 1872, when the British army slaughtered hundreds of *Kuka namadharis*, the *Sarabarah* manipulated temple's authority in seeking approval of this heinous act of colonial brutality. In June 1887, when Duleep Singh, the deposed Maharaja of Punjab and the youngest son of Maharaja Ranjit Singh, left England against the wishes of the British government to return to his homeland and serve his land and religion as did his father, the *Sarabarah*, instead of lending a helping hand to him, came forward in support of the British interests. He convened at the temple a special meeting of the Amritsar Singh Sabha only to proclaim him an outlaw and to warn all Sikhs of dire consequences if they helped him. The worst of it came after Jallianwalla Bagh massacre in 1919. In a special *diwan*, which the *Sarabarah* had manoeuvered, General Dyer, whose brain had conceived and executed one of the most heinous massacres, which had shocked mankind across the globe, was

Sri Guru Granth Sahib retires for night: After the concluding rites for night at Sri Harimandar Sahib are over, the head or *granthi* in-charge takes the *Aswari* on his head and brings it out from Sri Darbar Sahib. Here on its door awaits the Palki Sahib for the *Aswari* to accomplish in it the rest of the divine journey from Sri Darbar Sahib door to *Kotha Sahib* at the Akal Takht.
At the *Darshani Deorhi*, crowd of devotees awaits for one of the most divine phenomena and the moment the *Aswari* arrives at the *Darshani Deorhi*, the atmosphere begins reverberating with *'Bole so nihal, Sat Sri Akal'*.

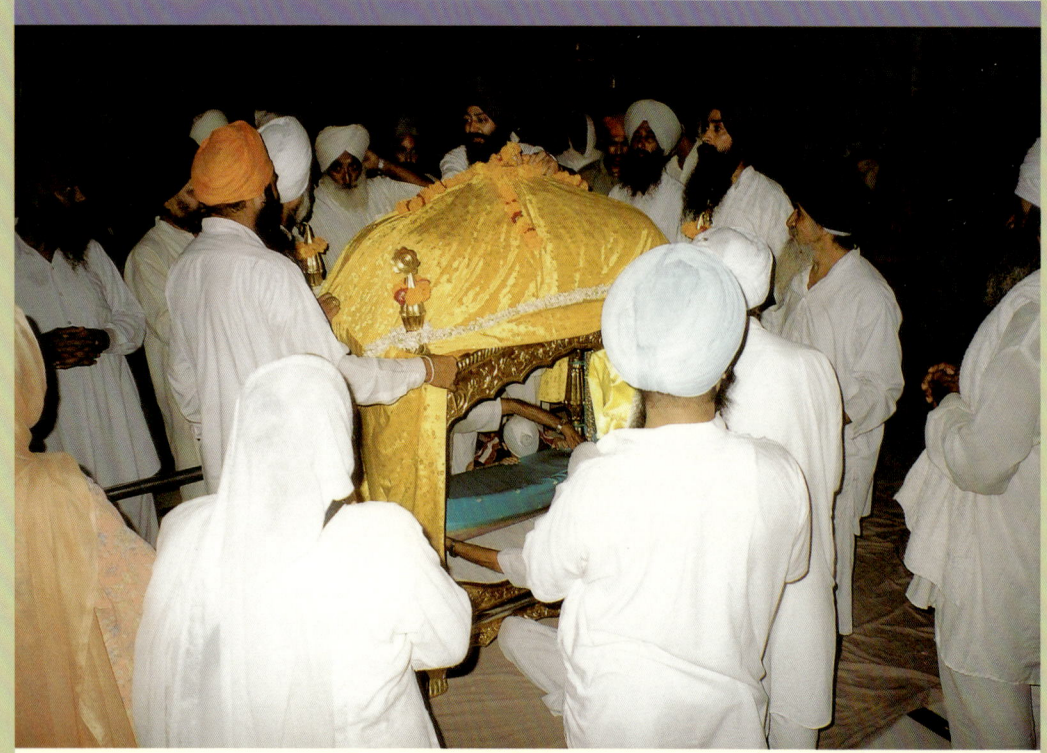

Palki Sahib:
The Palki Sahib is as much sacred in Sikh *Panth* as any other object and hence even when not carrying Sri Guru Granth Sahib, it is treated with great reverence. Both times, in the early morning, much before the day break, and in the night, after the Aswari evicts Palki Sahib, either for Prakash at Sri Harimandar Sahib, or for retiring in the Kotha Sahib, the empty Palki Sahib is conducted in great ceremony and full honour to its allotted chamber. In its southern wing, close to Lachi Ber, the *Darshani Deorhi* has the Chamber consecrated for the Palki Sahib to retire. The picture on the top shows Palki Sahib being brought back from the Akal Takht and the other one from Sri Harimandar Sahib.

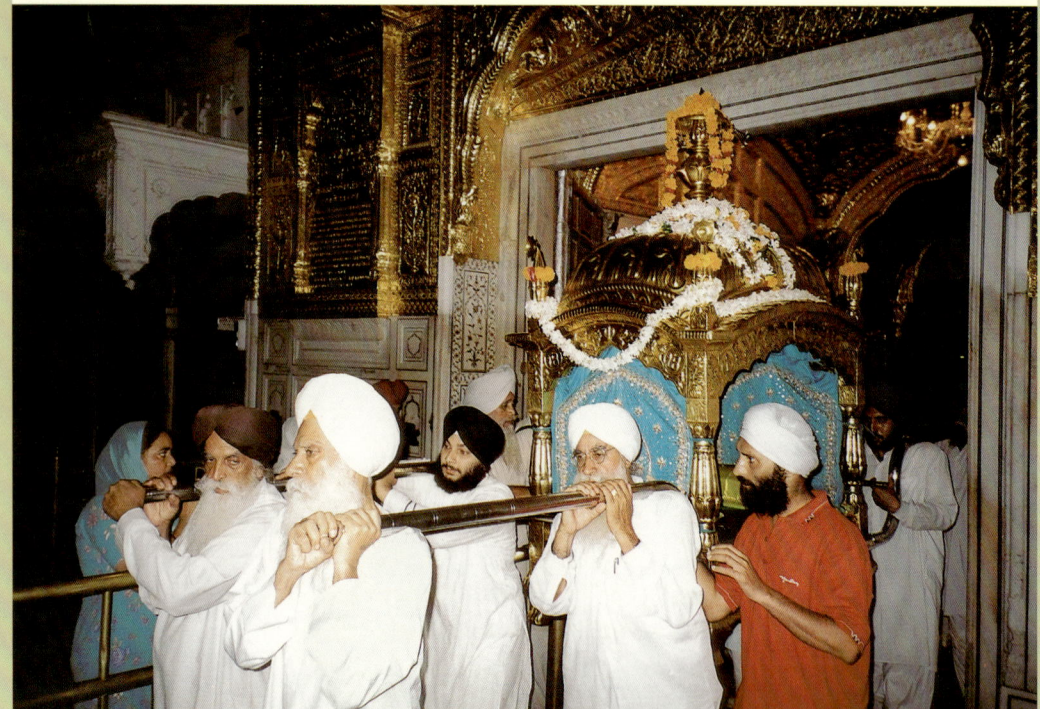

felicitated with a *saropa*. Thus, the period from 1849 to 1926, during which the British Government held the reigns of the temple management in its hands, either directly or through its touts, defined another phase of its degeneration. The observance of sacred rites, religious practices and other customary activities continued but they regained their spiritual glow and vigour and their definite shape and schedule only after the Gurdwara Act was passed and the management of Sri Harimandar was entrusted to the Shiromani Gurdwara Prabandhak Committee.

The Shape of Rituals and their adherence to the past

Rituals, religious practices and other celebrations, at the Golden Temple as they exist now, despite recurrent upheavals and turmoil, depict an amazing continuity. It begins its day as it was begun on *Bhadon sudi ekam*, *Samvat* 1661, when the Holy *Adigranth* was first installed in the temple. Most of the components, the rites as well as the material objects, which constituted a day's routine at Sri Harimandar then, are yet the same. In the *Guru ke Mahal*, the Holy Book reposed in a *kotha*, or the chamber consecrated for the purpose. After the Akal Takht came into being, the Holy Book reposed there in a similar *kotha*, revered as the *Kotha Sahib*. The doors, or the *kiwars* of the *kotha*, where reposed the Holy Book, were opened in full ceremony by Sri Guru Arjan Dev himself. The *kiwars* have as yet the same significance. Rather the time of opening and closing the *kiwars* is more strictly scheduled and pursued. This scheduling is not confined to the *Kotha Sahib* alone but also include the Akal Takht, the *Darshani Deorhi* and Sri Harimandar. For winter, there is one schedule and for summer and rains there is another. The *kiwars* of the *Kotha Sahib* are opened in full ceremony at 5 o'clock in the morning, that is, two hours after the doors of Sri Harimandar and the *Darshani Deorhi* and an hour after those of the Akal Takht are opened. The *granthi* on duty brings the Holy Book out from the *Kotha Sahib* and carries it to the *palki* on his head. *Sewadars* and devotees carry the *palki* on their shoulders and with this *Maharaj ji di aswari*, the journey of the Supreme, begins. A loud beat of a huge drum announces the departure. The *granthi* waves *chamwar*-flywhisk all way long. A lamp-bearer and a standard bearer lead the procession. Behind them and ahead the *aswari* there walks a band of musicians, known as *chauki*. They chant hymns, which the *sangat*, walking behind the *aswari*, repeats.

At Sri Harimandar, the *kirtan* starts soon after its doors are opened. The *kirtan* is followed by the *Asa di var*, which continues till the daybreak. Meanwhile arrives *Maharaj ji di aswari*. The *palki* carries Sri Guru Granth Sahib up to the door of the temple. There the *granthi* takes the Holy Scripture on his head and carries it to install it on the sacred *manji sahib*, laid under the *chandani* or *chanani*. After the installation, or the *prakash* ceremony is over, the Holy *sabad*, or the *vak* is taken from the Holy Book. This rite is repeated for a second time when the recitation of the *Asa di var* is over and for the third time at night before *Maharaj ji di aswari* makes its departure from Sri Harimandar for night's rest. The *prakash* ceremony is followed by the morning *ardas*. After the *Asa di var* has been recited, the *ardas* is repeated. The recitation of the *Asa di var* is stopped in between and is resumed only after a random *sabad* has been recited. After the *Asa di var* is over, there begins the recitation of *Anand Sahib*, which continues till noon and at 12 o'clock the *ardas* is offered for the third time. The *sabad-kirtan* continues except for special services rendered in between. In the afternoon, *ragis* recite the *charan kamal arti*, which concludes at 3 o'clock. After the *arti*, the *ardas* is offered for the fourth time. In the evening, *ragis* recite the *sodar rahiras*, which is also followed by the *ardas*. The temple service for the day comes

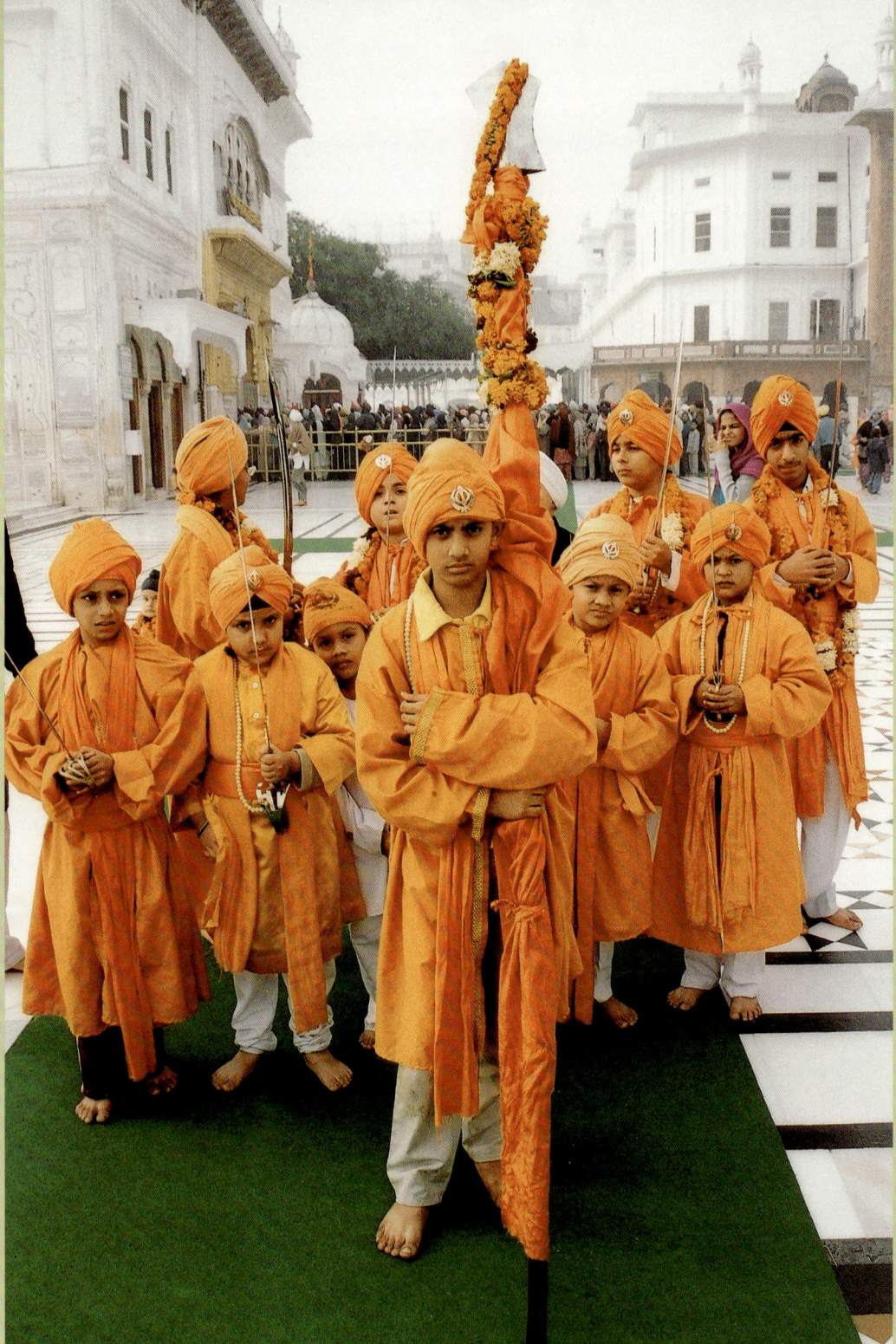

The procession of the ceremonially dressed school children: The daylong routine at Sri Harimandar Sahib brings forth, besides the chaukis-type regular public rituals, several unique events of great dramatic intensity and spiritual appeal. Sometimes a queerly dressed Nihang-jattha and sometimes a group of uniformly clad school children, as here, carrying Sri Nishan Sahib and other emblems of Khalsa, would draw to them every eye to seek delight, derive food for the soul and get elevated.

to a close with the recitation of the *kirtan sohila* and after this the *ardas* is offered for the last time. The temple has eight *ragi-jatthas* for its daylong *sabad-kirtan*. Each *jattha* sings for an hour at a stretch and keeps rotating. In one hour, the *jattha* recites some three *sabads*. Sri Harimandar has elaborate arrangements for the *akhand-path*, *khulla-path* and *saptahik path* of the Holy Scripture on its top floor.

The loud drumbeat, such as marks the departure of the *Maharaj ji di aswari* from the Akal Takht, is repeated when the *aswari* comes back from Sri Harimandar. At the time of the completion of the *ardas*, both in the morning and the evening, the drumbeat is repeated. The *palki* has great ritual

significance in the Sikh tradition, as the *palki* related tradition was initiated by none else but Sri Guru Arjan Dev himself. He had used it on two great occasions, one for transporting the *Bani-pothi* from Baba Mohanji's house at Goindwal to Ramdaspur, and the second, for carrying the Holy Granth to Sri Harimandar for installation. Every time, when the *palki* is taken from, or is brought back to the place where it reposes, that is, the chamber flanking the *Darshani Deorhi* on its southern side, a set of rituals is observed. The *karah prasad*, both when the devotees offer it and when they receive it, is yet another sacred rite in the Sikh tradition. The *karah prasad*, though distributed to the visitors round-the-clock, has a special significance when distributed after the recitation of the *Anand Sahib* and the *charan kamal arti*.

The Enshrining Bir

The *Bir*, enshrining in Sri Harimandar, is one of the two rare manuscribed old copies of Sri Guru Granth Sahib, which were prepared from the *Damdami Bir* of Guru Gobind Singh. Commissioned by Guru Gobind Singh, the *Damdami Bir* was prepared at Talwandi Sabo in 1706. The first of these two copies, consisting of four volumes and bound in gold, was prepared under the supervision of the famous Sikh martyr Baba Dip Singh. This *Bir* is quite old and fragile. It hence usually reposes in the *Kotha Sahib* and is brought to Sri Harimandar only on very special occasions. The other *Bir* is bound in silver and it is mostly this silver-bound *Bir*, which is installed in the temple for worship. The *Akhand-path* and the recitation by individuals is performed with printed *Birs*. The sanctum sanctorum is kept lit the whole night with the *jot*, or a *ghee*-fed lamp. It is lighted before the evening prayer begins and is extinguished in the morning only after the recitation of the *Asa di var* is over. To take a handful of the *amrit* from the *Har ki Paudi*, swallow its few drops and sprinkle the rest over oneself and others, is another essential part of the Golden Temple rituals.

The Rituals at Akal Takht

Soon after the *Maharaj ji di aswari* makes a departure, the Akal Takht begins its other rites. The *vak* is its first step. The Holy Book is opened at random and the *sabad*, which opens, is read out to the *sangat*. The venue then shifts from the first floor to the ground floor and here *ragis* recite the *Asa di var*, which is followed by the recitation of a *sabad* from a random page of the Holy Granth Sahib. With this concludes the morning rites at the Akal Takht. It occurs exactly when the recitation of the *Asa di var* begins at Sri Harimandar. The Akal Takht is also the repository of the sacred arms. After the *Bani*-related morning rites are over, these holy arms are put to display inside a golden railing called Bangla sahib. In the evening, the Akal Takht again has the *sabad kirtan* for about an hour and a half. This is followed by the evening prayer known as the *sodar rahiras*. The Akal Takht has its own independent *ragi-jattha*.

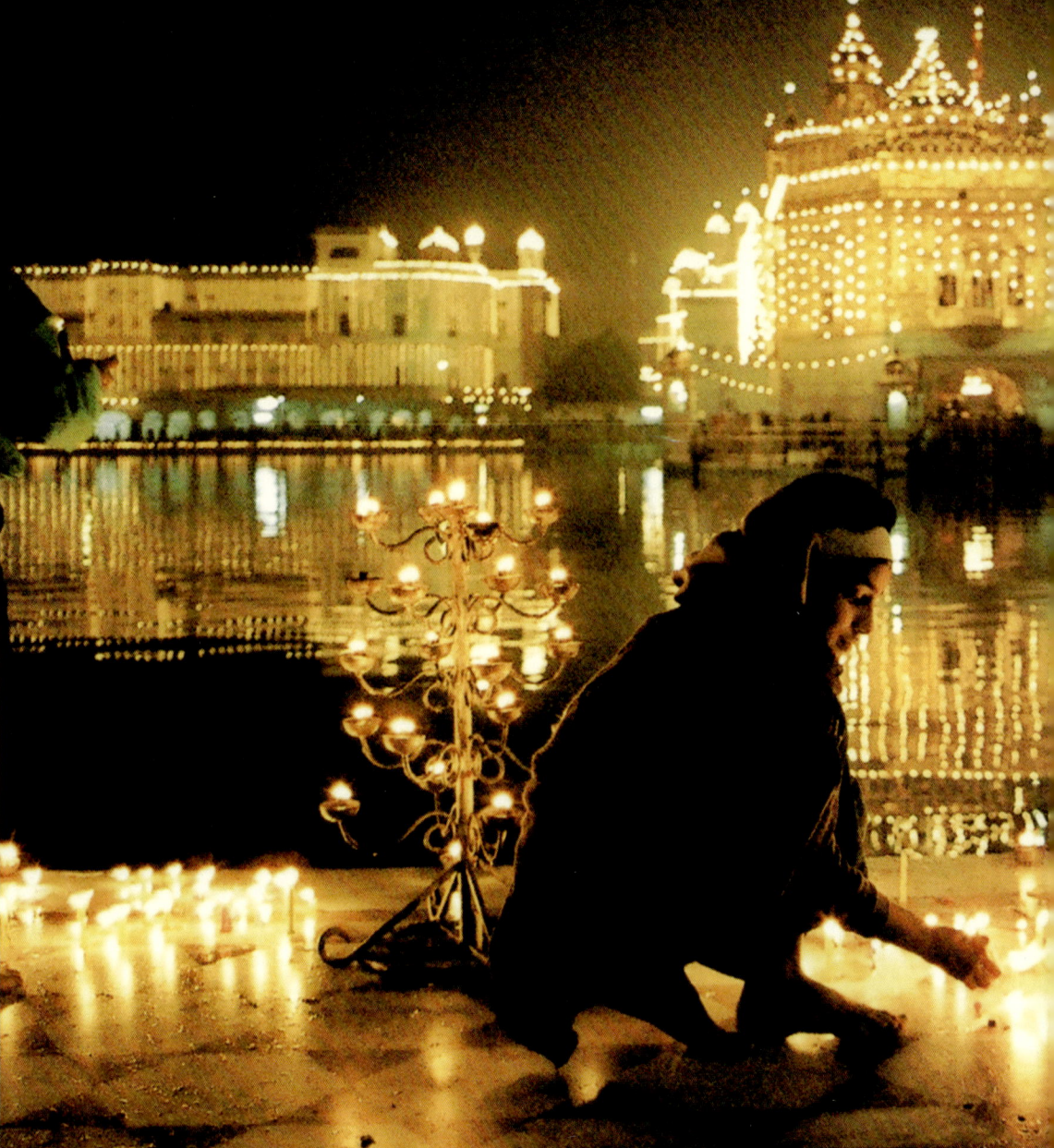

Sri Harimandar on Baba Nanak's birthday on 26 November, 2004 and devotees lighting candles: The Providence has enough light for every one but, despite that all have to light their candles, or else wherein would merge the God-given light. On *Gurpurabs* and other auspicious occasions, devotees throng the Temple premises, light candles and get enlightened within and without. Sri Harimandar along with subsidiary shrines and buildings bathe in light as it is the day when *Panth's* founder and the giver of the light Baba Nanak was born. Thus, it is by the light that the homage to the light-giver is paid.

Chaukis

Chaukis, called the *Chauki Sahib*, constitute another essential tradition of the temple rituals performed everyday. The *chauki* is a kind of procession of the devout Sikhs, which moves along and around the *Amrit-sarovar*. It blends with spiritualism Sikhs' martial character. Everyday there are five *chaukis*, three in the evening and two in the morning. The first *chauki* proceeds from the Akal Takht soon after the *sodar rahiras* is over. Whatever the season, the rains, or the bitter cold, the devout Sikhs gather in large number at the Akal Takht to take out the *chauki*. Ahead of all, there goes the *chobdar* with a mace in his hands. He clears the passage and cautions all to stand up in reverence for the *chauki*. The procession is led by a standard bearer and another carrying on his head a sword, named *sri sahib*. The *chauki* consists of two parts, each led by one *mashalchi*, or the lamp-bearer. Its forepart walks reciting *sabads* and the hind part repeats them. After it has circum-ambulated the entire *parkarma*, it enters the Golden

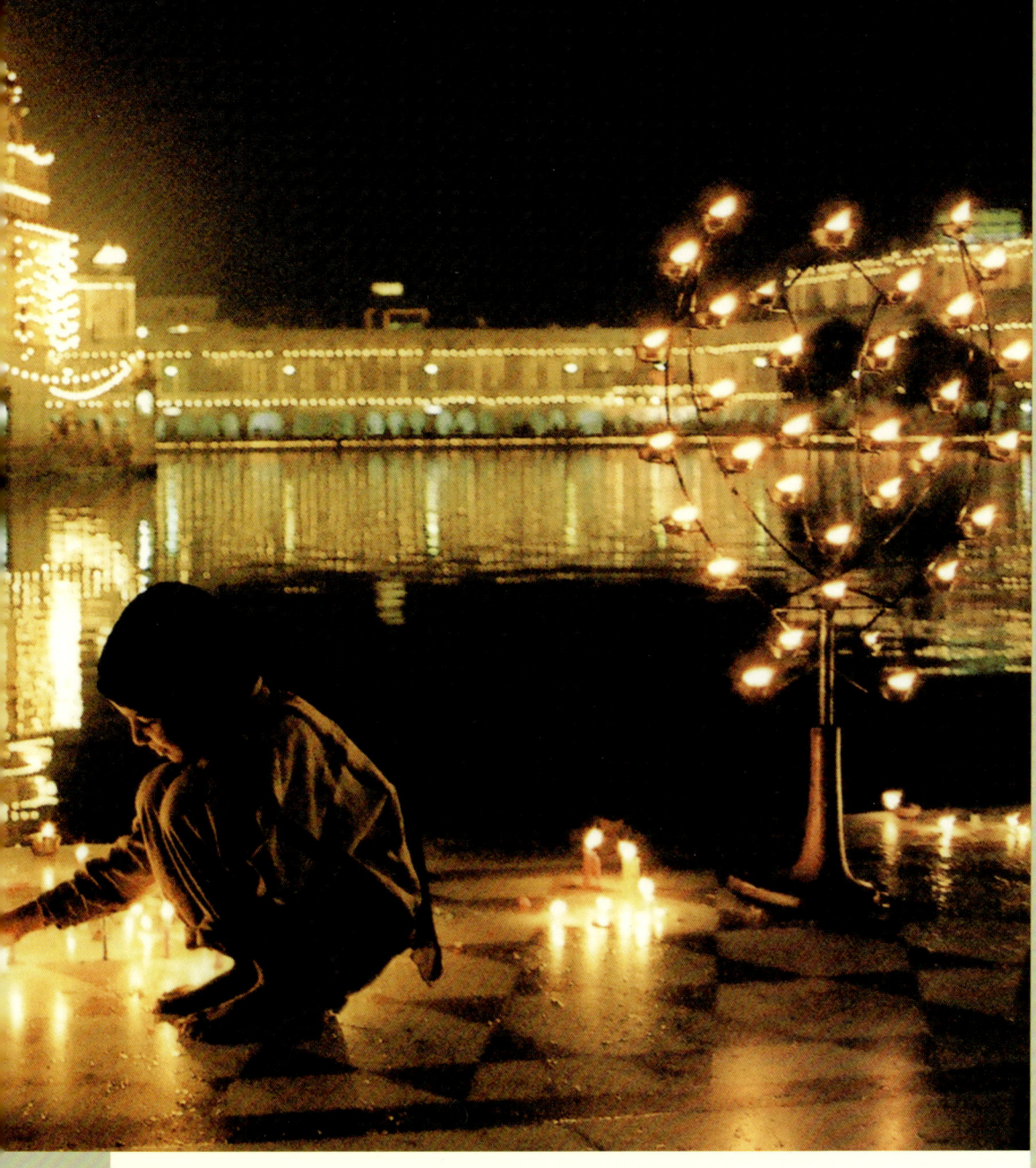

Temple where it first perambulates the Holy shrine and then enters the sanctum sanctorum and offers *ardas*. *Karah prasad* is distributed to its members and the *chauki* disperses. This *chauki* is followed by another two *chaukis* of similar kind. There are two similar *chaukis* in the morning also.

Some scholars claim that the *chauki* cult was initiated by Guru Hargobind to keep alive the sacrifice of Sri Guru Arjan Dev and to combine martialism with spiritualism. Others attribute its origin to Baba Buddhaji, Bhai Gurdas and other devout Sikhs. Every evening, when Guru Hargobind, imprisoned by the Mughals, was away from them, they used to lead a similar procession, carrying arms and chanting *sabads*, to boost the morale of Sikhs, keep the memory of their Guru fresh in their minds and pray to the Almighty to bring him back. They began this practice, when they returned from Gwalior after meeting Guru Hargobind imprisoned there. It came to be known subsequently as the *chauki*. Initially there prevailed only one *chauki*, but subsequently, other prominent Sikh leaders and devotees initiated four others.

Periodical Celebrations

The *sangrand*, or the solar transition, which takes place on the first day of every month of the Indian calendar, is considered highly auspicious in the Sikh tradition. A dip in the *Amrit-sarovar* on the *sangrand* is one of the holiest rituals of the Sikhs. On every *sangrand*, the scene at the Golden Temple is that of a *mela*. As significant is a dip on the *amawas*, or the *masaya*, as the Sikhs call it. The *amawas* is the last day of the first-half of a month. On every *amawas*, large gatherings of devotees, reaching here from far and wide, throng each and every part of the temple. Taking out a *chauki* at the *amawas* has special significance.

The Gurpurabs

The *Gurpurab*, as the term suggests, means Guru's festival. The celebration of a Guru's birth, death, or any other significant event of his life, may be called a *Gurpurab*. Sikhs celebrate birth and death anniversaries of all Gurus, though not with an equal thrust. The death anniversaries of Sri Guru Arjan Dev, Guru Teg Bahadur and Guru Gobind Singh, which are celebrated as the *shahidi diwas*, in view of their unprecedented sacrifice, are more significant than the death anniversaries of other Gurus. Guru Hargobind's *Piri* and *Miri* cult gave to Sikhism a new direction and Guru Gobind Singh's formation of the Khalsa gave it a new identity. Both, the *Piri* and *Miri diwas* and the birth of the Khalsa have in the Sikh tradition unprecedented significance. Broadly, these all are the *Gurpurabs*. However, in the strict sense, and in relation to Sri Harimandar, which gave to Sikhs a geographical identity, and the Khalsa, which gave them the identity of a community, three personal Gurus, Baba Nanak who founded the *Panth*, Guru Ram Das who founded the Holy city and the *Amrit-sarovar* and Guru Gobind Singh who founded the Khalsa, and the fourth Sri Guru Granth Sahib, which is the light of all ten Gurus and their manifest form, have special significance. Hence, the birthdays of Baba Nanak, Guru Ram Das and Guru Gobind Singh and the *Prakash-diwas* of the Holy Granth, respectively, the *Kartika purnima*, or the last day of the month of *Kartika*, *Kartika vadi doj*, or the second day of the first-half of the month of *Kartika*, *Poh sudi saptami*, or the seventh day of the second-half of the month of *Paush*, and *Badhon sudi ekam*, or the first day of the second-half of the month of *Bhadon*, are observed as the full-fledged *Gurpurabs*. Weeks' long lighting, display of fireworks, decoration, *langar* on massive scale, special rites including a more elaborate schedule of *ardas*, *chaukis* and *kirtan*, mark the celebration of these *Gurpurabs*. The display of *jalau* is a very special feature of these *Gurpurabs*.

Chhatra, an invaluable piece of Jalau: This precious gold chhatra, studded with invaluable diamonds, emeralds, rubies, sapphires, topazes, pearls and other precious stones, forms part of the Jalau displayed on six special occasions and *Gurpurabs*. A peacock motif adorns its apex. This peacock chhatra once formed part of an elaborate and rich canopy presented to Maharaja Ranjit Singh by the Nawab of Hyderabad. It was so splendid that Maharaja Ranjit Singh thought it could only be for Him who rules the rulers and offered it to Sri Harimandar Sahib, the true Patshah.

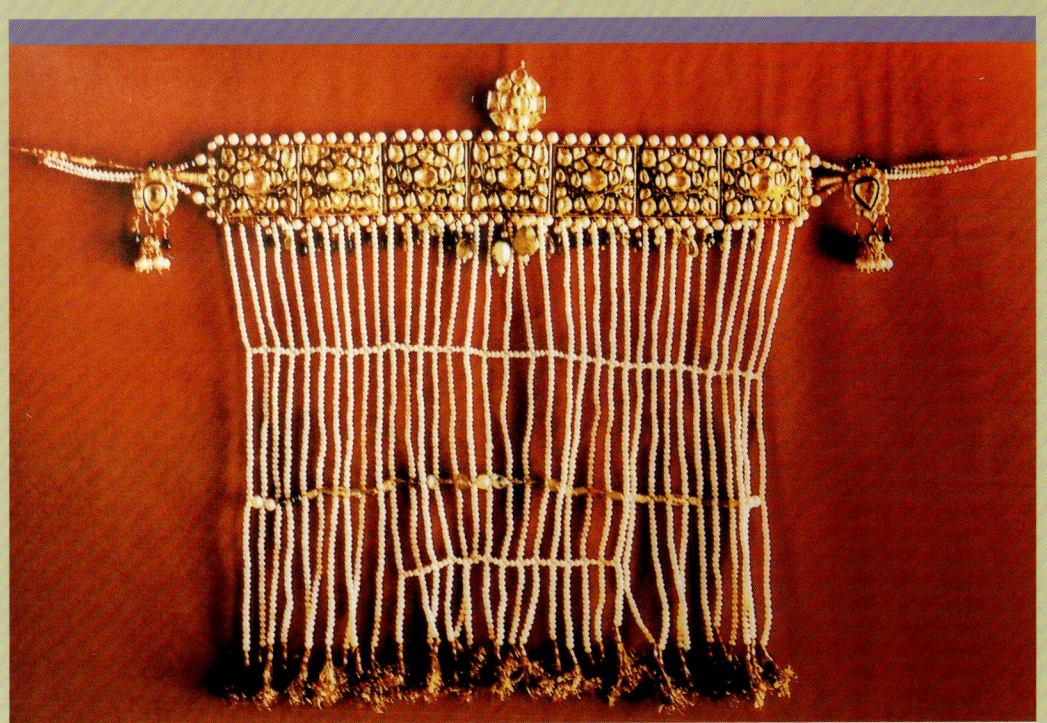

Jalau

Jalau, or the display of splendour, a term which seems to have been derived from the Arabic root *jalwa*, has a very special significance in the Sikh tradition, as also a different meaning. The Golden Temple has in its treasury, known as the *Toshakhana*, a number of precious articles, which include jewellry, canopies, crests, *chhatras*, gold-plated doors, arms and many other decorative objects. Collectively these articles constitute the *jalau*. The *jalau* is put on display on five occasions, the four above-named *Gurpurabs* and the fifth *Piri* and *Miri diwas*. During the 20th century, the *jalau* was displayed on two very special occasions, the first, in 1965, when the sacred relics and arms of Guru Gobind Singh were brought here from England, and the second, in 1973, to mark the completion of the *kar-sewa*. The Jalau is displayed primarily at Sri Harimandar but a part of it also at the Akal Takht and Baba Atal. The *jalau* displayed at Sri Harimandar consists of almost all classes of articles, but at the Akal Takht it consists only of the thirteen classes of such articles and at Baba Atal only of six. The *Toshakhana*, which houses the *jalau*, is situated at the upper floor of *Darshani Deorhi* and is always opened by a body of the Sikhs and never by an individual.

Ordinarily, presenting the temple in all its glory is 'the avowed purpose' of the display of the articles of *jalau*. This, however, is only half-truth. These objects represent, no doubt, temple's material grandeur, but it also aims at representing its unique spiritual power capable of inspiring devotees to give up whatever they considered the most precious in their lives. The display of the *jalau* is not an exhibition of the rare and precious objects. It is rather essentially a symbolic realisation of the fact that whatever has been entrusted to the Supreme, the Temple is Whose abode and manifest form, becomes the part of His eternal glow and always survives in all its glory, and also that

Sehra, a part of the Jalau:
This Sehra, an ornament used for covering the face of the bridegroom during the marriage procession till he is ceremonially unveiled, is also a part of the Jalau. Its upper part in gold that is fixed on the forehead, is studded with diverse precious gems. The laces, suspending from it, comprise beautiful pearls and again the pendants attached to each of these laces are invaluable stones. This Sehra was prepared for Prince Naunihal Singh, the grandson of Maharaja Ranjit Singh. But, after its manufacturer presented it to Maharaja Ranjit Singh, he felt it could not be for any human born and hence offered it to Sri Harimandar Sahib.

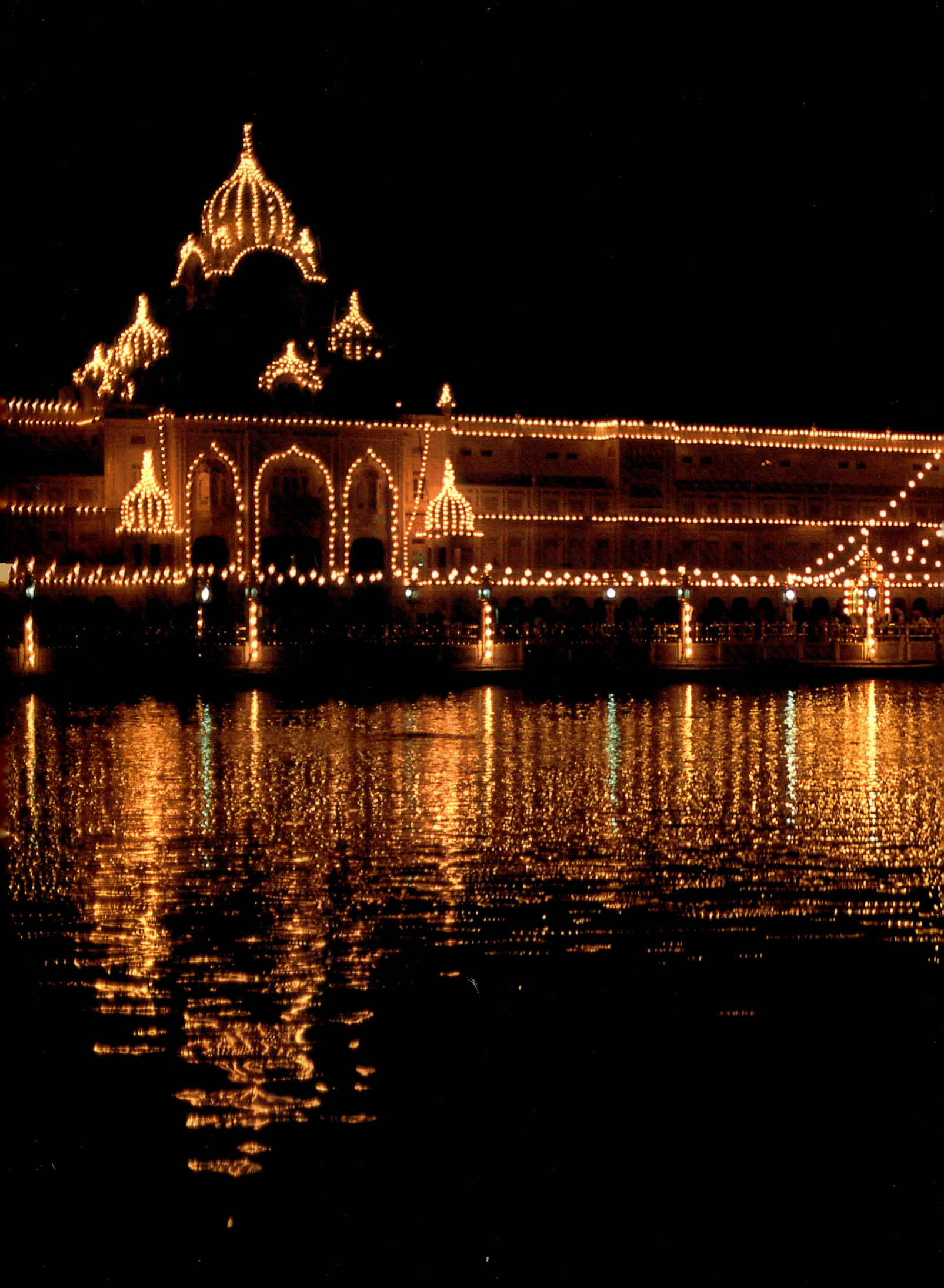

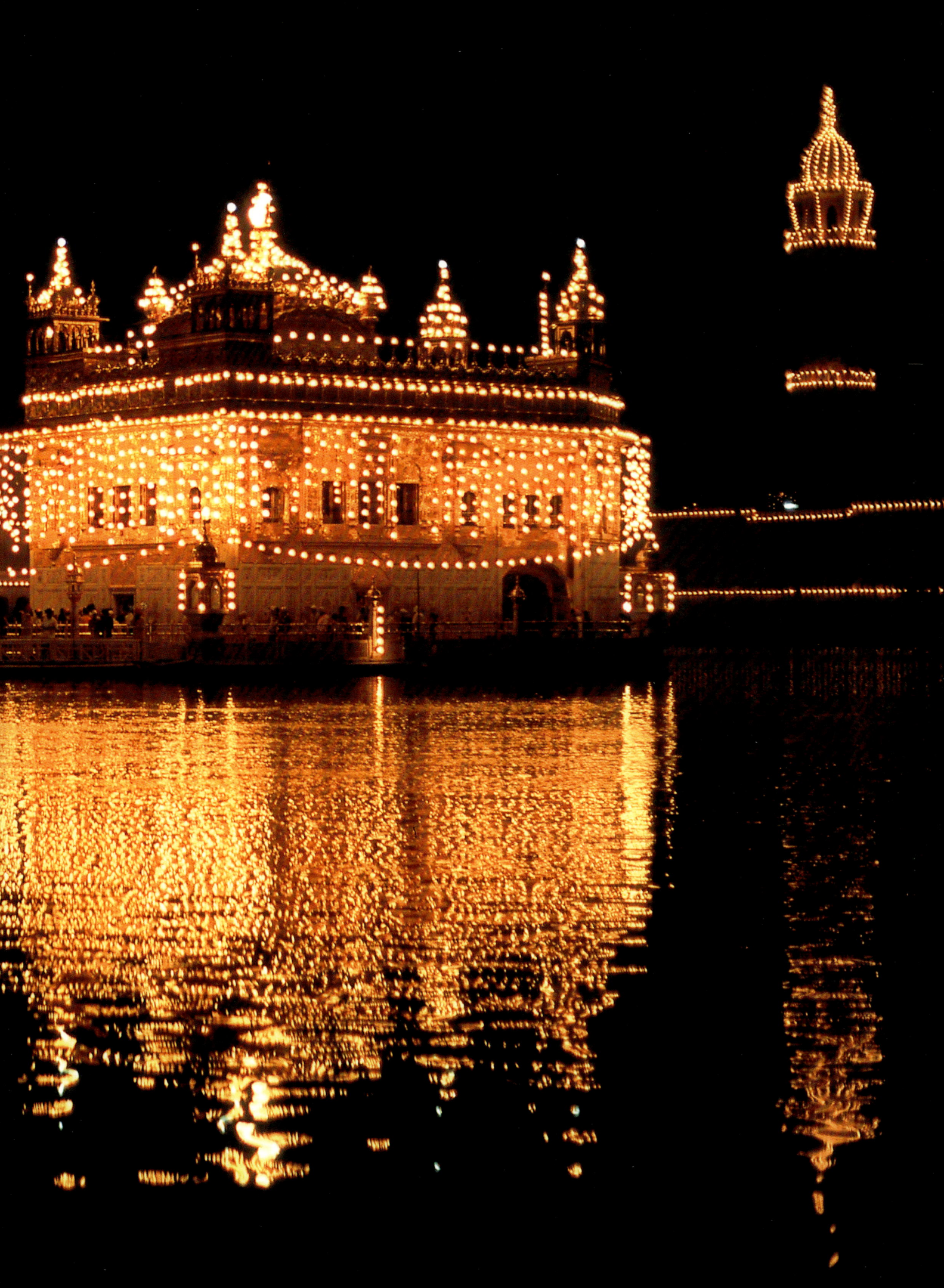

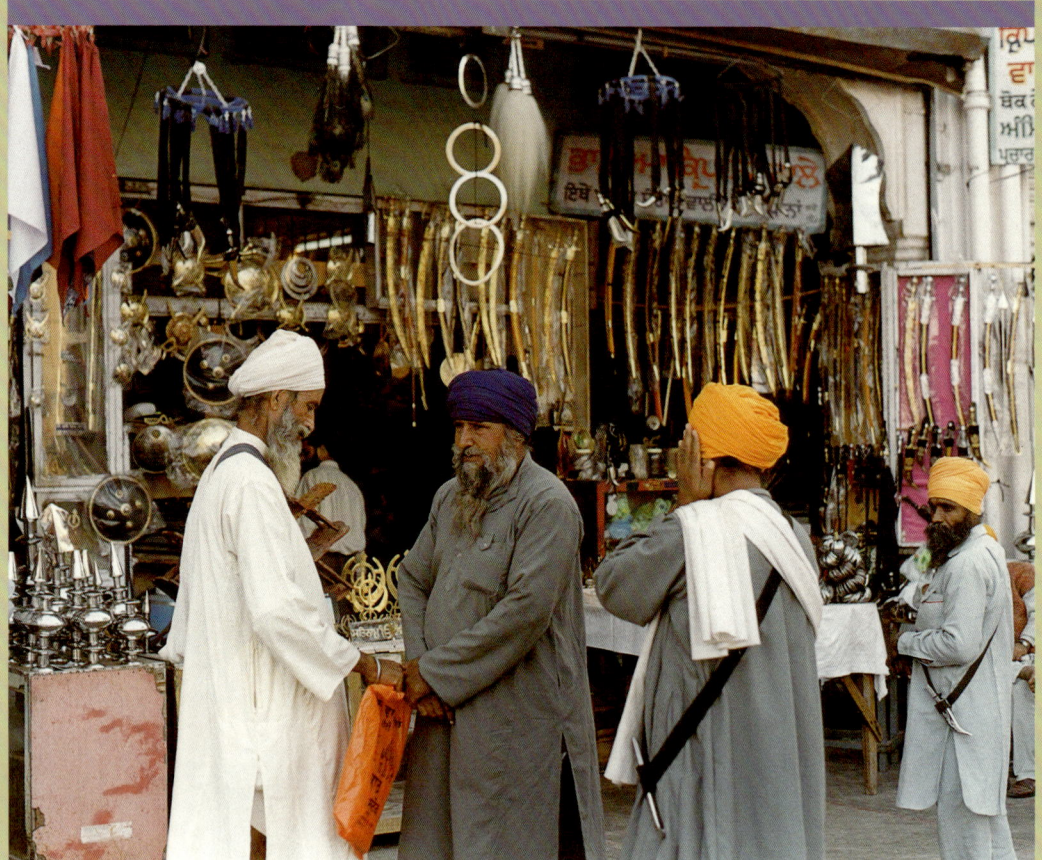

(Preceding Page) The glory magnified: A delightful sight, whether you see above the floor or under it, it is the same divine phenomenon, the same perception, the same glow and its alike form. In the sky also the same glory magnifies hundreds of times. Is it not the same unchanged Sikh analogy—He is One, the only One, *Ek-Omkar*, whether you seek Him in ocean, sky or on earth, in the temple, mosque or church, within you or without—but He is the Light, which seems to have a form but is formless?

whatever one keeps to oneself is lost with time and becomes non-existent. The *jalau* does not display the splendour of the Supreme, who is Nanak's *Karta Purukh*, as the same lay scattered everywhere from the depths of oceans to the heights of skies. It displays rather the best of the faithful, who has earnestly sought His benevolence to let his worldly possessions become part of His timeless divine glory.

Diwali and Baisakhi

Diwali and Baisakhi are two most significant festivals celebrated with unique jubilation at the Golden Temple. Though Diwali's authentic celebrations spread over three days and those on Baisakhi only over a day, yet in practice the festivities, lighting in special, begin weeks before and the turnout of pilgrims tremendously increases. Diwali is one of India's oldest festivals with an untraceable past. It is being celebrated, now for about three millennia, by the cross-sections of Indian society consisting of various faiths and sects. The Hindus relate it to the return of Lord Rama to Ayodhya after his 14 years of exile, the Jains to the *Nirvana* of their twenty-fourth *Teerthankara* Mahavira, and the Buddhists to the day of Buddha's enlightenment, though none of these religious contexts seems to attempt at giving it a religious, or ritual tilt. Diwali has remained, always and in all hands, a secular non-sectarian festival of light, which even the tribes that do not belong to any of these sects have been celebrating for centuries now by lighting their huts with a few isolated lamps. Even the Mughals and other Islamic invaders, who rejected most of the things Hindus celebrated, rejoiced this festival of lights.

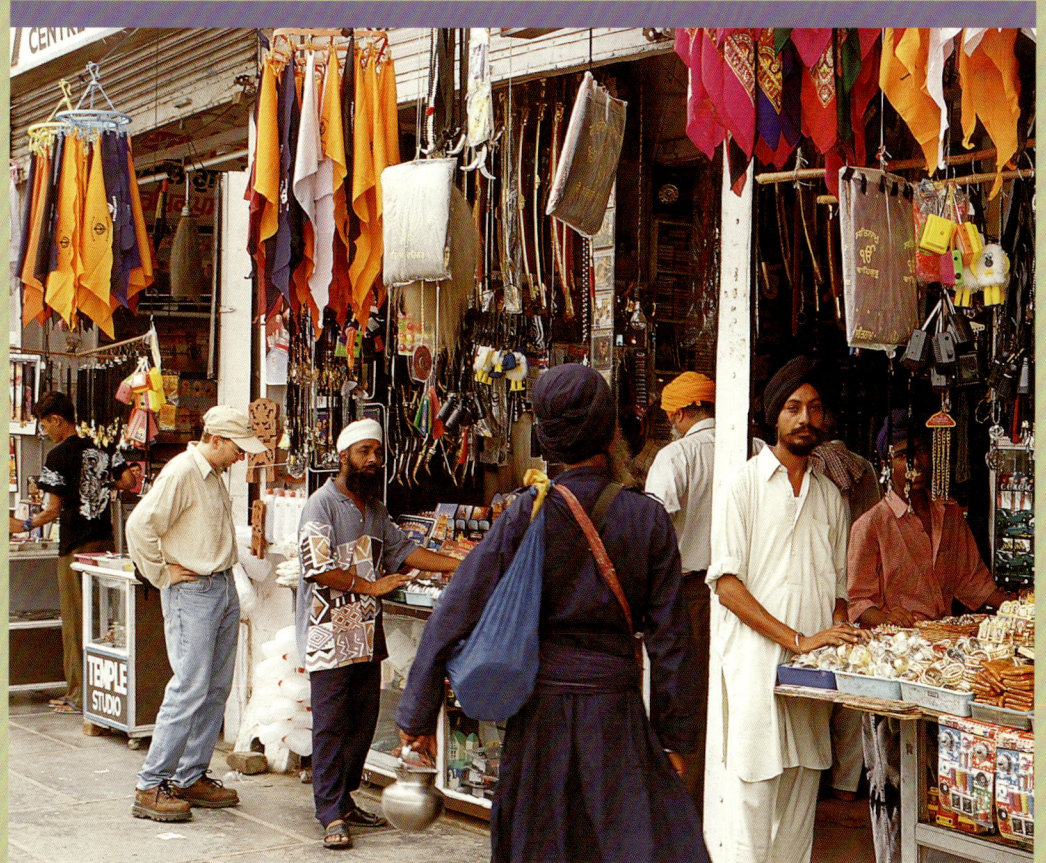

Most of the Sikhs relate Diwali to the release of their Sixth Guru Hargobind. As the Sikh tradition has it, it was on Diwali that Guru Hargobind returned to Amritsar after he was released from the Gwalior fort where the Mughals had put him under arrest. For commemorating his return, Baba Buddhaji and other devout Sikhs lighted Sri Harimandar, distributed food, held special *sabad-kirtan* and *ardas*, displayed fireworks and expressed their jubilation in whatever manner they could. A massive number of Sikhs gathered to welcome their Guru and for expressing their gratitude to the Almighty for their Guru's release. A special congregation was also convened on the occasion. There is no doubt that the Diwali must have been celebrated with the utmost thrust on Guru Hargobind's return to the Harimandar, but the claim that with this was begun its observance in the Sikh tradition seems to be erroneous. Sri Guru Arjan Dev regularly celebrated both Diwali and Baisakhi. After he ordained the principle of *dashamansha*, the one-tenth of a Sikh's income for the construction and maintenance of the temple and appointed *masands* for collecting it, Diwali and Baisakhi acquired a new significance. Special congregations were scheduled to be held on each Diwali and Baisakhi and all *masands* were directed to present to the temple, during these congregations, the *dashamansha*, which they collected during the period in between. Since then, *sangats* have been celebrating Diwali at the Golden Temple, sometimes in peace and sometimes in disasters at the cost of money and even lives, such as Bhai Mani Singh paid in 1734.

Baisakhi, the other most popular festival of the Punjab, is celebrated on the first day of the month of Baisakh which is also the first day of the *Bikrami*, or *Vikrami* calendar. Baisakhi ablution at Haridwar and other

The life at Sri Harimandar Sahib: Sikhism, the path for the household, does not bar or prohibit associating personalised things with religious activities. The shrine is as much the venue for solemnising a marriage or baptising a new entrant into the *Panth*. Here personal issues are resolved and feuds settled. At Amritsar, Sri Harimandar Sahib is not only Sikhs' holiest shrine but for things related to the sect and Sikh culture and tradition is also the best market site. From PVC containers for carrying *sarovar's* sacred water to a *kara* or *kirpan*, one may find everything here. And, who knows, while connaughting around in a leisurely mood, you meet an old friend with renewed warmth.

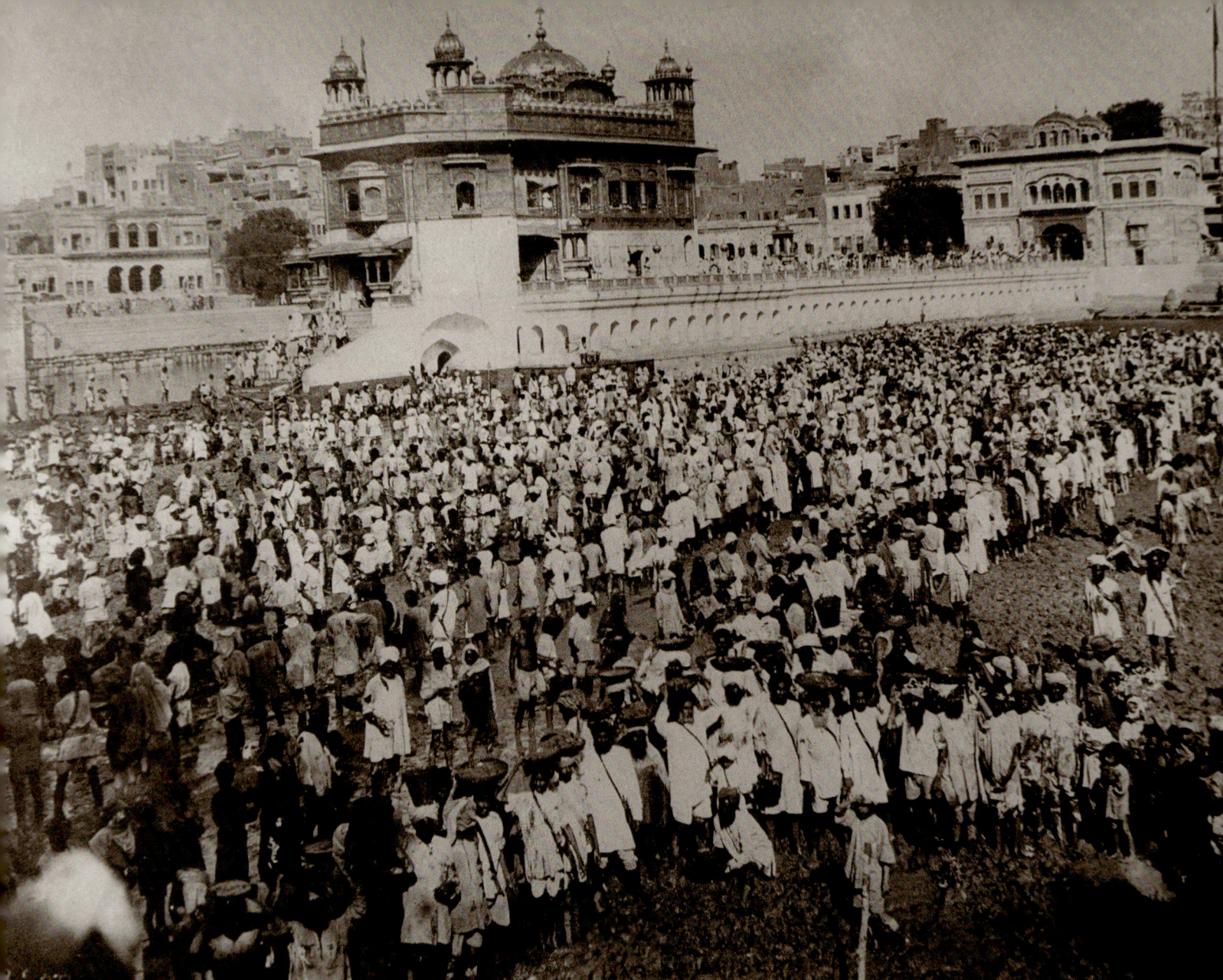

The first ever full-fledged *kar-sewa* of the *sarovar* in 1923: Though the concept of *kar-sewa* emerged later, the *kar-sewa*, that is, contribution of one's manual labour, had begun during the period of Sri Guru Arjan Dev himself, when various sangats from far off arrived at Ramdaspur and worked with their own hands at Sri Harimandar and the *sarovar* site. Around 1843, Maharaja Ranjit Singh's son Sher Singh began the *kar-sewa* of the *Amrit-sarovar* but his early death disrupted it. Afterwards, the *kar-sewa* of the *sarovar* was undertaken in 1923, which may be said to be the first ever full-fledged *kar-sewa* of the *sarovar*. This old photograph depicts devotees' enthusiasm on the one hand and captures how different were Sri Harimandar's surroundings on the other.

sacred places was in vogue amongst Hindus during Sri Guru Arjan Dev's lifetime. Ablution had much more significance in Sikh tradition. Diwali and Baisakhi compartmentised the 12 months of the year into almost two equal parts, and as such greatly suited for holding six-monthly congregations. Sri Guru Arjan Dev hence chose the Baisakhi for a special holy dip, a Baisakhi fair and for holding congregation at Sri Harimandar. Baisakhi gained unprecedented significance in the Sikh tradition in 1699, when on Baisakhi Guru Gobind Singh founded the Khalsa and gave to the community of Sikhs its own identity different from the Hindu way of life. Now the Baisakhi is associated largely with the birth of the Khalsa. Thick or thin, in peace or in persecution, for over 300 years now, the Sikhs have always thronged the Golden Temple on the Baisakhi for a holy dip and to commemorate the birth of the Khalsa.

Kar-sewa at Sri Harimandar Sahib

The *kar-sewa*, or the manual service rendered to the Holy shrine, is a very special event in the Sikh tradition and is considered highly auspicious for anyone participating in it. The *kar-sewa*, as a concept, may have been a later

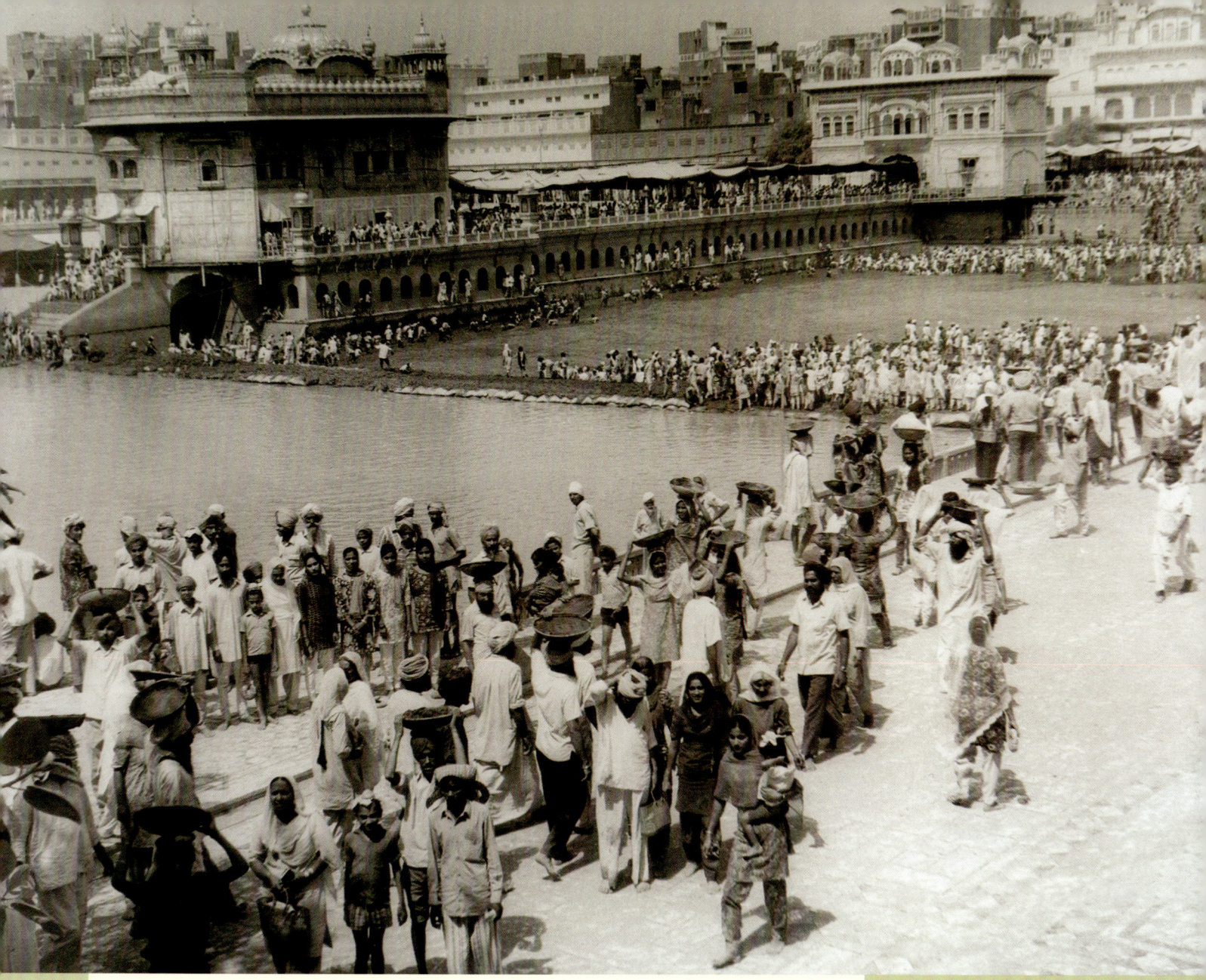

development but the Sikh tradition had it in practice since its initiation. As suggest the contemporary writings, most of the construction of the *Amrit-sarovar* and the Holy shrine was accomplished by voluntary manual service rendered by the Sikhs. Subsequently, time and again, the temple was pulled down and the tank filled with debris and every time the Sikhs came forward to reconstruct the shrine and clean the tank. But the services rendered have not been defined as the *kar-sewa*. Maharaja Sher Singh was the first Sikh leader to initiate *kar-sewa*, though due to his early death it was given up only after a few days. The 20th century had four occasions of *kar-sewa*; the first in 1923, the second in 1973, the third after 1984, and the fourth in March 2004.

The *kar-sewas* in 1923 and 1973 aimed primarily at cleaning the tank. The *kar-sewa* after 1984 included, besides cleaning the *sarovar*, a lot of repair work and reconstruction. The recent *kar-sewa* of March 2004, was carried out on a comparatively short notice. It seems, as if the bounteous Guru ordained this *kar-sewa* for the SGPC chief Gurcharan Singh Tohra to let him have the opportunity to serve His Darbar with his own hands before he abandoned his mortal coil. Shri Gurcharan Singh Tohra had a heart attack exactly when he was lifting from *sarovar's* bottom the

The second *kar-sewa* of 1973: The 1973 *kar-sewa* also aimed at cleaning the *sarovar*. The *sarovar* has numerous fish of multiple-varieties. For protecting them the southeast portion of the *sarovar* has not been fully emptied. The enthused crowd of devotees is eager to remove and take away whatever volume of silt it can, despite the fact that many of the women have infants in their arms and many men and women have bags and other load. The fully exposed substructure of Sri Harimandar is a fascinating sight.

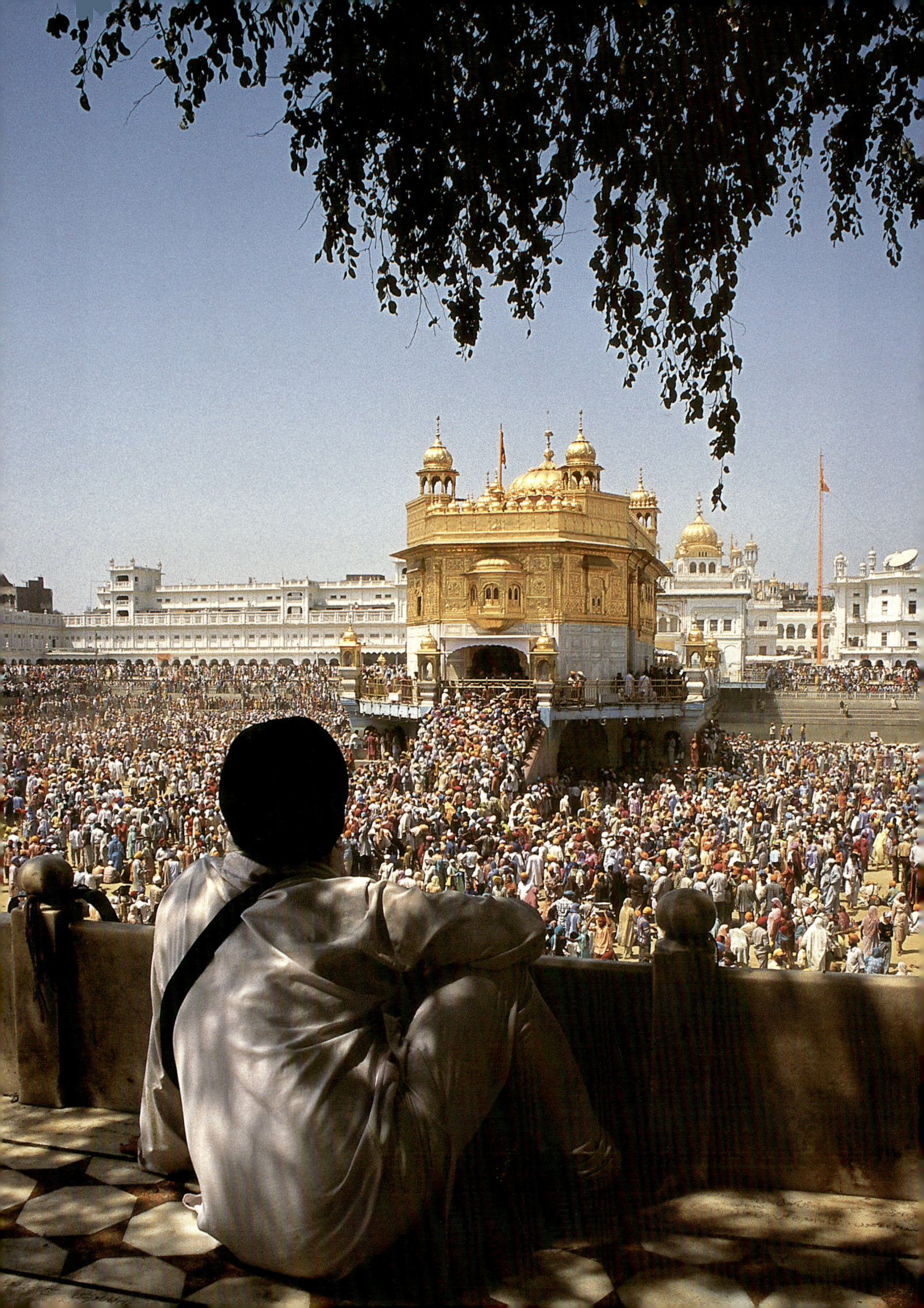

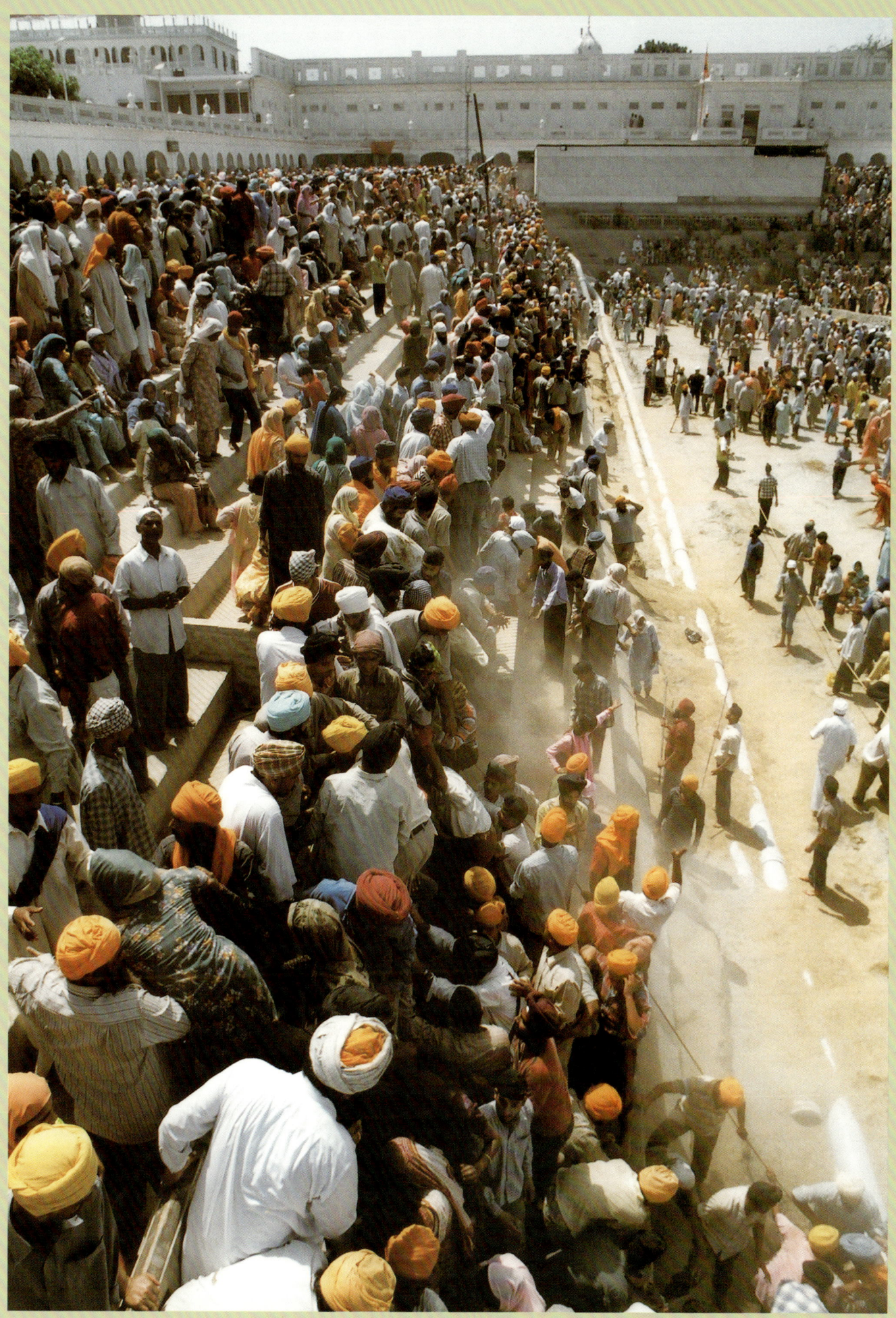

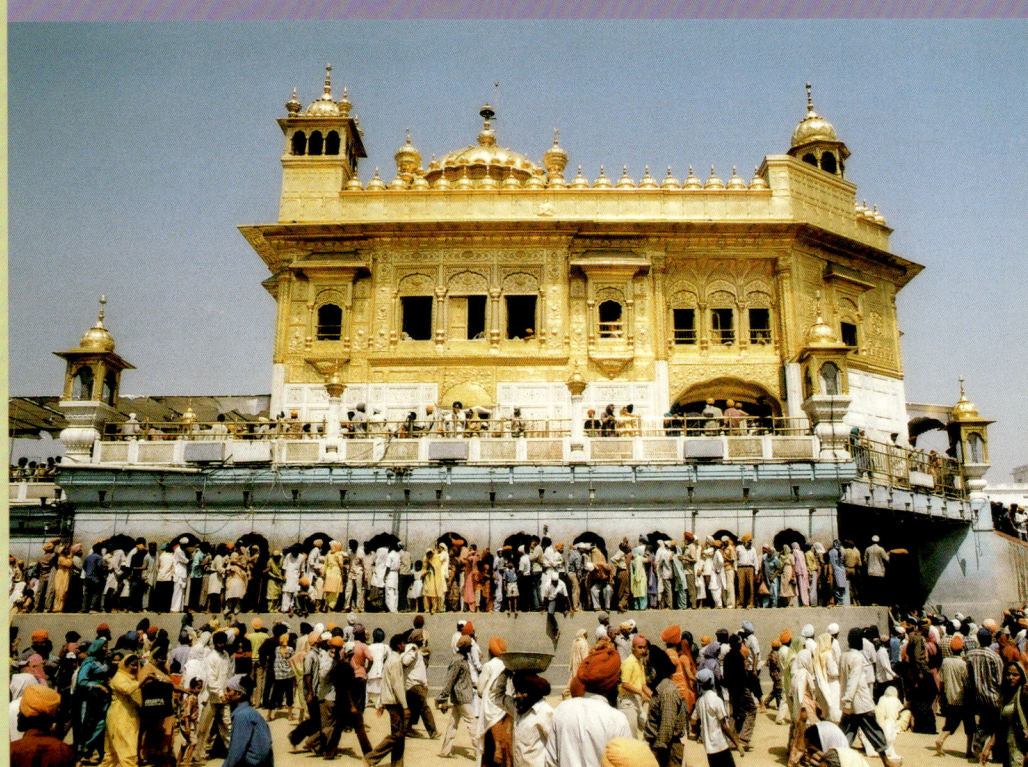

(Top) Three vertical sections of Sri Harimandar: Not many people know that Sri Harimandar has a very strong base inside *sarovar's* seventeen-feet deep waters. Besides the three apparent floors, the Temple has two sections of height under water, one, its sub-structure, a strong masonry, and the other, a seven-eight-feet high natural earthen platform.

(Bottom) Devotees looking for each grain of silt: Devotees' turnout in this *kar-sewa* was so massive that the third day the *sarovar's* bottom was as clean and dry as a cemented floor. Sikhs and non-Sikhs, men and women, old and young, from all walks of life and from within the country and beyond, thronged the *kar-sewa* site and the venue turned into a colourful fair, with cameras clicking, heads bowing and every hand groping for a handful of *sarovar's* mud, the holiest thing to bring home.

(Preceding Page Left & Right)
kar-sewa, March 2004:
The *kar-sewa* of March 2004 was just for seven days but had far greater dimensions. Besides cleaning the *sarovar*, it aimed at taking long term measures to keep the *sarovar* clean. The *kar-sewa* was hence coupled with *sewa* also, which included lining of *sarovar's* all four retaining walls as well as making provision was feeding the *sarovar* with the treated water by setting up a treatment plant and connect the *sarovar* by a concealed pipeline. The picture on page 27 shows a dual sand line, which defines the trench, dug for this pipeline. This trench revealed signs of a dried river buried under *sarovar's* bottom. In the *kar-sewa*, devotees were so full of zeal that they who did not have occasion to serve the *sarovar* made human staircases, by one standing over the other, to help people in and out *sarovar's* seventeen-feet depth.

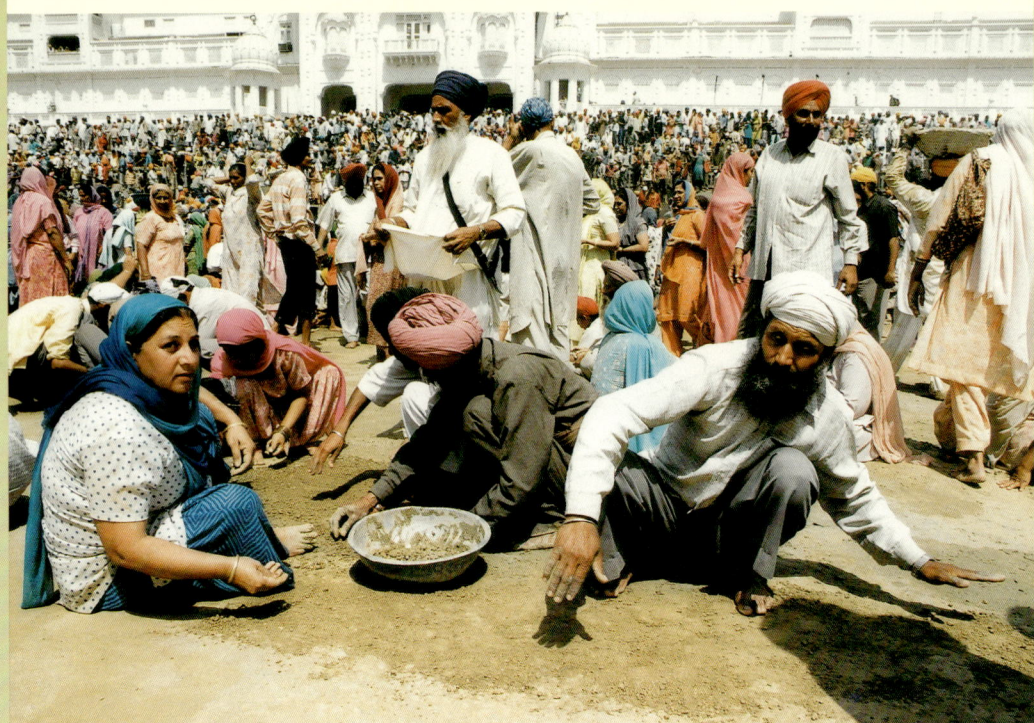

inaugural lot of silt and succumbed to it within two-three days. This *kar-sewa* had, hence, besides its spiritual magnificence, an emotional bearing as Shri Tohra had long served Sri Harimandar and the Sikh cause.

This *kar-sewa* was a special feature of the temple celebrations abounding in unique magnificence. The *sarovar* was emptied by 25th of March, except towards its northwest corner, where some quantity of water was retained for the fish and other aquatic creatures. The *kar-sewaks'* turnout

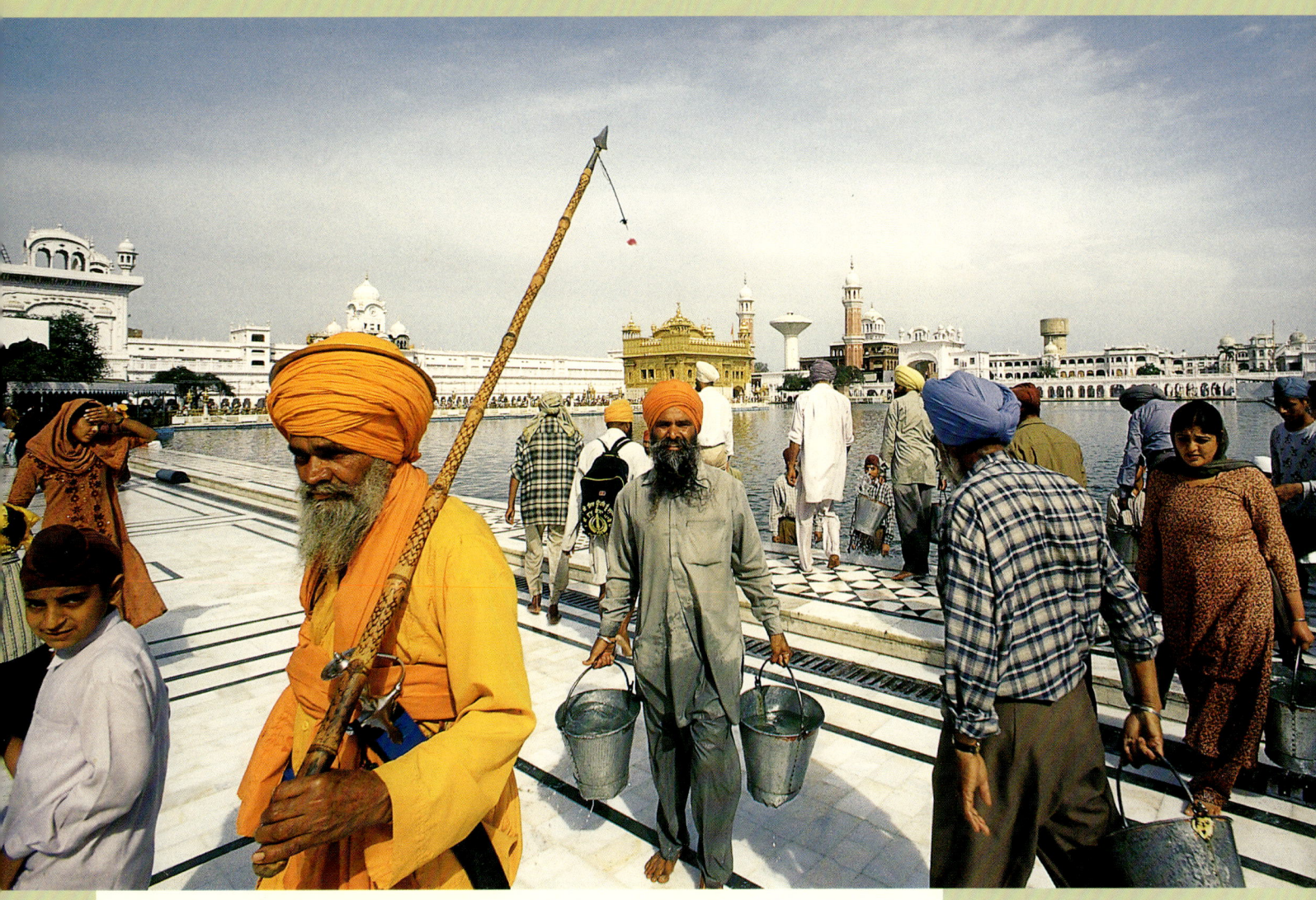

was so massive that the third day *sarovar's* bottom was as clean and dry as a cemented floor. Sikhs and non-Sikhs, men and women, old and young, from all walks of life and from within the country and beyond, thronged the *kar-sewa* site and the venue turned into a colourful fair, with cameras clicking, heads bowing and every hand groping for a handful of *sarovar's* mud, the holiest thing to bring home. For seven days, the magic continued and not an inch of the space of the temple premises was without a head bowing in deep devotion. Then, the eyes witnessed the phenomenon of celestial waters pouring in and the *sarovar* acquiring its usual form.

This *kar-sewa* also had a dimension different from earlier *kar-sewas*. Incidentally, before it was undertaken, the 200-year-old gold-plating of the Golden Temple including all subordinate buildings and the Akal Takht was removed to be replaced by the fresh gold-plating in 1999. Thus, when the *kar-sewa* began, the temple had a fresh glow and greater brilliance. It further aimed at providing to feed the *sarovar* with purified water treated at a water treatment plant set up for the purpose. *Sarovar's* retaining walls have been lined with beautiful blue synthetic sheets, lest such walls emitted any soiling material and rendered the water dirty. Now with its clean bottom, beautified sides and transparent blue waters, the *sarovar* has a face more divine than ever before.

Routine kar-sewa:
Besides specially scheduled *kar-sewa*, such as those of 1923, 1973 or 2004, devotees love to serve Sri Harimandir whenever they have the opportunity. Men and women, old and young, all would take a bucket and help cleaning the upper layer of Sarovar's water, or clean the floor, or help cooking in the Langar house.

(Following Pages)
The fourth day of the kar-sewa March 2004: Practically, on the fourth day, there was nothing to be done that hands could do. The venue and the atmosphere were now more of a colourful fair rather than that of *kar-sewa*. Into *sarovar's* depth, there poured people, the colourfully clad ladies, turbaned males and sportive children. For seven days the magic continued and during all seven days, not an inch of the space of Sri Harimandir premises was without a head bowing in deep devotion.

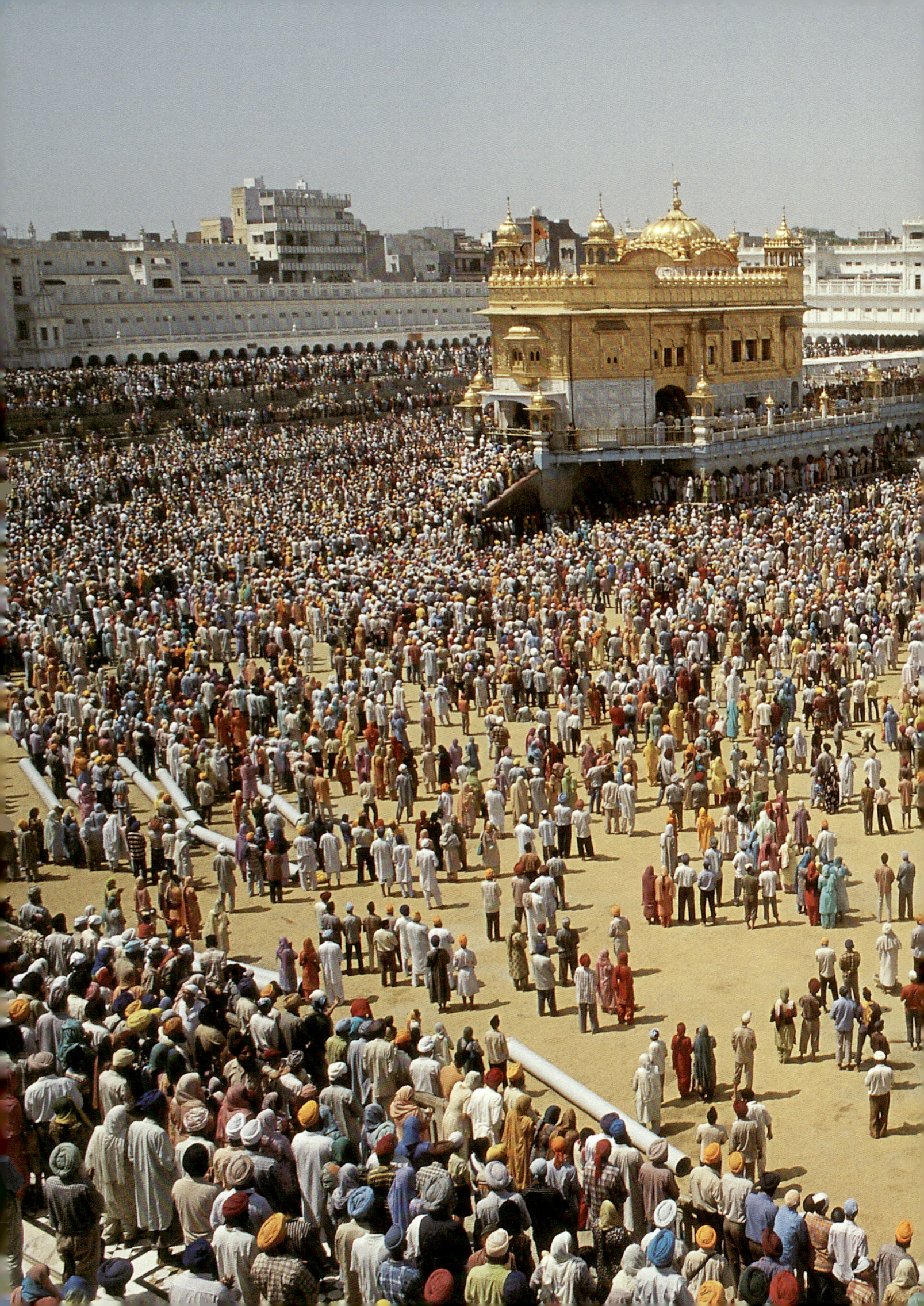

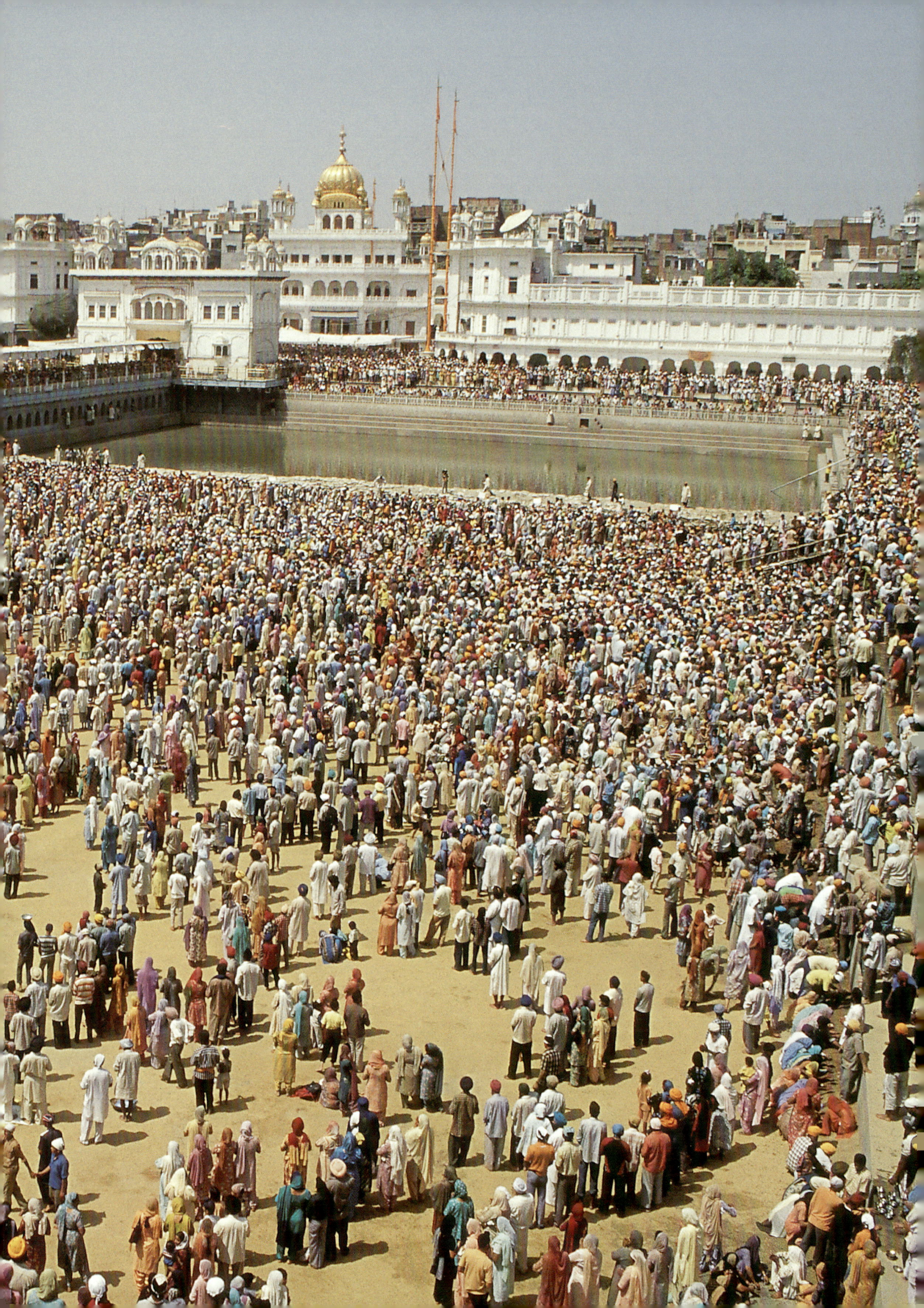

Other

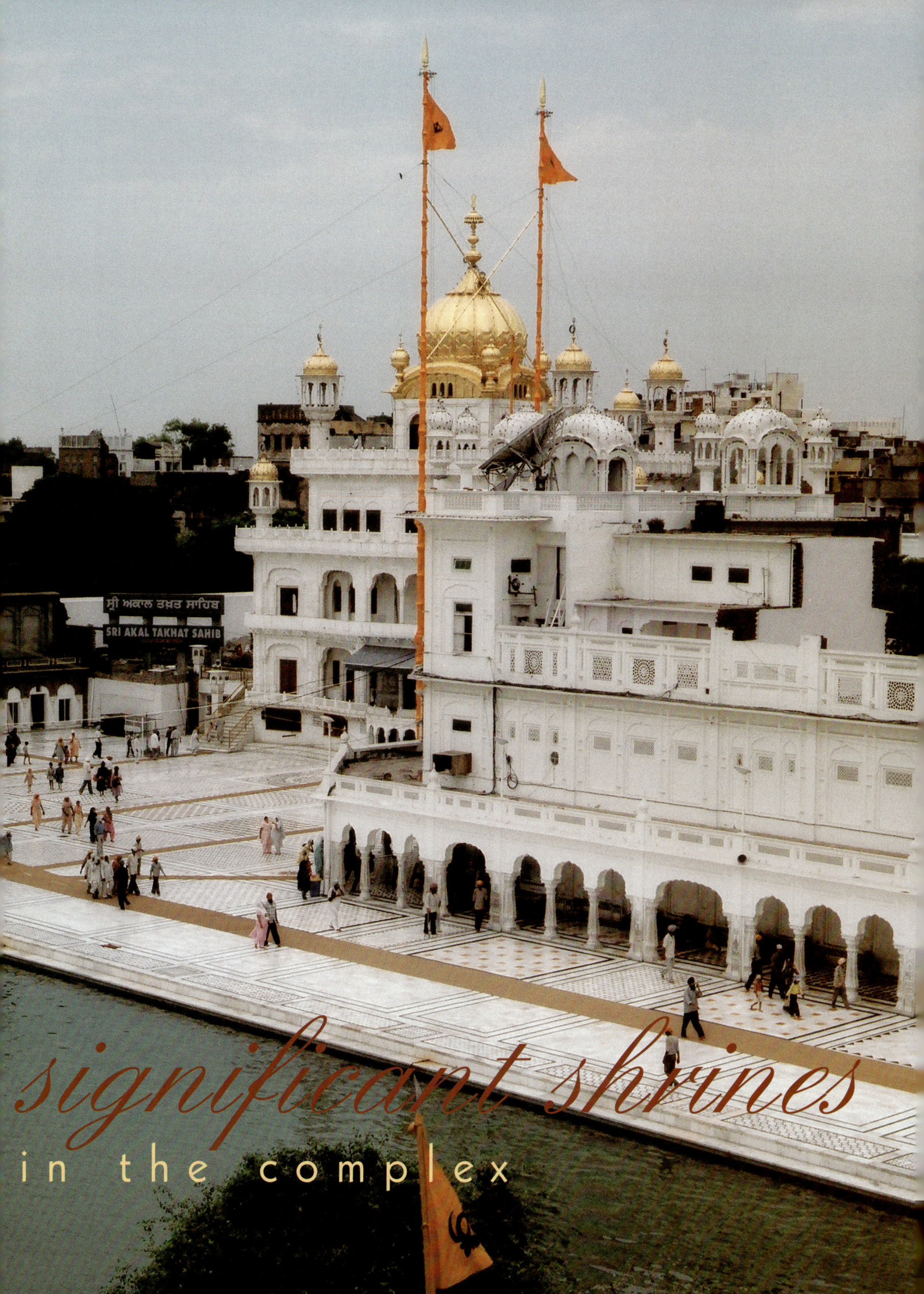

significant shrines in the complex

Sri Akal Takht

Sri Akal Takht, the highest seat of the religious hierarchy of Sikhs, during its passage of some four hundred years, had moments of unsurpassed glory and unchallenged authority, saw the mighty monarchs, like Maharaja Ranjit Singh bow before it with folded hands and the humblest ones rise to glittering heights. The history knows not any one born, the king or the subject, the rich or the poor, who ever dared flout its writ, or an ear, which did not pay heed to its call. Sri Akal Takht, a masonry institutionalised, manifests Sikhs' collective authority, an entity beyond time and beyond question. Whatever the issue, religious, social or political, the Akal Takht always came out with a solution, stood the supreme arbiter in all disputes, sought justice to the aggrieved and guided to righteousness the erring feet and the misled minds. It is said, the Akal Takht stands on the heap of the mud dug from the *Amrit-sarovar*, when the *sarovar* was deepened. The Akal Takht, whether the seat of the Timeless, or the timeless seat, could not be other than the Akal, the timeless, for it had its roots in *amrit*, the nectar, which the *Amrit-sarovar* yielded from its very being and created this perceptibly temporal seat of Sikhs.

The Akal Takht, initially called Sri Akal Bunga, or the abode of the Lord, represents both, a building structure for the camera and an institution for the 'faithful'. When plunderers and invaders, like Ahmad Shah Abdali, pulled down the building structure, the Akal Takht, the institution, functioned as before from its debris. Nothing ever changed as regards the functioning of the Akal Takht. It was still, and in every eventuality, the venue of Sikhs' highest assembly, the *Sarbat Khalsa*. Here congregated masses on Diwali and Baisakhi; the appointed ones held diwans on special occasions; and, the 'wisest' few met to deliberate and find solution to issues confronting the faith or the community. It was here that the norms of social conduct and codes of personal living were formulated; *Gurmat*, or the resolutions made in the presence and by the approval of the Guru, were made. *Hukamnamas*, the unfailing writs or edicts, were issued, justice was administered charging and chastising erring ones, homage was paid to martyrs, guests were received and felicitated, *pahul* was administered baptising new entrants to the faith, and, the strategy of defense and community uplift was chalked out. Though a constituent of Sri Harimandar complex, yet the Akal Takht always enjoyed an independent status. It has, in the political and temporal life of Sikhs, the same significance, as Sri Harimandar Sahib has in their religious life.

It is difficult to say when exactly the Akal Takht came into being. On the basis of *Gurbilas Chhevin Patshahi*, some scholars claim that its foundation was laid on June 15, 1606, by or by the order of the Sixth Guru Hargobind. As the tradition has it, it was only after its construction had been accomplished on June 24, 1606, that the 11-year-old Hargobind ascended the *Gurugaddi* as the Sixth Guru of the *Panth*. Dr. Harjindar Singh Dilgir, on the basis of *Guru ki Sakhis*, which appear in *Bhat vahi multani sindi*, almost a contemporary record, which the generations of the traditional bards maintained, and some other scholars

(Facing Page) The Akal Takht: Sri Akal Takht is the highest seat of Sikhs' religious hierarchy and unchallenged authority. Its *Hukamnamas* were obeyed even by the high and mighty monarchs, like Maharaja Ranjit Singh. Sri Akal Takht manifests Sikhs' collective authority, which has always stood beyond question. The Akal Takht was the concept of Guru Hargobind, although then it was probably an open platform to assemble and decide future course of action. It was known then and for quite long as Akal Bunga. It is now, with its five-storeyed towering height, one of the most commanding edifices of the Sikh *Panth* and a great architectural beauty.

(Preceding Page Left) Marble inlay: A comparatively late work, this marble slab with floral design clothes a section of *Darshani Deorhi* wall. It has used brighter colours and bolder designing patterns.

(Preceding Page Right) Two Nishan Sahib: These two Nishan Sahibs, situated from east to west, one towards Sri Harimandar and the other towards the Akal Takht and thus one representing *Piri* and the other *Miri*, have a long past. A *Udasi* sadhu Baba Pritam Das, who conceived the idea of feeding the *sarovar* with Ravi water by a canal, was instrumental in planting these Nishan Sahibs also. One day he brought two saplings of Sal tree and planted them here in the hope that after they grew to full height, they would serve as the Nishans of the new faith. His hopes came true and for long those Sal trees served as such. In 1831, however, they fell during a cyclone. Later, Desha Singh Majithia replaced the broken trees with two gilded poles. When these too got rusted, his son Lehna Singh raised gold-plated iron poles, which have been replaced by these saffron-clad Nishan Sahibs.

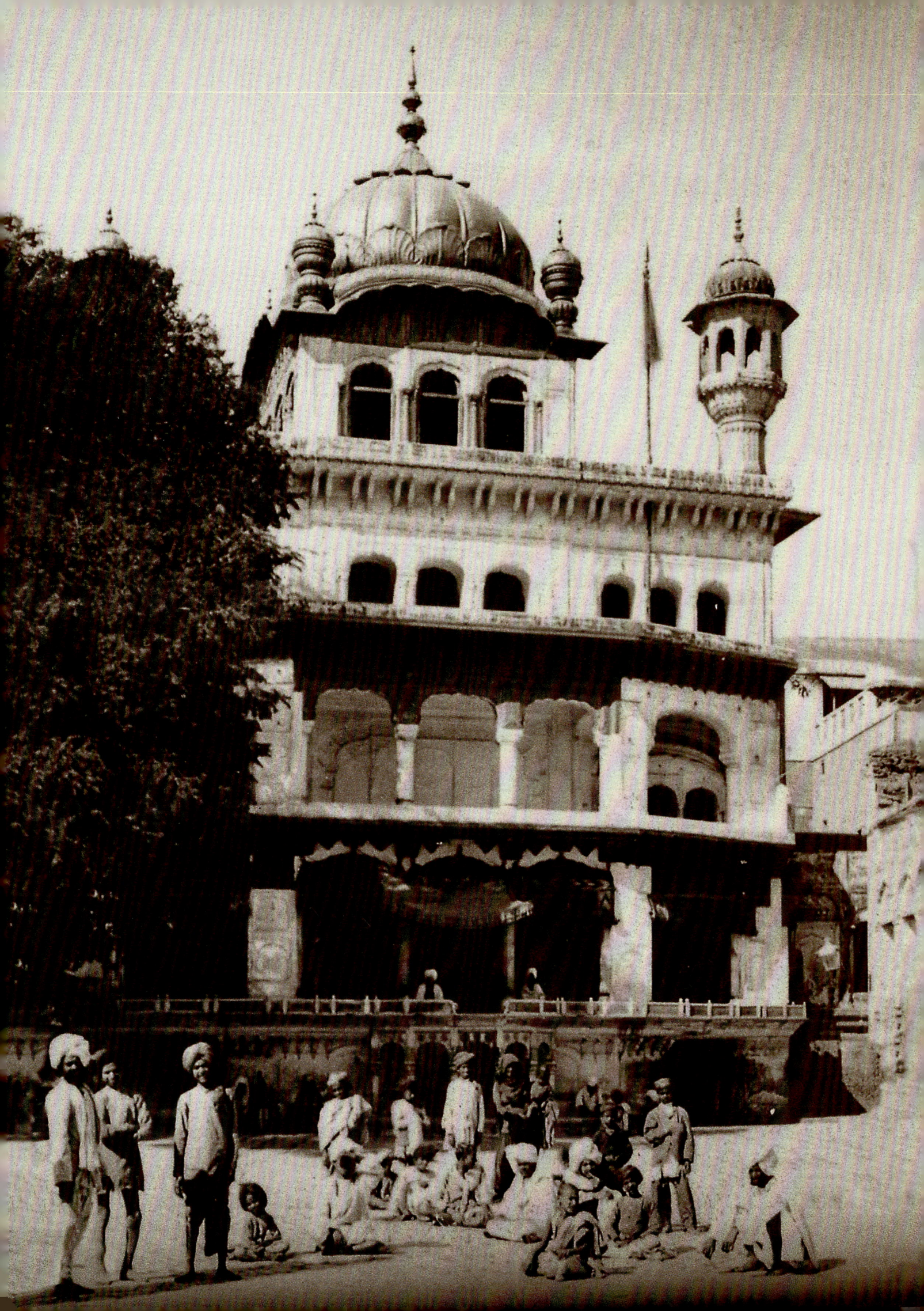

Sri Guru Hargobind:
This miniature portrays Sri Guru Hargobind, the founder of Sri Akal Takht and the propounder of the *Piri* and *Miri* concept, in characteristic Rajput style. He is seated against a bolster and is holding a falcon, the symbol of authority and royalty.

(Facing page) The Darshani Deorhi from Sri Harimandar Sahib:
Here is a majestic view of the *Darshani Deorhi* and Causeway with devotees moving to and fro and the Akal Takht and the two Nishan Sahib beyond contained within a three-armed frame. The view taken from the window of the first floor of Sri Harimandar Sahib has also caught splendour strewn over window door-planks and the glimpses of devotees seated within with their heads bowed in worship.

assign 1608 or 1609, as the year of its foundation. According to Dr. Dilgir, Mughal emperor Jahangir had ordered, along with the orders of the assassination of Sri Guru Arjan Dev, the custody of his son Hargobind also, to evade which the Sixth Guru, leaving Amritsar, had gone to village Daroli Bhai and was there for over one-and-a-half year.

Whatever such date, it is obvious that the Akal Takht, or the Akal Bunga, was built initially as an open brick-paved platform raised over the mound of clay excavated from the *Amrit-sarovar* and that some kind of structure was built over it subsequently, although during the lifetime of the Sixth Guru. It is unanimously held that around 1774, its first floor was reconstructed, which suggests that it had a prior structure, which was demolished and reconstruct-

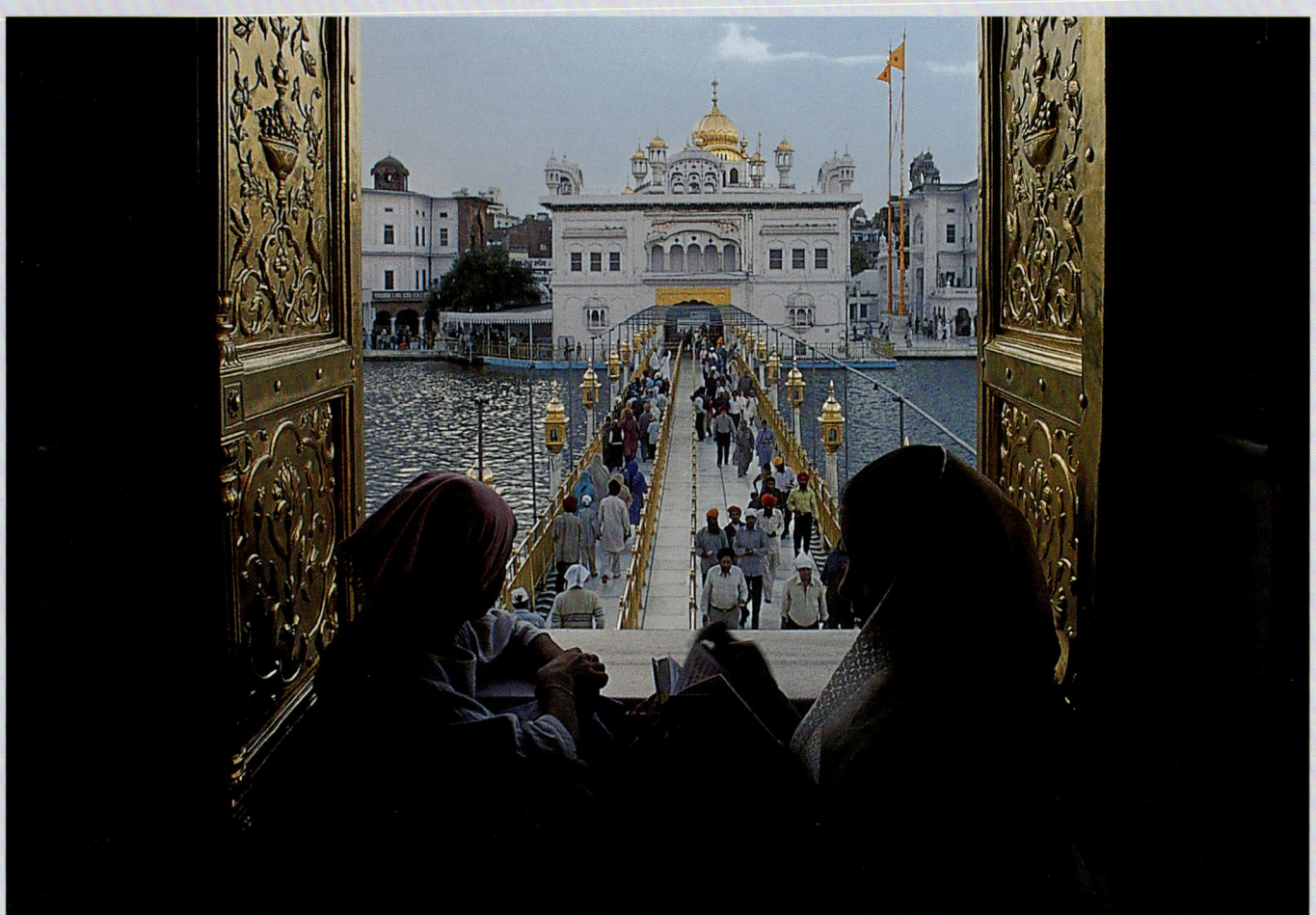

ed. It was, however, Maharaja Ranjit Singh, who raised the edifice to its five-storey height. The dome was subsequently gilded in gold by Sardar Hari Singh Nalwa. After 1984, the Akal Takht was twice reconstructed, but pursuing only it's original model.

The Akal Takht has a curious past. As the Akal Bunga, it served as the central record office of the Sikh power. When the Mughal Empire began waning, the numerous local power-centres and feudatories emerged on the scene. The Sikhs weren't far behind. A number of Sikh Sardars fought with their bands of Sikh fighters for their own independent occupation of one or the other tract of land and established upon the conquered territories their own independent principalities, or *thanas* as they were widely known. In almost no time, there emerged on the land of five rivers about a dozen Sikh chiefs with their independent *thanas*. A common factor that bound them together was their allegiance to the Akal Takht and Sri Harimandar. To evade infighting amongst these Sikh chiefs and for the unity of all Sikhs as a community, Sardar Jassa Singh Ahluwalia, a veteran Sikh and great warrior, came out with a new idea, which some of these chiefs accepted in consideration of his great martial power and others due to their communal inclination. Under the scheme each of these Sikh chiefs was required to maintain in his name at the Akal Takht a *misl*, a Turkish term for 'file' widely used in the entire Muslim ruled northern and central India. In this *misl* were recorded all his conquests and details of his exploits, that is, complete details of his territorial domains. This meant that their possessions had religious sanction and were identified under the authority of the Akal Takht, which

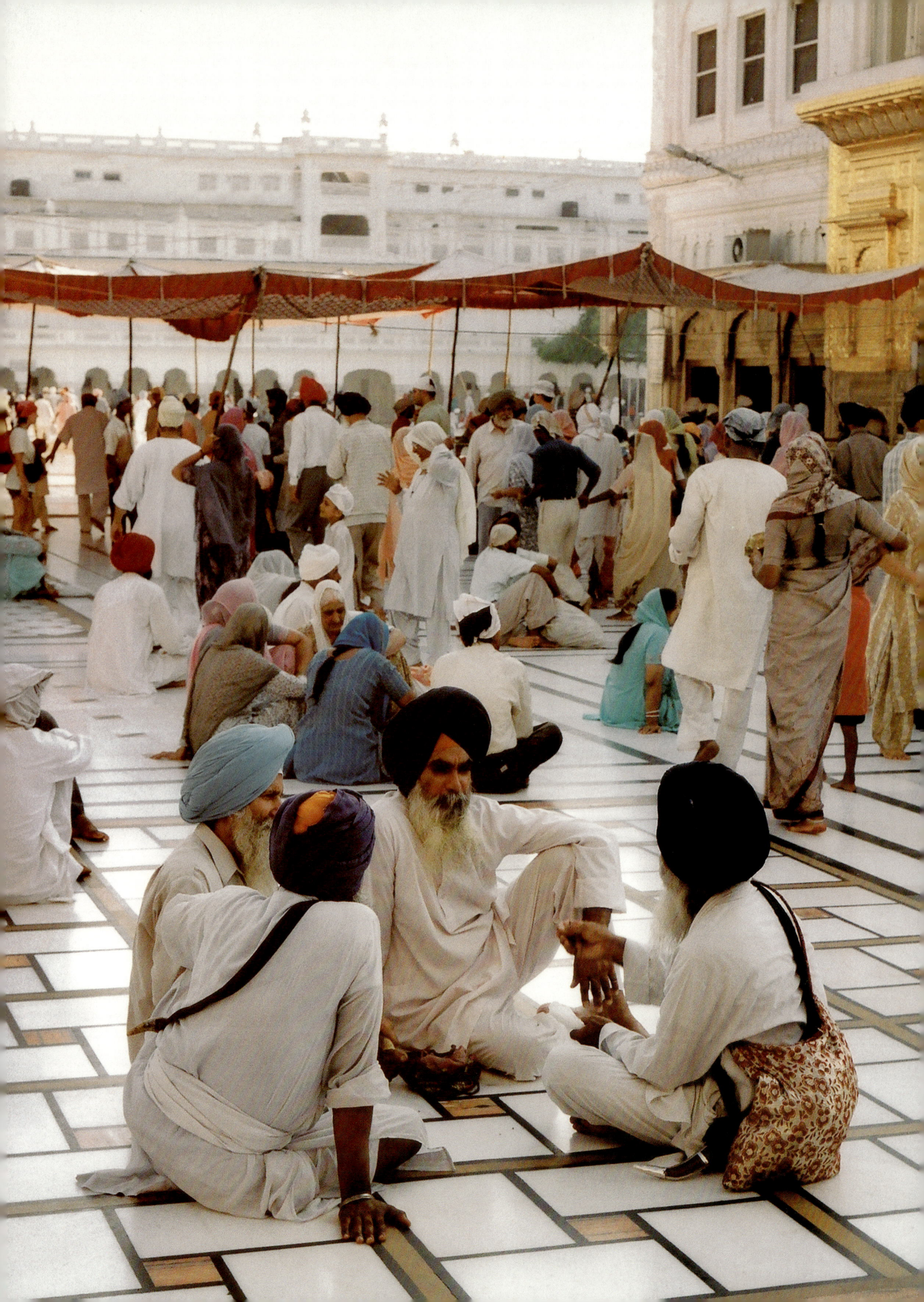

amounted to a kind of recognition of its independent status barring interference of other *misl*-holders. *Misl* defined the territories of a Sikh chief. As such, over a period of time, the term *misl* replaced other erstwhile terms, *zamindari*, principality, or state used to define territorial possessions and the Sikh chiefs came to be known as *misldar* instead of *zamindar* or prince. These *misls* holders had their seats, the small tracts of land known as *Kataras*, in Amritsar itself to remain in touch with and to participate in the affairs of the Akal Takht. Thus, the Akal Takht served as supreme political authority of Sikhs, though during the 18th century, some *misldars* grabbed the polity and the authority of this august institution and many a time derogated its prestige. They even began using the adjoining land as a cremation ground. Hence, when Maharaja Ranjit Singh began weeding out the unwanted elements and uniting Sikh power, his efforts came as the most cherished need of the Sikh world.

The Akal Takht, an apparently simple-looking building structure, has a considerably complicated architecture. The five-storey edifice, including the basement, has, at least up to the second floor, a quasi-pentagonal bearing. The third floor has a straight horizontal thrust with equal four sides forming a perfect square. The fourth floor is also a square but a domed one. In the centre of its ground floor, the façade has, on a raised and extended platform, a quasi-pentagonal projected marble portico, which is the frontispiece of the edifice and corresponds in its layout to the general character of the main structure. The quasi-pentagonal marble roof of the portico is supported on beautifully moulded marble pillars, which are joined mutually by cusped arches. Thus, the portico has, all around it, a chain of cusped arched openings. There runs around the whole façade a projected eave, or *chajja* surmounted by a parapet consisting of fretted marble slabs. It separates the first floor from the base storey.

The ground floor consists of a big hall with opening only on the northern side. The façade is flanked on its north and south by flights of stairs leading to the first floor. The first and the second floors have an almost identical façade. The first floor has, on its western side, only a single small opening, approached by the flight of stairs, which lead to the Akal Sar, the sacred old well. The central hall, on the second floor, has on its southern side a few rooms and on its northern side a large rectangular gallery. From this gallery, there open towards the central hall, three cusped arched windows. The second floor has on its southern façade three windows, shaded with beautiful half cupolas. Beautifully modeled eaves, projecting upon the rest of the façade, distinguish both floors, and even the third, which is supported on the elegantly moulded double brackets and surmounted by parapet and railings. The eave on the first floor covers only the eastern facet, while on other floors it runs along its three facets.

The third floor has a square plan. This floor consists of a large hall erected on square pillars with cusped arched openings. There are galleries on three sides of the central hall. The façade, with nine cusped arched openings, is remarkably different from that of the lower floors. This floor has, on all its four corners, beautiful octagonal kiosks surmounted by gold-plated domes and *kalash* finials. The beautifully modelled short octagonal minarets support these kiosks. The fourth floor is only an extension of the central hall and is square in

(Facing Page) Akal Takht's foreground: Akal Takht's foreground is a multi-purpose assembly or community venue. Here Sikhs gather not only for a *Diwan, Sharbat Khalsa* or other kinds of congregations, but also in leisure, to discourse and discuss and for personalised assemblies of friends and relatives. And, the Temple management helps by raising over here a *chandani*, if the days are hot.

The Akal Takht, Nishan Sahib and other shrines: The Akal Takht, as appears in this photo-vision, is an apparently simple looking building structure, but has as much complicated architecture. On sides, it is a straight formation, but in its front elevation it has a quasi-pentagonal bearing. The width of the foreground, the towering height of the two Nishan Sahib and the adjacent building with a massive entrance impart to the entire complex an exceptional grandeur.

plan. Above this structure, on a lotus-petal base, rises from a circular drum, the majestic fluted dome plated in glittering gold. A large *kalash* finial, with a *chhatra* over it, adds to its majesty. As suggests old records, the interior of the first and second floor had earlier, on its walls, fine murals depicting Sikh Gurus, the episodes from their lives and various specimens of flora and fauna. In its repeated reconstruction all these murals have vanished, although architecturally the new construction has adhered to only the old model.

The Akal Takht has its independent set-up and sources of income. The income from offerings alone is quite large. Besides, the Akal Takht has a lot of landed property in its name, which further affords it a sizable income as rent, etc. The Akal Takht has, on its staff, six *granthis*, four *sewadars* and four *ragis*, to perform rituals related to the Akal Takht and maintain the august seat where,

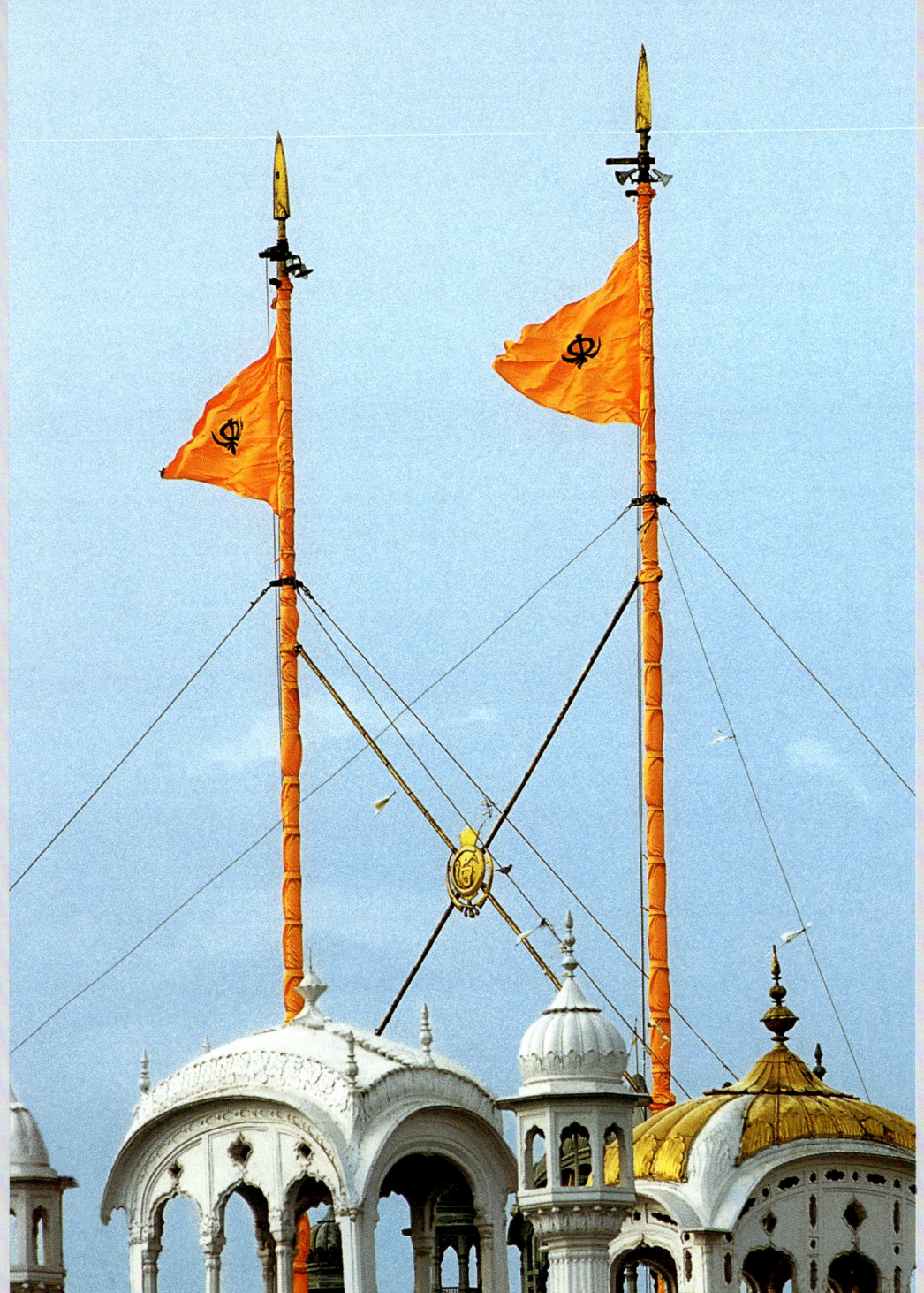

The cluster of domes, towers and kiosks: The two *Nishan Sahib* have otherwise also so commanding a view in the entire Temple complex but with the cluster of diversely styled domes, kiosks, towers, arches, eaves and finals, their beauty is exceptionally enhanced and the emblem of the *Panth* in the centre becomes so dominant.

in the *Kotha Sahib*, Sri Guru Granth Sahib reposes during night. This seat of the Sikh authority enjoys now, thus, also a spritual status.

The two Nishan Sahib

A pair of sacred *Nishans*, known as the *Nishan Sahib* representing the *Piri* and *Miri* concept of the Sixth Guru, constitute one of the most commanding views in the Golden Temple precinct. They stand east to west, one towards Sri Harimandar Sahib and the other towards the Akal Takht, that is, one representing *Piri* and the other *Miri*. Initially a couple of sal trees represented these *Nishan Sahib*. These trees were planted by Baba Pritam Das, the founder of *Sangalwala Akhara* and a sadhu of *Udasi* sect widely known for propounding

the idea of feeding the *Amrit-sarovar* with the water of river Ravi through a canal. It is said, this great missionary brought one day two saplings of sal tree and planted them in front of the Akal Takht in hope that they would grow high enough to serve as *Nishans* of the new sect. They grew as expected and as *Nishan Sahib* won people's reverence, but in 1831, a powerful cyclone uprooted them. Then, two gold-plated iron poles were erected in their place by Sardar Desa Singh Majithia. Later, with the passage of time, the gold-plating vanished leaving the poles awkwardly rusted. Consequently, Lehna Singh Majithia, his son, got them repaired and plated them with gold as before. Now the twins, *Nishan Sahib,* stand clad in saffron and bear amidst them the emblem of the Sikh *Panth*.

Gurudwara Baba Atal

The nine-storeyed majestic tower, known also as Gurdwara Baba Atal, with its forty-five meter height, is the tallest building in the Golden Temple complex as also in the town. Situated southeast to Sri Harimandar Sahib, the tower is dedicated to Atal Rai, one of the sons of Guru Hargobind. The tower was built initially as an humble memorial to commemorate his memory, but was subsequently elevated to a Gurdwara and is now for about 200 years a highly esteemed seat of the Holy Granth Sahib and Sikhs' live worship. It is said, Atal Rai had by birth exceptional spiritual powers and could accomplish things far beyond the domain of a born one. When Atal Rai was just nine years of age, one of his playmates Mohan, the only son of a widowed mother, died. Atal Rai could not bear the sight of the bereaved mother bewailing over the death of her son and wished Mohan came back to life. And, Lo! What he wished turned into a miracle. The corpse of Mohan began pulsating and revived to life. Atal Rai's father, Guru Hargobind, heard of it. He did not approve the act. He felt Atal Rai interfered with the domain of the Creator, who alone had powers to give or take away life. He exhorted his son that spiritual powers should have been displayed "in purity of doctrine and holiness of living" and not to intervene the course of nature.

The penitent Atal Rai resolved to atone his act and repair the course of nature by returning to it in exchange of Mohan's life his own life. With a determined mind he entered into the *samadhi* and, as avowed, abandoned, on 13th September 1628, his mortal coil. His remains were submitted to the sacred fire on the eastern bank of the Kaulsar, a pond adjacent to the *Amrit-sarovar*, where now stands the holy tower. Guru Hargobind had constructed the Kaulsar just a year before the death of Atal Rai. Supposedly, the pond was named after Mata Kaulan, an eminent Muslim female disciple of the Sixth Guru, but it seems the Kaulsar acquired its name subsequently. Mata Kaulan died a couple of years after the construction of the pond and in the lifetime of the Sixth Guru. If the pond was dedicated to her, as a natural sequence, she would have been cremated around it and not at Kartarpur, especially when the pond site was in use as a cremation ground till much after. Thus, it is more likely that the name evolved subsequently out of people's reverence for her. Near the pond, tradition assigns to her

(Facing Page) The tower of Baba Atal: This nine-storeyed forty-five meter tall majestic tower, dedicated to Atal Rai, one of the sons of Sri Guru Hargobind, is the tallest building in Sri Harimandar Sahib complex as also in the town. The nine storeys of the tower correspond to the nine-year life span of Baba Atal and thus project numerical symbolism.
The tower's architecture is ingenious, aesthetically splendid and quite amazing. By using diverse architectural devices—repeated arches, arch-motifs, oriel windows, projections, graphics, horizontals and verticals, pendentives, pilasters, elegantly laid string courses, diversely designed windows, chhajjas, and various kinds of brackets create dramatic effect and enliven the edifice with rhythmic vitality.

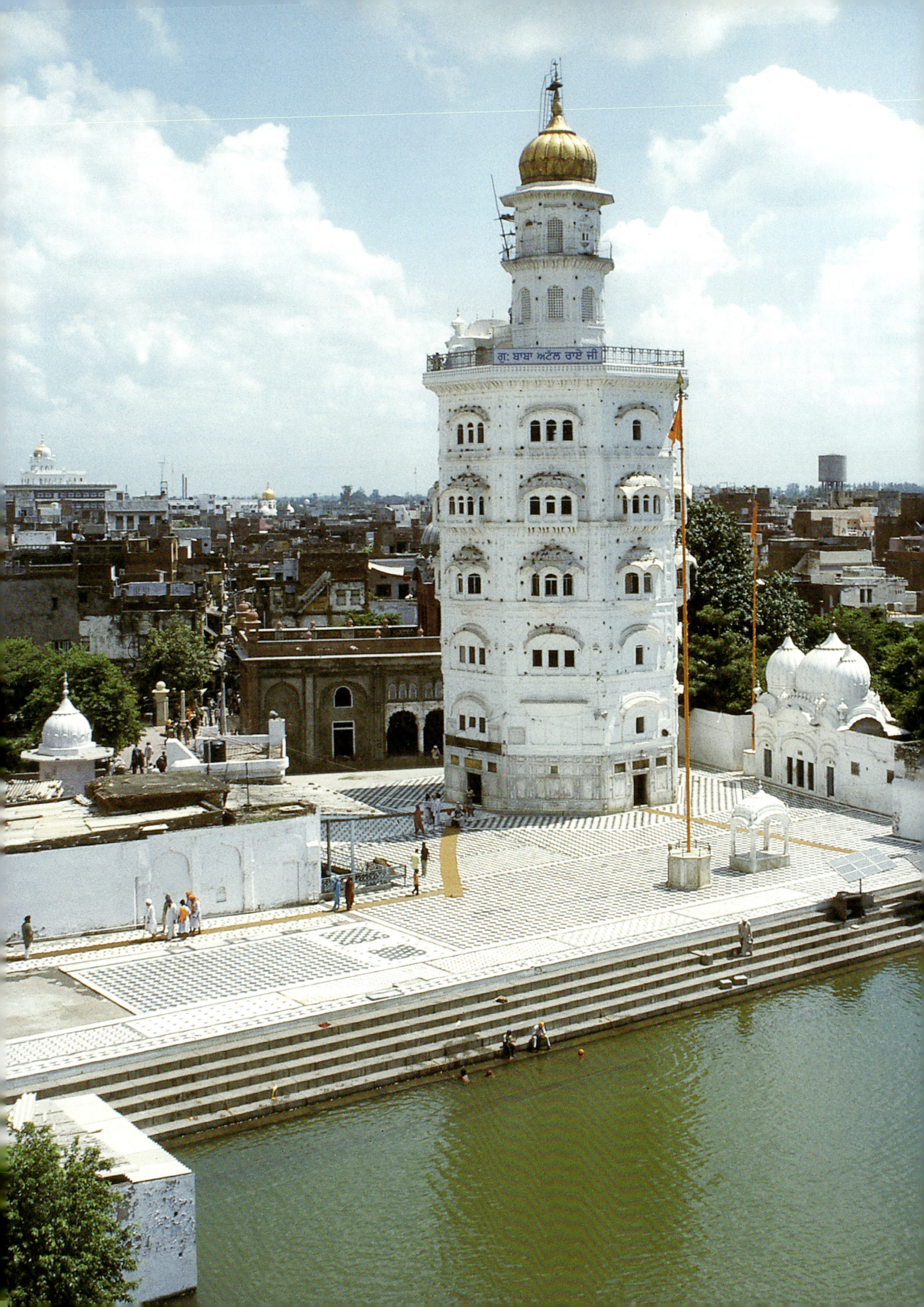

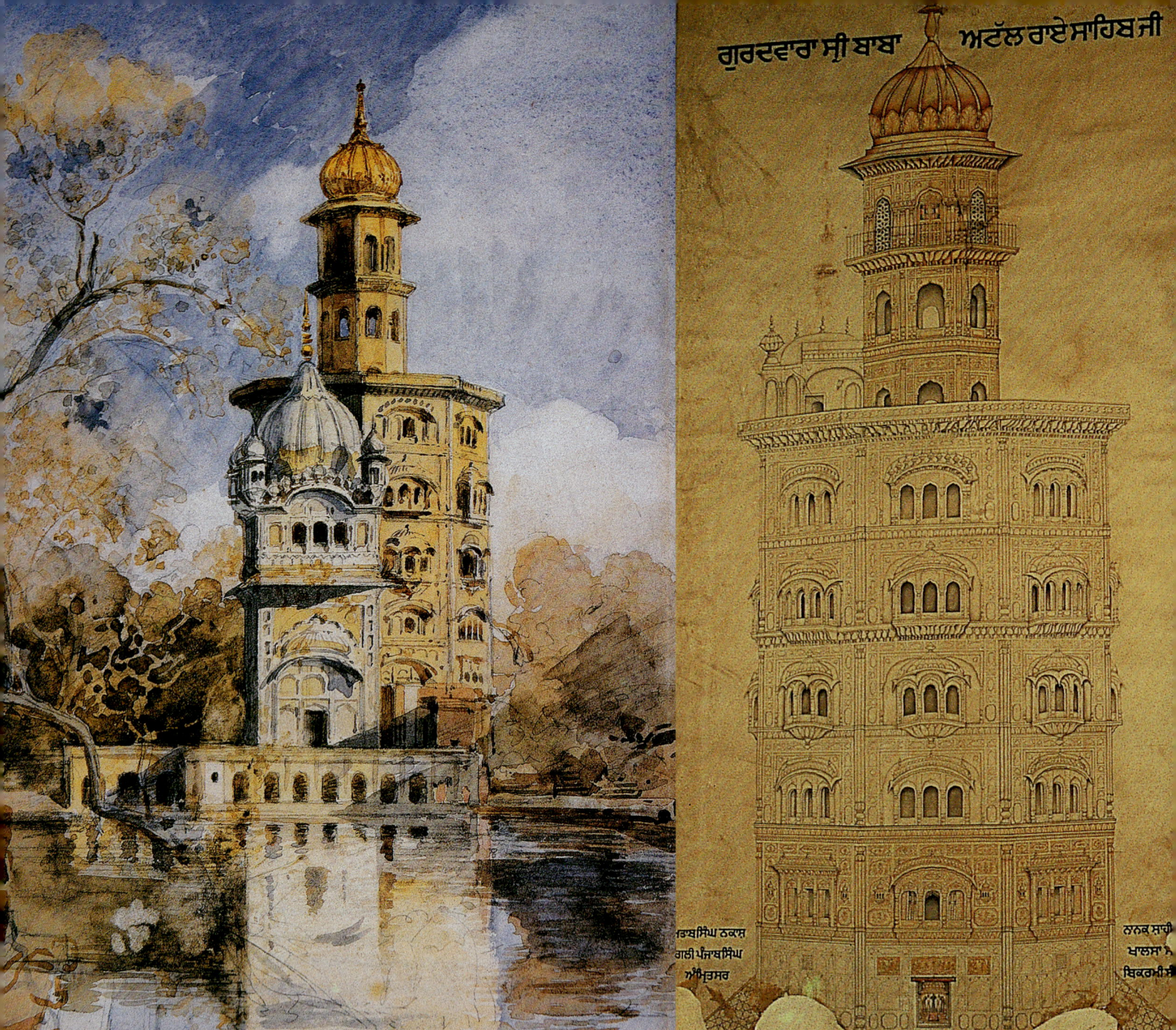

a spot, named Asthan Mata Kaulan, but how it came to associate with her has not been mentioned anywhere. Kaulsar, however, after it became the site of Atal Rai's sacrifice, acquired a new dimension. *Qaul*, a Urdu word of Persian origin, widely used in Punjab as *kaul* which meant 'vow', or 'determination', corresponds to Atal Rai's 'vow' under which he gave up his life. Maybe, the subsequent generations of Sikhs discovered in the name of Kaulsar reflections also of Atal Rai's *kaul*. Despite that he was just a child of nine, his unique act of sacrifice and his reverence to his father, to the Creator and nature earned him the epithet of Baba, the old grandpa of the family of Sikhs.

The nine storeys of the tower of Baba Atal, although constructed in phases with perceptible large gaps of time, correspond to nine years of Baba Atal's lifespan and thus acquire a numerical symbolism. The structure, as becomes evident from its architectural variants, is a phased growth to begin sometime around the last quarter of the 18th century. The Public Works Department Press, Lahore, while publishing, in 1892, the list of the "Objects of Antiquarian Interest

in the Punjab and its Dependencies" takes such date back to A.D. 1628, that is the year of Atal Rai's death. The Amritsar District Gazetteer, published around the same time, puts it as 1798. According to *Tawarikh Sri Amritsar,* a publication of 1889, by Gian Singh Giani, the spot had initially only an humble structure, which was substituted in 1750 by a three-storey memorial. In 1821, Maharaja Ranjit Singh got it erected to its present nine-storey height. The dome was gilded in 1830. The gilded plates, three on each of the four doors, were added during the last decade of the 19th century. Like Sri Harimandar, the tower was also a prey of invaders' cruelty and was as often demolished, repaired and renovated. Thus, a phased growth alone defines its architecture.

The tower of Baba Atal is the second most interesting, architecturally significant and aesthetically splendid building in the Golden Temple complex. Architectural devices–repeated arches, arch-motifs, oriel windows, projections, etc., make it look taller and at the same time break monotony. The use of graphics, horizontals and verticals, pendentives, pilasters, elegantly laid string courses dividing one storey from the other, diversely designed windows, *chhajjas*, and various kinds of brackets, one alternating the other, create dramatic effect of light and shade and enliven the edifice with rhythmic vitality. The inner face of the walls has been wrought with variously designed and multi-sized arches, which create graded recesses and tiers, and thereby, reduce the weight of masonry, strengthen the structure, divide the space and enhance the perspective of height. The painters, who created elaborate murals on the first floor walls, have intelligently utilised these recessed tiers created by arch-formations.

The tower consists of two octagonal rings, one inner and the other outer, obtained by structuring two walls ringing around a width of 125 feet. The wall thickness is about 5feet The construction has been carried out using *Nanakshahi* bricks, finely ground lime-mortar and vaulting technique of roofing. The superstructure of the tower consists of a gilded fluted dome and *kalash*-finial. The inner octagonal ring enshrines, on its ground floor, under a beautifully wrought brass canopy with exquisite *chhatri*, the Holy Sri Guru Granth Sahib. The outer octagon serves as the circumambulatory. This scheme of inner and outer rings persists till six floors. The other three floors are raised only over the inner octagon, which has a roof-plan different from the outer octagon. It has the roof only on the alternate levels, that is, after every two storeys. The other levels have only projected balconies. Access has been provided only to the outer octagon up to six storeys and the terrace above by two sets of stairs rising spirally through the breadth of the northern and southern walls. The seventh, eighth and ninth floors, erected only over the inner octagon, have been provided with stairways, but access to them is restricted.

The open terrace, which tops the sixth floor, has around it an extended balcony supported on beautifully modeled double brackets. This extended part has around it a balustrade with an iron railing surmounting it. The seventh floor has openings on all eight facets, but except the one, all are covered with fretted screens. The eighth floor has large window-openings on all eight facets, while the openings on the ninth floor, ranging from oriel window-types to trellised doors, are variously sized and styled. The eighth floor also has around its top an

(Facing Page) Two painted visions of the tower of Baba Atal:
These two versions of the tower of Baba Atal provide an interesting study of its phases of development. In the drawing on the left, the tower has adjacent to it another tower and the tank in closer vicinity. Its top floor has open windows. In the painting on the right, it does not have, nor it has now, the other adjacent tower. The windows of the top floor have been covered with fretted screens and so they are now. Obviously, the former one, a mid-19th century drawing, represents tower's early phase and the latter its late-19th century phase.

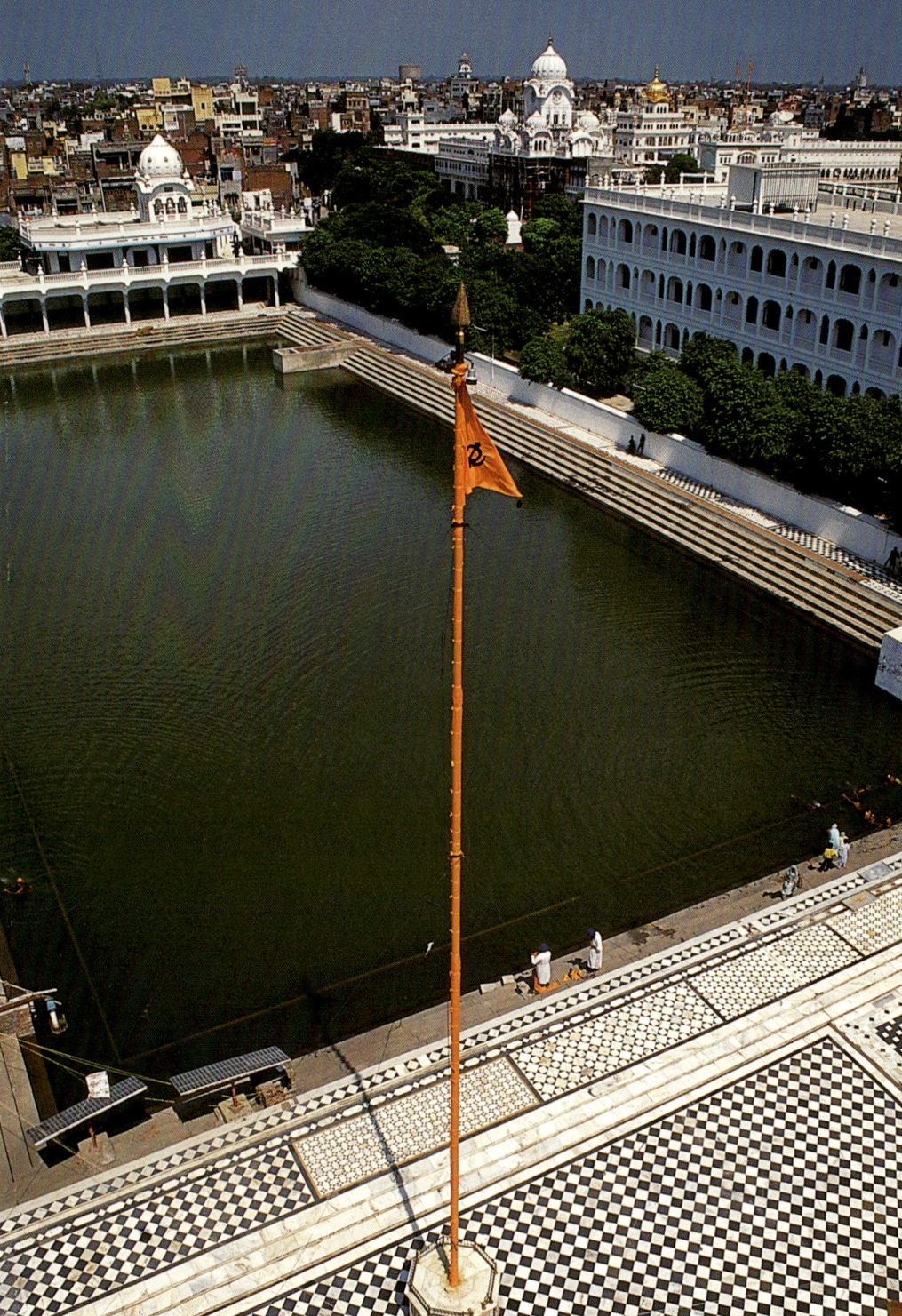

Kaulsar:
Kaulsar, constructed by Sri Guru Hargobind, is another tank in the Golden Temple premises.
It is situated westward to the tower of Baba Atal. On its north is situated the large size building of Mata Ganga Niwas. There are numerous legendary traditions in regard to the tank. According to one such belief, Sri Guru Hargobind got it constructed for Mata Kaulan, a Muslim devotee of the Guru; while the other notion relates that Mata Kaulan wished to build a tank with the money that she had left behind and a third belief assigns the construction of the tank to the memory of Baba Atal Rai.

(Facing Page) Two gilded copper plaques from the tower of Baba Atal:
In the course of embellishing the tower of Baba Atal, 12 gilded copper rectangular plates, with various legends carved on them, were fixed on the tympanums over all four door openings during the last decade of the 19th century.
Each tympanum has three plaques, a larger one in the centre and the two smaller ones flanking them. One of these two plaques depicts Baba Nanak seated with Bhai Balaji and Bhai Mardanaji and the other Sri Guru Gobind Singh seated on a throne. Behind him are seated *Panja-Piare* and before him stand his sons and devotees.

extended balcony. Atop the ninth floor, there runs a slanting eave and over it emerges, from a row of lotuses, the gold-clad dome with crest of *kalashas*, which looks like a golden bustard perching on a snow-covered hill-peak.

The lower six floors reveal three to four architectural characters and correspondingly as many phases of construction. The three lower floors seem to constitute the first phase, while the fourth, fifth and sixth, three other phases. The ground floor has four doors on east, west, north and south. The other four facets have square openings for ventilation. The main entrance is on the eastern side. Each of the four doors has on its lintel three gilded copper plates, a larger one in the middle and two square ones flanking it. These plates are engraved with themes related to Hindu myths and Sikh legends. Graphic formations, square

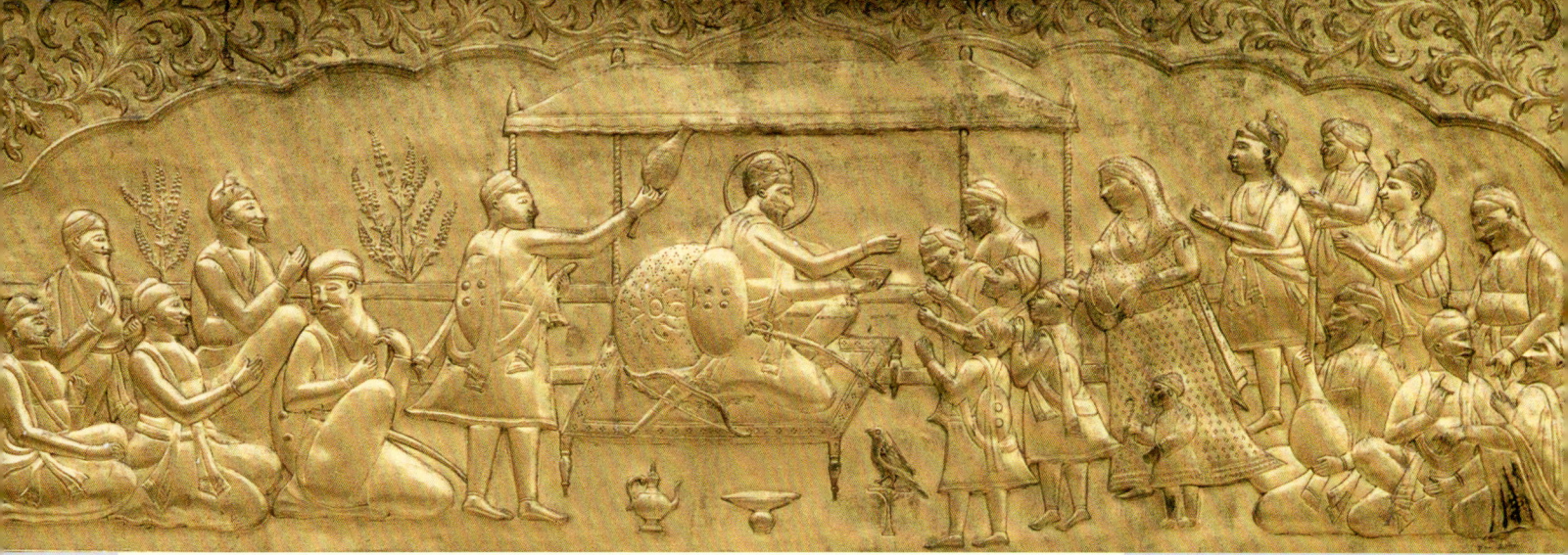

and rectangular cubes, created by projections and recesses, arched niches contained therein, and pilasters used for negotiating the corners, endow the outer space, all over the tower, a rhythmic vitality and a variegating effect. The interior of this floor had on its walls elaborate murals, which the marble-covering has now concealed.

The first floor has a changed scheme. The eastern and the western facets have windows with three rectangular openings, while those on the northern and the southern facets have a single opening. Inbuilt eaves, modelled on Bengal cottage-roof pattern, surmount these windows. Each of the other facets has two window openings contained within a rectangular inbuilt frame. The third floor has, on its all eight facets, semi-hexagonal oriel windows with three openings. The half-dome over them is a blend of Bengal and Mughal models reaching en route Rajasthan. The windows are supported upon beautiful lotus brackets. On the fourth floor, the semi-hexagonal oriel windows of the preceding floor have been substituted by balcony-windows carried on brackets used in pairs and duck-brackets alternating them. These windows have five openings and Bengal-style slanting semi-domes. The fifth floor follows the architectural model of the second floor except that the tiny oriel window-motifs are absent.

The interior of the first floor, with its innumerable murals, is the picture gallery of Sikh faith depicting its myths, legends and many significant events

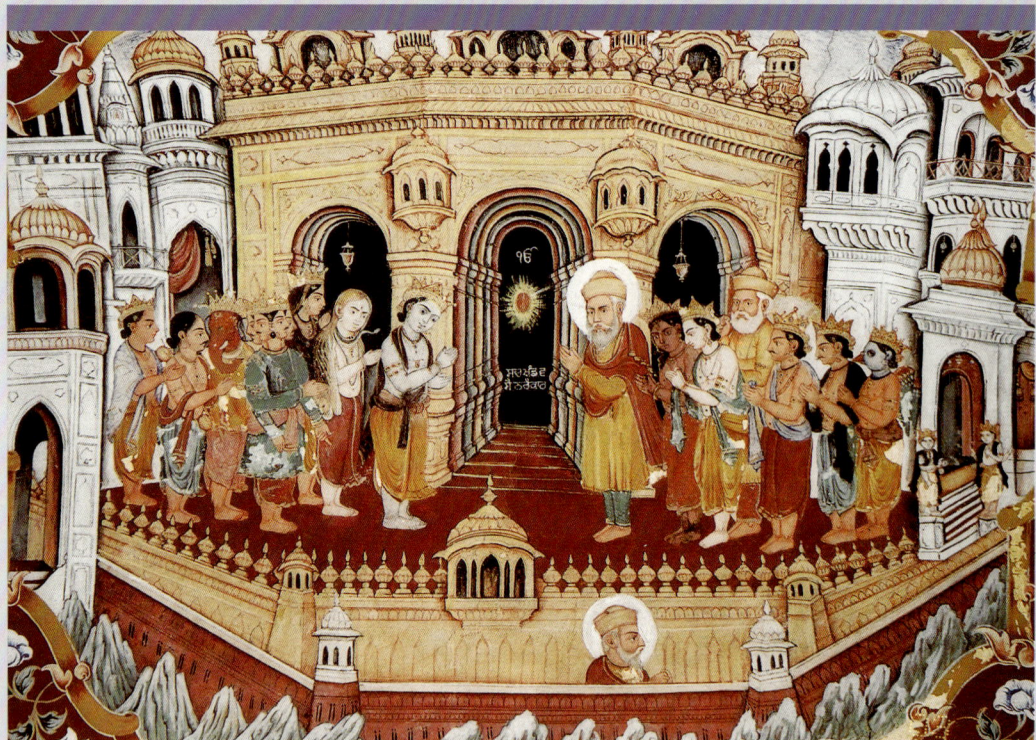

(Top) Prakash-utsava: The first floor walls of the tower of Baba Atal have painted on them excellent murals depicting various themes, but more particularly the *Janam-sakhi* episodes, of which 42-still survive. Of the two murals here, the upper one represents the *Prakash-utsava* of *Ek-Omkar* at Sri Harimandar Sahib with various Hindu gods and goddesses—Shiva, Vishnu, Brahma, Devi, Indra, Ganesha and Surya, etc., along with Baba Nanak and devotees are paying homage.

(Below) An episode from the Janam-sakhi: Baba Nanak is seated under a tree with Bhai Balaji and Mardanaji and two princes with folded hands are paying homage.

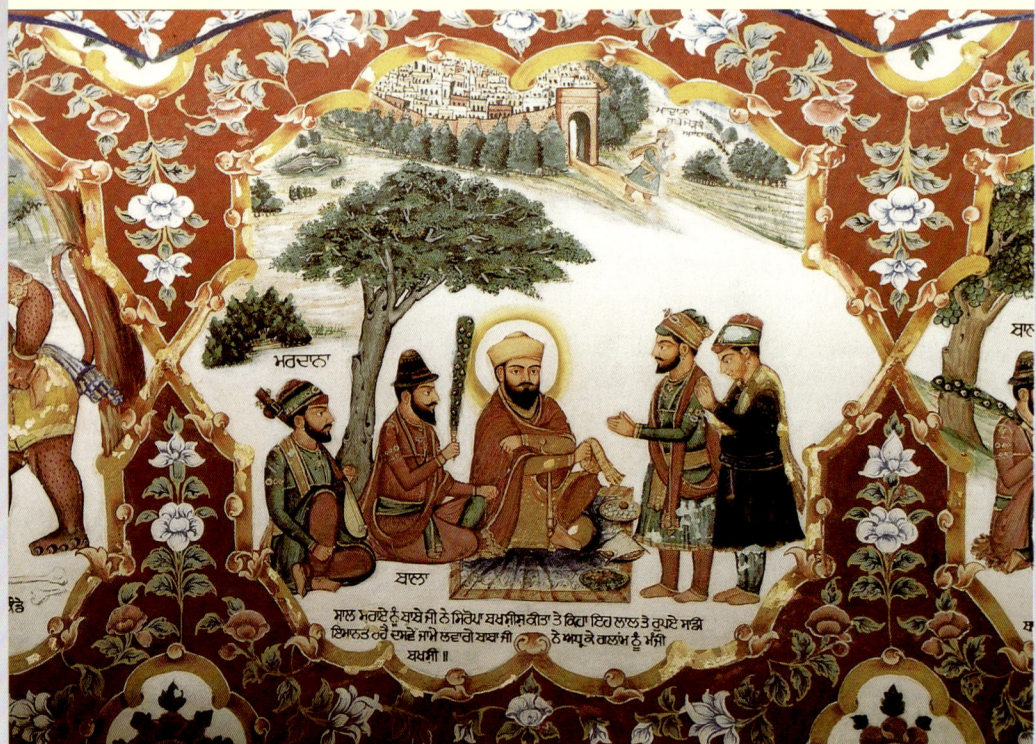

that occurred in the lives of Gurus as well in the tradition of the faith. Some of these murals depict the sacred Sri Harimandar Sahib and one of them the *Prakash-utsava* of *Ek-Omkar* at Sri Harimandar Sahib with various Hindu gods and goddess – Shiva, Vishnu, Brahma, Devi, Indra, Ganesha, Surya, etc., along with Baba Nanak and other Sikh Gurus paying homage. These murals are excellent in their depiction of birds, animals, floral motifs, creepers, *guldastas*, nature and architecture to include even *Baikuntha*, the abode of God. There

are others that portray various Gurus, eminent Sikhs, like Baba Dip Singh, Baba Buddhaji and saint-poets, like Raidas, Pipa and Baba Farid. Composed of various elements, folk and otherwise, and realistic and conventionalised, these murals present a unique panorama and a rich landscape throbbing with life-like vigour. An inscription makes a mention of Mehtab Singh naqqash, one of the painters who worked on the walls of Baba Atal.

Scenes, illustrating *Janam-sakhis*, constitute the larger segment of these murals. Some 42 panels, depicting the life of Baba Nanak still survive. The first of these panels depicts various gods praying the Almighty to let someone, able to redeem the earth from the evil of *Kaliyuga*, incarnate on it. The last one depicts Guru Nanak nominating Angad Dev as his successor. Various panels depict Baba Nanak with Bhai Balaji and Mardanaji and various rulers and rich men paying him homage. Scenes of his marriage, reception by his sister, his childhood, his visit to holy places, like Kurukshetra, and various legends and myths, some related to evil powers, one being the elephant demon, operating against him, are largely depicted in these murals. Sri Guru Arjan Dev, other Sikh Gurus and the two sons of Guru Nanak, Baba Sri Chand and Baba Lakhmi Das are also portrayed in them. The legend of Baba Atal has been portrayed on the main gate of the campus. Another significant series depicts the martyrs of Punjab to include the four sons of Guru Gobind Singh.

These murals, despite that the themes depicted in them and their form have not been interfered with, have been largely retouched making it difficult to assess their period. Michael Edwards is of the opinion that they were rendered during the early 19th century. Maharaja Ranjit Singh built its larger part by around 1821. He is not known to commission any such murals. Besides, one of the panels depicts Pandit Brij Nath teaching the child Nanak. The appearance of Pandit Brij Nath, as his teacher, has not been claimed in early *Jaman-sakhis* but rather in those of around 1880-85. Obviously, such illustrations could only be the subsequent works. Text inscriptions are a significant part of these murals, but the style of calligraphy used is considerably late. Company style effect, perceived in these murals, is a late phenomenon of about 1870-80. All this suggests that these murals might have been rendered during the last quarter of the 19th century. Indian red, ochre and other earthen colours, along with touches of gold, are more widely used in these murals.

The Gurdwara Baba Atal is in live worship and has its regular rituals and independent status. On *Gurpurabs, jalau* is also held here. The shrine has regular *langar*. As the tradition of faith has it, whatever the hour of the day, or night, one does not go hungry from Baba Atal's shrine. One has only to pray: *Baba Atal, pakki pakai ghal*, that is, "send me, O Baba Atal, duly cooked food" and the food he will get. In the past, some *samadhis* had cropped up around the shrine obstructing *Parkarma*. The same were demolished to have a freer circumambulatory. Now there is around the shrine a beautiful courtyard with mosaic of marble giving variegating effect. The shrine has attached to it some shops, houses, tracts of land, Kaulsar pond, Bazaar Baba Atal and Hansali street as its other properties and from them a substantial regular income.

Three Ber Trees and their Associated Shrines

The premises of Sri Harimandar have three Bers, or jujube trees, the Lachi Ber, the Ber Baba Buddhaji and the Dukh-Bhanjani Ber, which are the oldest inhabitants of the Temple complex. They were there before Sri Harimandar came into being and are not only the silent spectators of the journey of the new faith across the 400 years, but are also its active participants and benefactors. Had it not been for the charismatic role of the Dukh-Bhanjani Ber, there would not have been, perhaps, the *Amrit-sarovar*, the town of Amritsar or even the Sikhs' holiest shrine. It was largely because of the unique curing ingredients of the pond-water around the Dukh-Bhanjani Ber that Guru Amar Das had suggested his son-in-law and successor, Guru Ram Das, to develop this spot as the Sikhs' spiritual capital and the epicentre of their faith. It was in consideration of its ability to dispel all ailments and sufferings that Guru Ram Das called it Dukh-Bhanjani Ber, that is, the Ber that dispelled sorrows. In the Sikh tradition, it was after it cured Rajani's leprous husband that the Dukh-Bhanjani Ber began acquiring its ritual significance. The Dukh-Bhanjani Ber stands in the centre of the eastern plank of the *Amrit-sarovar*.

The Ber, revered as the Ber Baba Buddhaji, that stands on tank's northern bank, is not as legendary as the Dukh-Bhanjani Ber, but its role is as much significant. When Baba Buddhaji supervised the tank's construction, this Ber extended over his head its umbrella-like leafy branches for protecting him from parching summer and roaring clouds. Thus, though humbly, the Ber Baba Buddhaji served Guru's cause in its own way. The Lachi Ber, which flanks the *Darshani Deorhi* on its northern side, played a dual role, the transcendental and the material. When Sri Guru Arjan Dev supervised tank's construction, it served as canopy over him, not allowing even an isolated sunray to pierce across and

Dukh-Bhanjani Ber:
Dukh-Bhanjani Ber, which is about five hundred-years-old, is in a way responsible for the construction of the *Amrit-sarovar* and Sri Harimandar Sahib. It is situated in the centre of the eastern arm of the Parkarma. Numerous legends indicate that the healing quality of the waters under Dukh-Bhanjani Ber had attracted first Guru Amar Das and then Guru Ram Das to develop the site as a huge *sarovar* and found a township around here. The water under Dukh-Bhanjani Ber yet has the same healing properties and cures numerous ailments.

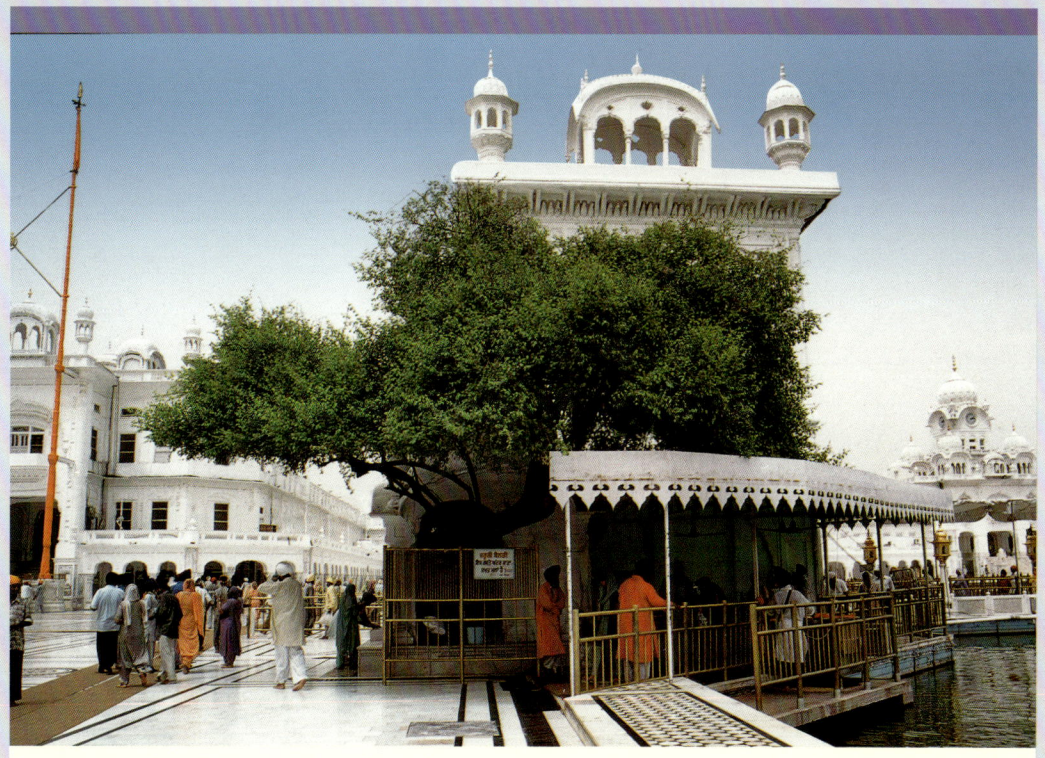

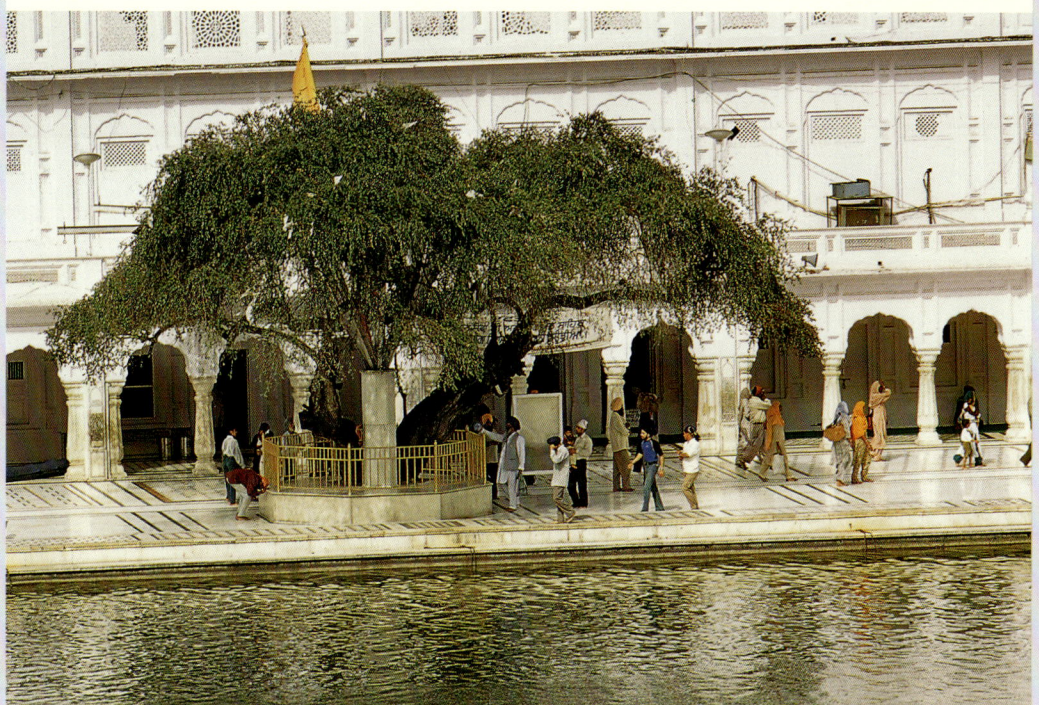

Lachi Ber and Ber Baba Buddhaji:
Two other jujube trees that have the sanctity of a shrine in the Sikh tradition are Ber Baba Buddhaji and the Lachi Ber. The lower one, the Ber Baba Buddhaji, stands towards the western end of the northern arm of the Parkarma and the upper one, the Lachi Ber adjacent to the *Darshani Deorhi*. As the tradition has it, Baba Buddhaji was one of the two Sikhs whom Sri Guru Amar Das had sent with Sri Guru Ram Das to assist him in the construction of the *sarovar*. Baba Buddhaji used to sit under this very jujube tree, and hence, it has his name associated with it. Lachi Ber has a different significance. Here Sri Guru Arjan Dev used to sit while supervising the construction of Sri Harimandar Sahib. It hence also has a Gurdwara attached to it.

disturb the 'Divine'. Things changed. The local Muslim chief Massa Ranghar occupied the Temple and desecrated it. Mehtab Singh Mirankotia, a veteran Sikh from Buddha Jauhar in Rajasthan, reached here to punish the intruder. The Lachi Ber preceded all others in assisting him. Besides giving him inspiration, the Lachi Ber gave to his horse shelter and safety to rest, as it was to this tree that his horse was roped.

Two of these Bers, the Lachi and the Dukh-Bhanjani, have associated with them small but independent Gurdwaras with the Holy *Birs* enshrining

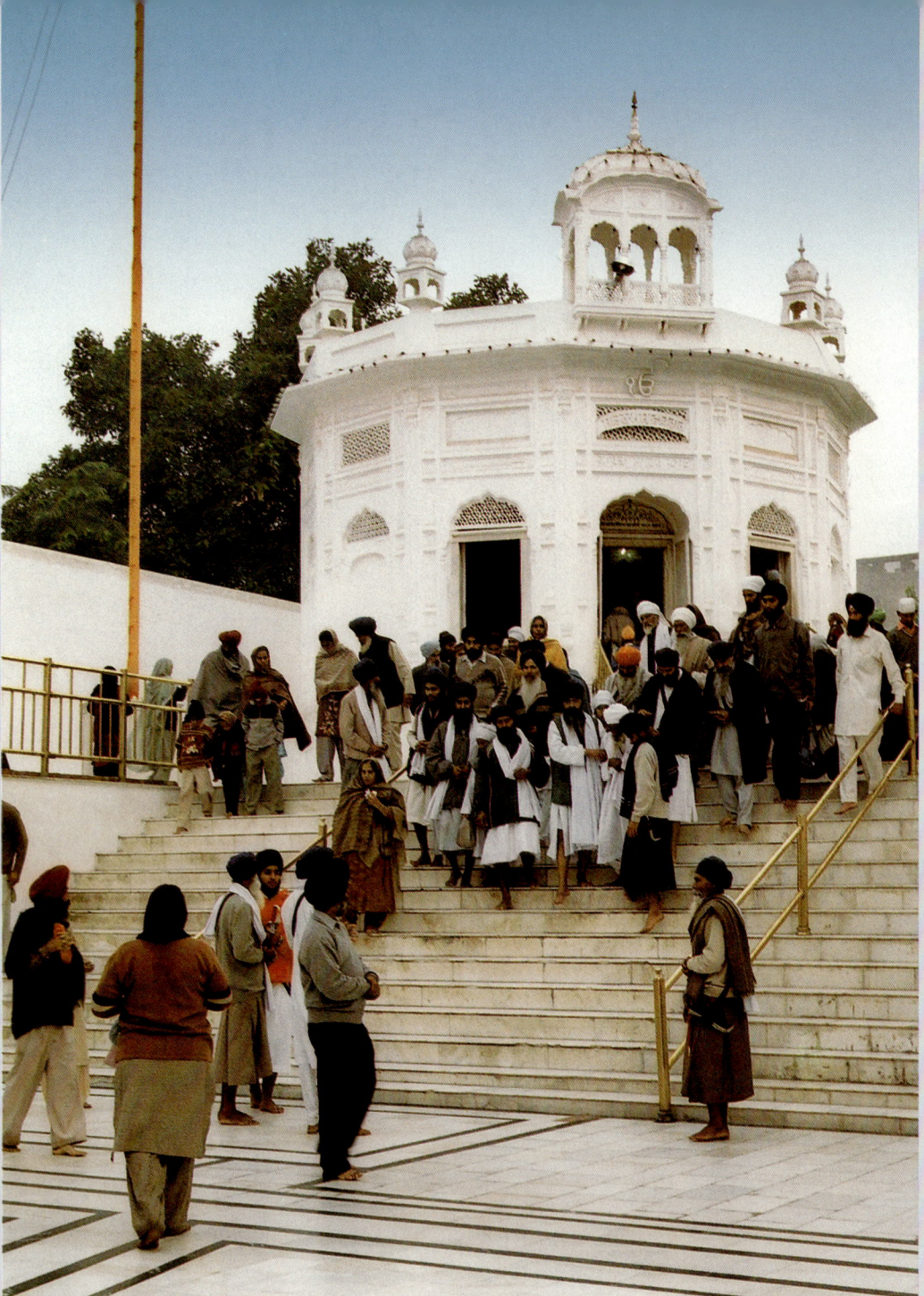

Gurdwara Thara Sahib:
Gurdwara Thara Sahib is a charming mini shrine with twelve sides. It is situated in close vicinity of the Akal Takht towards its north in the middle of Bazaar Thara Sahib. It is said, Sri Guru Teg Bahadur, after his ascendance, came to visit Sri Harimandar Sahib, but Sodhi Harji, the grandson of Prithi Chand did not allow his entry into the shrine. Sri Guru Teg Bahadur quietly returned but for a while, before he went back, he sat here on the *'thara'*, a raised land part. Gurdwara Thara Sahib commemorates the incident.

them and regular *granthis* and *sewadars* in attendance. The Ber Baba Buddhaji has around it a marble podium, which also has the status of a shrine. But, irrespective of their associated shrines, these three Bers have earned for themselves the sanctity of shrines. Incidentally, they yet adhere to their prior character. The Lachi Ber provided spiritual strength. It now serves all Temple visitors with the *karah-prasad*, the source of energy, the physical as well as the intrinsic. The Dukh-Bhanjani Ber yet dispels ailments and the Ber Baba Buddhaji yet protects from the parching sun. Every head that enters the Temple complex bows in reverence to Baba Buddhaji, every arm takes a handful of *amrit* from the Dukh-Bhanjani Ber and sprinkles it over his person and every hand extends towards the Lachi Ber for receiving Guru's benevolence in the form of *karah-prasad*. This Tree-trio extends its blessings perpetually and for all.

Athsath Tirath:
Close to the Dukh-Bhanjani Ber is situated a marble platform along with a chhatri. It was here where Sri Guru Arjan Dev used to sit when supervising the construction of Sri Harimandar Sahib. As the tradition has it, the *Bani-Pothi*, which Sri Guru Arjan Dev had himself brought from Baba Mohanji, the eldest son of Sri Guru Amar Das, was first brought here.
A dip in water near Athsath Tirath is believed to be equal to bathing at 68 holy places.

Gurdwara Thara Sahib

The Gurdwara Thara Sahib, a small shrine, is dedicated to the Ninth Guru Teg Bahadur, and commemorates his visit to Sri Harimandar. It is a simple conventionalised structure cast like a rounded platform with twelve sides. On parapet level there is on each angle a small minaret with a kiosk surmounting it. The main entrance is on its east and a *baradari* adorns its apex. It has a basement chamber, which is known as *Bhora Sahib* and is one of the most suitable places in the entire Harimandar Sahib complex for meditating in peace and quietude. The Gurdwara Thara Sahib is situated towards the northwest of Sri Harimandar and close to the Akal Takht in the midst of bazaar Thara Sahib. As the tradition has it, after his ascendance to the *Gurugaddi*, Guru Teg Bahadur came to pay homage to Sikhs' highest seat, Sri Harimandar which was

Baba Deep Singh:
In the southern arm of Parkarma, a small platform is dedicated to Baba Deep Singh. The founder of the Shahid misl Baba Dip Singh, fought till last to prevent the intruding forces of Ahmad Shah Abdali from entering into the Holy Temple. As goes the legend, he held his severed head in his left hand and with the khanda in his right, he continued to fight and chased the intruders from the Temple premises and abandoned his life only after the Temple was liberated.

(Facing page) **Bungas and Langar-ghar:**
There is no authentic record as to when the two bungas and Langar-ghar were built, but in their tenure, whatever it is, if the two bungas have witnessed millions of heads, mighty ones or otherwise, bowing at the threshold of Sri Harimandar Sahib, the Langar-ghar has fed as many stomachs, the rich or the poor, with alike benevolence and care. In-between the towering bungas, the *Baradari*, which comprises the apex of the Langar-ghar, has the look of a glittering princess guarded by tall, mighty soldiers.

then under the control of Sodhi Harji, the grandson of Prithi Chand. Instructed by him, the *pujaris* and *mahants* on duty forbade the Ninth Guru from entering the temple premises. It is said the peace-loving saint, did not dispute and returned. Before he left, he rested for a while here on a *thara*, literally an earthen platform. Later, Sikhs built over the earthen platform this Gurdwara known popularly as Gurdwara Thara Sahib.

Athsath Tirath, or sixty-eight pilgrimage centres

The Athsath Tirath, a marble platform cast in the shape of a *manji*, is only a minor member of the architectural commune of Sri Harimandar, but it abounds in as much sanctity. It is said bathing once at the *Athsath Tirath* is as auspicious as the pilgrimage of the 68 holy places in India. The *Athsath Tirath* is situated opposite the *Har ki Paudi* in the centre of the eastern bank of the *Amrit-sarovar*. It stands close to the Gurdwara *Dukh-Bhanjani Ber*. It is said Sri Guru Arjan Dev, while supervising excavation of the tank, used to sit here. After Sri Guru Arjan Dev was able to obtain from Baba Mohanji the Holy *Pothi*, containing *Bani*, it was brought from Goindwal first at the *Athsath Tirath*.

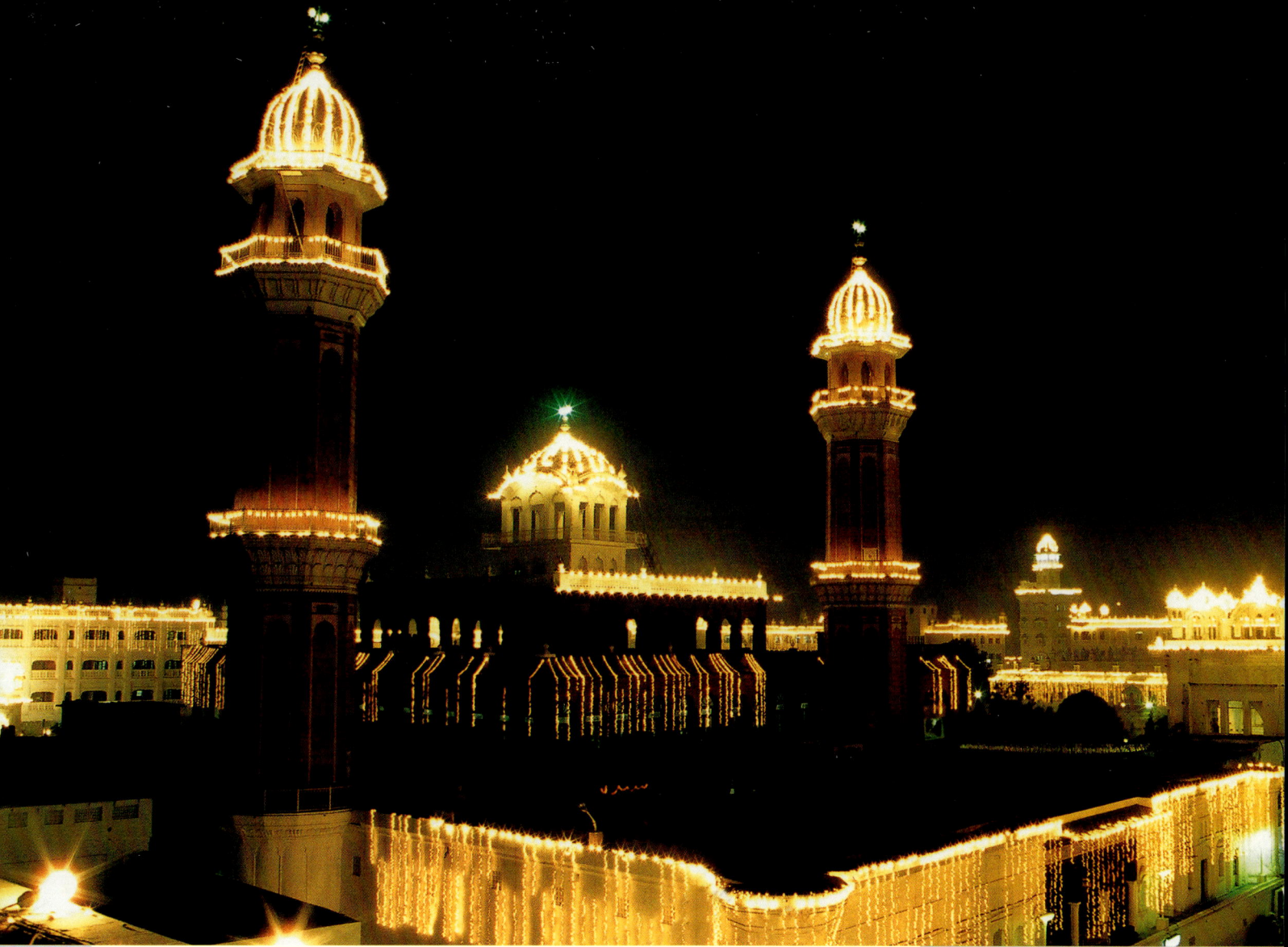

Manji Sahib

The Manji Sahib is a huge congregational hall used for lectures and mass religious activities. This hall is situated beyond the eastern entrance to the Golden Temple complex, opposite the Langar building and adjacent to the Mata Ganga Niwas on its north. Sant Bishan Singh initiated the construction of the Manji Sahib. It seems, before the *Amrit-sarovar* developed into a square form, its eastern bank was its functional side and fell on the highway leading to Peshawar and beyond. Hence, when day's work was over, Sri Guru Arjan Dev sat here on a *manji*, or cot, and distributed provisions and wages to the labour engaged in the construction of the tank. Quite possibly, the spot developed into a garden during his lifetime. After the tank had fully evolved and the construction of the Temple was begun, for convenience and security, the seat of Sri Guru Arjan Dev, as also the focus of *Panth's* activities, were shifted to the Lachi Ber on tank's west. Subsequently, the spot was developed into a proper garden, the Guru ka Bagh, dedicated to Sri Guru Arjan Dev. The *Udasi* sadhu Gopal Das made outstanding contribution in developing the Guru ka Bagh. The Manji Sahib is built using the larger part of the Guru ka Bagh. A beautiful marble platform marks the spot where sat Sri Guru Arjan Dev on the *manji*, his seat. The name of the hall commemorates this Sri Guru Arjan Dev related context of history. In an adjoining chamber, there enshrines the Holy Sri Guru Granth Sahib.

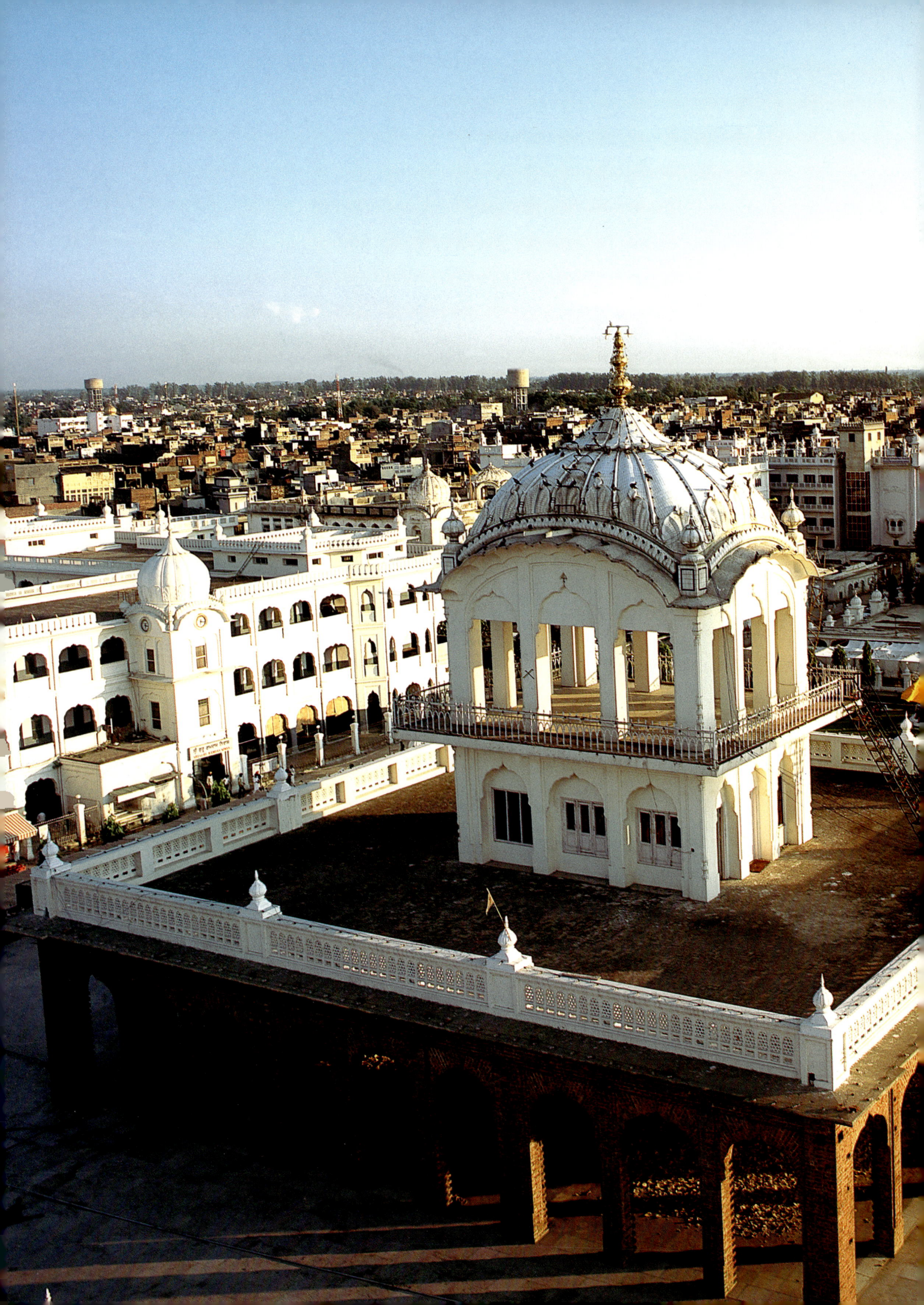

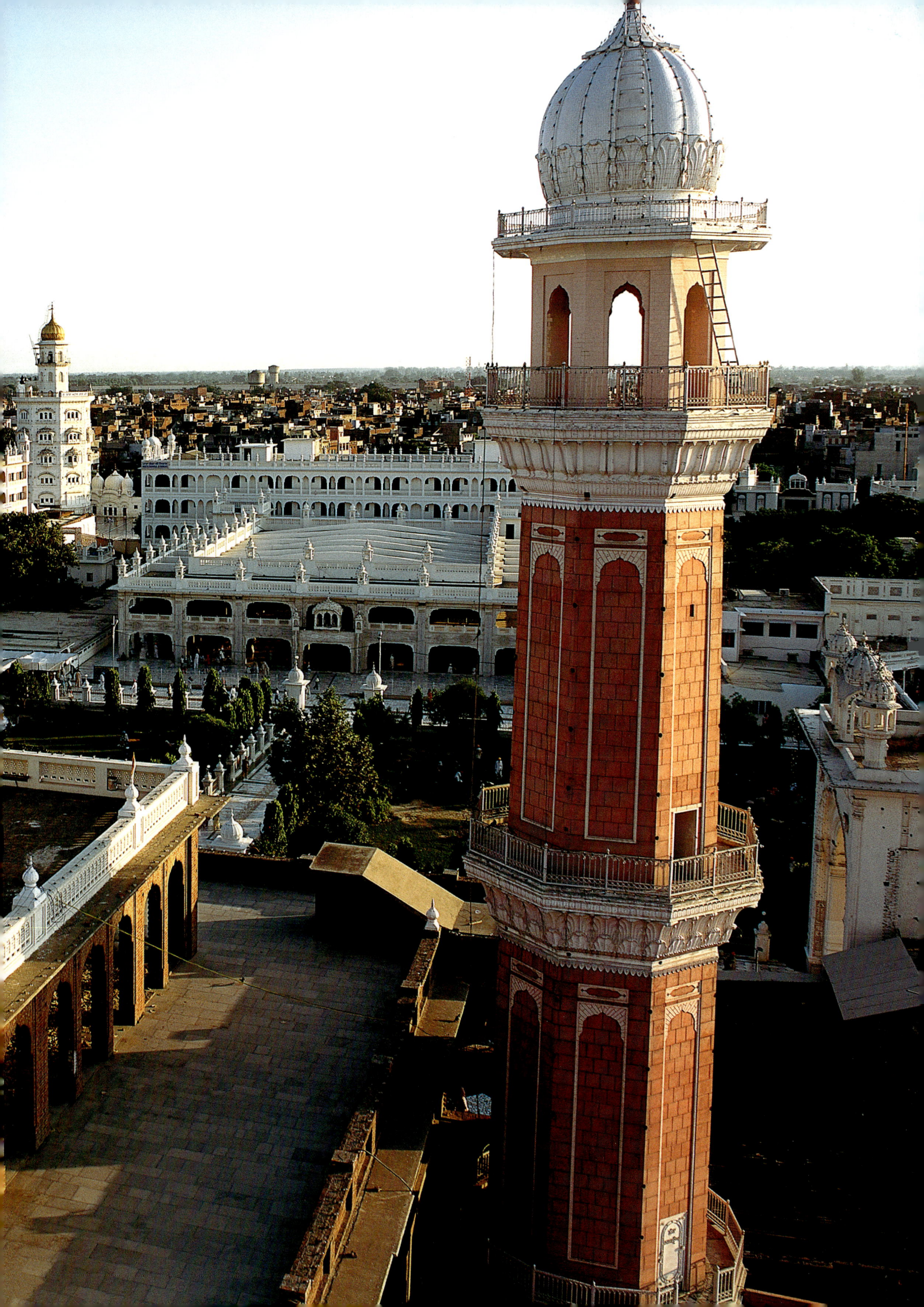

Langar: Langar is perhaps as early a tradition in the Sikh *Panth* as that of the recitation of the *Bani*. Langar, in the sense of feeding the needy, was born with Baba Nanak's '*Sachcha Sauda*'.
In the tradition of Nanak, Almighty's bounteousness was first realised in feeding the 'empty stomach'. Later, it also turned into a social institution of Sikhism, which led the *Panth* towards eradication of all discriminatory factors and building a casteless society.
In one of the two pictures, *sewadars*, both male and female, are engaged in cooking, while in the other, the Langar is being served.

(Preceding Page)
The tower and the town:
Though a panoramic view of the far-stretching township and the Temple complex, it also has in its focus a series of significant buildings, the tower or the shrine of Baba Atal, Manji Sahib, Teja Singh Samudri Hall, Mata Ganga Niwas, Langar-ghar and one of the two *bungas*. Perching on the square terrace, the dove-like translucent *Baradari* is stunningly beautiful.

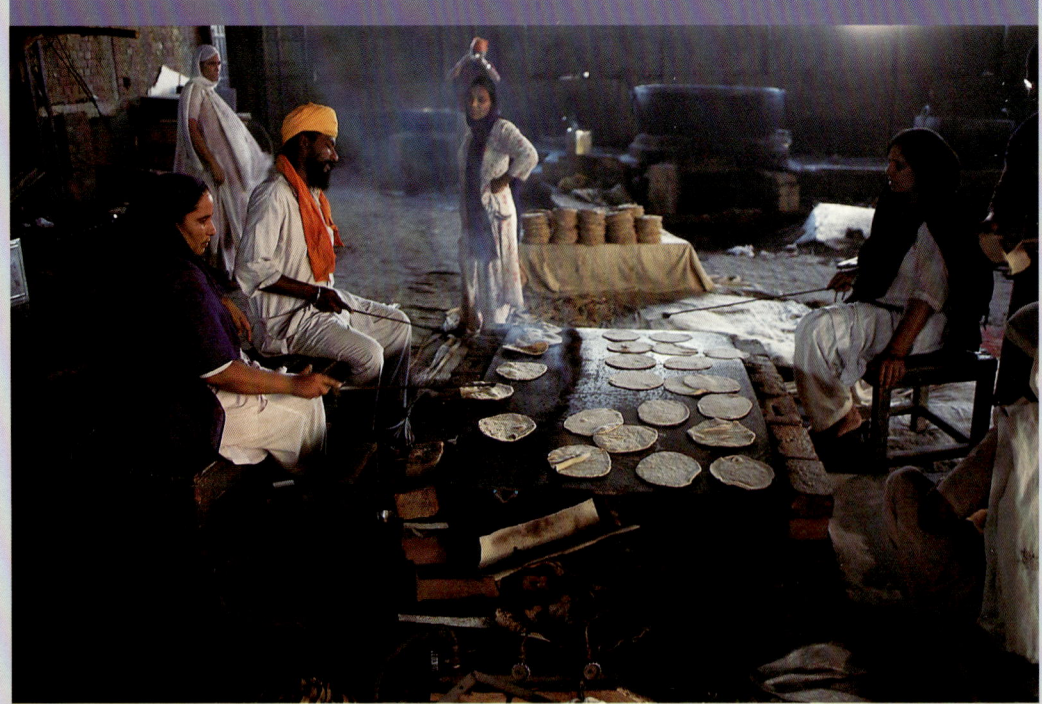

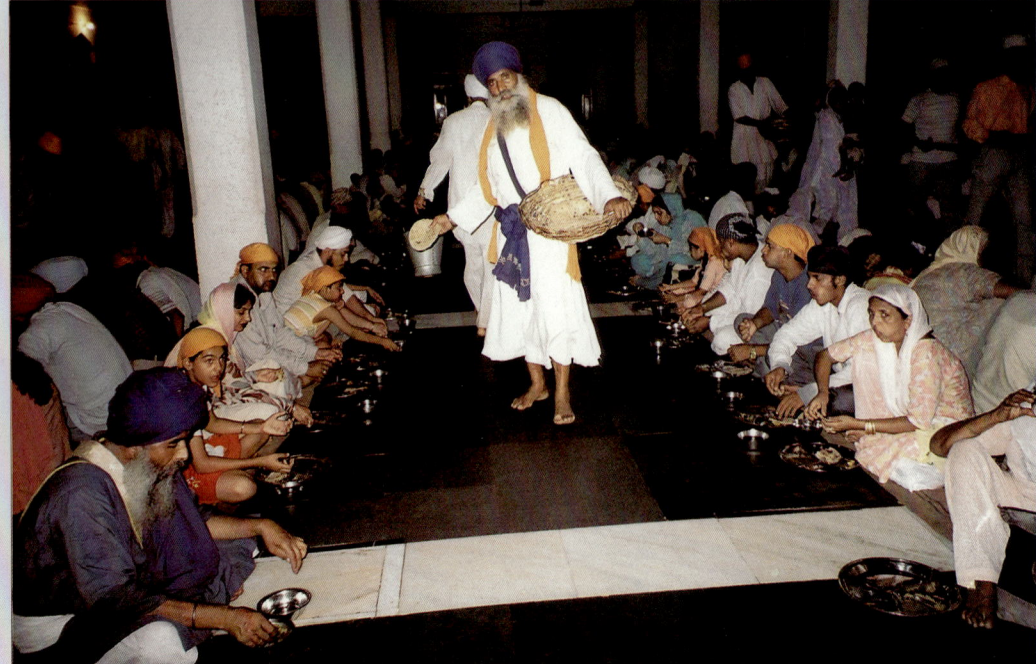

Langar Ghar and Langar

The Langar, or the community kitchen, is situated opposite the Manji Sahib. It is a simple functional building consisting of a number of colonnaded large halls, flanking verandahs and open marble clad spaces for dining and some smaller rooms for various other purposes. The Langar-ghar is structurally a three-storeyed building with the basement extra. Of the three floors, only the ground floor is its functional part. The two upper floors consist of a domed structure, which is more or less decorative in character. It lay in the centre of a large terrace. From outside it appears to consist of a single floor, but inwardly it is

divided into two floors. Different from most other buildings in the Golden Temple complex, which are either marble-covered or painted in white, the Langar-ghar has a brick-red façade, although its domed surmounting structure is the same milky white. The basement, which opens on the main building's north, houses stocks of eatables. This northern wing of the Langar has an administrative office, which records and controls all receipts and dispatches and assures smooth functioning of the Langar. This hind part of the Langar provides for cooking, cleaning of utensils and other related activities.

The Langar is both, the institution and the rite, and in both cases the earliest of Sikh institutions and rituals. The Langar was born with Baba Nanak's *Khara Sauda* episode. In the tradition of Nanak, Almighty's bounteousness was first realised in feeding the 'empty stomach'. Later, it also turned into a social institution of Sikhism, which led the *Panth* towards eradication of all discriminating factors and building a casteless society. The Langar is now the foremost and the most sacred ritual. The Langar at the Golden Temple daily feeds nearly 35,000 pilgrims on an average. On special occasions, the *Gurpurabs*, Diwali, or Baisakhi, the number of pilgrims feeding at the Langar crosses the figure in lakhs, but the bounteous Guru always has enough to feed each one of them. On the other hand, the pilgrimage is only half-achieved, if one returns without obtaining *parsada* at the Langar.

Shrine of Baba Dip Singh

Close to the southern entrance, there is, in the *Parkarma*, a semi-circular stepped marble podium with a donation box attached to it. This architecturally insignificant structure is known as the shrine of Baba Dip Singh, which commemorates his unique sacrifice for the *Panth*. Baba Dip Singh, the founder of the *Shahid misl* and the Damdama school of Sikh learning, laid his life defending the Holy Temple from the intruding forces of Ahmad Shah Abdali led by one of his generals, Jahan Khan. It is said, it was near Ramsar that the forces of Baba Dip Singh and Jahan Khan confronted. The intruding army was much larger and better equipped than the meagre Sikh forces. The Sikh forces fought with unique valour but could not prevail over the intruder. Baba Dip Singh was himself grievously injured. But, bleeding all over, he rushed to the Temple and when the invaders reached here, he obstructed them from entering it and fell dead on the spot where stands this shrine. As goes the legend, his head had been severed, but he did not let it fall. He held it in his left arm and, wielding his *khanda* with his right, chased the intruders and abandoned his life only after the Temple was liberated.

The Two Towers

The two granite-clad imposing towers, towards Temple's east-north, are popularly known as Bungas Ramgarhia. They are typically Islamic in their architecture, though are incorporated here for an absolutely different purpose. They are essentially watch-towers. Initially these towers had a spiral apex as they have now. It seems, during an invasion these towers were toppled down and when

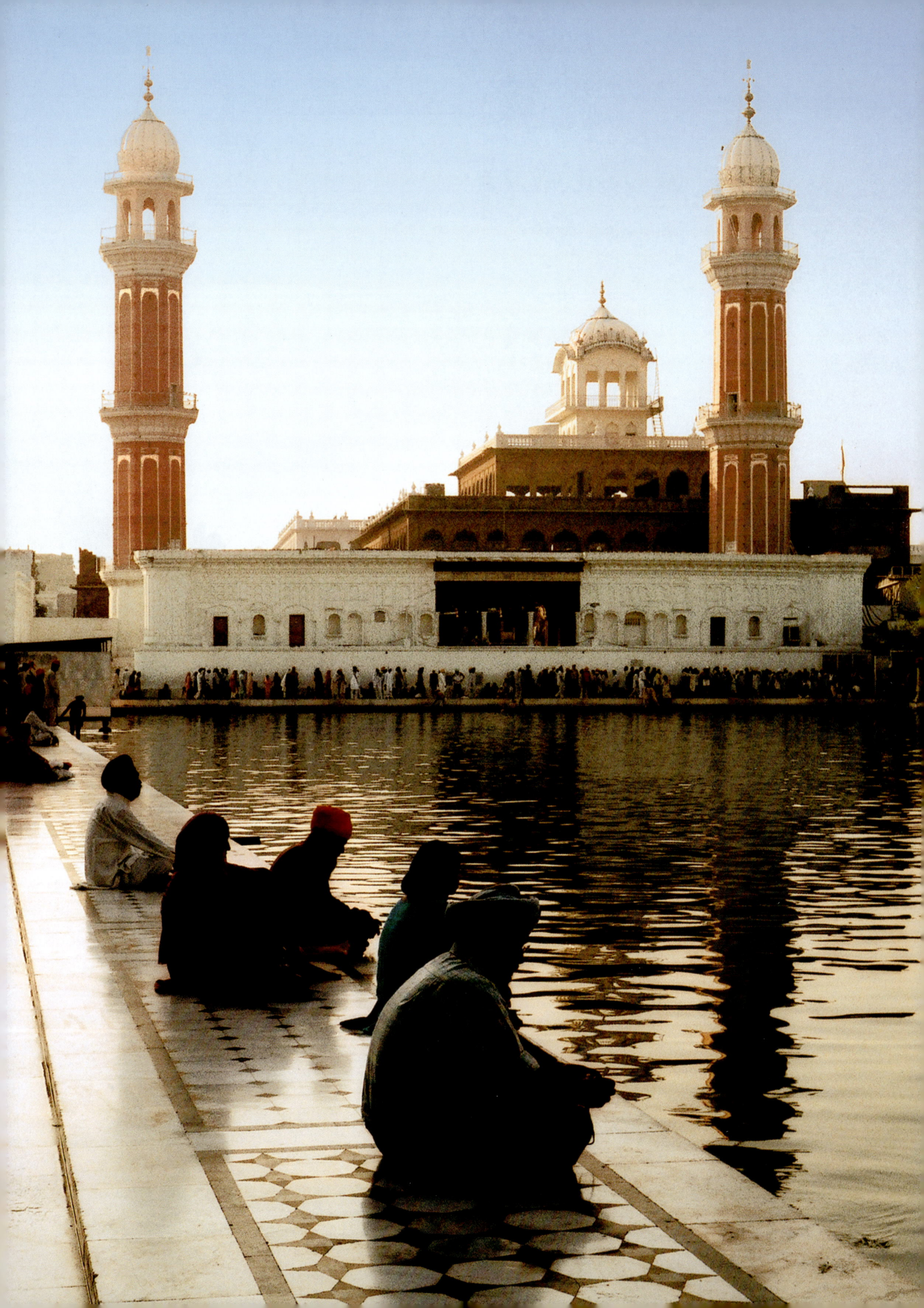

reconstructed, they were modelled differently, much like Lahore's Badshahi Masjid, with a flat roof atop. Till 1984, these towers had the same flat terraced apex with balustrade all around it, but when they were reconstructed after 1984, they were once again modelled with the spiral apex, such as they originally had. How these watch-towers came to be known as *bungas* is difficult to say as in the Temple's historical context the term *bunga* had quite a different meaning. The term *bunga* meant 'abode' and the Golden Temple had around it once a number of *bungas* falling under the four categories, namely, the misl *bungas*, the personal *bungas*, the community *bungas* and the ecclesiastic *bungas*. Even Akal Takht was initially called the Akal Bunga. In the Sikh tradition, these *bungas* had a vital role to include temple's security, as whatever their kind, they essentially housed the Sikh *jatthas* deployed to secure Sri Harimandar Sahib against invaders. Maybe, influenced so, these watch-towers, as the prime object of these towers too was temple's security, were also assigned the same name.

The Northern and the Southern Gateways

On all four sides, beyond the *Parkarma*, Sri Harimandar Sahib complex has a chain of buildings lying in a straight symmetrical line. They align on all four corners into right angles and constitute a perfect square. These buildings represent a blend of various building styles of Indian and Islamic origin with elements of Bengal, Rajput and Mughal architecture dominating. Broadly, they adhere to Rajput castles and functionally also they are non-ritual in use, such as residences of the Temple staff, various offices, stores and two large areas accommodate the Central Sikh Museum and the reference Library. This chain breaks on its west for accommodating the towering Akal Takht and on its east, north and south for portals for visitors' entry. The eastern gateway is comparatively an humble structure but those on the north and the south are massive three-storeyed towering buildings befitting one of the world's most visited shrines. Both, the northern and the southern gateways are identical in their architecture, yet the northern one constitutes the main entrance to the shrine. These portals and aligning buildings are the late entrants into the family of the Golden Temple building complex.

The northern gateway, the earliest of the three, evolved in 1862, when the British Government built here, after demolishing the *bunga* of Kanwar Naunihal Singh and the *attari* of Rani Sada Kaur, both highly revered by the Sikhs, a Victorian style clock tower. This act of the British grievously hurt Sikh sentiments. Hence, after the Temple management came under the Sikh control in 1926, this clock tower was pulled down and a lofty entrance was erected in its place. Its southern counterpart evolved under the principle of symmetry and beautification of the entire complex. The eastern one, it seems, has not been given the towering height of the other two portals, lest it obstructed the passage of morning sun, which illuminates the Temple to its utmost splendour.

The interior of both, the northern and the southern portals, have one-storey extra height. Their ground floor is practically the first floor from the *Parkarma*. The actual entrance on the ground floor has been divided into three sections by two rows of square pillars. The section in the centre has greater width than

(Facing Page) The day breaks: The east has unveiled its curtain of darkness and has allowed the sun to awaken. And, Lo! The rosy glow spreads all around. The milky white turns pink, like a coy maiden's face, and the crimson towers are yet to discover their true colours. The *sarovar* throws its dark blanket away and wears glittering gold and the devotees, as they know that a word of devotion uttered in the morning is equal to the whole day's penance, gather around the holy *sarovar* and commemorate the '*Nam*'.

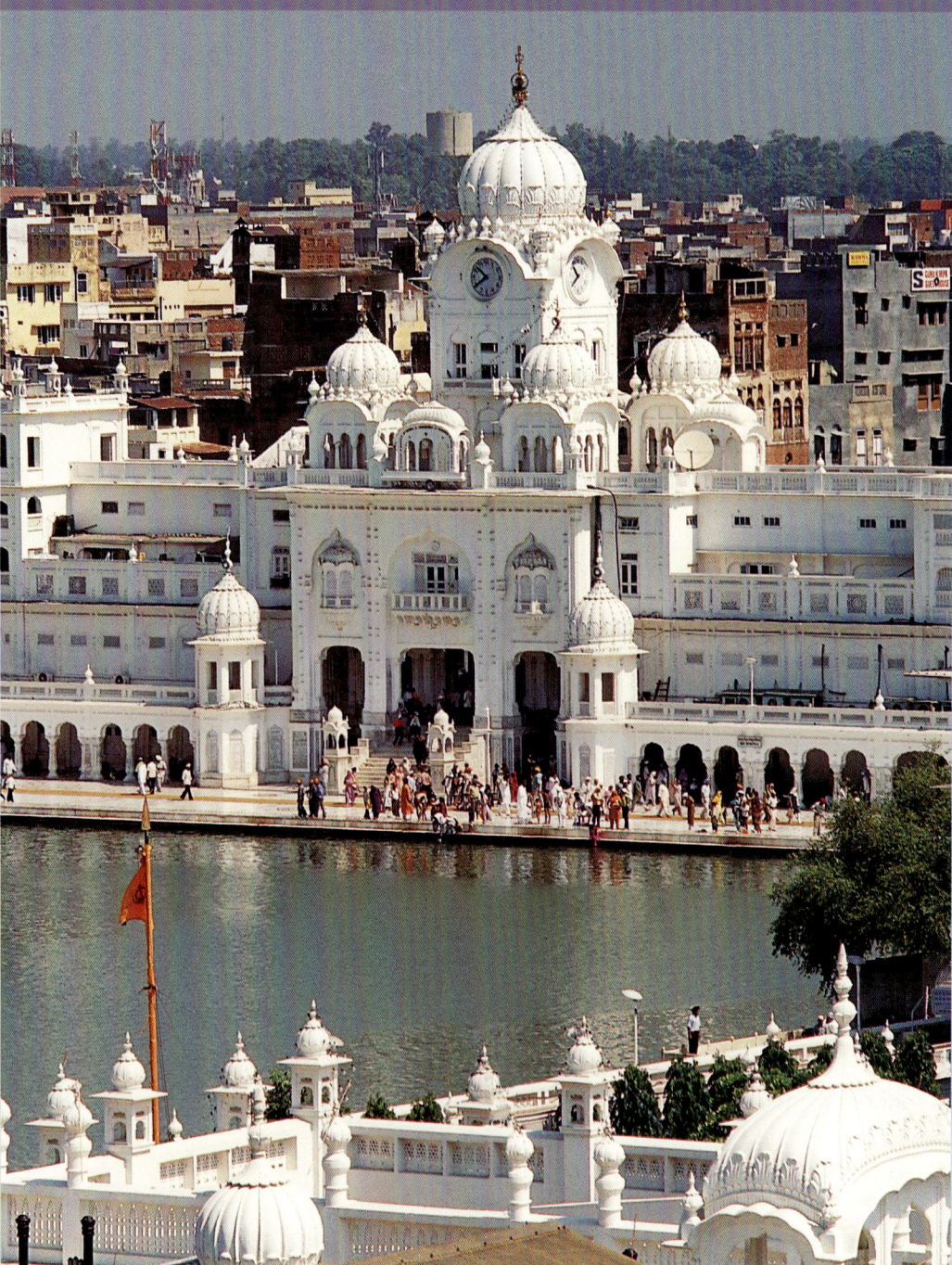

The Northern gateway:
The majestic three-storeyed Northern gateway is the main entrance to Sri Harimandar Sahib complex. From its terrace rises a two-storeyed clock tower with a fluted dome surmounting it. A cluster of three diversely designed kiosks define the exterior and the interior of the terrace parapet. This gateway, as also the others, is a late addition of the 1930s. Early, here stood a Victorian clock tower built by the British Government by demolishing the *Bunga* of Kanwar Naunihal Singh and the Atari of Mata Sada Kaur, highly revered by Sikhs. In 1925, the Temple management was passed over into the hands of Sikhs and the first thing they did was the demolition of the British tower and erecting in its place this present gateway.

the other two, though their depth is equal. The passage, from the exterior to the interior of the portals, in each section, constitutes a large spacious hall, which has on both of its sides enough space for pilgrims to sit, meditate and relax. The marble doorframes on both sides, the interior and the exterior, consist of corbelled arches rising from beautifully cast pillars. On both sides, there are stairways leading to the upper floors. On the interior side, all three sections have flights of stairs leading to the *Parkarma*. Octagonal kiosks flank them on both sides and the end parts of the parapets guarding the stairs have been negotiated with beautiful turrets.

Both portals have a domical superstructure surmounting them, beautiful pillar-based kiosks on all four corners and two rectangular *chhatris* in the

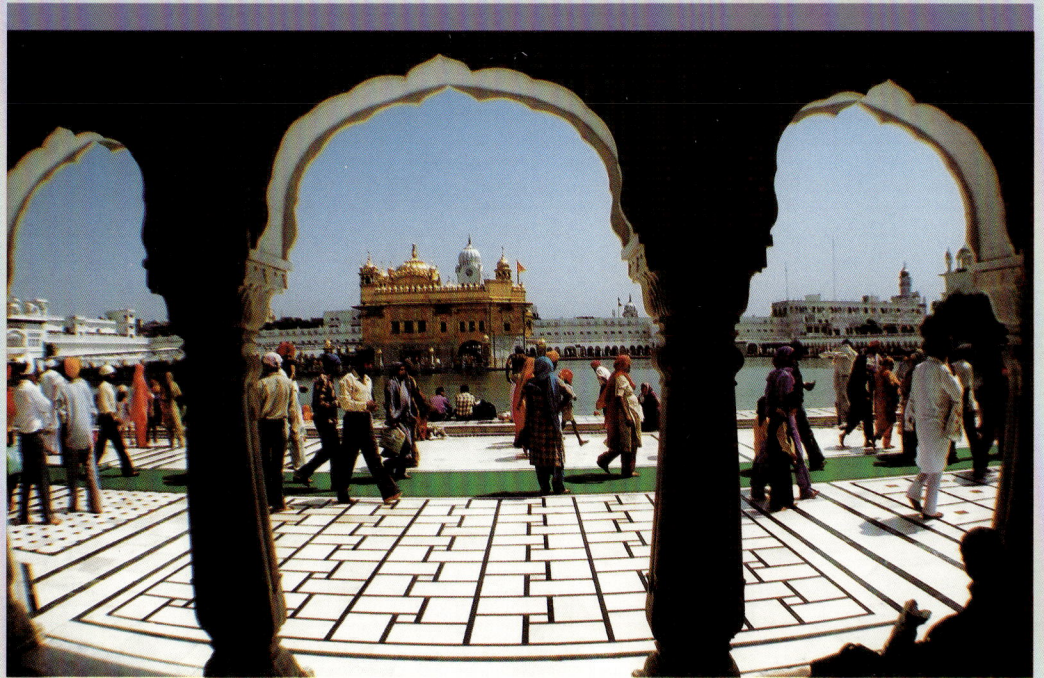

centres on both sides, the interior as well the exterior. All domes are fluted and circular except those of the *chhatris* in the centre. They are rectangular. The central dome has under it a towering square structure, which on its interior has two floors. The lower one, which constitutes building's second floor, is a chamber with three rectangular windows on each wall and the upper one, which constitutes building's third floor, is the clock chamber with clocks fixed on all of its four walls. These superstructures have beautifully designed eaves and elevation. On the terrace level, the entire building ring, covering all four sides of the complex, has a symmetrically designed eave on its interior, that is, towards the temple, as well as on its exterior. A parapet surmounts and defines the terrace, again across the entire building ring. The parapet has all its interior and exterior angles negotiated with corner turrets. Oriel windows, projected balconies and latticed parapets used on various levels elevate the entire façade to great magnificence.

So much for the building architecture, but more significant is the transcendental quality, that envelops this simple puritan brick structure and the total atmosphere around the august shrine. The moment one enters any of the gateways leading to the Temple, the magic begins working on him and spell-bound he walks into a realm so different from his own. Upon the seat of sapphires, there couches His Majesty, the gold-crowned monarch, who has at its command the entire creation and the time and the space, as its presence enlivens all created things and imparts its glow to each moment of time and each inch of space. The sun attends upon it to pay as levy a part of its brilliance and the moon and stars await their turn. The waters below bear it on their bosom and sing the songs of its grandeur and glory. The heights of skies bow to it and oceanic depths discover themselves at its feet. Across the corbelled doorframes, its beauty is exceptional. A huge mass of building structures, somewhat cumbersome, cluster around, but as a vast palatial expanse only adds to the glory of the crown. And, then there emerges from oceanic depths the gold-dressed Being, *the body visible of the invisible Supreme.*

His Majesty within an arch:
Couched upon a rich green carpet with a row of milky white structures behind, His Majesty, the Golden Monarch, has splendour beyond par. Though vastness is the part of its magnificence, but sometimes, as here, this vastness, when identified in smaller areas, is better defined.

Glossary

Abadi: Settlement; populated land-part exempt of land-revenue fees.
Akhand-path: Unbroken recitation of Sri Guru Granth Sahib.
Ardas: Prayer.
Arti: Prayer rendered with a lighted lamp and recitation of hymn.
Asadivar: A set of hymns from Sri Guru Granth Sahib; one of the special services rendered at the shrine.
Attari: A castle with two or more floors.
Bani/Gurbani: One and all verses, which Sri Guru Granth Sahib contains.
Baradari: A pavilion with twelve openings - three on each side.
Bhadon: The sixth month of Indian calendar.
Bhangi Misl: One of the many confederacies prevalent in Punjab those days.
Bhai: Brother; a term denoting exceptional reverence to someone.
Bibi: Elder sister; a term expressing exceptional reverence to a lady.
Bikrami calendar: Calendar with its Era commencing from the reign of the legendary Bikramaditya, usually spelt as Vikramaditya.
Bir: A popular nomenclature of Sri Guru Granth Sahib.
Chamwar/Chauri: Flywhisk.
Charan Kamal Arti: One of the special service rendered with a lighted lamp and recitation of hymn everyday in the afternoon.
Charbagh: A garden laid with four equal squares.
Chhatra: Umbrella, usually held suspending over a throne.
Chobdar: Standard-bearer.
Chowki: A seat; a ritual procession carried out around Sri Harimandar.
Dera: Camp.
Dharmashala: Initially, abode of righteousness; subsequently, accommodation for pilgrims.
Ekam: First day of a fortnight according to Indian calendar.
Farmans: Writs; communications ordering accomplishment of something.
Garbhagraha: Sanctum sanctorum.
Garund-Dhwaja: A pillar with Garuda (the bird that is the vehicle of Lord Vishnu) capital raised in front of all Vaishnava temples.
Ghat: Embankment with flight of steps leading to river or pond water.
Ghee: Melted butter.
Gompa: A Buddhist temple-type.
Granth: Collection of writings. Here, The Holy Scripture of Sikhs.
Granthi: A person appointed for reciting the Holy Granth.
Guldastas: Bunch of flowers.
Gur: Lump of raw sugarcane juice.
Gurdwara: Sikh shrine; door to enlightenment.
Guru: Spiritual teacher; Sikhs' Preceptor or Pontificate.
Gurugaddi: The seat of the Pontificate.
Guruship: Authority of the Pontificate.
Hansali: The canal that fed the tank around the holy shrine.
Hari: One of the terms to address the Almighty with.
Jagir: An estate or holding; assignment of a land or its revenue.
Jalau: Periodical display of sacred relics.
Jalwa: Splendour.
Janam-Sakhis: Testimonies of a great birth; tales related to Guru Nanak's life.
Jap Sahib: Hymn composed by Guru Gobind Singh, which commemorates the Timeless One by hundreds of names.
Japuji Saheb: Guru Nanak's first hymn; opening Canto of the Adi Granth.
Jaratkari: Art of inlaying coloured stones into a marble-clad surface.
Jattha: Band of soldiers, devotees or others.
Kachcha: Unfortified; that which has not been enforced.
Kalasha: Pot; in architecture, finial or apex of a dome.
Kaliyuga: Indian tradition divides the cosmic age into four aeons, of which the concurrent one is Kaliyuga.
Karah prasad: Food - usually prepared from flour, butter and sugar, distributed to devotees after it has been offered at the shrine.
Karta-Purukh: The Supreme; Doer of all things.
Kataras: Localities.
Khanda: A double-edged sword, highly sacred and significant in the sect.
Khula Path: Phased recitation of the Holy Granth.
Kirtana: Devotional music with hymns sung from the Holy Granth.
Kirti/Vijaya-stambha or mahastambha: An ancient building-type, a tower, usually erected to commemorate a great victory or other prestigious deed.
Kuka Namadhari: A sub-sect of Sikhs who wore pure white garments and produced ecstatic cries - kuka, while ending the recitation of a hymn during a congregation.
Lachi Ber: One of jujube trees in the Holy premises.
Langar: Community kitchen, or a kitchen for all, which every Gurdwara maintains.
Langar-ghar: Building-part where *langar* is run.
Magh: Eleventh month of Indian calendar.
Mahant: The chief of the band of recluses.
Mandapa: A temple's assembly hall.
Mandir: Temple.
Manji saheb: Sacred cot; congregational hall where Guru Arjan used to sit on a cot while supervising the construction of Sri Harimandar.
Masand: Sectarian officials appointed to collect Guru's share from a devotee's income.
Nam: Name; in the context of Sikhism, name of the Supreme.
Nam-simaran: Commemoration of the name of the Supreme.
Nanakshahi: A brand named after Guru Nanak.
Naqqashi: Designing, pattern-making, more often for embellishing a building's interior and exterior.
Nirvana: Salvation; freedom from the cycle of birth and death.
Nishans: Standards comprising a huge pole and flag.
Oudh: A Mughal province, later acclaiming independence. It developed its own style of art and architecture.
Pahul: Rite of baptising to Sikhism.
Pakka: Fortified and enforced.
Panth: Path; sect; community.
Pargana: A sub-division.
Parsada: Anything, mostly some kind of food, distributed amongst devotees after it has been offered at the shrine.
Patti: the name of a village.
Paush: the tenth month of the Indian calendar.
Prakash: Ceremonial installation of the Holy Granth.
Pran-pritishtha: Infusing life into an idol or other material form consecrated for worship by a ritual ceremony.
Pujari: A clergy responsible for performing regular rites in a temple.
Rabab: A musical instrument.
Rababi: The instrumentalist who plays on rabab.
Raees: A rich man with distinction.
Raga: A musical mode of classical Indian musical system.
Ragamala: A garland of *ragas*; all *ragas* threaded together.
Rigveda: The first of the four Vedas - India's earliest scriptures.
Rumala: A large scarf or sheet used for wrapping the Holy Granth.
Sabad-kirtan: Devotional music confined to singing verses only from the Holy Granth.
Sadhu: A recluse.
Samadhi: A tomb; in the process of meditation to fix one's mind into void.
Samavasharan: Deliverance of the first sermon by a Jain Tirthankara after his enlightenment.
Samavasharana-Stambha: The imaginary tower wherefrom a Tirthankara delivers his first sermon.
Sangat: Congregation; also a group of Sikhs congregating at one place.
Santokh-sar: The name of a tank at Amritsar.
Samvat: Era.
Saptahik path: Recitation of the Holy Granth completed in a week.
Saropa: Robe of honour.
Sarovar: Tank, pond, an essential element of Gurdwara architecture.
Sewadar: Officials of the sect.
Shahid Misl: One of principalities of those days.
Shikhara: Tower; a temple's superstructure.
Sodar Rahiras: Another special service rendered in the evening by reciting hymns known as Sodar Rahiras.
Sri: Goddess of riches, prosperity and fertility; a term used before some name to express one's reverence.
Stupa: A semi-circular building structure under Buddhist tradition, built over the mortal remains of Buddha and Buddhist monks.
Subedar: Officer in-charge of a Division or *Suba*.
Sudi: Lunar half of a month in Indian calendar.
Tetreya-samhita: One of the many commentaries on the Vedas.
Tirthankara: The supreme Jain monk who attains enlightenment. In one cosmic age, comprising four aeons, twenty-four monks attain the status of Tirthankaras.
Vaishnava: A follower of Lord Vishnu or one of his incarnations - Krishna, Rama, Narasimha …
Vihara: A Buddhist monastery where disciples of Buddhism could stay, study, meditate and perform worship.

Bibliography

1. **Aijazuddin, F. S.:** *Sikh Portraits by European Artists, London, 1979*
2. **Allen Marguerite:** *The Golden Lotus of Amritsar, Calcutta, 1955*
3. **Anand, Mulk Raj:** *Marg, Vol. X, No-2 (Ed.): Bombay, March 1957 & Vol. VIII-No-30, 1977*
4. **Archer, W. G.:** *Paintings of the Sikhs, London, 1996*
5. **Arshi, P.S.:** *Sikh Architecture, New Delhi, 1986; The Golden Temple, New Delhi, 1989; Darshani Gate and its Portals, Golden Temple (Ed.) Punjabi Uni. Patiala, 1999*
6. **Aryan, K. C.:** *Punjab Paintings, Patiala, 1975; Punjab Murals, New Delhi, 1997*
7. **Bhan Singh:** *Art of the Golden Temple, Advance, Vol. XI, No-3, Chandigarh, 1964*
8. **Brown, Percy:** *Indian Architecture; Islamic Period, Bombay, 1968*
9. **Col, W.O. and Sambhi P.S.:** *Sikhs, their Beliefs and Practices, London, 1978*
10. **Cole H. H.:** *Preservation of National Monuments in India; Golden Temple, Amritsar, Lahore, 1884*
11. **Datta V. N.:** *Amritsar Past and Present, Amritsar, 1967*
12. **Dr. Daljeet:** *Guru Nanak, A Portfolio, New Delhi, 1998; Guru Gobind Singh, A Portfolio, New Delhi, 1999; Mughal and Deccani Paintings from the collection of the National Museum, New Delhi, 1999; The Sikh Heritage: A Search for Totality, New Delhi, 2004*
13. **Dr. Harjinder Singh Dilgeer:** *Akal Takht Sahib, Concept and History, Amritsar, 2000 (Punjabi)*
14. **Fauja Singh:** *The City of Amritsar, New Delhi, 1987*
15. **Ganda Singh:** *Sikh Historical, Monuments and need of their preservation, The Khalsa Review, Lahore, June 1923; Golden Temple, Symbol of Piety and Heroism, Indian National Congress, Souvenir, Amritsar, 1956*
16. **Gian Singh:** *Twarikh Sri Amritsar, Patiala, Urdu-1919, Punjabi, 1977*
17. **Giani Bhajan Singh:** *Sri Harimander Shaib, Chandigarh, 1999, (Punjabi)*
18. **Golden Temple:** *An edited vol. of 34 Articles on the Golden Temple, Punjabi University, Patiala, 1999, by Parm Bakhshish Singh, Devinder Kumar Verma, R. K. Ghai and Gursharan Singh*
19. **Goswamy, B. N.:** *Piety and Splendour, Sikh Heritage in Art, New Delhi, 2000*
20. **Gurmukh Singh:** *A Brief History of the Golden Temple, Amritsar, Lahore, 1892*
21. **Gurmukh Singh:** *Historical Sikh Shrines, Amritsar, 1995*
22. **Gurnam Singh:** *Golden Temple, New Delhi, 1960*
23. **Harbans Singh:** *Encyclopaedia of Sikhism, 4 Vols. Patiala, 1992-99*
24. **Harbans Singh:** *The Heritage of the Golden Temple, S.G.P.C., Amritsar, 1957*
25. **Harnam Singh:** *The life of the Baba Dip Singh Sahid, Lahore, 1923*
26. **Iqbal Qaiser:** *Historical Sikh Shrines in Pakistan, Lahore, 1998; (In English, Urdu and Punjabi)*
27. **Jagjit Singh:** *Temple of Spirituality: The Golden Temple, Amritsar, 1935*
28. **Jodh Singh:** *Life of Guru Amar Dasaji, Ludhiana, 1955*
29. **Johar, S. S.:** *The Heritage of Amritsar, Delhi, 1978; Sikh Gurus and their Shrines, Delhi 1976*
30. **Kahan Singh:** *Encyclopaedia of Sikh Literature, (Mahan Kosh), Patiala, 1960*
31. **Kang, K S:** *Art and Architecture of the Golden Temple, Marg, Vol.-30, Bombay, 1977; Gurdawara Baba Atal, Marg, Vol.-30, Bombay, 1977; Wall Paintings of Punjab, 1979*
32. **Khan, M. W. K.:** *Sikh Shrines in West Pakistan, Karachi, 1962*
33. **Khushwant Singh:** *Ranjit Singh, Maharaja of the Punjab, London, 1962*
34. **Loehlin C. H.:** *The Sikhs and their Scriptures, Lucknow, 1958*
35. **Madanjit Kaur:** *The Golden Temple: The Past and Present, Amritsar, 1982; Personality, Motivation and Achievements of Sardar Jassa Singh Ahluwalia with special reference to his contributions to the Golden Temple, Golden Temple, Punjabi University, Patiala, 1999*
36. **Mehar Singh:** *Sikh Shrines in India, Delhi, 1975*
37. **Mohindar Singh:** *The Golden Temple, New Delhi, 2002*
38. **Narinderjit Singh:** *Around the Golden Temple, Amritsar, Not Dated*
39. **Parkash Singh:** *The Golden Temple and its Chequered History, The Sikh Review, Calcutta, 1964*
40. **Patwant Singh:** *The Golden Temple, New Delhi, 1988; Gurdwaras, In India and Around the World, New Delhi, 1992*
41. **Paul, Suwarcha:** *Sikh Miniatures in Chandigarh Museum, Chandigarh, 1985*
42. **Prof. Joginder Singh:** *Sri Harimander Sahib, New Delhi, 1989 (Punjabi)*
43. **R. Nath:** *Some aspects of Mughal Architecture, Delhi, 1976*
44. **Randhawa, M. S.:** *Kehar Singh and Kapur Singh: Two Punjabi Artists of the 19th Century, Chhavi, Bharat Kala Bhawan, Golden Jubilee Vol.-I, 1971; Sikh Paintings, Rooplekha, New Delhi, 1971*
45. **Rupinder Khullar and Asharani Mathur:** *One day at the Golden Temple, New Delhi, 1997*
46. **Sethi, G. R.:** *The Golden Temple of Amritsar, The Modern Review, Madras, 1930*
47. **Srivastava, R. P.:** *Punjab Paintings, New Delhi, 1983.*
47. **Vijay N. Shankar and Ranvir Bhatnagar:** *The Golden Temple, A Gift to Humanity. New Delhi 2004*

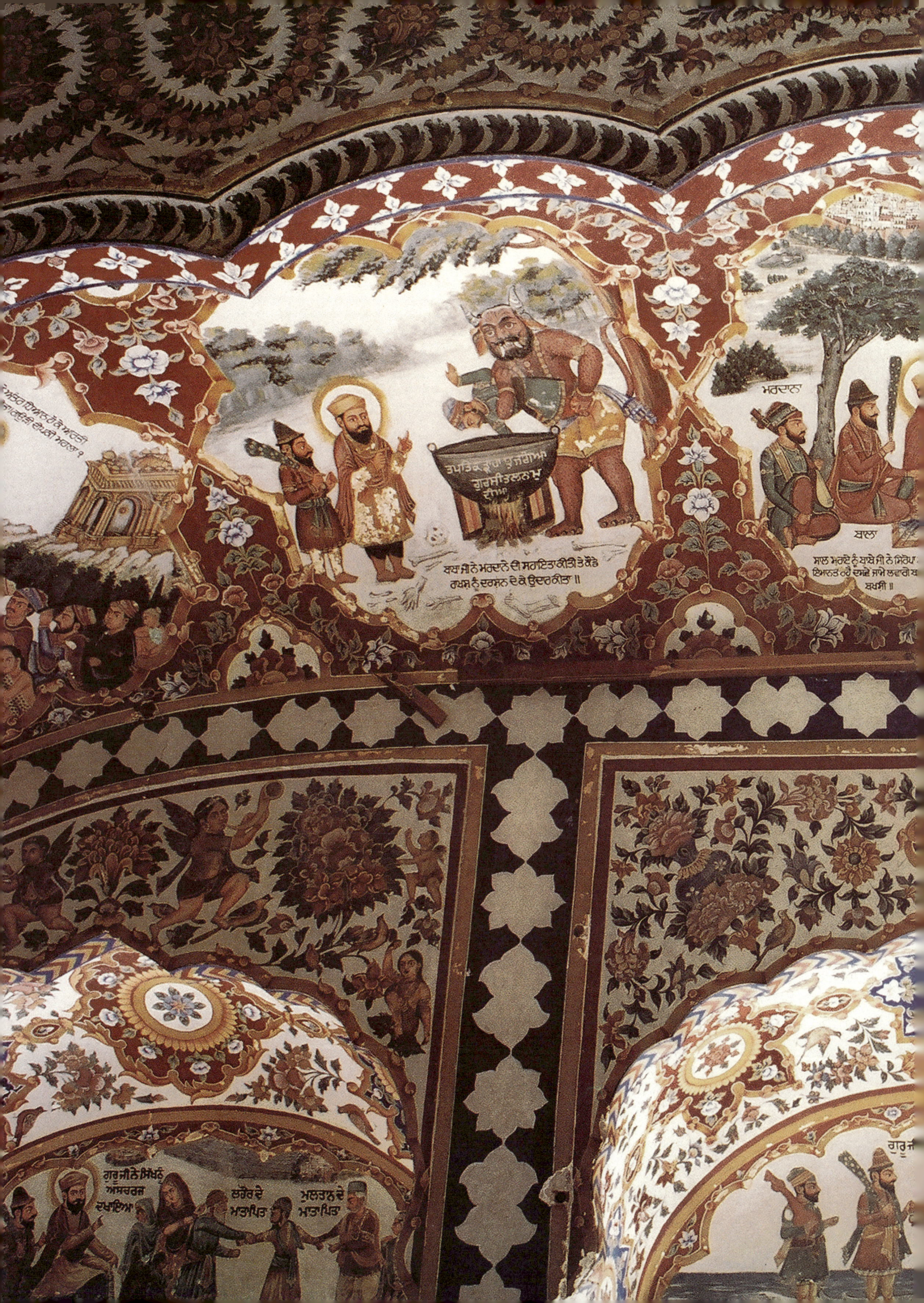